Donated to

**Visual Art Degree
Sherkin Island**

THE GLORY OF VAN GOGH

Nathalie Heinich

THE GLORY OF VAN GOGH

AN ANTHROPOLOGY OF ADMIRATION

Translated by Paul Leduc Browne

PRINCETON UNIVERSITY PRESS PRINCETON, NEW JERSEY

Originally published in France as *La Gloire de Van Gogh:*
Essai d'Anthropologie de l'Admiration

Library of Congress Cataloging-in-Publication Data
Heinich, Nathalie.
[Gloire de Van Gogh. English]
The glory of van Gogh : an anthropology of
admiration / Nathalie Heinich ; translated by
Paul Leduc Browne.
p. cm.
Includes bibliographical references and index.
ISBN 0-691-03269-6 (alk. paper)
1. Gogh, Vincent van, 1853–1890—Appreciation.
I. Title.
N6923.G63H4513 1996
759.9492—dc20 95-21216

Publication of this book has been aided by a subsidy from
the Ministère de la Culture de la Communication, France

This book has been composed in Janson

Princeton University Press books are printed
on acid-free paper and meet the guidelines
for permanence and durability of the Committee
on Production Guidelines for Book Longevity
of the Council on Library Resources

Printed in the United States of America
by Princeton Academic Press

10 9 8 7 6 5 4 3 2 1

To the memory of Laure Bataillon

In attempting to understand strange behavior or an exotic value-system, there is no point trying to demystify them. When discussing the belief held by many primitive people, it is futile to proclaim that their village and home *is not* at the Center of the World. It is only to the extent that one *accepts* that belief, that one understands the symbolism of the Center of the World and its role in the life of an archaic society, that one can come to discover the dimensions of an existence which is constituted as such precisely by the fact that it regards itself as being at the Center of the World.

(*Mircea Eliade,* The Sacred and the Profane)

We work in the dark—we do what we can— we give what we have. Our doubt is our passion and our passion is our task. The rest is the madness of art.

(*Henry James,* The Middle Years)

Contents

Preface

UTTER that so familiar name—"van Gogh"—and a series of motifs spring to mind: the great artist ravaged by madness, his severed ear, Arles, the Irises and Sunflowers, his brother Theo, his tragic death, the *peintre maudit*, the unrecognized genius, his contemporaries' incomprehension, today's record prices for his paintings, and so forth. Today, when such commonplaces are virtually universal, hardly anyone would dream of questioning the received image of van Gogh, of asking what it comprises or whence it comes. That is, however, what this book will do. By retracing the construction of the van Gogh legend chronologically and thematically, we shall discover how a real individual, called Vincent van Gogh, was gradually constituted as a public figure noted for his singularity, admired for his greatness, and celebrated as a virtual saint. From the first writings about his work in 1890 up to the most recent displays of love for him, consensus about his excellence has grown for an entire century. While falling short of unanimity (for as we shall see, there is no celebration without criticism), this consensus is all the more remarkable in that the relativization of taste is an a priori law of the world of painting.

But it is not enough to tell how the van Gogh who died in 1890 became the van Gogh celebrated in the 1990s. What is important is how his case sheds light on the van Gogh "effect," on what stems from him, is summed up in him, and no longer involves just one individual destiny, but, more generally, the status imparted to great singular figures. To be sure, any number of examples could be used to bring the problem into focus, from Joan of Arc to Napoleon, Hitler to Claude François, or Rousseau to Kafka. What makes van Gogh particularly interesting is that he represents today, for a very wide audience, the first great artistic hero.

Such a project may seem fraught with difficulties given the state of the social sciences. After all, their traditional vocation is to divest things of their singularity. The scientific construction of an object of research, especially by way of statistics, requires a labor of generalization that is antithetical to any singularization. Singularity is paradoxical because it can only be analyzed to the extent that it can be compared, and therefore generalized, hence desingularized, that is, stripped of what constitutes its specificity. Nevertheless, that is what I shall attempt to do. I shall deal with van Gogh's singularization as something that confronts us with phenomena that transcend this one case. These phenomena arouse too many suspicions of irrationality to be taken really seriously in the world of scholarship. However, there is sufficient investment in them to warrant a scholar's interest.

In making its object so "popular," in every sense of the word, such investment flies in the face of another academic tradition, namely the view that an object's excellence results from its rarity (just as the goal of singularization contradicts the notion that an object's scientific character is predicated on its general nature). The logic of scholarship tends to measure the quality of an area of research by its originality, too often compelling a researcher to ignore the themes most laden with emotion, and thus—because they are stigmatized as vulgar—dooming them to remain below the very threshold of thought.

This choice leads to a third transgression of the norms: I have adopted the object of my research, van Gogh, as something people have "preconstructed" and invested in. I have not, in my capacity as a social scientist, "constructed" it.[1] On the contrary, I analyze it as it presents itself, both in its ordinary "preconstruction" (inasmuch as it functions as a myth), and in its social-scientific "construction," indeed "deconstruction" (inasmuch as it is stated [énoncé] or denounced [dénoncé] as a myth). Common sense and scholarly discourse will therefore both be treated in the same way, with a concern for symmetry that aims to demolish the "great divide" that no longer separates the anthropologists' "them" (primitives) and "us" (those who are civilized), but rather now separates "us" (those who construct or deconstruct myths) from "them" (those who believe in myths) among social scientists in our own society.[2]

That is also why I prefer to speak of the "anthropology" of admiration rather than of sociology, even though I am studying phenomena belonging to our society, with which reader and scholar are a priori equally familiar. The discourse of sociology is still too caught up in normative expectations—which make of it an instrument for managing value conflicts or "social problems"—not to entail the risk of an apologetic or critical reading, which would seek arguments for or against admiration. To speak of anthropology is, on the contrary, to indicate that I hope that my readers may display the same detached curiosity, the same neutrality with regard to the values they observe, and the same taste for keeping a distance from the most familiar phenomena, which they would readily apply to faraway peoples.

In accordance with this anthropological outlook, I favor what is known as "participant observation" in ethnology, rather than the production of ad hoc material—statistics or interviews—that is practiced in sociology. Thus the work presented here was conducted exclusively through the gathering and observation of writings, words, images, and behavior relating to van Gogh. This choice is justified to begin with because such documents were rich enough to foster thought (this richness is symptomatic of what makes a "good object," namely one that is heavily invested in and,

consequently, very present in words, actions, and things). On the other hand, if I have not sought to get people to speak about van Gogh [*"faire parler" sur van Gogh*], it is not just because the subject "speaks for itself" [*"ça parle" tout seul*], but also because in matters of admiration and celebration every request for justification produces a backlash. For, in inducing interviewees (admirer, museum visitor, or pilgrim by the graveside) to provide an account of their experience, one forces them out of their participatory stance, which does not fall within the province of "critique," and throws them into a position of justification.[3] This, however, amounts to enrolling the addressee in the community of admirers and celebrants; that is why it could not be solicited without displacing both the position of the object observed, and the position of the observer.[4] This is a risk I have preferred not to take.

This research is part of a work-in-progress devoted to the history of the notion of "artist" in France. I shall not deal here with the genesis or previous history of the phenomenon under scrutiny; they will be the subject of a future book. I have chosen to center my topic on France, excluding other countries, although I have taken the internationalization of the phenomenon into account. Short of a genuine comparative study, the juxtaposition of different national contexts, by merely adding up the data, loses in explanatory power what it gains in breadth of description.

Finally, to these warnings that bear on what is expected in social science must be added a precaution aimed more specifically at readers who are not specialists in history, sociology, or anthropology, but are interested in my topic above all because it involves van Gogh. He has been the target of investment in a manner that raises a fundamental problem: one cannot avoid an emotional engagement with him—either in "being taken with" him [*en y étant "pris"*], or in growing estranged from him [*en s'en déprenant*].[5] So it goes with admiration: the mere fact of distancing oneself by taking an interest in the characteristics of admiration rather than in the admired object implies withdrawal, detachment, or disengagement. From the point of view of the admirer, such an attitude tends to be perceived as a refusal to admire and, directly or indirectly, as a critique or denunciation of admiration itself. There is, in other words, no "neutral" position. Every neutralization per se means taking a stand. Although as respectful as possible of the "axiological neutrality" assigned to the scholar, my approach therefore runs the risk—but there is nothing I can do about it—of disappointing the expectations of the artist's admirers.[6]

This work was accomplished thanks to the Centre national de recherche scientifique (CNRS), in the framework of the Groupe de sociologie politique et morale of the Ecole des hautes études en sciences sociales. I have

benefited from long exchanges with Francis Chateauraynaud and Charles Fredrikson, as well as from the criticism and encouragement of Jean-Paul Bouillon, Luc-Henry Choquet, Elisabeth Claverie, Jean-Pierre Criqui, Dario Gamboni, and most especially from the attentive gazes of Marc Avelot, Luc Boltanski, and Michael Pollak. May this book be my thanks to them all.

Part I

DEVIATION, RENEWAL

One

From Silence to Hermeneutics

THE POSTHUMOUS MAKING OF
VAN GOGH'S OEUVRE

THE FIRST article specifically devoted to van Gogh was published several months before his death in 1890 by Albert Aurier. This young French critic enthusiastically praised van Gogh, that "isolated figure." Two years later, a Dutch critic was already calling van Gogh a "genius."[1] By 1905, Dutch and French critics had cemented the main elements of his "legend": passion, tragic fate, devotion to art, heroism, and martyrdom. Finally, three decades after his death his "critical fortune" reached its zenith on the international scene.[2]

In marked contrast with this evidence of both swift and affirmed recognition, the legend put forth to this day (and today more than ever) gives the impression that van Gogh was the victim of incomprehension. Here, for example, is just one of the many colorful, semihistorical, semifacetious stories of uncertain origin and status still current:

> One day, Père Numa-Crohin loaned one hundred *sous* to Vincent who, with thoughts only for painting, quickly forgot about the loan. On a day that the notable was drinking at the Ravoux inn, Vincent remembered that he was in debt to the worthy man. That very day, Vincent borrowed a wheelbarrow, filled it with canvases and called upon old Numa-Crohin. . . . "I cannot pay you back," apologized Vincent, "but take the paintings, perhaps you will profit by them!" Numa-Crohin, who was a good fellow, but did not care much for the artist's painting, refused: "Let us consider that you have paid me back," he said. And Vincent went off with his wheelbarrow full of paintings. *The legend tells* that the worthy man's wife added: "You could, at least, have kept the wheelbarrow." One can imagine, at the present time, that the descendants of this old Auvers family regret their ancestor's decision![3]

What are we to make of this motif of incomprehension, indissociable as it is from the image of van Gogh that has reached us? To what extent is it justified—and, if it is not, or is only partly so, why does it remain so insistent?

The Motif of Incomprehension

The discrepancy between the public's legendary lack of understanding and the critical reception van Gogh actually received can be explained in terms of the difference between these two levels of recognition. Nonspecialists spontaneously tend to lump them together in the common and undifferentiated category of the "public" ("people"), pitted in a global manner against "the artist." Reality is more complex. At least four subsets of observers and judges of painting may be distinguished; they are uneven in number and removed to varying degrees from the artists. There are first of all the peers (who are both colleagues and competitors), then the critics, followed by the dealers and collectors, and finally the general public. Those are the "four circles of recognition";[4] the closer they are to the artist, the narrower they are.

Of these four categories it is the general public that generally takes longest to award its recognition—the more socially removed people are, the greater the time lag seems to be. If there was, in the case of van Gogh, a lack of understanding or an unwillingness to understand, it most likely stemmed from this nonspecialized audience which, between "laughs" and "trepidation," must have demonstrated much more stubborn, even hostile opinions, and for much longer: "Here I am finally in the fifth room, the one which is first of all devoted to curious and unusual things, where there are bursts of laughter, where young admirers lecture to each other, where discussions and trepidation come easily."[5]

But we are reduced to conjecture here. While critics necessarily leave traces of their activity in newspapers and specialized works, by contrast the general public's opinion is condemned to the ephemera of the spoken word, and is scarcely handed down to posterity—except where public opinion surveys are available, and they of course did not yet exist at the time. Hence, I can and will analyze in the finest detail the criticism published at the time; but as a historian I cannot really gain access to ordinary perceptions and judgments that do not fall within the ambit of any special, authoritative discourse or practice. Only anecdotes have reached us, through the memories of some witnesses of the time. This is fragile testimony because it is subject to forgetfulness, and all the more so when it was written down after the fact. It is subjective testimony because it is liable to be deformed, and all the more so in that the witnesses bought into that system of opinions.

Several stories in Ambroise Vollard's *Souvenirs d'un marchand de tableaux* illustrate the motif of incomprehension. For example, an art lover was drawn to van Gogh's *Field of Red Poppies*, but eventually preferred to pur-

chase a Detaille for his daughter's dowry. Detaille, an official painter, was a student of Meissonier specializing in patriotic canvases and was a solid investment at the time. Twenty-five years later his work had ended up in the attic of the Musée du Luxembourg, while the price of the van Gogh was already over 300,000 francs.[6] Vollard's depiction of an outraged art dealer suggests that incomprehension could also be found among the professionals of the art world.

> Van Gogh had until then succeeded only in generating laughter, when he did not arouse anger. One day I saw an art dealer beside himself with fury: "The nerve of some people!" he explained. "I had an enthusiast considering a *Cook* by Joseph Bail, and this fellow came and offered to sell me a canvas by someone called van Gogh, a landscape with, in the sky, a multicolored moon which looked like a spider's web. Just the thing to keep the customers coming back!"[7]

Only a few art lovers escape being put on display in this gallery of missed opportunities, blunders, or judgments heavily contradicted by posterity. There is Père Tanguy, famous for having transformed his paint shop into a place to exhibit the great unknowns. There is the collector who was so attached to his *Sunflowers* that, when his physician prescribed a shock to pull him out of a dangerous state of prostration, only the threat of selling the painting succeeded in curing him.[8] Finally, as far as the judgment passed on van Gogh by his peers is concerned, Vollard minimizes Gauguin's or Emile Bernard's praise and emphasizes their reservations. He thus presents as examples of rejection the ambiguous words of Renoir and Cézanne. "It was even worse for van Gogh [than for Cézanne]: the boldest could not manage to stomach his painting. How could anyone be surprised by the general public's resistance, when the most liberated of artists, like Renoir and Cézanne, could be seen, one reproaching van Gogh for his 'exoticism,' the other telling him: 'Quite honestly, your painting is mad!'"[9]

The First Critical Reviews

Despite the hazards of this fragmentary and most likely not impartial documentation, we can accept that van Gogh's work, in the first generation after his death, encountered a lack of understanding from the general public at the same time as it met with the recognition or interest of a small number of art lovers or specialists, including the critics. Taking only the negative reactions of the general public into account—laughter, shrugs, indignation—one would be hard pressed indeed to understand how the "isolated van Gogh" became "van Gogh the genius." How, in other words,

did attention, interest, and admiration arise out of the indifference and oblivion to which the marginal are doomed? How, as a result, were a set of pictures constituted as *works*, and these works into a series of masterpieces?

We shall carry out this investigation by means of an exhaustive examination of the complete body of the first published texts on the works of van Gogh (see Appendix A). Even then, a distinction has to be made. Specialized criticism, whose role was just beginning to lean toward the discovery of original talent rather than toward the confirmation of the canons, must not be conflated with journalistic writing which is closer to the general public. The critics' texts do not reflect some "public opinion," but the very specific point of view of specialists in aesthetic judgment. They are subject to determinations that are all the more complex and subtle for having been developed in a realm of tight competition, which is restricted to a few people and a few days, a few weeks or a few months, according to the topicality of exhibitions.[10]

The method employed here will borrow less from sociology (which would not be satisfied with the study of texts alone[11]) and from art history (which would be content with a selection of the most relevant), than from history, in keeping with the two objectives that are specific to the historian's work: "to follow the plot" and "to clarify."[12] Let us therefore follow the enlightened opinion of the experts step by step through the critical reviews published in France on the occasion of the first collective exhibitions (*Salons* and dealers) at which van Gogh's canvases were shown. These reviews were written during the ten years following the painter's death, when no exhibition devoted specifically to van Gogh had yet taken place. The first, marking the outcome of this critical activity, was to open at Bernheim's in 1901. The first catalog in French was published on that occasion, followed by others in 1905, 1908, 1909. No book reproducing his works was published until 1907. The first biography appeared in print in 1916 (see Appendix B).[13]

From Silence to Speech

> Mr. van Gogh vigorously paints broad landscapes, without very great care for the value or exactness of the tones. A multicolored multitude of books evolves towards a tapestry; such a motif, although suitable for a study, cannot afford the pretext for a painting.

These are the first published lines about van Gogh. They appeared in April 1888, two years before his death, in Gustave Kahn's review of the Salon des Indépendants, which included various representatives of the "Neo-

Impressionist Group" (in particular Seurat, Signac, Pissarro, to mention only the best known among them).[14] This roster explains the brevity of the commentary, which in no way awarded pride of place to van Gogh among so many others.

What does this short text say? On the one hand, it speaks of the paintings' motifs ("great landscapes," "a multicolored multitude of books") and their appropriateness ("this motif, which is suitable for a study, cannot be the pretext for a painting"). On the other hand, it addresses the technique of execution ("vigorously paints," "without very great care for the value or exactness of the tones"). What remains unsaid? The man behind the painting, who is evoked only by his name ("Mr. van Gogh"). Does the text pass judgment? Hardly. The statement first and foremost describes subject and technique. What form does this judgment take? An ambivalent one, with the rather positive connotation of "vigorously," and the negative one of "without very great care," and of "cannot be the pretext for a painting."

That which is painted, the art of painting, the painter (or also the motif, the picture, the author): these are the objects of discourse. Silence, neutrality, judgment: they mark the degree of opinion. Positive, negative, or ambivalent: they constitute the form of this judgment. Object, degree, and form of opinions will thus be the principal variables in our "plot" throughout this decade of critical reviews. An ambivalent judgment bordering on neutrality, dealing with painting and what is painted to the exclusion of the painter: such is the shape of the first printed point of view on van Gogh—and the least one can say is that there is not much there to make a fuss about.

No more, for that matter, than in the few lines—still concerning the Salon des Indépendants where the *Irises* and the *Starry Night* were exhibited—penned a year later by Félix Fénéon.[15] Without stigmatizing them, the general, detached, and even skeptical tone ("Mr. van Gogh is an entertaining colorist") takes aim with the preciousness of a dandy at the "extravagances" ("even in extravagances such as his *Starry Night*") committed by pictorial material that occludes the subject or, in other words, painting that covers up nature: "On the sky, squared into a broad weave by the flat brush, the tubes have distinctly placed cones of white, of pink, yellow stars; orangey triangles sink into the river, and, near the moored boats, baroquely sinister figures hurry along."

Fénéon was a modernist critic on three accounts. He defended the impressionists and neo-impressionists. He initiated an art criticism geared toward formal description much more than the content or subject of works of art.[16] Finally he practiced a stylistically very marked mode of writing, in keeping with his interest in work on pictorial *form* rather than in the motifs of paintings. Yet van Gogh is no hobbyhorse for him. Faithful to his stance

of critical modernity, he is content to note the technical particularities of the two paintings, neither giving them credit for being deliberately innovative, nor discrediting them as lacking in mastery. They are simple "extravagances," marked in their singularity, without further ado.

It is in this same year, 1889—van Gogh is still in Provence—that a critic breaks this neutrality for the first time: "Here are canvases by Vincent, tremendous in their ardor, intensity and sunshine." Even more laconic on the subject of van Gogh than Kahn and Fénéon, "Luc le Flaneur" published these few words in an article about several art dealers (Tanguy, Theo van Gogh, Durand-Ruel, and others), who defended those "unknowns of today, masters of tomorrow," in particular Cézanne, Guillaumin, Emile Bernard, Degas, Pissarro, Gauguin, Forain, and Renoir.[17] It is worth noting, in this first instance of a clearly positive judgment, the use of van Gogh's first name, "Vincent." This could indicate that the writer knew nothing about the painter, and deduced his patronym from the signature on the paintings alone. It is more likely, however, that he meant to distinguish Vincent from his brother Theo.

Luc le Flaneur was the pseudonym of Georges-Albert Aurier, the young critic who, a few months later, on January 10, 1890, published in *Le Mercure de France* the article on van Gogh that was to become famous for having been "the first published during [his] lifetime."[18] To be more precise, it was the first devoted specifically to van Gogh, along with a few other "isolated ones," such as Groux, Carrière, and Henner. Van Gogh had previously been mentioned in short reviews. Here, now, was a fairly long article, a feature at least as remarkable as its expressly laudatory character. At this stage in our analysis, the question is not so much how van Gogh was appraised, but how he was, simply, noticed, chosen as the object of a specific text, thanks to which he escaped from the virtual silence of occasional minor reviews. It is first necessary to inquire not into what was said about his painting, but into the very fact that something could have been said about him, rather than nothing at all. The traditional criterion in matters of opinion—"pro" or "con"—is not relevant at this stage. Just speaking means taking a stand. In Aurier's case, this could only be a stand against the silence of his peers, or almost, on the subject of van Gogh, much more than against the general public's harmless invective.

A better measure of the polemical dimension of Aurier's words is provided by his vehement declaration of support, two years later, for the impressionists, symbolists, and "young innovative artists," and of opposition to the "critics," the "regular customers," the "dealers," and the "juries."[19] It is plain to see how, in differentiating van Gogh from other artists, he differentiates himself from other critics, from whom he distinguishes [*se démarque*] himself by the mere fact of noticing [*remarquer*] a painter.[20] The writings of this young, twenty-four-year-old critic not only trans-

formed van Gogh's critical fortune, but also significantly boosted his own (brief: he would die three years later) career. His review "having achieved great success, he was offered the art column in *La Revue indépendante*."[21]

From the Ancients to the Moderns

> An excessive nature in which everything, beings and things, shadows and lights, forms and colors, rears up, stands up with the raging will to howl out its essential and very own song.

The rhetorical emphasis with which Aurier expresses his admiration owes much to the context of underlying polemics, where not only individual tastes but collective partisan stands, coteries, and cliques confront each other. At stake here is not just the clash of independent and official art, on the familiar lines of the previous generation, but also the proliferating markers between different categories of independent art. Fénéon, for example, saw a distinction emerging in the 1880s between neo-impressionism and impressionism, which had already become classical, so to speak, in the eyes of the most advanced members of the avant-garde. For Maurice Denis[22] and Aurier,[23] respectively, the 1890s introduced the new artistic tendencies of neo-traditionism and symbolism.

Aurier's outburst in favor of van Gogh must therefore also be understood as the pretext for taking a more general stand, with respect not just to van Gogh, but to all contemporary painting and criticism, divided—in the image of the artists—between ancients and moderns and, among the latter, into several unevenly advanced categories. Thus the judgments expressed in Aurier's virtual manifesto tell more about their author than about his object,[24] who had become the standard-bearer of a struggle for modernity, the "cause" in an aesthetic guerrilla war in which the positions of the critics get replayed at the same time as those of the artists.

This situation had become normal after the preceding years' struggles on behalf of the impressionists—to which the very existence of the Salon des indépendants, where van Gogh was exhibited, bore witness.[25] For it was from then on virtually official that the criteria of taste had shattered. The fundamental line of demarcation between the "good" and the "bad" no longer operated on a unilateral scale opposing good painting (guided by the academy) to bad painting (deceived by fraud). The traditional criterion of common values reproduced by academic apprenticeship was joined with a modern criterion of rare values invented in the repeated break with the canons, in the individualized creation of new ways of doing things.

This swing from tradition to modernity marks the passage from a system of values that favored "relative" excellence (in that, like the superlative, its

measure was comparison with its peers and the representatives of tradition),[26] to a system favoring "absolute" excellence, in that only negative comparison—distinctive and no longer imitative—with others is allowed. These are two antinomic ways of constructing greatness. On the question of creation, they find anchorage at the two opposed poles of the spectrum of artistic value that reaches from technique to originality.[27] In the first case, emphasis is laid on technical competence, measured by the mastery of the canons. In the second, originality is affirmed in irreducibility to, or at least differentiation from, recognized models. This shattering of reference systems can also be described, following Luc Boltanski and Laurent Thévenot, as a tension between two "natures": in the evaluation of pictorial values, the "inspired" nature of modern innovation—favoring distance from routines, novelty, individualized invention of new and original skills—is superimposed on the "domestic" nature of academic tradition, which favors proximity, seniority, maintenance of the existing ties in the community.[28]

This polemical duplication of reference systems in matters of painting had already begun with the Romantic movement of the 1830s, around Delacroix. It continued with the Realist movement of the fifties, around Courbet, reaching its high point with the general public and the critics from Manet and the impressionist movement of the 1860s and 1870s onwards.[29] The institutionalization of this duality had begun with the proliferation of exhibition sites.[30] Its officialization gave rise to one of the great artistic scandals of the century's closing years, the Caillebotte affair which towards 1894 shook "public opinion." The latter was divided as to whether the state should accept a donation largely made up of impressionist works. This "division" was in fact to lead to the legacy being broken up, only a fraction of it being exhibited at the Musée du Luxembourg.[31]

The old and new, classical and modern, academic and avant-garde reference systems are not only different, because they are founded on heterogeneous values. They are moreover incompatible, by virtue of the fact that modernity, answering to an ethic of rarity, is precisely constructed on the refusal of the traditions that an ethic of conformity would favor. One is denounceable as snobbery, the other as conformism. The reciprocity between nonacademic artists and modernist critics must be understood in this highly polemical context. The artists offered the critics the opportunity to defend and illustrate their positions, while the critics enabled the artists to escape denigrating contempt or, worse still, the scornful silence of the traditionalists.[32] Van Gogh's case illustrates the strength of this new cleavage. The moderns invest in van Gogh as an oddity to be elucidated and as a standard to be unfurled in a battle over boundaries, in which the abundance of counterreferences provided by the academy is opposed by the rarity of buttresses offered by the state of modern painting.

From Modernity to the Avant-Garde

But the stakes were not only of an aesthetic nature. From the moderns' point of view, the party of tradition, of the community of values learned and reproduced in the academy, is associated with the bourgeois (philistine). The party of innovation, of the rarity of values invented in inspired independence, is associated as much with the artist (the genius) as with the people (the lower classes).[33] Thus Aurier's article on van Gogh can contrast "the contemporary bourgeois mind," "bourgeois sobriety," and the "minutiae" of "our pathetic art of today," with the art of the moderns, which only "his brothers, those artists who are truly artists . . . and the blessed souls of the common folk, the very humble folk," can understand.

In this ethic of rarity, this logic of severance from what is common and run-of-the-mill (personified by the bourgeois or the grocer), aesthetic positions coincide with social or political ones. The bourgeois majority is contrasted with the minority doubly embodied by the (marginalized) artist and the (oppressed) people, both of which are denigrated or scorned by the bourgeois. The critic's activity becomes very much more than a mere question of taste left to the arbitrariness of subjectivity. Rather, it is very much an attitude toward the world, an ethic, and even a politics projected into the values of creation. Typically embodied by the poet or the painter, creation came to be an object of investment, as it crystallized a dual logic of distinction from the commonplace and of increasing rarity of the elect. In this logic of inversion, poverty was converted into proof of quality, opposition into a mark of greatness, and marginality into a principle of excellence.

Embodied in the figure of the left-wing intellectual in the same way as the figure of the grocer typified bourgeois conformity, the notion of the avant-garde exemplifies this logic. There has been a slippage in the meaning of the term "avant-garde." Originally pertaining to the study of war, then acquiring a political dimension with the Saint-Simonians during the first half of the nineteenth century, it finally becomes specifically artistic with Baudelaire. Well beyond questions of taste or opinion, the avant-garde apology of innovators is built upon the religious model of prophecy. Projected onto the political plane, it adopts the figure of the anarchist leader, so familiar in the current events of the time. On the artistic plane, it appropriates the figure of the precursor-genius, revolutionary by virtue of his art and, as much as possible, revolted by society.[34]

Of course a prophetic critic had to be able to designate, amid the many "independent" or "isolated" painters, an artist-prophet able to embody the new truth of art—and beyond this, perhaps, the new truth as such. On the artistic and social planes, Aurier can be seen projecting a doubly messianic expectation on to van Gogh: "the obsession, which haunts van Gogh's

brain, of the current necessity of a man, a messiah, a sower of truth, who would regenerate the decrepitude of our art and perhaps of our stupid, industrialist society."[35] This renovating messianism attributed to van Gogh is directly associated with his affinities with the common people—a motif which was to recur as a leitmotiv in his biographies:

> Vincent van Gogh is, indeed, not only a great painter, who is enthusiastic about his art, his palette and nature; he is moreover a dreamer, a rapturous believer, a devourer of beautiful utopias, living by ideas and dreams. For a long time, he revelled in imagining a renewal of art. . . . Then, as a consequence of this conviction of the need to begin everything anew in art, he hit upon—and long cherished—the idea of inventing a very simple, popular, almost childish manner of painting, one that could move humble folk who do not refine [sic], and could be understood by the most naive of the poor in spirit.

This dual reduction—to the state of hobbyhorse in the polemical universe of art criticism, and to the rank of virtual prophet enrolled in a largely nonartistic cause—may be what induced van Gogh to react when, having read the article, he wrote to Theo, then to Aurier himself, to tell of the unease it caused him, and of his desire not to be spoken of.[36] Biographers would tend to attribute this reaction to a refusal, as remarkable as it is worthy of respect, of the false values of renown. But is it not also due to van Gogh's sense of alienation in being invoked as the paragon of a cause, but in fact merely being used like some skewered butterfly as a suitable specimen to represent a school (art-history version), or like some choice thoroughbred as a favorite likely to bring triumph to its stable (art-criticism version)?

From Common Sense to Scholarly Discourse

Be that as it may, the avant-garde critic's voluntaristic populism is at odds with his elitist manner of speaking. Guided by common aesthetic values, the "people" and the "bourgeois" are equally likely to miss the subtleties of the critics' discourse. This is the essential property of the ethic of rarity that guides the scholar, and that Huysmans so perfectly embodied in the artistic and literary field of the 1880s. For even if he intends to lean on the people, the better to dissociate himself from the bourgeois, the scholar by his utterances alone brings about a break between common sense, which belongs to the ordinary world of everyday language, and scholarly discourse in its avant-garde form. This contradiction is irreducible. As possessors of knowledge struggling against the material domination of the possessors of wealth, the avant-gardes cannot develop the instruments of their

intellectual domination other than by cutting themselves off from their popular allies.

Thus Aurier's aesthetic avant-gardism is most likely to disconcert, indeed exasperate, the poor he exalts, no less than the rich he abhors. First he picks a painter characterized by the rarity of his work rather than by respect for the common values that are most accessible to nonspecialists. Then he practices a very formalistic style of writing, notably peculiar in the anthropomorphic lyricism of its descriptions. Finally, he adopts an equally formalistic point of view, focusing less on the subject or the referent of the paintings (as spontaneous perception would, projecting the categories of the ordinary world on to the works of art),[37] than on the signifier—in other words, form, technique, and stylistic peculiarities: "strange, intensive and feverish works," "sometimes (but not always) great style," "investigations of a most curious order," "vigorous execution," "powerful draughtsmanship," "dazzling color."

This indissociably plastic and literary formalism was not unique to Aurier. Various critics of the late nineteenth century focused both on the technical peculiarities of pictures (demonstrating the specifically aesthetic perception developed by scholarly discourse), and on stylistic effects (showing how close art criticism was to literature). Aurier merely carried this tendency to extremes, transforming the probable insufficiency of his visual culture into a stylistic resource. This induced him to emphasize the form of his own writing rather than van Gogh's form, that is, his painterly technique: "Such is, and without exaggeration, although one might think so, the impression left on the retina by the first looking at the strange, intensive and feverish works of Vincent van Gogh." If Aurier waxes literary more than he analyzes style, it is that, contrary to Fénéon, a properly plastic sensibility was no doubt not his first and foremost characteristic.

From the Eccentric to the Categorical

Modernism, avant-gardism, scholarly elitism, formalism: beyond his taste for the few paintings to which he refers, Aurier's text clearly forms part of a broader movement that not only transcends his and van Gogh's personality, but also more than the field of painting and art criticism. It is a miniature expression of an aesthetic and ideological partisanship. The latter remains informal, unlike political parties; but its ethic of rarity just as compellingly brings together those who henceforth derive their sense of honor from being unlike the common herd, from withdrawing from ordinary values in order to reconstitute small communities of practices, tastes or opinions around extraordinary values.

It thus becomes clear why this defense of a "robust and genuine artist" did not remain purely eccentric, although the text could have drowned in indifference, like van Gogh's paintings themselves, had no one singled them out amidst the anonymous mass. Far from being as isolated as the work it was defending, Aurier's "outburst" was taken up by most of his peers, and came to represent an opinion commonly held among critics, a quasi-*doxa*. Initially suspended in silence, van Gogh's painting in this way took on a *categorical* value, that is, became a category of reference, and was praised more and more categorically.

Thus, although both reviews devoted to him shortly afterwards in the context of the Salon des Indépendants were markedly less radical than Aurier's manifesto, they did seem rather favorable. The first noted the "ferocious thickening-out," the "exclusive use of easily harmonizing colors," which "lead to powerful effects" and "make a strong impression."[38] The author of the second review, explicitly siding with "our friend G.-Albert Aurier," hailed van Gogh as a "great artist," whom he compared to Salvator Rosa as a "tormented spirit." He went on to describe him as an "instinctive," "rare genius," "a born painter," a "rapturous temperament," gifted with "a power of expression [that] is extraordinary," who "glimpses objects within nature, but only really sees them in himself," with a "harmonious strangeness" in which "line and color unite."[39] The same writer returned to this topic a year later, describing van Gogh as the one "who was and remains a great painter of this century," and labeling his *Resurrection* as the "masterpiece of the exhibition of the Indépendants and, moreover, a masterpiece," concluding with firm concision: "All has been said about this admirable artist."[40]

In the meantime, in March 1891, more than a year after Aurier's article, therefore, and still concerning the Indépendants where van Gogh was now exhibited posthumously, Octave Mirbeau had published a solid analysis that engaged in just as sustained praise of this "magnificently gifted," "shimmering," "instinctive," "visionary" painter, who had "wonderful qualities of vision," "acute sensitivity," "moving nobility," and "tragic grandeur," acquired at the cost of "unremitting labor" and a "life without rest."[41] Two other brief reviews published during that same spring of 1891 confirmed his outlook. The first evoked a painter who had "died tragically," who was "unbalanced" but "original and impulsive," whose "means of expression [indicate] a strong and rare personality," and whose "several [powerful] works" "evoke tragic or gentle sensations."[42] The second spoke of a "chaste, . . . relentless worker and a mystic," who had "a powerful imagination [and] all the gifts of the painter."[43]

In April 1892, in an article entitled "The Symbolists," Aurier once again hailed the "powerful originality" and "unforgettable strangeness" of this

"extreme and sublimely unbalanced artist," heaping praise as dithyrambic as two years before on "his genius," "his lofty and multiple preoccupations," and "the blinding intensity" of his canvases.[44] Around the same time, another article was published in relation to an exhibition at Le Barc's, where van Gogh's drawings were shown for the first time. In an apology of "inspiration," this article on a more technical level praised the "first-rate drawings," that "many 'artists' (the serious ones) would be incapable of drawing," and that were due to an "inspired" painter, "skillfully modeling with the paste itself," with the "rare eye of an experienced colorist."[45]

In September 1894, a short paragraph devoted to van Gogh in relation to a trip to Provence (rather than an exhibition) celebrated his "genius," his "magnificent sincerity" and his "colorist's temperament," able to render "the excess of this nature" to such an extent that, in the face of it, "only one name could spring to mind" (van Gogh's own) next to which Mr. Signac's proved "pitiful."[46] The following year, an exhibition at Vollard's drew a commentary that was still full of praise, although less dithyrambic. Here, the writer hailed the "famous, colorful, and frank sunflowers," the "new forms of that poor and simple furniture," as well as a "magisterial portrait of himself" (the first mention of a self-portrait), and remarked on the pleasure he felt before these "characteristic, bold, new, ruggedly attractive canvases."[47]

The year 1896 brought with it the publication of the first work of aesthetics in which van Gogh's name appears, next to those of Puvis de Chavannes, Gustave Moreau, Odilon Redon, Paul Gauguin, and Cézanne. Inclusion in such a select body necessarily implied high praise, since it meant being picked as one of the few names worthy of being remembered.[48] Despite some reservations or, at least, ambivalence ("through this chaos, occasional bolts of lightning"), the author judges van Gogh very favorably: a "broad, unctuous paste," tones that "blossom in sprays of fireworks," thanks to which he "found . . . ways of lifting the colored scale to a high level of intensity," "one feels an ardent spirit endeavoring with difficulty to find a way out," "a fervent, feverish, almost delirious pursuit of the maximum wealth of colored splendor." Finally, an exhibition at Vollard's in January 1897 gave rise to renewed praise. Discussing van Gogh's landscapes and portraits (freed from the "original resemblance and aspect under which people had been accustomed to see them defined"), André Fontainas speaks of an "effervescence of lights" and an "unbelievable feast for the eyes." He concludes that van Gogh is "one of the first and most resolute . . . observers," and plays a "considerable" role next to Cézanne "in the most recent movement of French painting," noting that his "influence appears as important as that of Gauguin."[49]

A Disqualified Disqualifier

There is only one exception to be found amid this concert of praise, an article Charles Merki wrote about an exhibition at Le Barc's in 1893, three years after van Gogh's death. The title alone, "Apology of Painting," indicates that here again van Gogh is the pretext for staking out a more general position with respect to painting.[50] Merki advocates an attitude diametrically opposed to that of Aurier and other critics. He defends the traditional qualities of "excellence of brush-work," "acquired knowledge," "skill of the hand," "deftness," and "execution." In even stronger terms, he assails the (false) values of modernity, "symbolists," "impressionists," "daubers," "authors of pastiches," "cheats," who are "clever" and "deranged." In general, he attacks "contemporary painting," this "derision" adulated by the "clans" and "cults," the "snobs" and "little women," the "idolatry" and "fame for a week." Courbet, Manet, van Gogh, Gauguin, Toulouse-Lautrec, Signac, Maurice Denis, Vallotton are expressly designated as targets of this all-out attack against every embodiment of modernity, even if representatives of the academy, such as Meissonier, Detaille, or Bouguereau are not spared either. The occasion of this settling of accounts was the "chamber of horrors" in which were gathered the works of "contemporary painting," which bore the threefold stigma of being in poor taste ("love of ugliness, of vileness"), being a hoax ("humorous sketches, workshop jokes"), and being insane ("lunacy in its final stage," "work of a brotherhood of madmen").

Having therefore decided to examine "whether the alarm of the curious before Vincent van Gogh's pastries and Mme. Jacquemin's stiffs is not, in good faith, a tiny bit legitimate," the author dwells with obvious jubilation on the former: "But I am beside myself with happiness in naming Vincent van Gogh." Merki's argument does not so much consist in detecting van Gogh's faults and failings as in taking up the qualities sung by other critics, but in an ironic vein. Thus the work's "loftiness" quite literally designates the thickness of the layer of pigment on the canvas. "This is a genius, a purebred colorist (you know, today, everybody is recognized as having genius). He has found not only admirers, but imitators. His so abundant color, which in many places is several centimeters high, has aroused infatuations. And yet, how can one not believe it is a fraud?"

Fraud, vulgarity, and lunacy make up the threefold stigma of the painterly avant-garde: absence of seriousness, absence of taste, absence of reason. This triple accusation feeds upon a peculiarity that Fénéon had detected very early on, namely the way "matter" overshadows the "subject," painting the object painted, the concreteness of pigment, the colored ef-

fect. This technique subordinates the pacified purity of a dematerialized signified (the "ideal nature" of classical aesthetics) to the aggressive impurity of a raw signifier, reduced to the vulgar immediacy of the materials, of the instrument, of the gesture.

> This man has fought with his canvases. He has hurled clay pellets at them. He has taken mortar from a pot, and flung it before him while tasting the scoundrel's joy in striking blows. Whole trowelfuls of yellow, red, brown, green, orange, and blue, have burst into flower like the fireworks of a basket of eggs thrown from the fifth story. He has brought this to the pump and, with his eyes closed, has drawn a few lines on it with a finger soaked in gasoline. Apparently, this represents something, pure chance, no doubt. And, as a wag has it, one cannot quite make out "whether conscientiousness is a pair of shoes, or the shoes conscientiousness."

Beneath the rhetorical pleasure of displaying such wit and eloquence, one senses a real indignation at what is seen as a triple insult to the common codes of representation, the common norms of good taste, and the criteria of serious-mindedness. Those are the markers that give meaning as much to the endeavors of "genuine" painters, as to the no less negligible efforts of people of good faith who have come out to see painting. Failure to respect these codes is thus most likely to be perceived not only as a transgression of customs and norms, but as an insult.

However, this outburst does not seem to have generated any other effect on critics than the silence reserved for objects of contempt. It was no doubt merely a borderline manifestation of points of view expressed orally by laymen and not in the least shared by specialized critics. At any rate, that is what is suggested by an unusual, to say the least, "Note From the Editors," which prefaces the article with a warning to the reader not to attribute the author's point of view to a journal with a rather progressive cultural outlook:

> As the liberty to say everything is our only raison-d'être, all our articles in fact being signed, we consider it supererogatory to deny the review's responsibility for what is printed in it. Nonetheless, as fairly clear tendencies may be inferred nowadays from the publication as a whole, and as we are precisely offering a series of letters of Vincent van Gogh, we would no doubt bewilder our readers too much if we failed to declare that Mr. Charles Merki is expressing purely personal opinions here.

There is no better way to say that the attempt by the article's author to disqualify van Gogh was far from gathering unanimous support from his peers. Three years after the painter's death, lack of understanding did indeed seem to be the attitude of the general public that did not understand

his art. But it was no less characteristic of specialists who, for their part, were virtually unanimous in not wanting to understand that he could fail to be understood.

From the General to the Particular

Having examined the argument of the only opponent on record, we turn to the admirers' version. Here we may take advantage of the fact that specialized criticism is in no way restricted to accumulating adjectives or describing received impressions. What distinguishes it from the opinion of journalists or the general public is its ability to ground its judgments in the analysis of objects. What are therefore, in that first decade of commentaries, the criteria invoked in making an oeuvre of a few exhibited paintings, and in making a major painter of an oeuvre?

To begin with, praise for his painting highlights everything in it that looks like a deviation, as opposed to that which could liken it to already known examples (by showing that he mastered the codes of representation, for instance). Aurier singled out what looked like peculiarities in the "sometimes bewildering strangeness" of van Gogh's "intensive and feverish works," and in the "most curious studies," of this "painter [who was] so original and so apart." He especially focused on his "excesses." "What is peculiar to his entire work is excess, excess of strength, excess of agitation, violence of expression." This is "always a matter for pathology," and arises from van Gogh's hyperaesthesia. He is "neurotic," with the "excitability of a hysterical woman." Yet Aurier only passes seemingly negative judgments ("often awkward and heavy draftsmanship," "unpleasant crudities," "a certain lack of harmony," "dissonances," "sometimes (but not always) great style"), the better to vaunt the positive side of these apparent faults (vigorous execution, "powerful draftsmanship," "dazzling color," which can transmute forms into a "nightmare," colors into "flames," light into "a fire," life into a "hot fever.")

Mirbeau goes even further, also resting his praise on a polemical defense of "personality" and "style" against "fraud," "triteness," the "indifferent crowd," "obscurity" and "injustice"—all embodied by Meissonier. Van Gogh, whom he compares to Rembrandt, appears to him as the triumph of personality, of individuality, of singularity, so that even his excesses or negative qualities ("strange, disjointed") can be turned into proofs of value. His paintings can "be picked out in the blink of an eye" amid a crowd of others thanks to "his special genius that cannot be otherwise, and that is style, that is, the affirmation of personality." "Accepting no other guide than his personal impressions," he "had that which differentiates one man from another: style." Thus the critic imposes his own criteria of value,

flaunting his break with standards that, by contrast, are the foundations of academic aesthetics.[51]

Tardieu similarly favors the "ego" and the "affinities of the moral being" in van Gogh, seeing in him "a powerful imagination [and] all of the gifts of the painter." He does however express some reservations (this "strange painter," who has "very little of what is frankly known as 'common sense,'" has become "perfectly incomprehensible"), and goes so far as to "admit" some perplexity which he seeks neither to conceal, nor to lessen: "Of the ten canvases exhibited at the Indépendants, I must admit that I only understand two or three." This is the very watershed between celebration and stigmatization, where particularity can meet with progressive-minded acceptance of wonderful originality, or conservative rejection of intolerable excess.

Evoking a "fanatic, a true believer" who "was never fraudulent," who "painted in a feverish state" and who "may indeed have had the good fortune to be a bit mad," the critic Francis for the first time alludes to van Gogh's madness—moving to the outer limits of particularity. To this he adds two important images: incomprehension, by virtue of which the diagnosis of madness is merely imputed out of ill will ("long considered mad, a fraud, who was taking the general public for a ride"); and autodidacticism, which links up with the theme (recurrent in artists' biographies)[52] of innate talent. He "never had a master," "never touched a paintbrush before he was twenty," and "no teacher ever taught [him] the art of drawing," so that he "was unquestionably 'inspired.'" "Then comes the need to produce freely, no longer respecting anything": praise for this inspired, self-taught man buttresses the modernist disqualification of respect for academic rules, the transgression of which then appears as the cause of incomprehension. From that moment on, incomprehension no longer sanctions incompetence but, on the contrary, has value so authentic that it escapes ordinary evaluation.

Finally, an article on Delacroix reveals that van Gogh has become not only a recognized artist, but also a "case" called upon to back up arguments which are not necessarily about his paintings per se.[53] The author takes up two parallel examples of a contradiction "between the man and the work": on the one hand, the opposition between Delacroix's *Journal* (an expression of the "healthiest of men, I mean in terms of his strength and clarity of mind") and his work ("the work of a sick man"); and on the other hand, the equivalent opposition between a few letters of van Gogh which had just been published by *Le Mercure de France* (in which he "judged matters of art with incomparable wisdom, moderation and lucidity," and in which "the conditions and limits of painting have never been spoken of better") and his works, "which are absolutely those of a madman, beyond all reason and all beauty." This is a remarkable argument. It does not merely subsume

van Gogh's painting under the motif of madness. In opposing the man and
the work, it also associates lunacy with the *work* and reason with the *man*.
A generation later, the man comes to be considered mad, and his work the
ultimate example of authenticity.

From the Painter to the Person

Excess, personality, subjectivity, originality, madness, mystery, and mar-
ginality are all signs of rarity favored by the critics, who stress what is
uncommon in van Gogh. Bringing to the fore what is peculiar to his paint-
ings means no longer viewing the artist merely as the author of canvases
but as a person, and as such as irreplaceable and irreducible to any qualifi-
cation and equivalence.

Aurier's articles provide some biographical or, at least, psychological
data, no doubt gathered from Theo. He describes van Gogh as "a kind of
drunken giant," a "terrible and panic-stricken genius," a "compatriot and
not unworthy descendant of the old Dutch masters," an "enthusiast," "a
utopian," gifted with a "visionary's soul," with a "profound and childish
sincerity," with "great love of nature and of what is true," awaiting a mes-
siah, and wanting to "regenerate art." Mirbeau also takes an interest in this
"unbalanced" mind, who "was doomed to death at an early age" at the end
of a "disconcerting life," "a troubled, tormented spirit," with "vague and
ardent inspiration," "drawn to the heights," "apostle or artist". Tardieu
takes up the same themes. "Vincent van Gogh, that so curious an artist who
sadly died last summer. Vincent van Gogh is a Dutchman, he admired
Delacroix, Courbet, Millet, and Rembrandt. His life is one of the oddest
psychological novels one could dream of. He was chaste, they say, a relent-
less worker and a mystic."

This information could only have been received by word of mouth, as
the words "they say" indicate. In September 1891, an important though
brief article by Emile Bernard furnished the first genuine biographical ac-
count of van Gogh's career. Bernard's account brings his friend van Gogh
back to life both physically ("red-headed . . . , an eagle look and an incisive
mouth") and spiritually ("excessive in everything," "vehement," "a
dreamer," "in love with art," "more personal than any" although he had
been initiated into pointillist technique, as well as the painting of "Mon-
ticelli, Manet, Gauguin, etc.")[54] Bernard mentions that this "Dutch, Prot-
estant, . . . pastor's son" "seemed destined from the start to holy orders; but
although he did enter them, he left them for painting." However he em-
phasizes what is most relevant to van Gogh's work as a painter, for exam-
ple, the brief episode at Goupil's, the first influence of Israels and Rem-

brandt, the lightning passage at Cormon's, his taste for the "Japanese," the "Indians," and the "Chinese," in whom he found "the surprising techniques of his harmonies, the extraordinary flights of his drawing, as he found deep within himself the raving nightmares with which he relentlessly oppresses us."

A year and a half later, Emile Bernard once again wrote about van Gogh, this time in *Le Mercure de France*,[55] adding three important biographical elements. The first is a dramatized reference to Theo: ". . . that these two brothers, as it were, made up but one idea, that one found sustenance and lived from the thought of the other, and that when the latter, the painter, died, the other followed him into the grave by only a few months, under the impact of a rare and edifying grief" (it will be noted that Theo the art dealer, who "thus paid his debt to the only true artists he ever met," is presented as Vincent the artist's debtor). The second is a picture, a self-portrait by Vincent. The third is the publication of letters written to Bernard by van Gogh. As the painter's personal history enters into public circulation, accompanied by his writings and facial features, a broader audience begins to form a picture of a unique artist recognized (i.e., identified and found to be of worth) by a small circle of connoisseurs, but also of a personality who is beginning to be passed on to posterity through the efforts of those who knew him.

A short time later, Paul Gauguin's first published memoir of his friend[56] evokes the "sun flowers" (*fleurs de soleil*, later to become the painter's emblem), van Gogh's love of yellow, and his "need for warmth." Gauguin is the first to introduce the theme of humility in depicting van Gogh, a man "suffused with charity" and "love of the meek" (this "young priest" who "believed in a Jesus who loved the poor"). Gauguin is also the first to link the theme of madness to van Gogh *the man*, as opposed to the artist or his work. Having metaphorically connected this madness to a common colorist's quest ("when we were both in Arles, both mad, in continual battle for beautiful colors"), he applies the qualifier "mad" to the young Vincent in a markedly less figurative sense than previous reviewers, even if he clearly remains ironic: "Undoubtedly, undoubtedly, Vincent was already mad."

Finally, Emile Bernard briefly takes his friend's case up again four years later.[57] He attributes characteristics jointly to the work ("an oeuvre") and the man ("Vincent"), without being clear as to which qualities belonged to which, amidst the contradictory mixture of "complexity" and "unity," "turbulence" and "equilibrium," "logic," "consciousness," "madness" and "genius." The theme of genius deserves special mention. In van Gogh's case it comes to be associated with madness through the affirmation of his deviance. Instead of branding him with the stigma of incoherence, deviance causes him to be celebrated as an exceptional figure. The (in

van Gogh's case, exemplary) construction, then glorification, of an artistic and (to an ever greater extent) biographical singularity, crowns this little decade of commentaries among French critics.

From the Painting to the Oeuvre

This artistic and biographical process of particularization—artistic because its object is *style*, biographical because its focus is on van Gogh the man— is accompanied by a symmetrical and contrary process of generalization. Initially, this involves the passage from the one-time description of a few actually exhibited paintings to commentary on the virtual totality of an oeuvre (in the sense of the entirety of an author's creations). Taking into account the painter as a person is what makes such extension possible. The artist's signature backs this up, and its manifestations include instances where painter and work are spoken of in identical terms.

Aurier inaugurates this attention to a totality of works guaranteed real or alleged coherence because they bear the painter's name, when he writes of the "naive truthfulness of [van Gogh's] art," the "artlessness of his vision," his rapturous, "sometimes ingenuously delicate," "occasionally grotesque," "often sublime," "profound, complex, very distinct, powerful, male, obscure art." Aurier carries out a twofold process of aggrandizement. He establishes himself not just as a critic whose job is to educate public opinion about *works*, but as a historian whose job is to confer status on a *body of work* (an oeuvre). In a parallel move, he constitutes the painter as a "genuine artist," and not as some hack or other who has decided to exhibit his products. There is thus a shift from description to judgment, and from one-time criticism of a few paintings to putting a whole body of work into perspective in a general way.

In his 1892 article, Aurier alludes for the first time to van Gogh's abundant production, assessed at "a thousand canvases" (a somewhat inflated figure, since the first critical catalog registered 850 pictures). He relates this prolixity itself to the "promise" of a potential life's work interrupted because the artist "died too young, alas, to have left the work promised by his genius." Two themes appear here: van Gogh's end was not only tragic (suicide), but premature—and, correlatively, his work remained *unfinished*.

Meanwhile, Mirbeau also praises van Gogh's "considerable," "superior" "oeuvre," that comprises an "enormous number of drawings," and is blessed with "intensity of vision," "richness of expression," "powerful style," "abundant originality," "eloquence," and a "prodigious ability to render life." It is hard to separate this characterization of the work from what Mirbeau says of the painter himself, as when he speaks of a "delicious talent," although "too violent, too excessive," or again when he discusses

matters on the more general level of "art." There is a coincidence here between the characteristics of van Gogh's actually exhibited paintings, and the characteristics that could be deduced by relating those paintings to trends imputed to van Gogh's work as a whole.

From the Oeuvre to Art History

The generalization of the horizon of reference comprises a second moment, relating the "oeuvre" thus reconstructed, no longer merely to the totality of a personal undertaking but, more broadly, to the totality of the painter's endeavors recorded in art history. Whatever place is assigned to him, every artist compared to the masters or integrated into a school accedes to a status that is markedly distinct from the undifferentiated mass of painters.

Aurier's comparison of van Gogh's work with existing trends offers the first example of this widening focus. At times the aim is assimilation, through an emphasis on the place van Gogh deserves in art history: "He has been subject to the ineluctable atavistic laws. He is well and truly Dutch, of the sublime lineage of Franz Hals." At times, on the contrary, the aim is to underscore van Gogh's difference by remarking on his peculiarity: "Oh, how far removed from the beautiful, the grand old art, the very healthy and very level-headed art of the Netherlands! How far removed from Gerard Dow, Albert Cuyp, Terburg, Metzu, Peter de Hooghe, van der Meer, van der Heyden." As for van Gogh's integration into contemporary trends, Aurier defines him both as "a realist in the fullest sense of the word" and "a symbolist," practicing a "naturalistic art" with "idealist tendencies." This paradoxical association bears witness to the difficulty of collapsing stylistic particularities into general tendencies, at the same time as to the necessity of such an operation for criticism's work of accreditation. In 1892, Aurier emphasizes van Gogh's kinship with symbolism, and links him to Gustave Moreau, Puvis de Chavannes, the Pre-Raphaelites, Odilon Redon, Sérusier, Emile Bernard, Roussel, Ranson, Vuillard, and finally Gauguin, of whom he was "his friend and, if not his pupil, at least his passionate admirer." Once again, praise for the painter gives rise to a manifesto for a movement which by that very token receives credit—if it is not created—by the commentators.

The critic Antoine had also attempted to link van Gogh to recognized trends, and in particular with Seurat ("the initiators of the young artists exhibited") and Gauguin, inasmuch as he held both to be marking their differences from the "realist" school and to be carrying out a "return toward the past" which some have labeled "neo-traditionism." "These are two very dissimilar and most curious trends to consult to learn about the

masters of tomorrow," he concludes, calling upon posterity as an instrument of consecration, after having used the present or the immediate past as an instrument to locate and integrate the isolated individual within a collective movement. Finally there is Mellerio's attempt to connect this "Dutchman suffused with the spirit of the North" to a painterly movement bringing together "chrono-luminarists," "neo-impressionists," "synthesists," and "mystics."

Hermeneutics and Authenticity

A painter's entry into history thus comprises two moments: the emergence from silence that differentiates him from his peers, then recognition by specialized critics that establishes his greatness by a twofold, contrary movement of particularization and generalization. Particularization is accomplished when it is no longer the themes painted (familiar to ordinary people or to academic canons) that are foregrounded, but rather the specific characteristics of painting, and when painting itself is related to the painter as a man. There is a gradual slippage toward biography that confirms the historical evolution of the criteria of pictorial judgment, from "canvases" to "careers."[58] Generalization does not index critical commentary to the particularity of the few works exhibited, but rather to the totality of an oeuvre made up of an infinite set of canvases, whose suggested coherence, built around the author's name, can then take its place in the yet more general totality that is art history.

What is going on here is the opening of a "hermeneutic space," a universe of systems of interpretation within which van Gogh's name has been taken up, in ways of relating to him that pertain as much to psychology or psychiatry as to aesthetics or history.[59] That we truly are dealing with something new, an interpretative space, is confirmed by the fact that the description of canvases and the reactions they provoke (whether accompanied or not by an evaluative judgment) tends to be replaced by a search for meaning, by the attempt, backed up by arguments, to relate the particularity of a painting to more general structures. The latter include not only the totality of the world's objects accessible to representation (i.e., the immediate work of "recognizing" the subject), or even the totality of themes germane to the history of painting (i.e., the "iconology" defined by Erwin Panofsky),[60] but also the totality of technical and stylistic possibilities (i.e., aesthetics and art criticism), as well as the totality of the works produced by an artist during his lifetime (which is documented by art history), and, finally, the totality of determinations detectable in his biography (which pertain to psychology, psychoanalysis, or sociology of art).

Only the supposed existence of an enigma can sustain such hermeneutical work, as proliferating interpretations aim at some resolution. How else could discursive investment in an object (image, text, or event) be justified, other than by supposing that there is something there to be understood, to which immediate perception offers no access? That is why, in artistic matters, a work has to be constituted as an enigma (an authentic enigma, which exists prior to the effort of elucidating it), in order for hermeneutical activity to take place. This can be the enigma of the work's greatness or novelty, the enigma of its author, meaning, or origin. Art history abounds in such instances,[61] ensconcing hermeneutical activity in potentially interminable discursive production. For the enigma only ceases to exist when interest in it ends (whether it has been resolved or simply abandoned) and is redirected toward some other enigma: from the smile of La Gioconda to the identity of Mona Lisa or (in a more modern register) from the true subject of Giorgone's *Tempest* to Piero della Francesca's patrons.[62]

As Maurice Denis wrote in 1909 regarding van Gogh,[63] "the enigma of [this] genius" is the enigma of the strangeness of his painting ("the disturbing, troubling, display of an alien nature, a nature that is both really real and virtually supernatural," "the sometimes bewildering strangeness of his works," according to Aurier), the enigma of his mystery (the "mystery of the sketch about to blossom into a masterpiece," according to Mellerio), or the enigma of the madness of a man who "died mad." Whatever its specific object, it is this enigma that justifies the narrative's "emplotment," to use Paul Ricoeur's expression.[64]

The *opening* of the hermeneutical space is be understood in two ways. First, the construction of the object as an enigma *inaugurates* the hermeneutical space. It then also allows the latter to *expand* its reception, both in space and in time. Little by little, discourses extend spatially to a wider audience, combining the narrow circle of specialists and the sphere of the general public. They also extend temporally to a future audience. The condition for entering posterity is a hermeneutical operation that relates paintings to the generality of a pictorial oeuvre and to the particularity of personal experience, and that enables the paintings to transcend the mere *contingency* of artistic endeavors that did not lead to anything (whether such attempts were "impressive" by their originality or by their shocking character). Silence about works of art would end up sanctioning such contingency, and thereby their invisibility, dooming the critics' efforts to mockery or indifference.

For contingency to be avoided and the labor of interpretation to receive the stamp of authority, the authenticity of an artistic approach must be attestable. This alone guarantees that singularity is not the effect of a simple lack of skill, of pure chance, of a delirium without further conse-

quences, or of falsification (the "fraud" that serves as anathema to those who hold to tradition). It is also the only guarantee that the enigma is worthy of being presumed to exist and of being unraveled.[65] Three criteria are necessary for the construction of authenticity. The first is permanence. Without it, there is nothing to ensure that a moment of inspiration is more than a chance or one-time event, which no personal gift could translate in a lasting way into a homogeneous body of work displaying the constancy of a creative personality. Amid the utterances of van Gogh's critics, two factors bear witness to this permanence: the generalization from the actually visible pictures to an overall body of work of which these pictures are but elements; the extension of the painter's name, namely the gradual transition (aided by biographical investigations) from the name as an artist's signature to the name as a man's identity.

The second criterion of authenticity consists in the possibility of imputing universality to the work. Without this, even a constant artistic effort supported by real talent might only reflect its author's solipsistic preoccupations, which could be cut off from any general interest likely to enter into history or be handed down to posterity. This requirement of universality may find a basis of support in the reference to something transcendent. It can be indexed to a force greater than the subject, by which the latter is held to be possessed, for example the artist's or healer's gift, the poet's inspiration, the prophet's vision, the mystic's ecstasy.[66] Here, generalization from the work to the history of art is what enables fundamental aesthetic tendencies to be highlighted, while the expression of the emotions aroused in the critics by seeing the pictures lends authority to their universalization. In relating the powerful impression the pictures produce (the literary rendering of which occupies the lion's share of Aurier's first article), the critic thus "touched" certifies their capacity to be "received" (even if only by a few), to have meaning for someone other than their creator and, consequently, to exceed the latter's own subjectivity (even if the reason for this is not immediately clarified by those who experience it).

The third criterion, finally, is the interiority of creative inspiration, without which the most impressive, coherent work could be mere imitation, pastiche, external influence, superficiality, or lack of sincerity. Praising van Gogh's "profound and almost childish sincerity," his "good faith," and the true vision in his paintings, Aurier asserts that "the external and material side of his painting is in absolute correlation with his artistic temperament." Similarly, when Tardieu vaunts the "gift of superior truth" and the "beauty of the worker's temperament" (rather than the "imitation" of "nature," the "external reality" that "the painter can thus never grasp," and that "is therefore not the reality that we must seek in the work"), he deploys a thoroughly modern aesthetic, giving pride of place to the creator's

interiority, to the detriment of the mimetic or idealizing functions that had traditionally competed for centrality in the aesthetic of the academy. When Emile Bernard in turn asserts that "it is not necessary to learn fine arts in a school," and that "the Beautiful is not the imitation of a pre-established type," he expresses the idea (that was still paradoxical at the time, even if it has today become commonsensical) that the creator must find his true inspiration within the interiority of his own personal re-sources. Henceforth, the work of art is a prime location for the consoli-dation of the imperative of interiority.[67]

Similarly, van Gogh's refusal of any imitation or external influence is affirmed by the repeated highlighting of the particularities of his painting, and thus of its originality. The interiority of inspiration is valued more than the mastery of skills foreign to the artist's personality. The lack of technical ability can thus appear as proof of quality, and defects can be construed as a sign of sincerity. Aurier had already suggested something similar: "Despite the sometimes bewildering strangeness of his works, it is difficult, for those who would be impartial and know how to look, to deny or contest the naive truthfulness of his art, the artlessness of his vision. . . . A thousand significant details indisputably assert his profound and almost childish sincerity, his great love of nature and of what is true—of what is true for him, his own truth."[68]

Authentification (through the construction of authenticity) is thus the price the avant-garde critic must pay in order to accomplish his labor of interpretation (through entry into the hermeneutic space), without run-ning the risk of being discredited, and without the singular artist running the risk of being despised. The construction of a singularity worthy of admiration, that is, capable of withstanding extension in space and time, capable in other words of coming down to posterity, depends on six condi-tions: primacy attributed to rarity, and formalization of the scholarly dis-course within a critical space; particularization through stylistic originality and personality; generalization to the totality of a body of work and to art history; opening of an interpretive space and, in conjunction with this, construction of an authenticity made up of interiority, universality, and permanence.

Posterity and Singularity

By the time Mirbeau reviewed the first major personal exhibition of van Gogh at Bernheim's in 1901, the themes he rehearsed were well estab-lished: "Painful and tragic death," "mystical soul," "predisposition to lunacy," "fatal anxiousness" of a man who "dreamed the impossible,"

"passionate and exciting life," "vocation to be an artist," "need to prosely-
tize," "subconscious strength," "instinctive need," "apostolate of beauty,"
"strange, anxious and strong personality," "wonderful and abundant tem-
perament," "healthy art," "love of nature," "loathing of intellectualism,"
"different, rare" painter, "great and pure artist." Subsequent literature es-
sentially just confirmed and developed them. The only later innovation is
a political interpretation of van Gogh's position, in a 1905 article con-
struing him as a kind of anarchist. (The expression *peintre maudit* appears
for the first time in the title of this article.)[69]

This set of topics circulated widely in the generation that followed, in-
stituting van Gogh as a recognized master, integrated into the market and
into art history. Around the beginning of the 1920s, three decades after his
death, van Gogh became established for good as a major figure in the inter-
national art market, in the eyes of collectors, among painters (who recog-
nized him as a pioneer of modern painting), and for the educated public,
who had by then become familiar with the most dramatic themes of his
biography.[70] This familiarity extended to the works as much as to the
painter himself, since the inseparability of the work and the man (bound
together within the same name, which denoted both his identity as a mem-
ber of society and his identity as an artist) marks the works' entry into the
hermeneutical space and, correlatively, into posterity.

Growing numbers measure van Gogh's success even better than prolif-
erating words. Experts on the art market consider the first stage of van
Gogh's lifetime his "accursed" period. Its symbol is the fact that he only
sold one painting, and that for a low price. During the 1880s, when the
impressionists (Renoir and Pissarro especially) first achieved success in
selling their paintings, "only Sisley remained unrecognized. And, obvi-
ously, the two 'maudits,' Cézanne and van Gogh. When Vincent died in
1890, he had only managed to sell one canvas at a decent price, namely
Vignes rouges d'Arles, bought for 400 francs (1820F at 1974 rates) by the
sister of a Belgian painter who was van Gogh's friend."[71] During the fol-
lowing decade, the market really opened up, even for the three "maudits,"
so that "by 1900, van Gogh's *Roses trémières* sold for 1100 francs (5170F)."
From Sisley's death in 1899 onwards, "the price of impressionists sky-
rocketed": "On the eve of World War I, it was not only 'sure things' like
Degas, Monet and Renoir, that were out of reach; even 'maudits' like
Cézanne or van Gogh had become 'expensive painters.'" In 1913, "a *Still
Life* by van Gogh reached 32,500 francs (140,000F)," while twenty years
later the figure had doubled: "In 1932 a van Gogh was auctioned off for
361,000 francs (281,000F)." Today, it is notorious that van Gogh sells for
record prices with inflation raging in the market for impressionists. "One
might as well say that 75,000% appreciation in less than a century has to be
considered normal!"[72]

An excellent indicator of the "price" (aesthetic value no less than market value) given van Gogh's works, is the proliferation of forgeries, which began appearing before the 1920s. "Today at a sale by Nemes, a Hungarian subject, three fake van Goghs (7200, 4800 and 18,000 francs) and a genuine Renoir (22,000 francs) were sold; but the latter had been touched up so much that it was scarcely worth more than the van Goghs," René Gimpel wrote in his diary on November 21, 1918.[73] A first catalog of forgeries was published in 1930: "It was at that exhibition [1928] that I began having misgivings about the authenticity of certain canvases, which clashed with the genuine van Goghs they had been mixed in with." The author of these lines devoted part of his life to "purging the great master's oeuvre" of the "countless number of forgeries" attributed to him.[74] No less than nine studies of fake van Goghs were published in the 1930s (four of them in France), and eleven in the 1950s (seven in France).[75]

Thus, beyond the scholarly criteria sought out by critics and art historians, it became possible for van Gogh's painting to be celebrated in socially and geographically much broader circles. Van Gogh's "popularization" (in the twofold sense of wider circulation and admiration by a non-specialized audience) began at the turn of the century, when his works were monetized and circulated by dealers and collectors. It fed copiously on biographies of the artist, as well as on the ever more numerous reproductions of his paintings, and visits to exhibitions and art galleries.[76] "In my opinion, no other painter's style is as easily recognizable and verifiable as van Gogh's. Having paid no attention whatsoever to the traditions in force before him, and having refused to toe the line of the academicians, whatever their stripe, he expressed himself in a style that was absolutely his very own."[77]

What is specific to van Gogh's specific pictorial expression contributes to his popularization, by making his paintings particularly "recognizable," that is, identifiable as being by van Gogh, to a general public that is not necessarily very enlightened. A unique mode of expression is a fundamental asset for artistic celebration, at least after deviation has been freed of the burden of indifference and stigmatization, and has been endowed with value as a form of renewal. In the modern ethic of rarity, where originality reigns supreme, rather than the mastery of common codes, everything that contributes to singularizing pictorial expression becomes a "hold," a possible link with the object. Confronted with the enigmatic image, the non-specialist can hold fast to the artist's name. Meanwhile the work becomes a vehicle for the experts' expectation that it will raise the stakes in establishing a line of demarcation with regard to what is currently done (painters and critics adopt homologous approaches here).

Being hard to classify becomes a hallmark of the artist's authenticity. The critic's competence can be determined by his or her ability to re-

construct the categories that make it possible to classify what is unclassifiable. Van Gogh's originality can be measured by the critics' hesitation in likening him to this or that movement, as the numerous attempts to do so illustrate. But once his singularity had been certified and accepted by the specialists, there was no further need to pursue efforts at classification that ran counter to his irreducibility to any category. This irreducibility became a major argument for admiring him: "Van Gogh's works defy classification."[78]

The irreducible nature of the singular does not preclude its being linked to a group or other individualities. But this may only occur if they come on the scene after it, that is, if the singular appears as their precursor. This is a fundamental dimension of the recognition of the singular in modernity: its innovative character guarantees its break with earlier traditions and enables it to avoid being completely marginal. But this only holds true if it comes to be considered as a starting point of later movements, as the turning point when tradition is canceled out and a new tradition takes its place, even if the latter is a "tradition of the new," in the words of Rosenberg. Mellerio in 1896 described van Gogh as a painter devoted to "experiments," "feeling his way forward," seen as a precursor, "despite all [his] incompleteness," and who "seduced young minds that were enthusiastic about [his] originality"; while today the *Petit Larousse de la peinture* puts forward his "contributions to French fauvism . . . , to German expressionism . . . , Dutch-Belgian expressionism . . . , abstract expressionism."

Once again, it is symptomatic of the particularity of van Gogh's position that so many tendencies could be affiliated to him. He has not been established by posterity as the initiator of a new artistic trend, such as cubism in the case of Cézanne. He is seen rather as a precursor because he is held to personify a new aesthetic value, namely that value which, after him, has come to be granted more and more to the rights of artistic subjectivity. The artist's primary function is no longer to express the external objectivity of the world, of beauty, or of the ideal of beauty. Instead, it is at least as much to reveal the inner truth of a personality, and techniques of expression are henceforth subordinated to this goal.[79] Van Gogh heralds the triumph of *originality*, in the sense of what is new, and in the sense of what belongs to a person as his or her very own, what is irreducible to anyone else.

The greatness of the singular hinges on these two dimensions of originality, this mixture of innovation and personalization that van Gogh embodies for posterity by posthumously lending them a human face. The sheer amount written about him has, as a matter of course, affirmed and confirmed his singularity. As a condition and effect of the discursive activity surrounding him, the great man's singularity is what justifies his being celebrated; but each celebration also affirms it all the more. The exponen-

tial logic at work here is constitutive of every celebration. As we shall see, it is not only operative in the cultural economy of the aesthetic and ethical "value" attributed to the artist, but also in the market economy of monetary values attributed to his works.

A Funny Business

Carried out over a few years amid the small circle of specialized critics, the exploitation of van Gogh's singularity transmuted deviation into stylistic innovation. Van Gogh's works were constituted as his *work*, his *oeuvre*. Instead of being unusual, it became worthy of admiration rather than of contempt, irony or indifference. The complex operations required to bring this about show that there is no sure-fire prior guarantee that the singular will be identified, and celebrated, as original, new, and personal. As something irreducible to what is already known and recognized, it might well have been denounced as an error, a monstrosity, an aberration, or a scandalous breach of the rules. This happened, temporarily, to the impressionists. But it might also, simply, have been ignored. Such is the far more permanent lot of all of the "failed" artists who did not come down to posterity. "Isolated individuals" without masters, accomplices, or hangers-on, their work was dismissed as a meaningless oddity, as marginal because of a lack of technical mastery, as a naive whim or hoax designed to provoke, or even as a manifestation of lunacy. In a word, their work was relegated to the status of a fraudulent "whatever," beneath the very threshold of interpretive reason, of hermeneutics.

Van Gogh survived the risk of being misunderstood, because the scandal had already occurred, first with Courbet, then with Manet and the first exhibition of the *refusés*. Thanks especially to the impressionist revolution, the world (or at least the universe of art experts) was prepared to receive him. Originality in painting, or at least deviation from the canons, had already been constituted as a value, albeit a contested one. Van Gogh did not establish this value. He quite literally embodied it. That is why the only van Gogh "scandal" of his day consisted of sniggerings of no consequence.[80]

True, these signs of interest did not emerge until after his death. While this was obviously detrimental to van Gogh himself, it is hardly surprising considering that he died very young, after a brief career. When he committed suicide, he had been painting for less than ten years and had only just begun to exhibit his work.[81] To be sure, recognition was slower in coming than he would have hoped, as his letters make abundantly clear. But given how untypical his painting was of what was being done at the time, a two- or three-year delay between his reaching maturity as a painter and the first

signs of critical recognition seems rather short. Had he lived beyond the age of thirty-seven, it is clear that he would soon have enjoyed the satisfaction of being recognized and understood, at least by a small circle of connoisseurs. Rousseau, for example, only achieved recognition at the age of thirty-eight.[82] An expert on the art market reckons the following: "In 1913, the year in which a van Gogh was sold at a public auction for more than thirty-five thousand francs, Vincent (had God granted him life) would have been sixty, and Theo fifty-six years old. Many a painter has failed to achieve success before that age."[83] In writing this, Duret-Robert does not however take into account the fact that van Gogh would have produced more paintings had he not died young, and that his legend would have had less of an impact had he not committed suicide. These factors would probably have prevented his paintings from fetching such high prices.

The indifference from which he suffered is therefore merely due to the fact that the time of production and the time of recognition and celebration are punctuated by different rhythms. The production of a painting takes little time, while its integration into critical and market circuits naturally takes longer. What needs to be emphasized is the absence of any scandal, and the speed with which van Gogh was accepted by the critics. Meanwhile, the theme that van Gogh was not understood, which in any case is only relevant with respect to the general public, addresses the issue from the wrong angle. The essential thing is recognition by the critics, dealers, and collectors, for that is what provides access to notoriety and the market.[84]

But this illusion is quite revealing. In ignoring the difference between the general public and the experts, or between common sense and scholarly discourse, it highlights the gulf between these two kinds of appreciation. This phenomenon was new at the time and has today become fundamental. The illusion of a community of judges, which tends to extend the general public's incomprehension to all viewers, is nothing but the afterimage of an earlier situation, in which the "crowd" assembled in the Salons could pass judgment without feeling that its decisions were being reversed by more expert judges who claimed a monopoly of competence in the area. The worst that could happen to a person was the derision of cartoonists, who feasted on the Salons. In drawing on two common critical spaces, the exhibition and the press, cartoonists naturally generated incongruities by juxtaposing heterogeneous values, perceptions, and reactions. At the same time all of these became objects of public laughter at the hands of the cartoonists. Paintings and painters, the general public (aristocrats and bourgeois no less than the working class) and the experts (jury members), were all subjected to similar derision. For half a century, the "Salon caricatural"[85] embodied a particular genre. This came to an end when the common critical space (and with it the exhibition sites, audiences, and aesthetic

values) burst into fragments at the turn of the century with the institution-
alization of the avant-garde. From then on there were, as Mirbeau put it,
"those who know how to look," and the others.

But nonspecialists are not the only ones to entertain the illusion of in-
comprehension, due to an outdated sense of the audience as a whole. Crit-
ics themselves can be deluded in this fashion, not because they are ignorant
of the great divide in the art world, but on the contrary because they value
it, sharpened as it is by the effects of the general public's incomprehension.
Aurier's 1890 article displays the critic's prospective illusion that genius
will never achieve recognition, and reveals that this attitude is just as deeply
rooted as the general public's retrospective illusion that genius never did:

> [Will] this robust and genuine artist, this thoroughbred . . . ever know—every-
> thing is possible—the joy of rehabilitation, the repentant flattery of fashion?
> Perhaps. But come what may, even if fashion were to rate his pictures at the same
> price as Mr. Meissonier's little infamies (a very unlikely prospect), I do not be-
> lieve that much sincerity could ever enter into this belated public admiration.
> Vincent Van Gogh is both too simple and too subtle for the contemporary bour-
> geois mind.

The key word here is "rehabilitation," which belongs to the vocabulary
of "affairs."[86] It must be emphasized that there never was a "Van Gogh
Affair." For there to be an affair, there must at the very least be a common
universe of values and debate, such as the Salon in the premodern artistic
context (impressionist Scandal), the art gallery (Caillebotte Affair), the ju-
dicial system (Dreyfus Affair), or the cultural heritage (the Buren Affair at
the Palais Royal, to take a recent case). But once values (traditionalists vs.
modernists) and sites of debate (academic salons vs. avant-garde dealers,
mass-circulation newspapers vs. specialized journals and reviews) have
been sundered, no "affair" could divide public opinion, because the latter
no longer exists as such. There are only heterogeneous circles that nothing
brings together.

In the absence of something at stake for all, there was no reason for van
Gogh's painting to cause a public scandal for being unacceptable or offen-
sive. It was only in danger of being ignored, mocked, or, at best, admired
by a small circle of a few enthusiasts cut off from the general public. No
"affair" would be possible till the day that recognition of van Gogh ex-
tended to that broader audience and thus became a common value. His fate
would then retrospectively be read as an injustice to be denounced, as "ig-
noble contempt" to be deplored.[87] Thus, through a curious inversion, the
premature death he inflicted upon himself *gave rise* to the "Van Gogh
Scandal." The latter has swelled incessantly over the years, driven by the
theme of incomprehension that successive biographies have underscored.

Consequently, the whiff of scandal and denunciation that pervades the

case of van Gogh today can be explained by the contrast between the rela-
tive indifference he suffered for the short period when his ambitions as a
painter were not yet universally recognized, and the extreme celebration of
which he was later the object. Hence the scandal has at least as much to do
with the extraordinary character of that postmortem celebration as with
the ordinary sad fate he experienced during his lifetime. But those who
denounce this peculiar scandal are no longer the defenders of tradition
who, in an earlier era, denounced the scandal of impressionist painting. On
the contrary, they are the defenders of the modernity embodied by van
Gogh. Referring to Manet, Pierre Bourdieu has correctly described this
curious reversal as the effect of a "symbolic revolution" that was so suc-
cessful that we are no longer even aware of it.[88]

Thus there really is a "Van Gogh Affair" today. It is a funny business,
involving the living (ourselves) and the dead (van Gogh and his contem-
poraries), and it continues to ensnare us: witness the sheer number of
speeches, publications, and controversies about van Gogh that continue to
feed the theme of incomprehension that is constitutive of his legend. If my
aim consisted solely of countering a collectively held illusion (the incom-
prehension from which he suffered), and setting the record straight (the
clear and swift recognition he enjoyed), I would simply be rehearsing one
moment of the affair. Any protagonist in the debate could assume such a
position, and in seeking to deny that there was incomprehension, hence
injustice, hence grounds for an "affair," he or she would just give the latter
new impetus. However, the role of my research is not to take sides in the
debate (whether to revive or end it), but to understand its ins and outs, to
explain the reason for unreason, the rationality of an illusion.

That is why my purpose is not "to set the record straight" with respect
to van Gogh's critical fortunes, by minimizing or relativizing the theme of
incomprehension (just as it is not the anthropologist's aim to "demystify,"
as Mircea Eliade so well puts it, primitive people's belief that their village
is the center of the world). Merely to denounce the postmortem "errors"
and "distortions" of his biographers (who by the way are profuse in such
denunciations), would prevent us from understanding why this theme was
necessary for his legend to be constructed. This is the question I shall now
try to answer by developing a second explanation of the theme of incom-
prehension. Up to now I have sought to unveil the illusory nature of the
common belief in a unanimously hostile reception of van Gogh's work. In
what follows, I shall attempt to unearth the reason for this illusion.

Two

The Golden Legend

FROM BIOGRAPHY TO HAGIOGRAPHY

According to a census taken in 1941, no fewer than 671 articles and books on van Gogh were published before World War II:[1] 22 between 1890 and 1899, 35 between 1900 and 1909, 79 between 1910 and 1919, 220 between 1920 and 1929, 288 from 1930 to 1939 (see *Publication Statistics*). This spectacular inflation is due not only to the critics' favorable reception of his work, but also to the abundant references to van Gogh the man. We have seen that the highlighting of stylistic singularity opens the way to posterity, and goes hand in hand with the artist's biographical treatment. Let us now turn to the hermeneutical treatment of van Gogh's life.

Biography and Hagiography

While twenty-two articles on van Gogh were published in the decade following his death, in the three subsequent decades this number multiplied by two, four, and ten, respectively. Publishing statistics (table 1) show that when the figures are sorted according to categories (table 2), the increase can be seen to be due mainly to the writings about van Gogh's life, and not solely to catalogs or studies of his work.[2] The first collection of letters to Emile Bernard (some of which had already been published in 1893)[3] came out in 1911, while biographies, memoirs, and psychiatric studies, which were absent before the 1910s, became and remained dominant thereafter.

The proliferation and biographical inflection of writings on van Gogh are accompanied by a very particular definition of their form and content. Carol Zemel has correctly stressed the role of "artistic prototype" conferred upon van Gogh by the ever more numerous demonstrations of interest in his career. Beginning in the second decade after his death, and multiplying in the 1920s, this process culminated then already in an idealized, spiritualized, heroic vision of his life.[4] This cemented the bases of a "legend" that warrants analysis, in addition to historical and statistical description.

The term "legend" is no metaphor in this context. The biographical celebration of van Gogh displays the main characteristics of the lives of saints, as compiled by Jacobus de Voragine in his *Golden Legend*. Quite

TABLE 1
Distribution by Decade of the Publications Inventoried by Brooks
Up to 1940 ($N = 671$)

No Date	1890–1899	1900–1909	1910–1919	1920–1929	1930–1939
23	22	35	79	220	288

TABLE 2
Distribution by Type of the Publications Selected by Rewald Up to 1960 ($N = 283$)

	Catalogues, Reproductions	Stylistic Studies	Correspondence	Biographies, Memoirs, Medical Studies, Novels
1890–1899	1	4	9	0
1900–1909	6	4	5	0
1910–1919	3	4	11	12
1920–1929	12	2	15	23
1930–1939	16	18	14	25
1940–1949	15	7		12
1950–1959	14	25		26

independently of the content of this celebration, some of its forms are canonical in hagiographical terms. The very proliferation of books on van Gogh bears witness to this. They repeat and perpetuate what has been said before, and no one seems able to arrest their plethoric production. The latter has less to do with information, therefore, than with celebration. Were it merely a question of enriching knowledge of a life, no new biography could appear without contributing some fresh information. But this is far from being the case; one need only point to the current proliferation of books, which is indexed to a temporality that is not that of historical research but that of collective celebration, with its commemorations, its exhibitions, and its pilgrimages.[5] Another trait belonging to this genre of hagiography is the casting of texts as narratives, memoirs, and novels, with their very own rhetoric ("Rachel unwrapped the papers. She stared in horror at the ear. She fell in a dead faint on the flagstones").[6] Of equal significance are the collective forms, that is, biographies recounting several "lives,"[7] or an account in stages representing the stations of the cross.[8]

But the transformation of biography into hagiography becomes especially clear in the content of the texts. Take Théodore Duret's *Van Gogh Vincent* (1916), the first book about the artist in French, which, a generation after van Gogh's death, could draw on articles or eyewitness ac-

counts.[9] The principal motifs later to be found in many biographies of van Gogh already figure prominently in it.[10] The following motifs are not without recalling the lives of saints.

A calling: "In his case there was a very clear vocation, which ended up becoming all-powerful."

An uncommon man: "He proved to be gifted with exceptional abilities and, by the end of his career, had raised himself through sheer originality to the level of genius."

Isolation, marginality, unfitness for practical, social, and commercial life: "A man of singular appearance . . . dressed in a careless fashion that likened him to the common folk. He was in financial straits. He was compelled to scrimp and save in extreme ways. He came to practice an art from which he apparently derived no profit."

Asceticism and poverty: "He had been unable to support himself through his artistic output; the words of the Scriptures, 'it is not given to a man to enjoy the fruits of his labor,' would make a very suitable epitaph to engrave on his tombstone."

Disinterestedness: "An artist, working disinterestedly in pursuit of an ideal."

Detachment from earthly goods and spiritual elevation: "If necessary, he was always ready to take on loneliness and hardship, and to give himself over to higher pursuits; he was a man for whom worries of a material order, preoccupation with success in his career, the search for prosperity, were non-existent."

Incomprehension and misappreciation by his contemporaries: "By their originality, his works seemed to be the crude efforts of a man flouting the rules of his art"; "he had remained unknown and not understood, unable to support himself by his work."

Martyrdom: "He stoically put up with violent suffering and died on the third day."

Finally, fulfillment in posterity: "It is a singular fact, disclosed by the history of painting in the nineteenth century, that the artists of that century who were most despised at the time of their demise later received the surest and most widespread appreciation. This has been proven by the cases of Cézanne first, and then van Gogh."

Such is the way the first biography deploys the constitutive elements of a hagiographic legend. To speak of a "legend" is, however, not to prejudge the historical validity of the narratives in question, since a true story may be treated as a moral tale, as the hagiographical tradition itself shows; the technical usage of the term "legend" has no pejorative implications in hagiography.[11] Moreover, the truthfulness of the narratives will not concern us here, except insofar as we shall explore possible distortions, omissions

or additions. Similarly, I shall only consider the story of van Gogh's life in order to determine what aspects of it made the legend possible.[12] Our concern is not with the "real life" of van Gogh, but with the legend itself, as it emerges both in the proliferating scholarly writings, and in the opportunity each and every person has to know "the man with the severed ear," at the very least through hearsay and without access to the texts. It is indeed the peculiarity of legends that a *common* culture may be recognized in them, in both senses of the word "common," that is, shared and popularized.

An Apostolic Vocation

The Christianization of van Gogh's biography is illustrated by the titles of novels and short stories inspired by his life, for example, *The Apostolic Life of Vincent Vingeame*, or *The Believer*.[13] It is primarily fueled by the first stage of his "passion," the period "prior to van Gogh" namely, when Vincent the pastor's son tried to take up his father's career.[14] The terms vocation, preaching, apostolate, and priesthood, which have been applied in a figurative way to van Gogh's later career as a painter, characterize the early part of his life quite literally. "To love humanity without being able to communicate with men: this was Vincent van Gogh the Preacher's admission of failure. From this point on, there was only one way for him to achieve communion with God and his neighbor: the brush and the tube of paint. He made his decision to become an artist in 1880 at the age of twenty-seven. His apostolate merely changed tools."[15] Finally, his later stay in Arles, "land of eminence," was a great stroke of good fortune for hagiography.[16]

But it is van Gogh's correspondence, at least as much as the circumstances of his life, that fuels this evangelical, or rather "Sulpician" hagiography.[17] Quest for God, faith and hope, aspirations toward the infinite: Emile Bernard reported that van Gogh himself voiced this transfer to painting of his religious feeling.[18] (See "An Apostolic Calling.") The overlap between religious experience and artistic creation makes it possible for people to project the spirituality of van Gogh *the man* onto his work, despite the virtual absence in his painting of directly religious subjects (the fact that van Gogh himself made the overlap explicit makes this projection all the easier). Van Gogh's abstention from religious subjects has been interpreted as a form of abnegation. "Actually, van Gogh wanted to paint Christ, saints, and angels. He did decide against it because it excited him too much. Instead he chose the simplest objects. But the religious impulse can be detected in them, even if one is not aware of the motives expressed in the letters."[19] In a more modern vein, it has also been read as a transfer

AN APOSTOLIC CALLING

— *Need for religion*: "That does not prevent me from having a terrible need of—shall I say the word?—of religion. Then I go out at night to paint the stars" (*Letters of Vincent van Gogh to His Brother Theo*, 543, September 1888, III, p. 56).

— *Search for God*: "To try to understand the real significance of what the great artists, the serious masters, tell us in their masterpieces, *that* leads to God: one man wrote or told it in a book; another, in a picture" (ibid., 133, July 1880, I, p. 198).

— *Faith and hope*: "And the moral of this is that it's my constant hope that I am not working for myself alone. I believe in the absolute necessity of a new art of color, of design and—of the artistic life. And if we work in that faith it seems to me there is a chance that we do not hope in vain" (ibid., 469, 1888, II, p. 533).

— *Reaching for infinity*: "If what one is doing looks out upon the infinite, and if one sees that one's work has its raison d'être and continuance in the future, then one works with more serenity" (ibid., 538, 1888, III, p. 39).

— *Dedication to work*: "Today again from seven o'clock in the morning till six in the evening I worked without stirring except to take some food a step or two away. That is why the work is getting on fast" (ibid., 541, 1888, III, p. 48).

— *Inspiration (compulsion)*: "I simply couldn't restrain myself or keep my hands off it or allow myself any rest" (ibid., 225, August 1888, I, p. 437).

— *Inspiration (possession)*: "I have a terrible lucidity at moments, these days when nature is so beautiful, I am not conscious of myself any more, and the picture comes to me as in a dream" (ibid., 543, September 1988, III, p. 58).

of spirituality from the man to the work, through a homology between religion and painting.

> Vincent paints as he prays and preaches. He prays and preaches in spite of the sinner that he is, just as he paints in spite of the failures of his life as a man. Holy scriptures and colors are the anguished and frenzied search for the same light, the same salvation. He is a painter as he wished to be a pastor. Vincent entered into painting. Without reservations, a missionary and a martyr. And his portraits are the glorious body that his painter's faith invents.[20]

Van Gogh's own testimony makes legitimate the projection onto his life of a religious motif absent in his paintings. Such projection can also find a basis in the similarity of the features that lend authenticity to the creator's

calling to dedicate himself to art, and to the believer's calling to dedicate himself to God, namely vocation, revelation, conversion, dedication, inspiration.

> *Vocation*: "From the age of nine on, van Gogh displayed a strong predisposition to draw; but his artistic calling did not become clear to him until relatively late in life" (*Petit Larousse de la peinture*). *Revelation* is often invoked in connection with van Gogh's arrival in Provence, or with the mission he is said to have given himself so that "everyone might see clearly." *Conversion*: "Before painting himself, he had to die to himself. It is only when he was exclusively devoted to painting that Vincent could paint himself. Dead to himself, he had *become* painting, and nothing else. This awesome mutation lasted eleven years."[21] *Dedication to work*, many times illustrated in van Gogh's accounts of his use of time. *Inspiration*, finally, is evoked in its dual dimension of compulsion and possession by superior forces, what Rudolf Otto called the "feeling of being creatural."[22]

A Model of Saintliness

The spiritualizing and Christianizing interpretation of van Gogh through his apostolic vocation is made all the easier by the fact that his writings contribute to it, and that its various aspects are in many ways common to both the artistic and the religious universes. However, to this vocational dimension must be added a pathetic dimension characteristic of models of saintliness.

There is first of all the theme of loving one's neighbor, to which van Gogh's life (see the Borinage episode, when he devoted himself to the poor miners before dedicating himself to painting) and correspondence bear witness (see "A Model of Saintliness"). But the biographer's quill tends to transform this simple Christian virtue of loving one's neighbor into heroic saintliness, into imitation of Jesus Christ. A Dutch critic in 1914 speaks of "love of neighbor practised entirely in the Christian sense" in the image of the "legendary saints," of "fanaticism to do good and later in his art, to be true," "of his entire existence [that had become] a self-sacrifice . . . to be pitied no less than the saints."[23] Pastoral compassion is followed by painterly passion, and it is in the throes of the latter that van Gogh suffers the most, an essential experience for any saint. Suffering is conjoined with that fundamental quality, patience, which is all the more deserving the more it is shot through with discouragement.[24]

In addition to this, he has another saintly attribute, the presence of a companion. This is not in the strict sense an "invisible companion," as analyzed by Peter Brown, but the incarnation thereof in an alter ego (as Felix is for Paulinus, the "guardian of Paulinus's identity and, almost at times, a personification of that identity").[25] This is the role held by Emile

A MODEL OF SAINTLINESS

— *Love of neighbor*: "You are kind to painters, and I tell you, the more I think it over, the more I feel there is nothing more truly artistic than to love people" (*Letters of Vincent van Gogh to His Brother Theo*, 538, 1888, III, p. 39).

— *Suffering*: "But I always think of what Millet said, '*Je ne veux point supprimer la souffrance, car souvent c'est elle qui fait s'exprimer le plus énergiquement les artistes*' [*I would never do away with suffering*, for it often is what makes artists express themselves most energetically]" (ibid., 400, 1885, II, p. 362).

— *Patience*: "'*J'ai la patience*'—how quiet it sounds, how dignified. . . . I say this to explain why I think it so foolish to speak about natural gifts and no natural gifts" (ibid., 336, September–November 1883, II, p. 188).

— *Discouragement*: "Now I am once again in such a period of struggle and discouragement, of patience and impatience, of hope and desolation. But I must struggle on, and after a time I shall know more about making water colors" (ibid., 169, 7 January 1882, I, p. 302).

— *Poverty*: "Thanks for your letter, but I have had a very thin time of it these days, as my money ran out on Thursday, so it was a damnably long time till Monday noon. These four days I have lived mainly on 23 cups of coffee, with bread which I still have to pay for. It's not your fault, it's mine if it's anyone's. Because I was wild to see my pictures in frames, and I had ordered too many for my budget, seeing that the month's rent and the charwoman also had to be paid" (ibid., 546, October 1888, III, p. 67).

— *Humility*: "The figures in the pictures of the old masters do not *work*. I am drudging just now on the figure of a woman whom I saw digging for carrots in the snow last winter" (ibid., 418, 1885, II, p. 401).

— *Abnegation of glory*: "I cannot bother about what people think of me, what I have to think of is *getting on*" (ibid., 388, 1885, II, p. 336).

— *Chastity*: "The love of art makes us lose the true love" (*Letters to Emile Bernard*, B 8, [11], June 1888, III, p. 496).

Bernard, the guardian of van Gogh's memory and editor of his correspondence: "After an exhibition that I alone organized, after the silence of his fellow painters and of the press, all that remained was for me to try to get people to appreciate Vincent by revealing his spirit, his struggle, his life."[26] It is especially the role of Theo, whom no biographer fails to mention. Assigned an ambivalent position, somewhere between the sacrificed brother and the scapegoat, his contribution sometimes gets minimized ("while Theodore was lacking in Vincent's genius, he did display the urbanity, practical mind, and commercial skill that Vincent had shown

himself to be so deficient in"),[27] and sometimes exalted ("it is so absurd, almost intolerable, that no portrait of Theo should exist").[28]

Love of neighbor, suffering, patience, the presence of a witness for the sake of posterity: to these passive virtues that make it possible to project the topics of saintliness onto the painter's vocation, the motif of asceticism adds a sacrificial dimension. It appears under various guises: poverty, humility, abnegation, and chastity. Backed up here again by van Gogh's correspondence, these ascetic features are abundantly rehearsed by his biographers, starting with poverty: "Van Gogh's destitution is the consequence of his occupation as a painter, of his vocation. When he *enters into painting* he makes a vow of poverty; painting exacts an exorbitant tribute from him. The canvases to be painted, the oeuvre to be made, are his priority."[29] This material poverty is itself the cause of physical decay, of illness.[30]

The ascetic disposition expressed by that double destitution is also fulfilled in van Gogh's proximity to humble folk. This motif of humility is applied indifferently to the man and his work, since "van Gogh saw himself first of all, very consciously, as the painter of humble folk, exalting their thankless toil, just as he had formerly undertaken to bring them the Gospel's consolation, and just as he had tried to offer a home to a prostitute" (*Petit Larousse de la peinture*). Regularly evoked by biographers, this motif was introduced very early on by eyewitnesses: "People noticed that he was not portraying bright things, the ones we attribute beauty to. . . . It seemed however that in painting too, our young man had a predilection for what looked rather wretched."[31] Commentators have made this the object of an aesthetic, sociological, and even philosophical hermeneutic. "This motif [toil] had already, thirty years previously, inspired van Gogh's sketches of peasants, and he had laid it down as a real principle: van Gogh requires of the painter precisely to represent the peasant *at work* (a problem evaded by the Ancients) and to paint motion for its own sake—i.e., the motions of labor, in which another element with deep philosophical-cultural implications may be found."[32] Twenty years later, this theme of peasant labor also inspired Martin Heidegger's thoughts on van Gogh's "shoes"; much discussed by Meyer Schapiro and commented on by Jacques Derrida, Heidegger's ideas promoted van Gogh to the dignity of an object of philosophical discussion. This is the first example of an open polemic about a painter between philosophy and art criticism.[33]

Poverty and humility go hand in hand with the self-sacrificial motif of abnegation. This theme appears in van Gogh's letters, and his biographers exploit it thoroughly. However, they tend to reconstruct it, not as a fate suffered by the painter, but as a voluntary choice that he joyfully accepted, whether with respect to earthly goods or glory: "Vincent's disdain, nay, his contempt for glory, does not forbid us from gazing upon him, but it does impose certain demands. It compels us to gaze upon him with his own

gaze, with his own gaze alone."[34] The biographers are not content to make a virtue (indifference to money or fame) of necessity (poverty, obscurity). On a more fundamental level, they carry out a radical reversal of values with respect to van Gogh. Artistic excellence is to be achieved not only through asceticism, but through an asceticism experienced positively as a choice, rather than negatively as the effect of marginalization.

Made into a value rather than a misfortune, the painter's abnegation of wordly goods displays his independence of any external determination. "He does not think, see, experience, according to the given frameworks, but on the basis of his own identity."[35] This insistence on abnegation is typical of denunciations of fame based on "the nature of inspiration," as analyzed by Boltanski and Thévenot. However it is also an assertion of the interiority that contributes to authenticity in matters of creation. "The resigned certainty of Vincent, who is not awaiting recognition, reveals that what is at stake, painting, concerns no one else than himself; he has no wish to impose on anybody or prove anything to them. The portraits he paints of himself are his business alone. Painting establishes his solitude."[36]

And yet, van Gogh's letters disclose an obvious ambivalence toward market success. It is the object of both hope and denial. At the time, the "vocationalization" of art was not yet a matter of course, and could still arouse many a fit of rebellion.[37] The commentators give absolutely no account of this ambivalence; they tend to reduce his relationship with success to one dimension only, abnegation. This inflection is very revealing of the role played in hagiography by the motif of disdain for material and worldly success, the vanity of riches and of earthly glory. The same goes for the equally overestimated motif of disdain for sex.

Poverty, humility, abnegation of any fortune, the ascetic requirements of saintliness, would not be complete without abnegation of the flesh. It is true that the motif of chastity can be detected in van Gogh's correspondence. Certain passages evoke the theme (so rife in Romantic literature) of the contiguity of sexual and creative energy, and of the need to sacrifice the former for the sake of the latter. But this motif, even more than that of renouncing success, gives rise to obvious biographical manipulations, which tend to desexualize the artist by exonerating him as much as possible from having compromised himself with the pleasures of the flesh.

Thus van Gogh's biographer P. Cabanne engages in an insistent labor of purification, suggesting that van Gogh preferred to sever his ear than to have to listen to impure words. "Several explanations [of his mutilation] have been put forward. Some have claimed that the painter heard impure words in a brothel, and on returning home cut off the defiled ear in a fit of religious despair. Others believe that one of the prostitutes he was seeing had asked him jokingly to give her one of his ears, in a parody of a bullfighting ritual."[38] Another suggestion is that van Gogh engaged in

intercourse only for the sake of hygiene. "To tell the truth, Vincent had no carnal desire for woman as an object and source of pleasure; he only saw prostitutes later on for reasons of hygiene, intercourse being for him the condition of balance between mind and body. In his eyes, woman was first and foremost the mother." Another theory is that any depravity in van Gogh should be imputed to a congenital disease. "As Auvers had no brothel, the pleasures Vincent engaged in were nothing if not solitary, as René Secrétan confesses, who also calls attention to van Gogh's taste for erotic photographs and books. According to Dr. Doiteau, this form of sexual perversion occurs frequently among epileptics." In the same vein, even van Gogh's relationship with a prostitute gets imputed to the charitable spirit of the savior, who sacrifices the purity of his existence for the redemption of a Mary Magdalene.

> What does it matter that his chosen companion was the dregs of society, the plaything of chance customers, and socially the object of general contempt? Is not Christine the living proof of society's guilt? It is men themselves who drove her to degeneration. She is the victim of vileness, cowardice, lust, the basest appetites, a new Mary Magdalene hoping for redemption, of whom he, Vincent, will be the savior.[39]

It is in similar fashion that Vincente Minnelli, the director of the 1956 film *Lust for Life* (based on Irving Stone's novel of the same name), gives voice to this concern for desexualization. The only episode of van Gogh's life that he says he eliminated is the one where the painter appears as the object of passionate love: "Corwin [the scriptwriter], thankfully, had already eliminated Irving Stone's use in the novel of an imaginary lady as love fantasy. The intrusion of this element was so at odds with van Gogh's asexuality that it struck us as ludicrous."[40] Minnelli thus erased the one countersacrificial moment (imagined by Irving Stone), in which van Gogh was given something (love) that he refused to take.

But Minnelli neglects to mention something else he suppressed in the film: the episode in which van Gogh went to offer his ear to the prostitute. That is the last, but not least, effect of the puritanical reinterpretation of the biography of the accursed artist, who has been sanctified by asceticism and charity.

Martyrdom and the Figure of Christ

What no script could dispense with, on the other hand, is the scene of mutilation itself. For it is of course thanks to the double bloody sacrifice of his own flesh, and then of his own existence, that the biography of a painter who so literally paid with his life (mutilation, madness, suicide)

lends itself so admirably to being reduced to the portrait of a martyr, be-coming the object of a virtually universal legend to be added to the legends of the saints. Isolation, wretchedness, physical and moral suffering, the general public's incomprehension (ironically emphasized by the *single* picture he sold, the *single* article published during his lifetime) merely con-firm van Gogh's dual calling as artist and as martyr of art. Without its tragic episodes van Gogh's case would merely have been one of many, just one more to add to the (short) list of accursed artists and unrecognized geniuses.

It is in keeping with Catholic dogma to hold that violent death trans-forms into martyrdom the practice of "bearing witness" to faith by despis-ing the body and worldly goods.[41] Suicide is no obstacle to this.[42] This is even truer when a witness vouches for the martyr's "beautiful death," as Gauguin did in van Gogh's case: "When he died, he was utterly clear-minded, in love with his art and without hatred of others."[43] Van Gogh is a prime subject for Christian hagiography, and the circumstances of his death only contribute to this. His protracted demise, lingering on after the pistol shot, recalls the resurrection of many "miraculously resurrected saints" who were "called back to life"; it above all evokes the figure of Christ: "He stoically put up with violent suffering and died on the third day."[44]

In this way, heroic martyrdom is supplemented by an allusion to the figure of Christ. The first such allusion came from the pen of Emile Ber-nard, in a letter to Aurier.[45] The identification with Christ is sometimes explicit: "Christ stopped at Eboli. Van Gogh stopped at Arles," a journalist declares in an interview.[46] Sometimes it shows up in slips of the pen, such as the error frequently made by biographers, who give December 24 (rather than 23) as the date of the tragic mutilation episode. It is just that it seems so easy to slide from the figure of the martyr to that of Christ, the martyr of martyrs. The motif of redemption gets taken up in connection with the fate of van Gogh's work itself: "Such work could bear witness to what made man's greatness and wretchedness; on Judgment Day, that work would suffice to save the Human Race."[47]

The sanctifying motifs of vocation and asceticism, and the martyrologi-cal motif of violent death, are thus conjoined in the legendary life of van Gogh with the projection of a Christlike countenance, a mixture of ordi-nary Christology and scholarly tradition. Elias Canetti reports that after "the publication of Meier-Graefe's *Vincent*, van Gogh became the most distinguished topic of conversation at the boarding-house table.... It was at that time that the van Gogh religion arose, and Miss Kündig once re-marked that she had only understood what Christ was all about since com-ing to know the life of van Gogh."[48]

Identification with the figure of Christ does not appear directly in van

Gogh's correspondence, and is hardly to be found in his work.[49] On the other hand, artists at the time were beginning to seek out such identification explicitly. In 1887, under the title "Visions," the Salon des XX in Brussels exhibited a series of six drawings by Ensor representing *Christ's Haloes, or the Sensitivities of Light*, the prelude to a group of paintings and engravings in which he was to portray himself as crucified; two years later, in 1889, the year he joined van Gogh in Arles, Gauguin painted his *Autoportrait au crucifié*. In that same year, on January 4, Nietzsche signed his last letter to Peter Gast, "The Crucified."

Prophet Unwittingly, Hermit Involuntarily

While exceptionally pure, van Gogh's case is not an isolated one. The shift from the work to the man merely crystallizes a more general process of folding artistic excellence into the religious forms of greatness.[50] It is not easy to determine the extent to which this is a projection by posterity or the artist's own investment, such is the impact the latter seems to have on the former. But the religious heroism imputed to van Gogh seems to stem far more from biographical reconstruction than from lived experience. Although the painter clearly did adopt some evangelic themes, there is nothing to indicate that he did so in the case of the Christlike and martyrological countenance attributed to him.

Furthermore, how could van Gogh have internalized the projection of religious excellence onto artistic activity, when there existed no role model for this at the time?[51] He could not even have consciously grounded his experience as an artist in the model of a hero who braves death in the general interest, for visual arts had not yet been made into a medium of hero-building. Van Gogh had read the French translation of Carlyle's *On Heroes, Hero-Worship and the Heroic in History* on its publication in 1888. However, Carlyle only includes divinities, prophets, poets, priests, kings, and men of letters in the ranks of the heroes.[52]

Van Gogh was in the innocent situation of all great preheretical reformers. They arrive on the scene before the schism that posterity sees them as initiating. As such they cannot sustain themselves on the belief that they are on the right side, since the world has not yet been sundered. They cannot live as heretics in the name of the values they will come to embody, since those are not values yet. Such is the lot of "status creators" who are, in spite of themselves, models of an authenticity they inspire others to emulate, without being able to imitate it themselves. Van Gogh is the first great martyr figure instituted in modern art. His case is akin to the "martyrdom that is suffered, but is not voluntary," as the *Golden Legend* has it. This is what Catholic theology defines as the "holy innocent," the martyr

who did not will martyrdom, the martyr before there were martyrs, not knowing yet that he is suffering and will die for a cause which will, thanks to him, become a common, sacred cause after him.[53] In the absence of external support, of a community propping up individual faith with a shared conviction of its truth, van Gogh does not appear to have had any head start on his own fate as an artist, any model upon which to base any certainty about what he was, what he had to be, and what he was to be. "And then came success. Today no one would dare to admit to not understanding this man that no one understood, that no one could understand, because he wanted to tell us that he loved us, as no one had said it before him, and because he therefore had to say it in a language that no one had spoken before him."[54]

This singular position—"no one"—can be constructed in various ways, on the model of the preacher, the herald, or the prophet. There is however no basis for supposing that van Gogh ever felt that he was a preacher filled with an unshakable faith in an art that was to come. For that to be the case, he would have had to be convinced that he possessed the truth about art. However, his letters constantly reiterate his struggle to discover such a truth. Through his work, on the other hand, van Gogh could be likened to a reforming prophet, thanks to whom painterly heresy was turned upside down after his death, becoming a new orthodoxy—what a dream-fate for a Protestant, especially one who had failed in his career as a pastor! But it remains true that his writings bear witness to his constant uncertainty. While he displayed all the features of a "reformed man" of painting, he was less a prophet active in *showing* the way to others than a solitary experimenter engaged in *clearing* it.

Van Gogh was clearly permeated with the evangelical models of sainthood, but not, however, to the point of seeing himself as a hero (martyr, prophet, or artistic Messiah). On the other hand, his correspondence does give voice to another aspiration, which the biographers do not stress at all, namely the longing to be a coenobite monk, living in a community. This was an ill-fated aspiration, for he never fulfilled it. Just as he had been unable to *feel* that he was the preacher of a new religion, so he was unable to *live* as a coenobite monk according to his wish, experimenting with a new monastic order reserved for a few artists.[55] If he was alone, it was very much against his wishes. He dreamed of a small community of painters that would share the mission of disseminating the artistic gospel. This modern coenobitism is evoked many times in his biography, even though the word itself may not appear there. (See "An Involuntary Hermit.") In this explicitly monastic project, Gauguin, pictured as a abbot, evokes the fighting monk who "hopes for success" and wants to "win his battle." By contrast, Cézanne, with his bourgeois marriage, assumes the guise of a contemplative monk, while van Gogh embodies the abnegating monk.[56]

AN INVOLUNTARY HERMIT

— *Ideal of the artistic group*: "More and more it seems to me that the pictures which must be made so that painting should be wholly itself, and should raise itself to a height equivalent to the serene summits which the Greek sculptors, the German musicians, the writers of French novels reached, are beyond the power of a single individual; so they will probably be created by groups of men combining to execute an ideal held in common. . . . All the more reason to regret the lack of corporative spirit among the artists, who criticize and persecute each other, fortunately without succeeding in annihilating each other" (*Letters to Emile Bernard*, B 6 [6], 1888, III, pp. 485, 490).

— *Nostalgia for guilds*: "Furthermore, the material difficulties of a painter's life make collaboration, the uniting of painters, desirable (as much so as in the days of the Guilds of St. Luke)" (ibid., B 11 [13], July 1888, III, p. 503).

— *Project of an impressionist cooperative*: "All the same, the artists couldn't do better than combine, hand their pictures over to the association, and share the proceeds of the sales, so that the society could at least guarantee its members a chance to live and to work" (*Letters of Vincent van Gogh to His Brother Theo*, 468, 10 March 1888, II, p. 531).

— *Dream of association*: "And this would be the beginning of an association. Bernard, who is also coming South, will join us, and truly, I can see you at the head of an Impressionist Society in France yet" (ibid., 493, 29 May 1888, II, p. 577).

— *Need for comrades*: "We must try not to become ill, for if we do, we are *more isolated* than, for instance, the poor concierge who has just died. These people have their own set, and see the comings and goings of the household, and live in foolishness. And here are we alone with our thoughts and there are times we could wish we were fools too. Given the physique we have, we need to live with our own crowd" (ibid., 495, 6 June 1888, II, p. 580).

— *Join the Foreign Legion, take refuge in hospital*: "However this may be, if I knew I'd be accepted, I'd join the Legion. . . . Where I *have* to follow a rule, as here in the hospital, I feel at peace" (ibid., 589, 2 May 1889, III, p. 161).

— *Reference to the old monks*: "That is what makes it necessary to combine as the old monks did, and the Moravian Brothers of our Dutch heaths" (ibid., 524, 1888, III, p. 17).

— *Gauguin, the abbot*: "when it is a question of several painters living a community life, I stipulate at the outset that there must be an abbot to keep order, and that would naturally be Gauguin" (ibid., 544, 1888, III, p. 60).

A Double Nature

"And if it were not that I have almost a double nature, that of a monk and that of a painter."[57] Van Gogh saw himself as endowed with the "dual nature" that both he and his biographers sought after. His life accomplishes and simultaneously authorizes the projection of religious tendencies onto artistic creation, a projection that was on its way to being established in the nineteenth century, but that he, more than any other, was literally to embody. He represents the first successful personification of the "sacralization of the aesthetic sphere" (to use P. Junod's expression), a process that can be detected from the early nineteenth century on.[58]

To be sure, the ancient world and the Renaissance provide exceptional instances of art being "made divine," of the creator (and especially the poet) being regarded as the instrument of divine inspiration.[59] But with the modern period and the system personified by van Gogh, there is a significant change: the theme of the divine in its explicit form vanishes from the artistic domain; there is no longer talk of inspiration by the divinity, of sainthood, of cults, of pilgrimages, of relics, of sanctuaries, of salvation. Henceforth artists derive their authority, so to speak, from themselves alone. The highest form of recognition is awarded to the greatest artists in the name of creation, not religion. It is as though art itself had become a form of religion; or, to be more precise, as though the admiring behavior traditionally crystallized in the cult of the saints were henceforth expressed through the celebration of artists.

In this new artistic context the reference to religion is not only implicit, but also selective. Among the religious countenances projected onto van Gogh, it is important to distinguish between those he evokes himself (a man converted, ascetic in spite of himself, who felt like an anchorite or a hermit, who wished to be a coenobite), and those his biographers looked to after the fact (the vocational devotee and the sacrificial saint, the martyr and the prophet, even Christ). Furthermore, even when biographical accounts involve themes made explicit by van Gogh himself, they take on the apologetic and emphatic tone of hero-building celebration. By contrast, van Gogh himself tends to play them down, acknowledging them in a descriptive tone, or even complaining about them in a resigned or accusatory tone.

The biographers are selective with respect to the religious models they invoke. Furthermore, in evoking aspects of sanctification, they also supplement what the painter himself actually said emphatically, in form and content. Finally, these additions or emphases help to establish the saintly figure on a bedrock of "negative" virtues. Van Gogh stresses such "positive"

secular qualities as *work*, but his biographers hardly do. As for sacred qual-
ities, they do not make much of the thaumaturgical power of healing or
salvation either, unless one includes therein the salvation of painting in the
face of academic decadence. The virtues called upon by the biographers
are passive (vocation, patience, love of one's neighbor), and especially neg-
ative: asceticism, abnegation, sacrifice, suffering, contemporary incompre-
hension. The motif of incomprehension reemerges here, martyrdom and
persecution being its extreme forms. It is the emblematic motif of the es-
sentially sacrificial construction of the artist's biography that occurs in the
making of hagiography.

This key motif of van Gogh's posthumous story is combined with an
equally fundamental effect, which we encountered previously both in the
biographical operation of celebrating and making a legend of his life, and
in the critical operation of celebrating and making an enigma of his work.
This is the effect of singularization that is inherent in any biography. By
singling a person out as the object of a narrative, biography confers a spe-
cific character upon him or her. This is accentuated by the effort to raise
the person up above the common run of people, to disentangle the events
of his or her life from the humdrum ordinariness of people without partic-
ularities, of men without qualities. Sacrifice and singularity are thus the
two major motifs that hagiography stamps on the artist's life after the fact,
just as incomprehension and originality are the two main keys applied to
his work.

The projection of religious models onto the artist is apologetic, pathetic
and sacrificial. Even when it conforms in part to the historical truth of the
artist's own self-projection, it still assumes forms that are more akin to the
construction of legends than to the description of facts. The ease with
which this projection took place points to a real proximity between the
religious and artistic universes. They share many properties: inspiration,
vocation, revelation, dedication to a task, ascetic abnegation, detachment
from the present, indifference to material or wordly success, minimization
of any explicit rivalry with one's contemporaries, permanent doubt about
one's excellence, projection onto posterity of one's aspirations to achieve.
These are criteria of authenticity both for religious experience as defined
in Christendom, and for artistic experience as it has been constituted in
modernity.[60]

These two domains do not partake of the same substance, any more
than one (art) is the mere imitation of the other (religion). Their proximity
only becomes manifest in certain historical conditions. Neither identical
nor mimetic, these two "natures" are homological: their elements are not
linked in a relationship of superimposition, generation, or even resem-
blance, but by a common model or matrix, the principle underpinning a
structural identity.[61] That homology is what makes possible the artist's

internalization of religious models, their projection by biographers, and their assimilation by posterity.

There is no reason to suppose, however, that the hagiographers or their object ever make fully explicit the characteristics of this common matrix which engenders the experience of the creator sanctified by modern art, as well as that of the saint celebrated in the Christian tradition. And because the real is not reducible to what people say about it, it is time for us to go beyond the description and analysis of the interpretations proposed by the biographers, which have circumscribed the discussion thus far. The time has come to bring to light those factors that underpin the homology between a certain type of religious experience and a certain type of artistic experience, and that make it possible to explain the success of the hagiography of van Gogh, the ease with which it "caught on" in our culture, to the point of forming a legend known and accepted by all. I shall base my analysis on a parallel between two series of texts, van Gogh's correspondence and the apophthegms of the Fathers of the desert, these two orders of experience shedding light on each other.

The Artist in the Desert

The reader will have noticed that obedience, never evoked, is missing from the evangelic aspects of asceticism and abnegation favored by the biographers (humility, poverty, and chastity). Obedience is the prime condition of submission to the community rule to which van Gogh seemed to aspire so much. But it is the contrary of obedience that makes an artist's greatness. His solitude and suffering, later his excellence and glory, are born out of the refusal to bow to the norms, to fall into step with tradition, to obey the canons. His strength lies in being the opposite of a follower of the sworn faith, an obedient servant of the common law, to the extent that he contributes to removing, transforming and reforming that law.

Neither prophet nor coenobite, van Gogh's lot is akin rather to that of the anchorites. In late Antiquity, once Christianity had been instituted as the established religion, faith could no longer be expressed through the proven path of martyrdom. The anchorites sought after solitude, each to reinvent forms of sainthood not dictated by the common law. The hermit's life was the most extreme form of this search for excellence through physical separation and ascetic abnegation of the community. The well-known monastic movement by contrast represented an intermediate achievement. It was the lot of the Fathers of the desert to invent hybrid models between the absolute solitude of the hermit and the constraint of the monastic order, such as the virtual hermit affiliated to a community that he regularly has contact with, such as Symeon the "stylite," who exhibits for all to see

his retreat from the inhabited world, such as the master who is assisted by a disciple who owes him obedience. "Vincent paints as an anchorite prays. He has to go through the desert. He is alone with his painting as the hermit is alone with God, and each picture is an act of faith. His life as a painter is pure fervor."[62]

The analogy between van Gogh and the anchorites has received exceptional attention from his biographers.[63] It crops up too (but on the much less lyrical mode of the observation or the complaint) in many passages of van Gogh's correspondence, indicating that van Gogh viewed himself as seeking after "a truth that is truer than literal truth," truer than the tradition of verisimilitude instituted by academic scholastics (see below, "The Artist in the Desert").

THE ARTIST IN THE DESERT

— *Deprived of recourse to tradition*: "I know very well that it is neither drawn nor painted as correctly as a Bouguereau, and I rather regret this, because I have an earnest desire to be correct. But though it is doomed, alas, to be neither a Cabanel nor a Bouguereau, yet I hope that it will be French" (*Letters of Vincent van Gogh to His Brother Theo*, 575, 30 January 1889, III, p. 133).

— *The prey of every happening*: "But there, we live in days when there is no demand for what we are making, not only does it not sell, but as you see in Gauguin's case, when you want to borrow on the pictures, you can't get anything, even if it is a trifling sum and the work, important. And that is why we are the prey of every happening. And I am afraid that it will hardly change in our lifetime" (ibid., 527, 1888, III, p. 20).

— *Inhabited by doubt*: "In the same way I am wholly unable to judge my own work. I cannot see whether the studies are good or bad" (*Letters to Emile Bernard*, B 9 [12], June 1888, III, p. 499).

— *Leaving it to nature*: "Of nature I retain a certain sequence and a certain correctness in placing the tones, I study nature, so as not to do foolish things, to remain reasonable" (ibid., 429, 1885, II, p. 427).

— *In the hope of future achievement*: "If we dare believe, and I am still persuaded of it, that the impressionist pictures will go up, we must paint plenty of them and keep the prices up. All the more reason for concentrating quietly on the quality of the work, and not wasting time" (ibid., 480, May 1888, II, p. 555).

— *Salvation through their work*: "It certainly is a strange phenomenon that all artists, poets, musicians, painters, are unfortunate in material things. . . . That brings up again the central question: Is the whole of life visible to us, or isn't it rather that this side of death we see only one hemisphere? Painters—to take them alone—dead and buried speak to the next generation

or to several succeeding generations through their work" (ibid., 506, 1888, II, p. 605).

— *Hit by despair*: "Now I as a painter shall never amount to anything important, I am absolutely sure of it" (ibid., 590, 3 May 1889, III, p. 163).

— *In hope of what is to come*: "But the painter who is to come—I can't imagine him living in little cafés, working away with a lot of false teeth, and going to the Zouave's brothels, as I do. But I think that I am right when I feel that in a later generation it will come" (ibid., 482, May 5, 1888, II, p. 559).

— *Detachment with respect to success*: "for our own part, let's keep our utter indifference to success or failure" (ibid., 524, 1888, III, p. 17).

— *Showing one's true face*: "What am I in most people's eyes? A nonentity, or an eccentric and disagreeable man—somebody who has no position in society and never will have, in short, the lowest of the low. Very well, even if this were true, then I should want my work to show what is in the heart of such an eccentric, of such a nobody" (ibid., 218, April 1882, I, p. 416).

— *To be oneself and to get on*: "Well, however that may be—I want to get on à tout prix—and I want to be myself. I feel quite obstinate, and I no longer care what people say about me or my work" (ibid., 442, December 1885, II, 466).

— *Invest in the future*: "But how difficult for many of us—and assuredly we ourselves are among the number—the future is! I firmly believe in the ultimate victory, but will the artists themselves gain any advantage from it, and will they see less troubled days? . . . It would be some comfort, however, if one could think that a generation of more fortunate artists was to come" (ibid., 467, February 1888, II, pp. 529–530).

— *Resorting to "we"*: "We must not have any illusions about ourselves, but be prepared to be misunderstood, despised, and slandered, and yet—even if things become worse than they are now—we shall have to keep our courage and enthusiasm" (*Letters to van Rappard*, R 17, November 1, 1882, III, p. 342).

— *Wretchedness of the cab horse*: "I do not know who it was who called this condition—being struck by death and immortality. The cab you drag along must be of some use to people you do not know. And so, if we believe in the new art and in the artists of the future, our faith does not cheat us. . . . And as for us who are not, I am inclined to believe, nearly so close to death, we nevertheless feel that this thing is greater than we are, and that its life is of longer duration than ours. We do not feel that we are dying, but we do feel the truth that we are of small account, and that we are paying a hard price to be a link in the chain of artists, in health, in youth, in liberty, none of which we enjoy, any more than the cab horse that hauls a coachful of people out to enjoy the spring" (*Letters of Vincent van Gogh to His Brother Theo*, 489, May 10, 1888, II, p. 570).

These complaints, these resolutions, these descriptions of his material and spiritual life also bear witness to the active role of his correspondence, not only in the reconstruction of his biography after the fact, but also in the very construction of this virtually hermitlike existence. The anchorite has stepped outside of tradition, not to renounce it, but to reinvent its purest achievements by himself; as such, he is permanently exposed to doubt. He is constantly uncertain about the quality of his actions and thoughts, about their conformity with rules of living that he must elaborate with no outside support. To bear witness through speech ensures a modicum of stabilization and communicability of experience, and guards the speaker against being carried away by doubt. The apophthegms of the Fathers of the desert, piously recorded by disciples or companions, have the same dual function (to crystallize a fluid reality and to maintain ties with others) as van Gogh's epistolary outpourings, carefully edited and published after his death by the keepers of his memory.

Once removed from the urban community, the anchorite could not find the truth of his actions and thoughts in a rule and ethic predetermined by the ecclesiastical authorities. Similarly, artists in the desert cannot find the truth of their works in a technique and aesthetic preconstituted by the academic authorities, and therefore made before and apart from themselves. The creator cut off from his or her own community is separated from ordinary mortals and has swept away all principles. Such was van Gogh during the virtual totality of his career as a painter and, especially, during his retreat in Arles (that "eminent land"). This position in the social universe is well symbolized in the physical universe by the desert of the Holy Fathers.

Just like the anchorite, van Gogh was experimenting with a form of fulfillment that demanded not only the material individualization of his existence, his bodily separation from the instituted community, but also the personalization of the criteria of excellence.[64] What is at stake is no longer how best to follow a rule written down once and for all for everyone, but rather how to experience in oneself the best way to approach excellence. This is a way others will follow should disciples grasp it, should the "elders' words" not be lost in the desert, should a small community of peers draw inspiration from it in order to institute a specific rule—a rule that will be all the stronger, all the more authentic, the more it will refer back to the person who inaugurated it.[65]

Henceforth, salvation can no longer be found in an example to be followed, or another person to initiate. Its source is either to be sought in the absolute exteriority of the mystical revelation emanating from the supernatural forces that allow saints to accomplish miracles, like Mary of Egypt levitating or walking on water. Or it is to be sought in the (no less absolute) interiority that the anchorite constructs for himself through prayer and meditation, or that the creator achieves by relentless work. Inspiration is

the link between the two. It is the conjunction of a timeless, unpredictable resource, which cannot be reduced to common experience, and of that resource's punctual realization in a particular being.

Deprived of any recourse to tradition, "delivered into the hand of fate" despite their efforts and trouble, and "incapable of judging [their] own work," the artists in the desert are permanently inhabited by doubt. They have nothing to fall back upon to feel "reasonable," other than referring to the rare predecessors they have chosen as guides, or simply appealing to "nature." That is why, like the anchorite of the early Christian era, they only find consolation for their current misery and solitude in the hope of some future fulfillment, in which they sometimes "dare to believe." Such fulfillment is predicated on the possibility of a bond being formed in posterity with those who will come after, the future "generation" for which the way must be prepared "without doubting or flinching." But it is also predicated on the hope that permanence is inherent in works of art. By allowing the creator to "speak to several subsequent generations," works of art are the instrument of moral survival in posterity, which is the salvation of "all artists."

However, hope alternates with despair, just as doubt does with faith— that certainty of being correct, that assurance of being on the right path, without which those who wander in the desert could not long withstand the isolation and the lack of support, even when tempered by a "correspondence" with others. The anchorite lacks reference points in the past of an established tradition. In a present that is so deserted, he can find no landmarks. He must project onto the future the end of uncertainty, the resolution of doubt, the moment of truth regarding the correctness of the chosen path to excellence. This future is no mere tomorrow, however. It is a future he will never see, a future after his own death, that life beyond this life, which the believer hopes to reach in the afterlife, just as the creator hopes to find it in posterity. The more acute consciousness of what is to come—in other words, those aspects of ethical or aesthetic accomplishment that exceed the subject's lifespan—is necessarily accompanied by a certain detachment, which may even be proclaimed "absolute indifference," with respect to present success and worldly satisfactions. The desirability of death (as long as it is in the presence of companions, and there is assurance of an afterlife) that is so strongly enshrined in Christian morality, is constructed in this way.[66] And it is the investment in posterity that crystallizes, as much as justifies, this feeling of transcendence, of something beyond this life, of incompletion, calling for a completeness that cannot be current, that can only be attained in the postmortem salvation of the works of art.

Those whose search leads them beyond beaten paths or instituted communities can experience this feeling of incompleteness in two ways: in aspiring to a future invested with potentialities that have not yet been actual-

ized in the present; in aspiring to a form of self-expression invested with capabilities that have not yet been exteriorized for others. Here we have the wish formulated by van Gogh to "show what is in [his] heart" to "most people" who see him as a "nobody," as "the lowest of the low." This painful awareness of the gap between the greatness of which the creator is potentially capable, and the little that he succeeds in actualizing, is the cause of perpetual inner tension that generates a feeling of not being understood. The subject cannot blame anybody else for this. At most he may blame his own inability to make himself understood, to extract from himself that of which he alone, perhaps, holds the key. This tension finds expression in a pair of opposing forms, megalomaniacal provocation and self-depreciating depression. This is a false resolution of the unutterable suffering of not being seen as he is, and it only adds to the mismatch between the subject and the world that makes the world smile and the subject suffer. The only way around this double flight from the common reality of the present is to project onto the realization of some work this need to exteriorize an inner power by actualizing it, that is, by leading it from the virtual to the actual. This projection beyond the self goes hand in hand with a projection beyond the present, with the investment in the future that cannot be dissociated from any extraworldly quest. Interiority becomes opposed to exteriority, just as the future to the present and the self to the other. Thus van Gogh in the same sentence associates the wish to "get on" with the desire "to be myself." This illustrates quite admirably the homology between two forms of discordance of the ego (realized as an actuality for the other or held in reserve as a potentiality for the self): on the one hand, the temporal gap between a wretched present and a grand future; and on the other hand, the mental gap between a miserable exteriority and a sublime interiority.

Detachment from the present, investment in the future: this relationship to time is logical for an unattached artist. Feeling a double need to be "out-going," he ties his own fulfillment to the exteriorization for his contemporaries of that of which he is capable, as well as to progression toward a goal projected beyond himself in the direction of future generations. But in order to fuel this hope in a "generation" to come (in the dual sense of a group and of engendering), and to turn present doubt or failure into certainty of future excellence, there must be recourse to an "us," to that minimal sharing that enables the loner to anchor his hope to some external support, and thus to escape from the double danger of megalomaniacal ravings and depression. It is here, in this "us," that the role of the avant-garde crystallizes, blazing a trail and gathering together the small number of the elect.

This notion of the avant-garde highlights the role henceforth played in the art world by investment in posterity. Two aspects combine here: on the one hand, an expectation of salvation, in other words the soteriological

dimension traditionally taken on by religious faith in an afterlife, and carried forward in the modern era by the creator's hope in posterity; on the other hand, the impact of the requirement of singularity that is common to three distinct figures: the religious figure of the prophet, the military figure of the scout, and the artistic figure of the creator. Ever more indissociable from creative excellence, singularity forbids (or at least discredits) sharing a common tradition and establishing links with contemporaries, taking refuge in imitation of the past or collective reference to the ancients, or enjoying the worldly satisfaction of contemporary recognition offered by fashion and the marketplace. So only the future makes possible a link with others projected into posterity. Henceforth, the search for authenticity can only take place in the future (potentially backed up by a past reconstituted as needed, on the basis of the "influences" that each artist is asked to cite). At any rate, it cannot occur in the present, which has become synonymous with impurity. The notion of the avant-garde, which makes the past obsolete and the present impure, gives a temporal dimension to success, and makes it possible to reverse the meaning of failure: contemporary incomprehension can become a promise of future recognition.[67] "To those who are dissatisfied with the times and with themselves, to the suffering modern crowd, to those who wait without getting, to those who dream without hoping, raising up their distraught souls toward various suns, freedom, passion, asceticism or glory—to all of those I dedicate this book that is about all of them, and that I wrote, fraternally, with them in mind."[68]

It was during van Gogh's lifetime that the new ethic of singularity, and the projection into posterity that crystallized the notion of the avant-garde, were systematized in French artistic circles. However, van Gogh did not himself resort to the term "avant-garde" (that would still have been rather incongruous in his day).[69] He uses the image of the cab horse: "a link in the chain of artists," "of some use to people you do not know," and paying "a hard price . . . in health, in youth, in liberty," like the cab horse "that hauls a coachful of people out to enjoy the spring."[70] This image cannot fail to evoke the anecdote of the beaten horse, the sight of which in a Turin street is said to have produced Nietzsche's first bout of madness, the same year as van Gogh's.

The Life of a Saint

"The whole of this fugitive life is divided into four periods: the period of deviation, or wandering from the way; the period of renewal, or returning to the right way; the period of reconciliation; and the period of pilgrimage," wrote Jacobus de Voragine in the mid-thirteenth century in his prologue to the lives of the saints collected in *The Golden Legend*.[71]

If there is indeed a homology between a certain Christian definition of religious excellence and a certain modern definition of artistic excellence, then de Voragine's typology can be applied to the destiny of van Gogh without indulging in mere metaphor, myth-making, or inappropriate extension of the religious model to areas to which it is not germane. As we have seen, van Gogh's work too was constituted as both deviation and renewal. Common sense classifies it as *deviation*, discrediting its singularity as abnormal, as an inability to fit into common forms. At the same time, critical discourse treats van Gogh's work as *renewal*, no longer perceiving eccentricity negatively here as the inconsequential isolation of an unattached, naive person, but viewing it positively as a new center, an instrument of regeneration, a requisite point of passage, a reference in which the work of future generations will take root, even if it may take the form of a "return" to an earlier tradition, in conformity with the reformer's scheme. Finally, thanks to "revelation" (of his talent, not his saintliness) and then "conversion" (of the critics) van Gogh was raised from the status of a deviant to that of a stylistic reformer, before becoming, by the second generation after his death, the embodiment of a prophetic renewal of the excellence of the creator, in forms much inspired by Christian hagiography.[72]

It remains for me to determine the function of this hagiographical construction of the artistic legend. That question will be my guiding thread through the different forms of *reconciliation* organizing van Gogh's posterity. The first point to investigate will be the impact produced by the underscoring of the making of van Gogh's legend. For there is nothing self-evident about the shift to the artistic domain of the religious forms of excellence nor, correlatively, about the shift to biography of recognition hitherto limited to works of art. When these shifts became explicit, they aroused strong reactions (such as the reader has no doubt just experienced), ranging from laughter to exasperation. This reveals deep lines of fracture that go well beyond the single case of van Gogh, but without which the latter could not be understood. That is what we shall now consider.

Part II

RECONCILIATION

Three

Van Gogh versus Vincent

THE ANTINOMIES OF HEROISM

THE HERMENEUTICAL representation of van Gogh's work as an enigma was followed in the 1920s by the hagiographical representation of his life as a legend. To paraphrase de Voragine, his elevation to a legendary status was the biographical form of "reconciliation" with "one who has deviated," but has been transformed into a "reformer." It would be tempting to object that the hagiographical moment not only comes *second* chronologically, but is *secondary* in order of importance to the aesthetic renewal brought about by van Gogh. Does the legend spun around his life matter, if what really counts is his work?

Criticism and Hagiography

Condemnation of hagiographical excess frequently occurs in the world of scholarship. Anxious to dissociate themselves from forms of celebration that are too vulgar, even biographers who have contributed to making van Gogh a saint sometimes stigmatize the "legend spread by so many bad biographies, by so many shortsighted exegeses and 'passionate lives,' including a Hollywood super-production 'filmed on location.'"[1] Such condemnation can lean in two directions: either denunciation of the biographical dimension, considered disproportionate with respect to what is owed the work; or denunciation of the religious dimension, considered out of place. Let us begin with the second of these points.

To highlight sanctifying motifs in the artistic domain is spontaneously regarded as a critical act. It is seen either as a critique of the religious disposition "in truth" concealed behind artistic celebration as commonly practiced, or as a critique of the religious interpretations concealing "the truth" of artistic creation as theorized by scholarly discourse. When such a "religious" reading is applied to a nonreligious area, it is interpreted as seeking to disclose hidden realities, in a critical or apologetic spirit. It appears as a critique of the religious reality concealed behind love of art, or as an apology of the artistic reality concealed by hagiography.

Religious frameworks may be projected in order to denounce the "illusion of belief" perpetuated by ordinary celebration "acted out" by religious

forces. Alternatively, such projection may itself be denounced as an illusion produced by scholarly celebration acting by means of religious artifice.[2] In this critical conception of the utterance as disclosure and denunciation, the religious relation to art is interpreted at best as inappropriate in all of its forms, as behavior that is ill-adapted to its object. At worst, it is seen as a hidden, baleful force to be unmasked, and neutralized.

A distancing process takes place when attention shifts from the object celebrated (van Gogh) to celebration itself (reviews, biographies, admirers). Given the role assigned to the social sciences today, this comes across at once as a critical distance[3] and is read in the prescriptive register of an affirmation of values, rather than in the descriptive register of a mere statement. A swing occurs from the apology of what is celebrated (the artist made holy) to the denunciation of the duped or duping celebrant. This denunciation finds expression either in derision or exasperation, either in the laughter that sometimes rewards the common practices of naive admirers who are the victims of religious illusion, or in the indignation that drives attacks on scholarly discourses that propagate that very illusion.

Etiemble's big book on the "Rimbaud myth" in the 1950s provides a historical example of the latter position. It consists in denouncing celebration in order to restore the truth about what is celebrated against the biographers' pious transgressions. A shorter and more recent example is Milan Kundera's anathema against the hagiography of Kafka (a case that is made all the more interesting to analyze by the fact that the celebration of Kafka, like that of van Gogh, occurred in the 1920s).

Milan Kundera launches a vitriolic attack on a novel by Max Brod that depicts Kafka under the pseudonym "Garta" ("this naive novel, this third-rate rubbish, this caricature of a Romantic plot which, aesthetically, is the precise opposite of Kafka's art.")[4] Kundera's aim is to denounce what he calls "Kafkology," which he tautologically defines as "any discourse destined to Kafkologize Kafka." (His words could just as easily apply to "Vangoghology.") Kundera assails the hagiographical[5] reduction of hermeneutics to mere biography,[6] a move betrayed by desexualization[7] and historical decontextualization.[8] He criticizes the minimization of the aesthetic dimension[9] brought about by a hierarchical inversion that incites readers to rank the man above his work.[10] He excoriates the trend toward exegetical and allegorizing hermeneutics,[11] and finally, the inflated commentaries that have less and less bearing on Kafka's work.[12] Kundera caps this indictment with a personal attempt at an exegesis of Kafka's art, and concludes: "To hell with Saint Garta! His castrating shadow rendered one of the greatest poets of the novel of all time almost invisible."

Were I similarly content to highlight the religious schemas invested in van Gogh, I would necessarily end up being caught in the conflictual play

of disclosure and denunciation. I would thus forfeit my ability to understand what is at stake in such criticism. More generally, I would be unable to grasp the system of positions involved in celebration, that collective and ritualized form of admiration.

Oeuvre vs. Man

There is an opposition between the hagiographical veneration of the artist and the critique of religious expectations projected onto art. On another level, there is an opposition between focusing on the man and focusing on his oeuvre. In fact, we may discern a homology between these two sets of opposites. The homology can be seen in the fact that denouncing emphasis on the man goes hand in hand with denouncing devotion, while the tendency to personalize artistic greatness easily fits into the sanctifying forms of the hagiographical tradition.

Every celebration of a singular person as a hero comprises two contrasting principles of imputing greatness: a "personalistic" principle, which reduces the action or oeuvre to its author's intrinsic merit; and a principle that could be called "operationalistic." The latter raises the authors up to the level of an action or oeuvre that is extrinsic to them. They are, so to speak, merely the occasion for it, its accidental actors, instruments designated from among many other possible candidates.

At one end of the spectrum, personalizing the great man makes up in proximity to ordinary values for what has been lost with respect to the specificity of his actions or works. An example of this is the "cult of celebrities" in the tabloid press, which intellectuals willingly stigmatize as a form of alienation characteristic of the masses. Under the exasperated or disdainful gaze of the specialists, books for the general public and works of popularization sprout up, the abundance of their color illustrations echoing the generosity of their rhetoric, designed to impress all of those for whom van Gogh is henceforth "the man with the severed ear." In the modern compendia of legends devoted to "accursed artists," the elevation of the hero is explicitly imputed to the exemplary character of his life, which cannot be dissociated from the greatness of his work.

> What is to decide whether such and such a great artist is 'accursed,' if not our admiration for the splendid reverse side of his life and his art marked by misfortune, unhappiness or scandal? . . . great painting always says something about the painter's life. . . . Biography is often the first step leading to works of art. . . . There are exemplary artists whose suffering is inseparable from their work. . . . Can one be a lay saint? Can one console men? When van Gogh regained hope, in 1880, art seemed to him to hold a power of charity.[13]

To be truly "touching," in the strong sense of the word, the martyr must be close to the common folk. That is a fundamental principle of the cult of martyrdom.[14] In extreme cases, martyrdom (or the dereliction of the accursed artist) may even be less the cause than the expression of a greatness that needs no specific action to bring it into being. Such is the case of the man whose sacrifice of his own life to a higher truth has separated him from the community, and who is thus great by virtue of his sacrifice before being great by virtue of his positive actions. Contrary to the miracle-working saint, works (in the sense of charitable works as well as created works) are merely a secondary dimension in the sacrificial saint. They only testify to his excellence. Being precedes action in him. Martyrdom is mere testimony, in the proper sense of the word. Thus, in the personalizing version of the celebration of van Gogh, the brilliance of his work ranks second behind his excellence as a person, which is essentially built upon the negative virtues of abnegation and self-sacrifice. As a person, he is both familiar, for he is a man like any other, and exceptional, for he has stood out from the crowd. The saint is the man who sacrifices himself. Celebrating him requires drawing attention to him as a man, and as one who has been sacrificed.

By contrast, the "operationalistic" celebration tends to highlight the literally extraordinary character of the objectified manifestations of his greatness (heroic acts or brilliant works handed down to posterity). This is what specialists engage in when, leaving aside biographical accidents and the person's moral qualities, they seek to bring out the sublime nature of an action, the specificity of a work of art, or the singularity of a process. In the ancient world, heroes were celebrated thus.[15] In the modern tradition, works of genius are.[16] The approach of English historian Roger Fry is a good example of this principle of celebrating an artist's work rather than the man himself. During the 1930s, he was one of the first to oppose the "myth" of van Gogh that was being created.[17] Nowadays the most modern exegetes denounce the "myth of the accursed artist" inasmuch as it conceals the oeuvre behind the man. They take care to celebrate the artist only to the extent that what is admired in him is not a person made great by suffering, but the author of great works.

> And glory is still killing him. Shy, rejected and miserable, solitary, despised and exiled, alcoholic and mad, the personality supplants the painter. A genius, a myth. And the curse occludes the painting. . . . Such a narrative tells nothing about painting. They tell Vincent's story so as not to see him.[18]
>
> Perhaps these so often unsigned canvases should at last be seen as an anonymous painting is seen . . . to clear away the mythology of the *accursed artist* (the accursed artist . . . a job, a conventional repertory role like the greybeard, the duenna or the confidant; you know whom you are dealing with. . . . We are not

done with Vincent; every painting is an enigma). . . . No word could *exhaust* the *subject* of Vincent van Gogh. Because his work of color and silence belongs to seeing, not speaking.

The work of art is regarded hermeneutically and mystically as the depository of an enigmatic meaning that the commentator must reveal, while at the same time he must renounce any ambition of mastering it verbally. From this perspective, life cannot provide access to the work's meaning ("The incidents of a man's life in no way explain his work"),[19] even supposing that every biography does not become a deleterious mediation, an obstacle to the truth of art. Thus aesthetic hermeneutics contrasts with artistic hagiography as the work does with the man. From a personalistic perspective, the man can be regarded as the proper object of celebration, his oeuvre merely the (more or less adequate) mediation thereof. From an operationalistic perspective, the man can appear as a bad mediation, as obstructing the path to the oeuvre.

In any event, both outlooks involve some mediation. The oeuvre mediates the man in the celebration of the saint. The man mediates the oeuvre in the celebration of the hero or the genius. What varies is the aim of celebration (depending on whether the presence of the man or the meaning of his oeuvre is at issue), and the value attributed to the mediation (depending on whether it conceals and must therefore be ignored or denounced, or whether it reveals what it mediates and must therefore be commented on or celebrated).[20]

Scholarly Discourse vs. Common Sense

Biography is a battleground for two ways of conferring value upon a singularized individual. Operationalistic celebration pits the uncommon character of the hero or genius, author of exceptional actions or works, against personalistic celebration, with its common essence of the saint-in-person made great by suffering.[21] But a second opposition is superimposed on this system, namely the contrast between scholarly discourse that favors the hermeneutic of the work of genius, and common sense that favors the hagiography of the sanctified person.

This is a fundamental pattern in matters of celebration, extending well beyond the case of van Gogh. Peter Brown has emphasized the distinction between the practices of the "elite" and those of the "crowd" in the first manifestations of the Christian cult of saints. There, as elsewhere, the representatives of the "elite" constantly denounced the excesses of the "crowd."[22] Those who denounce forms of the martyr-cult that have been labeled "popular" tend to relegate them to the status of mere extensions of

paganism. In exactly the same way, the popular cult of accursed artists in modernity tends to be stigmatized, through ironic distance or grieving commiseration, as an extension of Christianity, as left-over gullibility, lack of culture, and spiritual poverty.[23]

We should not, however, confuse scholarly discourse with "the elite," or common sense with "the people." That would be to ratify the confusion generated by experts (the main holders of discursive resources) in marking themselves out as superior and therefore akin to the elite, in contrast with "what is common," which they regard as inferior and thus linked to the people. The term "popular" can only be used here if it also includes those privileged strata (bourgeoisie or aristocracy) who are distinguished by material wealth rather than by intellectual and spiritual resources. That is why I shall substitute "common sense" for "popular," and "scholarly discourse" for "elite." In matters of worship as of culture, the relevant opposition is not between those who own the *material* goods and those who do not, but between those who hold superior *intellectual* or *spiritual* goods and those who do not (whether such goods involve the priestly monopoly of "goods of salvation," to paraphrase Max Weber, or the scholarly monopoly over the meaning of artistic, scientific, or philosophical works).

Occasionally rehearsed in the clash between laity and initiates, or between traditionalists and the avant-garde, the opposition between scholarly discourse and common sense is far from being natural. It is an antinomy historically constructed by the scholarly world, by means of a process of dissociation from everybody else.[24] What remains is to explain this duality of systems of celebration, which takes the form of an opposition, a tension, or simple coexistence. The scholarly condemnation of the most common form of the personality cult could be regarded as a process of *distinction*, in the light of the concept elaborated by Pierre Bourdieu.[25] Such an analysis would have the merit of highlighting the resources more or less consciously required by the scholarly endeavor, as it requires a certain familiarity with the use of aesthetic categories and the history of works of art. But it would nonetheless be lacking. Were I to explain the resources and intentions of the scholarly position, but to take the common position for granted, I would fail to make explicit the resources and intentions in which the latter finds support. That would simultaneously make the common position *unthinkable*, other than as an amorphous residue of the scholarly position. The absence from sociological thought of the common position's other dimensions may be likened to inverted elitism. The objectifying reduction carried out by the sociologist favors the privileged merely by making them an object of study. Analysis must therefore go farther. The popular position must also become an object of conceptualization, thus preestablishing the symmetry that is indispensable to making the objects' properties explicit.

Criticism directed to the scholarly world has one thing in common with scholarly critique. Both tend to identify the "public," believers and admirers, with the "common people," and the people with the "less privileged" sectors of society. Implicit therein is the postulate that the popular position only exists "by default," that is, in the absence of the resources mobilized by scholars to argue for the necessity of focusing on the specificity of works, rather than the ordinary existence of people. But this is to ignore that the authoritative values of the "dominant group" (scholars in this case) do not just contrast with the absence of values of the "subordinate group" (non-scholars), but perhaps rather with other value systems. For there is also a break, a dissociation, a distinction implicit within the common admiration of the hero-in-person. This process distinguishes its subjects from all of those who lack the knowledge or sensitivity needed to recognize and celebrate the great man (and not just the great creator), to feel compassion before a human being's suffering, and not just to appreciate colors laid out on a canvas.

In the "common" system of values, the key to excellence is to seek to be close to others, and to be ostentatious about it. Closeness can be achieved through the immediacy of a relationship with another, or by way of mediation. Unequal access to resources (such as the cultural capital necessary for the learned celebration of works of art) is not so relevant here. What matter are the different aims involved. Common admirers may invest in immediate proximity to "great ones" because this brings them superior gratification, rather than because they lack the means to appreciate the works of art. In fact, admiration for the great one's works can be superimposed on this attitude without necessarily replacing it or competing with it.[26] To be a person is by definition the common condition of all human beings, even if it is a singular condition that is more excellently fulfilled by those who have been made into heroes. By contrast, works are not given to all. In principle only a few can accomplish them. This contributes to explaining why the scholarly world tends to value the rarity of works (even if they are academic), rather than the ordinariness of persons (even if they are uncommon).

Personalistic forms of celebration are thus associated with common practices, while operationalistic forms conversely are germane to scholarly practices. By definition, scholars handle discursive instruments with great ease. To the extent that they can argue that greater value should be imputed to works, the operationalistic mode tends to be more authoritative, both with respect to forms of celebration and to the choice of objects to celebrate. Just as sainthood is only authentic in the hagiographical tradition on the condition that it is recognized by the ecclesiastical authorities, so the cult of artists today is only legitimate if it is recognized by artistic authorities.[27]

It is not then a matter of contrasting the learned distinction of the "dominant group" with the popular indistinction of the "subordinate group." At issue are two different ways in which people distinguish themselves, by setting their sights either on the oeuvre or on the person. As distinction goes, the first (scholarly) variety is no more "distinctive" than the second (common) one. It is above all much more "distinguished," more "distingué." An explanation in terms of distinction holds true for two opposing types of behavior, and this reduces its relevance. A more fruitful approach would instead highlight the opposition between the two systems of distinction, the two ways of constructing excellence, namely the search for greater proximity to common values in an ethic of conformity, or the quest for the greatest possible distance from those values, in an ethic of rarity.

A scholar guided by the ethic of rarity constructs excellence as a critical demarcation directed against support for common practices, or "beliefs" in his vocabulary. To begin with, hagiographers criticize the common sense that doomed the martyr to incomprehension. On a second level, aesthetes such as Etiemble, Kundera or van Gogh's most modern biographers[28] criticize forms of hagiography that are too common, too vulgar. Finally, on a third level, sociologists equipped with Pierre Bourdieu's theory of domination[29] criticize the aesthetes' scholarly distinction. Remaining within the ambit of critique condemns one to espousing a scholarly outlook. But that is only one of the various positions that could be adopted with regard to the world (namely a polemical or selective one). For the analysis to be complete, one must withdraw from the scholarly world, by withdrawing from the ambit of critique. Symmetry between objects of research is thus restored, ending imbalance, and placing common sense, as well as various levels of scholarly distance from common sense, on an equal footing.

Two paths only are open to those abiding within parameters defined with respect to the dominant group's "distinction." *Popular educators* criticize the alienation imposed on the laity by failure to recognize true values (namely those of the initiates, who enjoy the privilege of not being ignorant of the fact that admiration should be directed to *works*). *Popular agitators* criticize the violence meted out to "so-called ignorant people" by those who "claim to be learned," who intend to impose their values upon everyone and to forbid the popular adulation of the great man. In the first case, the cult of van Gogh would be denounced. In the second case, the condemnation of this cult, or its recuperation by the orthodoxy of galleries and authorities, would be. But both cases are likely to ensnare naive sociologists of art who hope to set things straight in the clash of values over van Gogh (as in the more general conflict of cultural values), but find themselves forcibly enlisted in one camp or the other, "for" or "against" the

popular fervor displayed by nonspecialists and denigrated by scholars—a cruel dilemma, at least for those who wish to be learned *and* close to the people.[30]

Van Gogh vs. Vincent

His works, taken by themselves, would undoubtedly rank high among the great artistic creations of the last 500 years; his existence taken as a whole, which without his art would never be quite distinct, but which speaks clearly especially through that art, is of singular greatness. . . . His works spring from this combination, thanks to the identity of his religious, ethical and artistic impulses.[31]

As early as 1922, Karl Jaspers pointed out that in some ways van Gogh was the best example of the reconciliation in posterity of the polarities of "work" and "life." Van Gogh's artistic personality admirably lends authority to the association of the two opposed ways of imputing greatness, that is, through the oeuvre and through the man.

Among the contributing elements, there are first of all the characteristics of van Gogh's touch, where the graphic image of a psychic state is evoked through the metaphor of "torment": "His touch truly takes on the forms of his moods."[32] But there is also his extreme particularization. It makes him easily recognizable, and thus contributes to personalizing his work through the spontaneous association between the form of his brush strokes and his authorial name. Before being "recognized" (in the sense of appreciated) for its plastic qualities, the work can be "recognized" (in the sense of identified) as attributable to van Gogh. Scheler saw therein the hallmark of works of genius, "a source bearing witness to its own origin."[33] For several generations van Gogh has embodied an exceptional correlation between the celebration of a work and the cult of a man.[34]

More even than the formal characteristics of his paintings, it is the abundance of van Gogh's self-portraits that facilitates the condensation of plastic expression into its recognizable aspects, and of the man into his irreplaceable ones: "He becomes his painting. His work is his life; it is not his life that is his work."[35] It does not seem to matter that van Gogh justified his intensive production of self-portraits by a lack of money to hire models. The self-portraits nonetheless proliferated, and are now well ensconced on postcards and in widely circulated publications. This ensures the large-scale dissemination, not only of his style, but of his face—that most special badge of a man's identity. In addition to the frequency of his self-portraits and the peculiarities of his touch, van Gogh's name plays an important role in personalizing his work. As a signature, the name is the

point of conjunction where the man is brought into play in the work of art and the work receives a personal stamp. And because the signature is the ultimate bearer of artistic identity, the task of explaining its particularity in van Gogh's case has fallen to an artist.

> It is the difference between family name and given name. The family name is what one does. . . . Our human action is in the family name; it involves the money side of things; it is what we do, what enables us to eat, but the given name is what enables us to love. . . . It is no accident that van Gogh signed his pictures "Vincent"; that is why they are worth so much money; it is because van Gogh's painting was done with his given name, and not with his family name.[36]

Van Gogh's correspondence offers a most pragmatic justification for the decision to sign with his given name.[37] But of course this "simple reason" does not lessen the symbolic charge of such a gesture—see the recurrence of "Vincent" on fake van Goghs.[38] His biographers have not failed to emphasize it either ("Vincent, the first painter, no doubt, to paint in the first person").[39] Some have even derived from it an argument for likening him to kings, emperors, and great artists of the past.

> Van Gogh no longer signs van Gogh, he signs Vincent, and he explains why. Why do people sign with their given name? They may sign with their given names as a king does: Baudouin. That is customary. They may sign with their given names out of pride: it is I, my given name suffices. It was Rembrandt who first signed R.V.R. (Rembrandt van Rijn) and later only with his given name, like an emperor. Or they may sign with their given names as van Gogh did, explaining to his brother: "*I sign so that those who see me understand that I am saying 'thou' to them.*"[40]

The proper noun is *the* means above all others of naming someone, not in his or her capacity as an individual equivalent to any other, but as that "basic particular," the person, who cannot be reduced to any categorization.[41] However, there is a fundamental difference between the family name and the given name. The former reflects the vast space of a nation, and the differentiation of lineages. The latter reflects the confines of the family, and the differentiation of individuals.[42] The given name thus adds a dimension of proximity to the factor of particularization that any proper noun represents. These two properties make possible the reconciliation of the singular greatness of the works attributed to van Gogh, with the familiar proximity of the pictures signed by Vincent. *Vincent*, therefore—the personalized and (so to speak) "domesticated" hero, to whom anyone at all can come close through his biography—vs. *van Gogh*, the innovating artist, whose works specialists have the task of authenticating, and to whose cult they have the responsibility of lending their authority.

By offering himself to posterity through his given name, Vincent is more closely connected to the cult of saints—a cult so intimately linked to given names, that in Christendom given names have their origins in the patronyms of apostles and martyrs.[43] Thus, the name of Vincent van Gogh (a hero made into a genius by virtue of his work, and into a saint by virtue of his personality) fuses two forms of admiration: that allotted Vincent, like a saint in the Christian tradition; and that allotted van Gogh, a genius in the tradition of modern art.

A Heroic Model

Drawing both on admiration for the man and admiration for the work, the celebration of van Gogh also links the Christian tradition of sanctifying martyrs to a broader (and not necessarily religious) tradition of heroizing great singular figures. We can now integrate the analysis of forms of celebration into a more general model, which encompasses artistic and religious greatness. An anthropology of admiration can only profit from establishing parallels between the "saint" of Christian history, the "genius" of cultural history, and the "hero" of Antiquity or political history, with their common features (such as the necessary presence of a companion by the side of the Christian saint or epic hero)[44] and their specific characteristics (the saint, for example, must have a real historical existence).[45]

The biographical treatment of van Gogh borrows several motifs from the heroic tradition. There is, for example, the theme of predestination embedded from the day of his birth in the strange chance that caused him to be born one year to the day after the death of an older brother whose name he was given: "Vincent Wilhelm van Gogh, the painter, born on March 30, 1853, 'came forth' one year to the day after his namesake."[46] A portentous birth is a recurring characteristic of mythical heroes.[47] In van Gogh's case, it tends to be viewed as the premonition of a curse ("surely no one was more accursed, more overwhelmed by fate"),[48] the fulfillment of which is the tragic death by suicide of a man ravaged by despair, in conformity with the motif of tragic destruction that is inseparable from any postmortem heroizing.[49] Curse or mere chance, this circumstance of his birth is at any rate treated as an original mark of separation. Religious anthropology sees therein a distinctive characteristic of all sacralization.[50] "One year to the day after the deceased's birth, the pastor's wife brought a second son into the world, who was given his brother's double name. This tragedy, and the coincidence of dates, may not have been without a bearing on the divergent behavior and character that *separated* Vincent, during his childhood as a 'changeling,' from his parents, and brothers and sisters."[51]

What also comes across here is the emphasis on the precociousness of traits or dispositions already emergent in childhood (another characteristic topic of the constitution of the artist as a hero and of the construction of his vocation).[52] These dispositions may be specifically artistic: "From the age of nine on, van Gogh displayed a great aptitude at drawing" (*Petit Larousse de la peinture*, among many others). They may also be of a moral nature, such as deviant tendencies or eccentricity: "From childhood onwards, van Gogh's character demonstrated undeniable signs of queerness."[53] The fact is that precociousness ensures the interiority, and thus authenticity, of a greatness that cannot, as a trait emergent in earliest childhood, have been instilled by any external agency. It goes hand in hand with the theme of autodidacticism. Both converge in the motif of the gift, which entails both the virtual superfluousness of any learning, and the immediacy of expressions of talent.[54] While some critics insisted on the fact that he trained himself, reality is more ambiguous. He began dedicating himself to painting quite late, and his apprenticeship consisted both of work accomplished on his own, and of lessons or advice received from other painters, in workshops or academies, in the Netherlands and Paris. The motif of the autodidact therefore constitutes a tendentious rereading of his biography. It is analogous therein to the motif of sexual purity or that of detachment with regard to success.

Mutilation, finally, may be read as a realization of that "total act" which Otto Rank views as the principle of differentiation between the artist and the "average man."[55] Van Gogh's severed ear ends up evoking the blinded eyes of Oedipus as one of the great self-sacrificial acts of Western culture. His biography readily conforms to a set of motifs denoting exceptionality. These motifs tend to transform his artist's work from a cause of his uncommon status into a consequence of a native predisposition, embedded in a *fatum* characteristic of a "world in which poets, heroes and saints frighten other men."[56] Combining the "exuberance" of the genius and the "spirituality" of the saint, the figure of van Gogh moreover meets the dual requirement of dedication to "what is noble" in art, and of an "overabundance of spiritual will," which Max Scheler saw as the special characteristics of heroes.[57] Doubly marked by the tragic death of martyrs and the native curse of heroes, van Gogh's life inspires in one of his biographers a "religious fervor" that seemed too daring even to Stendhal writing about the national hero, Napoleon. The life of Vincent van Gogh . . . , may only be spoken of with a kind of religious fervor. One ought to give this beautiful and dramatic story an epigraph drawn from the opening words of Stendhal's *Napoléon*: 'I am filled with a kind of religious feeling on writing the first sentence of the story of Napoleon.'"[58]

The process of making the artist into a hero after the fact is constitutive of biographical reconstruction, which invents nothing but emphasizes,

highlights, erases, and touches up. It is a process similar to those Harcourt photographs which never betray, but rather *process* their models.[59] Each one of a series of celebrities gets bathed in the same light. In this way the very work of photographic celebration homogenizes the countenances of these personalities who are as singularly admirable as they are admirably singular. But that is the work of those bio*graphers*, hagio*graphers*, and photo*graphers* who *set down* the features of a celebrity for posterity. For his part, van Gogh had no "set" idea of what he was to become. It was all the more difficult for him to view himself as a hero because he had no artist-heroes as role models, not even from reading Carlyle, as we have seen.

But he had also read *Tartarin de Tarascon*, and his letters speak of it with remarkable enthusiasm.[60] Tartarin, the ultimate anti-hero, is the reverse of van Gogh as well as the embodiment of the hero-turned-upside-down. Completely unauthentic as an imitation of imitators ("the soul of Don Quixote in the body of Sancho Panza"),[61] he does not aspire to temporal posterity, but to spatial extension ("the wind of great voyages was blowing and giving him bad counsel"). He does not cultivate asceticism, but the comfort of a body "full of middle-class appetites and domestic require-ments." Everything is turned upside down in him: popularity becomes ridicule, what is strange becomes familiar, what is far becomes near, what is large becomes small, what is savage becomes domestic. Thus Algiers becomes Tarascon, the lion of the desert becomes a tame animal, and the great heroic hunter a ridiculous little man. But lo and behold—the fic-tional inversion turns into a reversion of fiction into reality. While waiting to be revealed as a hero to posterity and being mocked by his contempo-raries as a naive impostor, the painter finds consolation for present misfor-tune in laughing at the misadventures of a fictitious character who seeks to demonstrate his heroism, only to be mocked as a naive impostor.

From the Work to the Man

There are two opposing ways of arguing the case for the greatness of the heroized van Gogh. Either *he was unhappy because he was great* and, as a great artist, was unknown for his work (this model conforms to the figure of the genius made authoritative by scholarly admiration). Or *he was great because he was unhappy* and, as an unhappy man, was personally sacrificed (this model conforms to the figures of the saint or martyr familiar to com-mon admiration).

However, the second contingency was traditionally reserved for those who achieved singularity through the excellence of who they were or how they acted, and not through the excellence of their works as material objects. As Max Scheler correctly emphasizes, the saint differs from the

genius in being characterized by uniqueness, which precludes any equiva-
lences, as well as by presence, which precludes any reduction to his
works.[62] The possibility of treating the artist as a genius, a saint, and a hero,
all in one (as we have seen throughout these three chapters), introduces
quite an innovation into the artistic domain. As a bearer of antinomies, that
innovation engenders much resistance, however. While there is nothing
incongruous about calling van Gogh a genius (irrespective of the state of
debate among experts with regard to his calibre or authenticity), calling
him a saint is hardly self-evident. It requires an operation of disclosure or,
rather, contextualization and elucidation. Although admiration for the art-
ist joins them, the genius and the saint do not exist on the same plane, do
not belong to the same order.

But, in this new conjunction of the spheres of the work (van Gogh) and
the man (Vincent), the important thing is not just the association of heter-
ogeneous systems of hero-building. What also counts is the duplication of
these spheres, in which professional competence (however defined) was
traditionally the only point of reference. Henceforth ethical excellence in
the conduct of life is superimposed on technical or aesthetic excellence in
the creation of works of art. While an artist may be great by virtue of his
life as well as his work, there is no longer any reason why he should not be
great by virtue of his life and *not* his work. Valerio Adami defines van Gogh
as "a great artist grafted onto a mediocre painter." It has become possible
to set the greatness of the artist's personality off against the mediocrity of
his painter's skills. Such a contingency is scarcely imaginable in the
premodern era, when being an artist was still inextricably bound up with
plying a trade. All of this leads to the idea—which has become so popular
that it no longer seems incongruous with respect to earlier traditions—that
one can and (especially) must be an "artist" before being a painter, sculptor
or, more generally, creator of works of art.

Van Gogh's case is a fundamental moment in the progressive superim-
position of the biographical excellence of the author on the professional
excellence of the painter. To be sure, he is no doubt not the first or only
artist to have been popular thanks to his exemplary life, and not just the
quality of his work. But he does not so much embody the new era inaugu-
rated by the "prophet" van Gogh, as a "paradigm shift."[63] He crystallizes
tendencies that had hitherto remained latent, dispersed, or unrealized,
even in fiction. Among the many novels or short stories that began por-
traying painters in nineteenth-century French literature, there are cases
"invested" on an aristocratic model, as in Balzac's *Le chef-d'oeuvre inconnu*,[64]
or dedicated and sacrificed to their art, as in Zola's *L'oeuvre*. There does
not seem to be any truly "accursed" artist, that is, one who is both un-
known *and* a genius.[65] In this sense, the real van Gogh was "stranger than
fiction"—which caught up thereafter in the many novels inspired by his life

(a dozen before 1960). New hero of modern times oscillating between the genius and the saint, van Gogh henceforth appears less as a precursor (the impressionists, among others, were that before him), or a leading figure (which he never was), than as a "model" for posterity. That model was later a source of inspiration for the "leaders" of the different avant-garde movements,[66] as the avant-garde began to establish itself as the new artistic paradigm at the turn of the century, barely one generation after van Gogh's death.

In order to analyze the forms of celebration of the artist, it has been necessary to highlight not only what heroes are made of, in contrast with "average men," but also (and especially) what the average man's admiration for the hero is made of—a fitting program for an anthropology of admiration.[67] Accomplishing this has meant retracing the logic of celebration in the scholarly world, which is differentiated from common sense by polemical distinctions organized in three moments: first of all, admiration vs. incomprehension; then, scholarly admiration for works of art vs. ordinary admiration for the man; finally, condemnation of the domination imposed by scholarly admiration and the alienation brought about by ordinary admiration.

The process of admiration that produces such splits, as well as common attitudes to adopt with respect to the "accursed," could be applied to many other artists, such as Cézanne, Rimbaud, or Kafka. But the case of van Gogh adds an extra dimension, which helps to explain its exceptional impact. Van Gogh was not only "accursed" in his painting, but also sacrificed in his humanity. To this we now turn.

Four

Madness and Sacrifice

THE AMBIVALENCE OF SINGULARITY

VAN GOGH was heroic in his singularity. But he could also have been considered mad, just as his oeuvre, which was so innovative in its originality, could have remained unknown, could have been treated as a mere oddity, a laughable incoherence, or an ephemeral eccentricity. Every singularity reaches such a watershed. By making integration into commonly accepted categories problematic, nonconformity can slide at any moment either into the greatness of a necessary "renewal," or into the insignificance of contingent "deviation."

The Hypothesis of Madness

"I am whole of Spirit, I am the Holy Spirit,"[1] van Gogh wrote on the wall of his room.[2] Van Gogh's diagnosis of his own mental health immediately contradicts his self-sanctification in this punning antinomy (but with what irony?). Here again, we can see how exceptionally powerful an example van Gogh represents. He underwent the ordeal of madness and his deviation exposed his very self, not just his work, to the risk of disqualification.

He testified to this himself, as did the people and institutions around him (see below, "Awareness of Madness"). And yet the motif of madness did not appear immediately in the literature on van Gogh. The reader will recall that in 1893 a critic had emphasized the contradiction between the sanity van Gogh displayed in his letters, and the lunacy of his works, "which are absolutely those of a madman."[3] Conversely, three-quarters of a century later, it seemed self-evident for Marthe Robert to declare that "nothing in his colossal art betrays his demented ravings or grimaces of madness, and yet he is mad, he knows it himself."[4]

When Duret used the word "madness" in the first van Gogh biography in 1916, it was only with reference to the painter's work and with the aim of denouncing any condemnation of it. By then van Gogh's qualities seemed authentic enough for his madness, far from discrediting him or his work, in fact to establish his credibility.

> Van Gogh's work was long held in complete contempt, and its fantastic aspects and overexcited vision have a lot to do with that. They allowed people to say,

AWARENESS OF MADNESS

— "When I came out of the hospital with kind old Roulin, who had come to get me, I thought that there had been nothing wrong with me, but *afterward* I felt that I had been ill. Well, well, there are moments when I am twisted by enthusiasm or madness or prophecy, like a Greek oracle on the tripod" (*Letters of Vincent van Gogh to His Brother Theo*, 576, February 3, 1889, III, p. 134).

— "They have lots of room here in the hospital, there would be enough to make studios for a score or so of painters. I really must make up my mind, it is only too true that lots of painters go mad, it is a life that makes you, to say the least, very absent-minded. If I throw myself fully into my work again, very good, but I shall always be cracked. If I could enlist for five years, I should recover considerably and be more rational and more master of myself. But one way or the other, it's all the same to me" (ibid., 590, May 3, 1889, III, p. 166).

"this is the work of a madman!," and thus to denounce it in summary fashion. But if called upon today to pass judgement from afar on van Gogh's art, we would be sorry were it devoid of its share of imagination ardently at work. Were that lacking, *originality* and *inventiveness* would also not be very pronounced. There is in fact a reason why works of art that contain the fantastic and the unreal cannot be discarded, or seen by any eyes other than the most serene: it is that they too display perfect *sincerity* and *spontaneity*, that *they contain nothing artificial*. It is that van Gogh did not resort to any peculiar process or technique in producing them. He followed his own path, at work before *nature*. In the works that afford glimpses of them, the fantastic and the unreal therefore rest on a *real foundation*; they did not emerge from an overexcited imagination, other than to blend with a *true basis*, with which they are one.[5]

So long as van Gogh's biography remained in the shadows, the sense of deviation focused on his work. It was transferred to van Gogh himself as soon as he became an object of specific interest as a person, not just as a painter. The motif of madness did not really emerge until the second generation after his death. From the moment that the oeuvre was constructed as a *renewal*, it ceased to be deviant, and that attribute was conferred upon the man. Thus 1924 witnessed the first publication in France by a psychiatrist of an article mentioning van Gogh. In 1926, the artist was evoked in a book on the "art of madness." In 1928, the first psychiatric study entirely devoted to him was published.[6] Thereafter, similar studies proliferated, in France as much as elsewhere. There seems to be no end to this in sight. During the centenary of van Gogh's death, the dossiers on him compiled by the press still included attempts at nosographic interpretations.

The very multiplicity of diagnoses forbids any conclusions that could allow the case to be considered solved. Georges Bataille remarked on this as early as 1930 when only a minute part of the literature had been published.[7] In the early 1940s, nearly a dozen different diagnoses had been recorded in some twenty studies.[8] Thus, just as the biographical literature is an open production that can be reiterated indefinitely (in conformity with the hagiographical model), so the psychiatric literature never seems to have quite finished with the van Gogh "case."

However, the number of attempts to elucidate the psychiatric case is on a par with how much is made of van Gogh's painting. The painter's madness seems to arouse more and more interest as his painting gets increasingly valued. By contrast, a nobody with analogous symptoms would never have been the object of such research. All of those who write in this vein concur: "recognition" of a painter's work (in the sense of its acceptance) and "recognition" of its author's mental illness (in the sense of its nosographical identification) are indissociable, whatever the specific degree and nature of the connection established between the two. "His ailment and his Genius are one—just as he himself, automatically, alternately treated and *intoxicated* himself with his Art," wrote Dr. Paul Gachet for example, in his preface to Doiteau and Leroy's book. J. Audry, for his part, claims: "I think that the signature of his condition can be detected in his dishevelled trees, his nights full of strange stars, his singularly bent characters."[9] Considered consubstantial with his work, the man's madness henceforth appears neither accidental nor contingent, but necessary.

> He was absolutely helpless in everyday life, he was forever tripping up. His view of life, as well as of art, was grandiose and disinterested; truly, in this too, he was terrifying and beautiful. He went mad, of course, it could not have been otherwise. Not as a result of his struggle against incomprehension and meanness, not as a result of his ideas of disillusioned greatness. The cause of all of this did not reside outside of him, but within him.[10]

Gauguin was fully aware of how psychiatric interpretations threatened to discredit painting, as he wrote to Emile Bernard shortly after van Gogh's death: "You know how much I love Vincent's art. But given the public's stupidity, it is scarcely the right time to recall Vincent and his madness at the very moment that his brother is in the same situation! Many people say our painting is madness. It hurts us without doing Vincent any good."[11] Psychiatrists do not take an interest in a supposedly mad painter merely because he is apparently mad. Indeed, they may do so because he is also demonstrably a painter! The fact remains that imputing mental illness to the artist can be dangerous. The singularity of creation may end up being attributed to the deranged mind of an isolated eccentric, instead of the genius of an artistic precursor. This way of treating the man is the

equivalent of the danger to which his works would be exposed if art criticism denied them any general value, reducing originality to a failure to master the canons. Thus the "creation of a sick mind," in the words of a Dutch critic of 1892,[12] could be similarly dismissed a hundred years later (but this time by psychiatrists) as the "martyrdom without meaning" of a "failed saint."[13]

In his 1922 study, Karl Jaspers clearly saw this danger of psychiatric diagnoses diminishing the value of works of art, and it is that very lucidity that Maurice Blanchot praised in his 1953 preface to the French translation of the book. Jaspers cautioned his readers against any attempt to use charges of madness as a prop for some aesthetic act of discrediting: "The recognition of certain great works as being schizophrenic should by no means be applied as a degradation. We see depth and revelation where it is genuine." Furthermore, he laid stress on those qualities that can rehumanize a man in the very situations where "psychiatrization" would relegate him to the dehumanized condition of a mental case. Those qualities are mastery of the illness ("As a last point, we have to refer to quite an unusual phenomenon in regard to van Gogh: *his sovereign attitude toward his illness*"), earnestness, and moral qualities.

> The deep sense of earnestness which pervades in all letters prior to and during the psychosis is the same throughout. These letters (and only about a fourth of them date from the time of the psychosis) are in their totality the documentation of a philosophy of life, of a human existence, of a highly ethical mind, the expression of an unconditional love of truth, of a deep irrational faith, of infinite love, of a bighearted humaneness, of an unshakable *amor fati*. These letters belong to the most touching expressions of the recent past. There is no relationship between this ethos and the psychosis. On the contrary, it is precisely during the time of the psychosis that it proves its worth.[14]

Another way of minimizing the importance or relevance of madness, if not its reality, consists of imputing it to organic or physiological causes, rather than to some original psychological disturbance. Being purely contingent, such causes do not affect a man's deepest identity nor, above all, his rightful membership in the community of normal people, in which anyone could by some ill chance be afflicted by such external and accidental misfortunes as being epileptic or allergic to absinthe, the exceedingly violent southern sun or the *mistral*.[15] Still other arguments are put forward to reduce the risk that a psychiatric diagnosis might discredit van Gogh aesthetically. Instead of being drawn from the arsenal of common morality or physiology, these arguments are borrowed from the topics of the exaltation of the singular, which construes the transgression of norms as a form of excellence. From that standpoint, van Gogh's work represents a "descent into the unconscious," a kind of "sacred madness" comparable to the

"fervor of the first Christians." The painter is seen as akin to an "eccentric vagabond," "descended from that race of eternal peregrines, Beethoven, Kleist, Hölderlin, Nietzsche, Poe, Rimbaud, hounded by the devil, seeking to exorcise him through art, toward the imaginary."[16]

Finally, the charge of madness can be relativized by transforming eccentricity into opposition, and deviance into rebellion against "society." For example, in 1905 the critic van Bever laid emphasis on the polemical dimension of an avant-gardism that he depicted as quasi-revolutionary. His register is neither artistic nor medical, but rather political, since madness, "the exaltation of the vital resources," is not so much the cause of deviant painting and behavior, as the effect of revolutionary heroism. "Revolt: that is the appropriate way of defining this painter who rebels against all current ideas, all conventions. . . . He was so revolutionary that few followed his logic to its ultimate conclusions—that logic which never ceased to tyrannize him, and drove him to madness and suicide more surely than his physiological defects could."[17] Once again, madness has been minimized. Van Gogh has been kept within the great human community, but at the price of assimilation into the limited community of victims.

From the Medicalization of Art to the Aestheticization of Madness

Van Gogh's madness is thus alternatively affirmed as a constitutive dimension of his personality, and minimized as a contingent or secondary event. This oscillation betrays the very ambivalence of madness, which is both qualifying and disqualifying, interior (therefore authentic) and exterior (therefore deranged). Such ambivalence is a constant in psychiatric studies of artists.[18] More generally, the risks inherent in construing artistic deviation as a psychiatric issue can be circumvented by virtue of the creative artist's very genius, and this greatly facilitates the medical profession's interest in creative personalities.[19] For artists and their admirers, there are two risks attached to the reduction of artistic deviation to a psychiatric problem: the hypothesis of madness may discredit the artist's oeuvre, and the artist himself may be banished from "the common humanity."[20] Once it has been derived from insanity, singularity is excluded from the common human lot, although not from common *humanity* as much as from *common* humanity. "Loneliness has taken Vincent back, the most horrible loneliness: Vincent van Gogh has been expelled from normal humanity; Vincent van Gogh has gone mad."[21]

The psychiatric literature on art (which began to emerge at the turn of the century) follows upon the artistic treatment of the theme of madness

(and no longer just melancholy) in nineteenth-century literature. It thus lends a psychological form to deviant phenomena belonging to the realm of aesthetics.[22] The years following van Gogh's death witnessed a spectacular blossoming of psychiatric studies of artists, driven by the joint development of psychiatry as a discipline, and of an artistic culture that had henceforth integrated, if not accepted, the aesthetic validation of deviation.[23]

"Psychiatrization," however, is an extreme form of occlusion of the singular. Without going so far as to impute madness to artists, it is enough to regard them as "cases" pertaining to science rather than aesthetics, in order to *dismiss* their uniqueness through a generalization that subsumes them under common characteristics, under types or categories that are no longer only aesthetic, but are psychological, sociological, or even physiological. In the direct tradition of the "physiologies" that were very much in fashion in the 1830s,[24] this process of naturalization was applied to artists toward the 1890s (concurrently with psychiatrization therefore), in a series of publications with scientific pretensions, either translated from German or written in French.[25]

The reduction of the singular is therefore no longer effected by way of psychiatric eviction from the common humanity of normal people, but, in a more general fashion, by way of the scientific process of desingularization. This consists in naturalizing a status (that of the artist) by collapsing it into types. The principle upon which these types are based is not derived from the particularity of extraordinary individuals, but from the generality of a condition naturally embedded in certain categories (categories which can be as particular as the "man of genius" analyzed by Galton in 1869 and Lombroso in 1888).[26] The emergence of the different scientific treatments of artistic manifestations of singularity must therefore be grasped not only in the context of the development of psychiatry, but also in that of the various attempts to rationalize exceptionality and deviation from the norm.

Van Gogh's case was widely commented upon by psychiatrists from the 1920s onward, and provides a vivid illustration of the ambivalent investment in the relation of art to mental illness that was at the heart of the intellectual and artistic movements between the world wars, when psychoanalysis was being popularized, and when dada and surrealism (in the 1920s) and "raw art" (in the 1940s) were emerging.[27] The ambivalence of madness finds expression in particular in surrealism, inasmuch as the latter seeks an acceptable compromise between the interiority of the hidden forces of the subconscious, and their exteriorization more or less under the subject's control. The quest for everything that is beyond the artist's control, for what is out of control, can then become the very object of a process in which a "creative person will perish,"[28] finding consummation in his

work, in a twofold affirmation of universality (no specialization, no estab-
lished artists, no technical qualifications or barriers, everyone has an un-
conscious) and singularity (no general rule, to each his own mode of ex-
pression, bizarreness and incongruity hold sway).[29]

A similar process had driven the development of raw art. To be sure,
those who specialize in it denounce any attempt to liken them to van
Gogh.[30] Nonetheless, their apology of the works of the insane invokes the
topics of the hermeneutics applied to the singular artist—in particular, the
minimization of the role of madness,[31] as well as the condemnation of
any attempt to impute creation to insanity. Such imputation is seen as
falsification.[32]

The fact is that van Gogh never succumbed to madness permanently,
but only intermittently. He always maintained ties to the community of
normal people, as Marthe Robert has observed: "The madness that on
occasion possessed him did not in the strict sense lead to insanity. The
madman is not irremediably lost, here."[33] This makes van Gogh that much
better an example of the process whereby psychological deviation becomes
artistically charged. In the oscillation between delirium and lucidity, the
constitutive ambivalence of madness in art can be maintained. From the
moment that it is linked to an equally deviant oeuvre, any madness may be
seen both as the inner driving force of creation (as something that belongs
to the artist himself), and as an external influence (as something that is
imposed on him against his will since, as a madman, he is "other" than
himself).[34] The imputation of madness thus becomes both a qualification
and a disqualification: a qualification, because the mad artist is authentic, in
that he is not conditioned by outside influences, routines, and imitations;
a disqualification, because he is doomed to inauthenticity from the mo-
ment that it is the *other* in him whose vision finds expression in his crea-
tions, beyond any possible generalizations, any permanence, or any chance
of his artistic gesture being shared by others.

Although van Gogh drew notice as an "isolated" artist, he was thus no
isolated case, far from it. There indeed lies the paradox of the singular,
who eludes analysis as long as his case cannot be generalized, and who can
only be analyzed to the extent that he can be desingularized. A generation
after van Gogh's death, there was a general movement of investment in
deviation and transgression, both in the psychiatric context of interest in
the deviant artist and in the artistic context of interest in the creative mad-
man. This movement crystallized on three levels: in van Gogh's oeuvre,
within the context of the renewal of aesthetic norms at the end of the last
century; in the man himself, within the context of the mystical investment
of the artist's vocation at the same period; and finally in his madness. In this
sense, van Gogh truly is at the intersection of the medicalization of art and

the aestheticization of madness. In the twentieth century, this has been the site from which the business of criticizing, superseding, and renewing common norms has devolved to artistic creation.

The Hypothesis of Sacrifice

Keeping the deviant within "the common humanity" requires that madness be relativized to a certain extent. However, this involves more than merely conferring aesthetic value on deviation, or minimizing the impact of the psychiatric diagnosis. The key is to come up with a hypothesis well suited to circumventing any attempt to generalize from the deviant case, or to give it a psychiatric hue. Such is the hypothesis of sacrifice, by virtue of which it is "this frenzy, this furious need to produce, to give all of himself in the work of art, that cost van Gogh his sanity."[35]

Van Gogh's very letters teem with expressions of such a feeling of sacrifice (see "Awareness of Sacrifice"). Significantly, this is especially true of the letters he wrote to his brother, who also "sacrificed" himself—for him. It is as though, by testifying to how much he was giving his art, Vincent could make up for what Theo had given him by enabling him to paint. This sacrifice is often presented as the loss of sexual and family life (marriage and "real love," "little women" and "living it up," "real life" where one "makes children" and not paintings). More generally, van Gogh claims to have sacrificed, for better or worse, his "whole life" to his work, in the process losing his "blood" and his "brains," his "life" and his "reason," as he wrote at the end of the moving and confused last letter that was found on him after his suicide—a suicide by way of which he made his brother, in his own words, "a dealer in dead artists."

Van Gogh's biographers have abundantly, and in every conceivable way, exploited his consciousness of having sacrificed himself for his art.

> *The sacrifice of his health*: "In order to afford paints and brushes, Vincent barely eats; he makes do with bread and smokes incessantly to stave off hunger pangs. As he is very weak, he suffers from dizzy spells and violent stomach pains."[36] *The sacrifice of his body*: "Every canvas he places on the easel, every tube he squeezes onto the palette in order to paint himself, means one meal less, one less chance to have it off." *The sacrifice, finally, of all of himself*: "What killed him was not the years of poverty, but what painting demanded of him.[37]

Van Gogh's suicide (blamed by some on a fear he would no longer be able to paint) marks the climax of his sacrifice, foreshadowed by the mutilation of his ear, the bloody surrender of a piece of himself.

The "dream" of film director Kurosawa offers an exemplary fictional

AWARENESS OF SACRIFICE

— *Love*: "As for me—I feel I am losing the desire for marriage and children, and now and then it saddens me that I should be feeling like that at thirty-five, just when it should be the opposite. And sometimes I have a grudge against this rotten painting. It was Richepin who said somewhere: 'The love of art makes one lose real love'" (*Letters of Vincent van Gogh to His Brother Theo*, 462, Summer 1887, II, p. 521).

— *Real life*: "Oh! it seems to me more and more that *people* are the root of everything, and though it will always be a melancholy thought that you your-self are not in real life, I mean, that it's more worth while to work in flesh and blood itself than in paint or plaster, more worth while to make children than pictures or carry on business, all the same you feel that you're alive when you remember that you have friends who are outside real life as much as you" (ibid., 476, 1888, II, p. 544).

— *Living it up*: "In any case, the studio is too public for me to think it might tempt any little woman, and a petticoat crisis couldn't easily end in a liai-son. . . . But with my disposition, living it up and working are not at all com-patible, and in the present circumstances one must content oneself with painting pictures. It is not real living at all, but what is one to do?" (ibid., 480, May 1888, II, p. 555, translation slightly modified).

— *His whole life*: "But my dear boy, my debt is so great that when I have paid it, which all the same I hope to succeed in doing, the pains of producing pictures will have taken my whole life from me, and it will seem to me then that I have not lived" (ibid., 557, October 20, 1888, III, pp. 92–93).

— *Blood and brains*: "But what is to be done? It is unfortunately complicated in various ways, my pictures are valueless, it is true they cost me an extraordi-nary amount, perhaps even in blood and brains at times. I won't harp on it, and what am I to say to you about it?" (ibid., 571, January 17, 1889, III, p. 117).

— *His life and reason*: "For this is what we have got to, and this is all or at least the main thing that I can have to tell you at a moment of comparative crisis. At a moment when things are very strained between living artists and dealers in dead artists. Well, my own work, I am risking my life for it and my reason has half foundered because of it—that's all right—but you are not among the dealers in men as far as I know, and you can still choose your side, I think, acting with humanity, but que veux-tu?" (ibid., 652, July 1890, III, p. 298, translation slightly modified).

interpretation of this deed (which has become so to speak paradigmatic of van Gogh's case). Kurosawa's van Gogh explains that he severed his ear while painting his self-portrait, because he found the organ too difficult to represent.[38] There are two aspects to this interpretation: economic rationalization and moral justification. In the first, self-mutilation is granted a function, a utility in the painter's work. In the second, mutilation is explicitly treated as the man's gift of himself to his art. On the level of fantasy, rationalization and moralization effect a twofold reintegration of the deviant into "the common humanity." However, the economic dimension is rendered in a fictional, if not burlesque genre, the stakes (technical convenience in the production of a painting) being quite out of proportion with the gesture (an irreversible blow to his bodily integrity and his humanity). The moral, sacrificial dimension, on the other hand, is a serious motif, as is demonstrated by its recurrence in the biographical literature. "This man, whose life is a succession of piteous failures in every area, does not despair, he pays the heaviest and most painful price for his work."[39]

The theme of sacrifice is surely the ultimate biographical cipher of this legendary life. It oscillates between "godlike asceticism" (he lives on very little, does not get married, does not eat) and "bestial frenzy" (he drinks, bleeds, goes to a brothel to offer a piece of his own flesh), the two extremes between which Greek religion sought to steer a middle course for sacrifice.[40] In both of these extreme cases, the "sacrificer," the "victim," and the "god" tend to become indistinct. This is precisely what happens in van Gogh's tragedy. In his self-sacrifice, sacrificer and victim combine: "Vincent offers himself at this magnificent and terrible festival, of which he is both the organizer and the victim."[41]

The theme of sacrifice recurs like a leitmotiv. It is as though, after interpretation in terms of "renewal" had testified to the greatness of the oeuvre and the man, "reconciliation" could now take place through two opposite, mutually reinforcing, ways of treating singularity in the biographical myth-making about van Gogh: banishment from the common condition by way of the hypothesis of madness, and heroizing reintegration into the community by way of the hypothesis of sacrifice. The saga of van Gogh's psychological isolation leads finally to spiritual community by way of a contradictory process in which, as a singular individual, he first gets dehumanized (as a madman), then rehumanized (as one who paid the price of madness for his art). The paradoxical outcome is that the more psychiatrists proclaim him mad, the more he can be declared great by his admirers.

If we take madness and sacrifice as two opposing hypotheses, we can assert that the second (moralistic) one cancels out the first (medical) one. Not only does science lose its purchase on the phenomenon—it gets enrolled in morality's service. The point is that the hypothesis of sacrifice

does not refute the hypothesis of madness. Instead, and more efficiently, it integrates the latter into another explanatory framework, in which it becomes an additional argument. He was no doubt mad, the admirer responds to the psychiatrist, but his greatness and humanity consist *precisely* in having gone all the way to the brink of madness and beyond. Once the deviant's suffering has been construed as a sacrifice, it has risen above contingency, it is no longer reducible to a mere concatenation of biological, meteorological, or sociological circumstances, any more than deviance can be reduced to madness. The latter no doubt retains some of its correctness as a hypothesis but, be that as it may, it loses all relevance. The hypothesis of sacrifice is what *saves* the artist-savior from the in-difference, from the formless chaos of abnormality, into which deviants are cast.[42]

Madness thus acquires value, as Nietzsche prophesied. This is no longer an aesthetic, but rather a moral process, since it is the price paid by the singular individual for the salvation of his or her fellows. Bataille has described the logic of this process, which turns on the notion of the gift intrinsic to every sacrifice.

> A proverb of Blake's says that *if others had not been mad, we should have had to be.* Madness cannot be banished from human *integrity*, which could not be achieved without it. Nietzsche going mad—in our stead—thus made that integral character possible; and those who went mad before him did not do so with such brilliance. But can a man's gift of his madness to his fellow men be accepted by them, without being returned with interest? And if the latter is not the insanity of the man who has received another's madness as a princely gift, what could compensate for such a gift?[43]

As the reader will have guessed, the compensation is guilt. The psychiatric hypothesis erased any wrong done to the excluded individual. It thus made it possible to feel innocent of an exclusion resulting from a handicap for which no one could be held responsible. By contrast, the sacrificial hypothesis reintroduces the excluded one into the community of exchanges, a community to which he or she is linked by the debt incurred by the gift of oneself, a debt that has finally been accepted.

From Sacrifice to Guilt

> Society has to its credit the famous heinous deaths of Villon, Baudelaire, Nerval, Nietzsche, Edgar Poe, Lautréamont, and van Gogh.

Prizing persecuted singularity in almost political fashion, Antonin Artaud's noted 1947 poetic pamphlet, *Van Gogh, le suicidé de la société*, presents the purest and most violent form of rejection of the psychiatric assessment of

van Gogh ("No, van Gogh was not mad").[44] Artaud stresses the fundamentally social or political character of van Gogh's deviance: "Van Gogh's painting does not attack a certain conformity of manners, but the very conformity of institutions."

That which, more than anything else, makes this text powerful and original is the spectacular process of ascribing guilt that it sets in motion. As such, it is in the direct lineage of the pamphletary genre. Heavily present in their utterances, the pamphleteers take on the mission of voicing what is hidden, of unveiling a secret, even a conspiracy. The logic of indignant denunciation, in which the potential accused can transform himself or herself into an accuser pointing out the culprit, is echoed on the formal level by the affective intensification of a pathetic discourse (fury, anger, indignation) in a readily digressive and reiterative mode, the vehemence of which mimes the effectuality of the spoken word.[45]

Artaud's text imputes guilt on several levels. On the individual level, he blames the physician, presenting van Gogh as his victim.[46] On the collective level, he accuses "society" of having inflicted the penalty of suicide on van Gogh.

> And where, in these ravings, is the place of the human ego?
>
> Van Gogh sought his own ego throughout his life with a strange energy and determination,
>
> and he did not commit suicide in a fit of madness, in the agony of not attaining it,
>
> but on the contrary, he had just succeeded in attaining it and in discovering what he was and who he was, when the general conscience of society, to punish him for having torn himself away from it,
>
> suicided him.

Thus van Gogh does not only get transformed into a sane ("logical") individual in the face of an alienating society, but moreover, and quite explicitly, into a "martyr," the "martyred van Gogh." His apparently senseless gestures thereby become heroic acts, which have simply not been recognized as such. It is the mission of the poet (equally treated as mad, equally suffering, equally singular) to reveal them: "As for the cooked hand, that was heroism, pure and simple; as for the severed ear, that is direct logic."[47] This inversion is fundamental. It forbids any psychiatric eviction from "the common humanity," and authorizes the subject's return to the community of his debtors by making his greatness (embodied in the brilliance of his works or the heroism of his actions) into the very cause of his exclusion, and his exclusion into the price of his greatness.

The community's debt to an artist consists of the price he or she pays as a singular individual for a contribution to the common good of art. The greater the work, the more extreme the self-sacrifice, the heavier the debt

will be. The martyr's sacrifice (and thus *gift*) of his or her own self and integrity can never be reversed. Consequently, the community can never absolve itself of the debt it owes the artist. That debt thus turns into infinite, constantly renewed, guilt: "Henceforth it will be impossible not to keep coming back to van Gogh."

Artaud's arguments did not fail to be taken up by others, in an insistent but more ordinary, familiar if not familial, register. *Irreversibility first*: "He was not loved—nothing has been healed, it cannot be healed, it is irreversible." "Let us not fool ourselves: van Gogh's exclusion is irreparable, incurable." "Van Gogh is dead. He is a corpse. And that is irreversible." *Then suspicion*: "*Who* killed Vincent?" "Today, the crowds' gaze sweeps over the traces of his exclusion—those canvases that throw his loneliness to the mercy of the multitude, which feasts its eyes on them without recognizing that loneliness. And without recognizing him. . . . But who led van Gogh's hand to a different instrument? Who made him turn it away from the canvas and on himself? Who made him destroy his model? Who killed Vincent?"[48] *Finally, the search for the culprit*—who, according to the Christian logic, cannot be the victim himself, even in a case of suicide, once martyrdom has been established.[49]

The search for the culprit begins with blame being laid on individuals. Various familiars of van Gogh are picked to bear the burden of guilt. The first in the line of fire is Theo, because he was closest to the victim and the latter depended directly upon him:[50] "Never again was Theo to visit his brother, even upon knowing that he was in the greatest distress. His pretext? He was too far away and what good would his presence do Vincent!" On an even worse note, there is question of "Theo's desertion, his betrayal, his evasiveness." Theo "drove Vincent to offer himself as a sacrifice, which he was to do by killing himself." The heirs are the next to be taken to task, more or less by name: "He died at the age of thirty-seven years and four months. Theo died at thirty-four. It does not take long to murder those who are in the way. And to grab the goods extorted from them under torture. And to name these goods a legacy." Partial responsibility for van Gogh's illness and death is ascribed to the medical profession, as often happens in bereaved families: "Dr. Peyron, who ran Saint-Paul-de-Mausole home, presided over all of this with incomparable incompetence."[51] Dr. Gachet, accused by Artaud of having reduced van Gogh to madness, also gets blamed for not having operated on him after his suicide attempt: "Vincent probably committed suicide, but others killed him." "Between the evening of Sunday the 27th, and Tuesday the 29th when he died at one o'clock in the morning, nobody tried to save, or even to treat Vincent van Gogh"[52]—an accusation that conforms perfectly to the Christian logic of martyrdom.[53] Finally, there is the inhumanity of the official

representatives of the Church, whose intransigence sentences van Gogh to the same fate meted out to Mozart (who died at just as young an age) a century earlier: "Father Tessier of Auvers-sur-Oise refused to lend the hearse for the funeral, alleging that Vincent had committed suicide, that he was a Protestant, and that he did not know him. . . . The parish priest at Méry-sur-Oise was more charitable, and loaned the equipment needed for the funeral."[54]

> Yes. It must be emphasized. Say and say again that van Gogh's labor is not a "triumph" of mankind, but a superb example of its defeat. Of its abdication. And of its cunning. Men such as Rembrandt, Artaud, Hölderlin, Nerval, Pasolini, and so many others, such as van Gogh, are not fringe elements, and did not create despite society. Society delegated them to put into practice the prohibitions which surround it, to commit, beyond its familiar crimes, the criminal acts with regard to the codes, to localize, in "works of art" that are swiftly sterilized by the media, the malignancy that still remains acute and threatening around those zombies. And, in those "works," society, and its zombies, can claim to recognize themselves to their true extent, which is the exception.[55]

In this manichaean opposition between the "good" represented by great singular figures and the "evil" embodied by the "codes," the "media," and all the representatives of "society," the very expression used by Artaud may be found, namely "society." Henceforth guilt is ascribed not only to individuals, but also to the collectivity.[56] Persecution cannot be ascribed to one clearly identifiable individual in van Gogh's case. Inevitably a collectivity is made to shoulder responsibility for his martyrdom, by contrast with the Christian martyrs or the heroes studied by Otto Rank. To be sure, one can try to incriminate the neighbors who signed a petition to have him committed, or Dr. Gachet for his negligence, or even Theo for his "cowardice" at the time of Vincent's confinement, for his "strange collusion" with Gachet at the time of the suicide.[57] But such accusations remain dubious. Such flimsy condemnations can scarcely be sustained before the informal tribunal of posterity. Guilt is essentially collective here, and is ascribed to the body that, more than any other, embodies the malevolent community today: "society."

The topic of collective guilt is perfectly grounded in law.[58] It furthermore acquired an ethical rationalization at the end of World War II, with Karl Jaspers' distinction between criminal, political, moral, and metaphysical guilt. The latter form can apply to the artist if "metaphysical guilt is the lack of absolute solidarity with the human being as such."[59] Like moral guilt, metaphysical guilt is triggered by a reproach that comes from within. As such, it cannot logically be collective; but it becomes so for "average thinking"[60]—average thinking or "common sense" for which van Gogh

becomes a special fixed point of reference. In any case, such guilt cannot, in Jaspers' view, be expiated. It is endless, and requires an unceasing effort to atone by way of purification.[61]

This topic is common also to the Christian tradition, as Guy Rosolato has pointed out.[62] The appropriation of another's suffering by collective guilt is a familiar theme in Catholicism: "Our debt will never be paid back."[63] Such appropriation of suffering in lamentation can act both as a consolation and as a consolidation of community ties, as Patrick Pharo has noted.[64] The martyr's sacrifice unites the subject and his object (the sacrificer and his victim) in one and the same person. Similarly, it joins the subject and object of vengeance (the avenger and his target) in one and the same "body" (the group, "society"): collective guilt truly is the martyr's reprisal.

From Incomprehension to the Fault

Van Gogh appears to have been conscious of the power to instill feelings of guilt that was locked within his life, and that exploded onto the scene after his death. In fact he anticipated that the obligations allotted to art (see below, "Awareness of the Fault") would be blamed on "society." But it was only after his death that his individual sacrifice could be transformed into collective guilt, and that the misunderstanding between him and his contemporaries could become an inexorable fault committed against him.

Death is as necessary to the validation of martyrdom as incomprehension is to the evidencing of a fault. It is death that distinguishes sacrifice—which rules out any recuperation during the lifetime of its author—from mere investment in the future, in which one simply defers the enjoyment of the fruits of one's efforts. The logic of sacrifice dictates a necessary opening onto posterity, beyond any present life. This opening alone makes it possible to move from the interested sphere of calculation to the disinterested sphere of the gift. In doing this, it allows justice to be done over several generations, and not merely within the restricted span of a human life.

In symmetrical fashion, injustice is as necessary to martyrdom as death is. For death must be accompanied by injustice in order to call for veneration, because it is only the natural form of separation from the community of the living, just as spirits are the latter's supernatural form. A "holy woman" who sacrifices herself for her children is not hallowed as a saint for that reason alone, any more than a deceased person is merely because he is dead. All veneration requires a "dissymmetry" between what is given and what is returned. Charles Mauron makes this point well with respect to the mother, the saint, or the artist—and in particular van Gogh.[65] Just as the

AWARENESS OF THE FAULT

— *Debt*: "At present I do not think my pictures worthy of the advantages I have received from you. But once they are worthy, I swear that you will have created them as much as I, and that we are making them together" (*Letters of Vincent van Gogh to His Brother Theo*, 538, 1888, III, p. 39).

— *Guilt*: "But the money that painting costs crushes me with a feeling of debt and worthlessness, and it would be a good thing if it were possible that this should stop" (ibid., 589, May 2, 1889, III, p. 162).

— *Making guilty by way of suicide*: "Remember that I would far rather give up painting than see you killing yourself to make money. One must have it, for sure—but has it come to the point where we must go so far to find it? You understand so well that 'to prepare oneself for death,' the Christian idea (happily for him, Christ himself, it seems to me, had no trace of it, loving as he did people and things here below to an unreasonable extent, at least according to the folk who can only see him as a little cracked)—if you understand so well that to prepare oneself for death is idle—let it go for what it's worth—can't you see that similarly self-sacrifice, living for other people, is a mistake if it involves suicide, for in that case you actually turn your friends into murderers" (ibid., 492, May 29, 1888, II, p. 576).

— *Society's debt*: "That's why painting ought to be done at the public expense, instead of the artists being overburdened with it. But there, we had better hold our tongues, because *no one is forcing us to work*, fate having ordained that indifference to painting be widespread and by way of being eternal" (ibid., 520, 1888, III, p. 7).

artist had to die to be celebrated, so it was *necessary, for that to happen*, that he not be understood in his lifetime. The motif of incomprehension, in which suffering and injustice are joined, is the condition of celebration since the latter "does justice" to those who had to suffer from the ignorance of their contemporaries.

When alive, the singular individual is nothing but isolated (if he or she fails) or a leader (if he or she succeeds). It is only once dead that one can become a model to whom everyone will be able to *pay* tribute, not so much for actions or works, but because of having suffered unjustly. Then the simple misunderstanding that one encountered—incomprehension, neglect, inability to look or to listen—can be transformed into an offense, and be felt subjectively by anyone who "puts himself in the victim's shoes," who sympathizes. The recurring tale of woe can alternate with laying blame on others or oneself. Complaints can arise, and the scandal be denounced: "The scandal is that in still refusing today to accept his

logic and the clumsiness, the botching it engenders, people admire his work."[66]

What occurs therefore is a construction of the artist's suffering as a scandal. This moment of the stage of reconciliation corresponds to the construction of the work as an enigma and the construction of the man as a legend in the earlier stages of deviation and renewal. The scandal is less an effect of the victim's suffering than a cause of the feeling of injustice experienced after the fact. It is evidence of greatness and authenticity. Just as it was necessary for there to be an injustice for there to be an "affair" allowing for justice to be reestablished, so it was necessary for there to be incomprehension for love and admiration to develop—just as it was necessary for there to be persecution (the persecution of the martyr which carries one to the limits of incomprehension) for there to be scandal, anathema, and atonement.

The association of individual self-sacrifice and collective fault thus constitutes a model of reintegration of the singular into the community thanks to his dedication to the common good (a model that is very prominent in the Christian tradition). In this way, the deviant threatened with exclusion from the human community is rehumanized, while suffering is converted into a principle of greatness, and madness into evidence of suffering. The reconciliation of the singular and the community proves necessary from the moment that the work's greatness, once it has been established, prohibits the elimination of the singular as a mere extravagance, as madness. Michel Foucault correctly points out the antinomy that exists as a matter of principle between oeuvre and madness: "Where there is an oeuvre, there is no madness."[67] But contrary to what he suggests, the guilt thus circumscribed is not directly connected to madness,[68] any more, for that matter, than the fault is directly engendered by incomprehension. Van Gogh's days as a preacher make this clear. His failure in le Borinage apparently did not activate any feeling of guilt. Guilt feelings can only emerge from the tension created by ignorance of a singularity—which can be ascribed to madness—*inasmuch* as it is associated with the greatness of an oeuvre—that can be ascribed to genius. Singularity then appears as the *price* of greatness, in both senses of the word: the "cost" for the individual, and the "value" for the community. It is within this dualism of "cost" and "value" that the double reciprocal link between gift and debt is established.

No doubt for the first time in history, at least on such a scale, the notion of a *fault* against an artist emerges with van Gogh, and we shall have to analyze its many repercussions. The figure of van Gogh embodies many potentialities far exceeding the bounds of art. Otherwise his fame would not extend well beyond the circle of art lovers: "Vincent van Gogh does not belong to art history, but to the bloody myth of our existence as humans," wrote Bataille with a very sure sense of drama.[69]

Singularity and Community

The gift of self, or self-sacrifice, allows the object of guilt to be circumscribed. It gives it a determinate form, a well-demarcated point of application, and an actual debt to be paid off. This can be seen as a "civilized"[70] way of dealing with the tension intrinsic to the singular's presence within the community. In the case of heroes, such tension is particularly acute, given the antinomy between their incommensurability and their role as standards of measurement,[71] and it is likely to crystallize forms of violence around the singular, according to René Girard's analysis of the scapegoat and Peter Brown's study of the hermit.[72]

Once it has been constituted as such, once it has emerged from ignorance, indifference, or insignificance, singularity is not accepted as a matter of course. When measured against common values, it can appear as a threat of subversion, danger, or impurity.[73] It threatens to flip the necessary into the contingent, the measurable into the incommensurable, the foreseeable into the improbable, and the order of what is known into the chaos of the unknown. Various ways to manage singularity then arise. The first is a desingularizing reduction brought about by generalization. This is the path followed by scientific attempts at categorization, examples of which we have already encountered. The second is disqualification through madness or crime, in other words eviction from "the *common* humanity," as in the case of any scapegoat (witches, for example).[74] The third solution consists in a process of heroization. Repulsion for the monster or pariah makes way for admiration of the great man.

In opposition to the scapegoat (the singular stigmatized as the culprit), it is not within a community of resentment and vengeance, but rather within a community of guilt and atonement, that the martyr or hero (the singular exalted as a victim) enables the collective bond to be forged or reforged, by establishing the sharing of the fault, which is experienced as "society's" fault. In both cases, a misfortune (that has been caused or suffered) is associated with the attribution of responsibility. In the case of the scapegoat (stigmatization) however, the singular receives the blame, whereas in the case of great singular figures (admiration), the community does. Nonetheless, in both cases a community is cemented, tested, and experienced in its recognition of misfortune and its ways of dealing with it.

Ascribing responsibility makes it possible for the singular to slide equally into guilt-purging stigmatization or guilt-generating admiration. This ambivalence is constitutive of singularity's very status. It brings out the psychological dimensions of the relationship to the fault, and in particular the possible inversion of guilt into resentment.[75] It also discloses (other ambivalence) the both exciting and appeasing role of sacrifice with

regard to guilt.[76] Admiration is in fact only one of the possible effects of heroization or, more simply, of recognition of another's excellence. The latter can also be experienced as a form of envy, which tends to purge guilt by minimizing the suffering to which the hero was subjected.[77]

In any case, regardless of the way heroization is experienced (as glorifying membership or critical reduction), it can play in different registers: in an aesthetic register, by highlighting the genius of innovative works; in a political register, by highlighting in a heroizing way the actions undertaken for the good of a community to be created, art and politics coming together in the modern self-actualization of vanguards; in a religious register finally, in the double figure of the martyr sacrificing his present life for the future of the common good, and the prophet heralding future values.[78] These different forms of heroization all coincide in their constant references to posterity. Death's irreversibility creates a dissymmetry by virtue of which owing a debt to an exceptional figure becomes inevitable. For the latter—a saint and no longer a hero—is from that moment on no longer in a position to give: except by resorting to the supernatural form of the gift, namely a miracle, or to the passive forms thereof, namely the admiration and love thus made possible, which unite the living in the debt they owe him.

While admiration therefore constitutes a way of "managing" singularity (not by stigmatizing it, but on the contrary by exalting it), the singular for its part contributes to creating community. It should be added that admiration (like its opposite, repulsion or contempt) creates singularity too. For singularity is not an objective state, a substance inherent in the essence of an object or being. It is a construct, and admiration is one of its special instruments. One could say that it freezes one image, brings out one aspect, extracts one moment from spatial and temporal continuity—and that the object thus detached can then be considered unique, irreplaceable inasmuch as it is endowed with spatial-temporal coordinates, with an official identity (whether the object involved is a person, a pet animal, or a fetishized object, such as a work of art for example). While it is true, therefore, that singularity, rather than remaining unnoticed or provoking repulsion, can arouse admiration, it also has to be seen that before admiration constitutes the greatness of the singular, it first constitutes it per se: admiration makes singularity.[79]

To conclude: while van Gogh is admired as a great man because of his singularity, he only began being considered singular once he became an object open to admiration. This process seems tautological, but we are beginning to see just how complex (and at the same time improbable) it is. This problematic conjunction of greatness and singularity characterizes both the status of art in modernity, and the correlative spilling over of the religious forms of departure from what is common (forms to which the

topics of sacrifice traditionally belong), into the artistic realization ("mise en *oeuvre*") of the greatness of the singular.

But while the displacement from the religious to the artistic domain is the most spectacular aspect of this phenomenon, it is not the most important. What is much more fundamental, because it is common to all heroization, is the shift to posterity of the moment of realization, which is henceforth detached from the present. The sacrificial motif of the creators dedicated to art's future common good thus becomes the temporal and spatial gap they experienced during their lifetime with respect to contemporary practices. The artists' distance from their peers becomes the length of time needed for recognition.

This displacement within temporality—this *temporalization* and *temporization*—allows both the transformation of the work's "deviation" into the "renewal" of art (measured by the succeeding movements for which it opened the way), and the metamorphosis of the deviant into a prophet and a martyr. By foregrounding the unjust dissymmetry (encapsulated in the motif of incomprehension) between the two moments of ignorance and recognition, the displacement makes the community's "reconciliation" with the artist both possible and necessary. It is the recognition of the victims' gift to the community, into which they are thus reintegrated in his singularity.

From recognition of the gift to recognition of the debt, the dissymmetry created by the shift from the present to posterity calls for justice to be restored by way of atonement. Here the fourth and final stage begins, namely the believers' *pilgrimage* to expiate their debt, a debt forever embedded in guilt for an irreversible offense, and therefore indefinitely redeemable. This is what we shall now seek to confirm.

Part III

PILGRIMAGE

Five

Money As a Medium of Atonement

PURCHASING AND REDEEMING

RECONCILIATION is followed by pilgrimage, by a time of multiple tributes to the sacrificial victim. Since the third generation after his death, van Gogh has gradually been integrated into popular culture in its various forms.[1] Today, his integration is greater than ever before. His popularity has been generated and demonstrated by a profusion of best-selling biographies, films (produced with ever greater frequency, and today numbering in the dozens; see the *Chronology* and *Film Statistics* in table 3), theatrical productions, ballets, operas,[2] songs,[3] advertisements, and images of all kinds—copies and pastiches, posters, postcards, T-shirts, and telephone calling-cards bearing the likeness of the most famous painter of self-portraits. There have recently been great exhibitions and record attendance figures,[4] great public auctions and record bids. Amid these innumerable objects, endless crowds, and incalculable sums of money, van Gogh's greatness can barely be measured in numbers and, once quantified, overflows any measure.

The van Gogh phenomenon becomes ever greater as it becomes more universal. It is henceforth part of the national[5] and international heritage, with works scattered through more than thirty European and American galleries. This is true not only of the work, but of the man as well, who has been passed onto posterity through his correspondence ("those letters, which complement the ones he wrote to his brother, belong to the heritage of all mankind").[6] But while the artist's greatness and universality are perceived as intrinsic to him, they are nonetheless the result of efforts to aggrandize and universalize him. Sometimes, this effort is quite open and explicit, as in the brochure of a foundation set up in 1988, which invited "our financial partners to join with us in making the *Fondation Vincent van Gogh—Arles* a place where Vincent van Gogh's universality is justified."

The fact is that once scholars had taken on the job of constructing van Gogh's greatness in their writings, the task was pursued by ordinary people. Henceforth anybody can demonstrate admiration by his actions and not just his words, and thereby "justify" it, by certifying the object's merit through the very accumulation of testimonials. Van Gogh is admired for

TABLE 3
Film Statistics

	Documentaries	Fiction	Total for Decade	(For France)
1948	A. Resnais		1	(1)
1952	1			
1956	1	V. Minnelli	3	(0)
1961	2			
1964	1			
1965	1			
1969	1		5	(3)
1971	3			
1972	1	1		
1973	2	1		
1974	1			
1975	4			
1977	2			
1978	1			
1979	2		18	(5)
1980	4	1		
1981	1	2		
1983	1	1		
1984	2	1		
1985	4	2		
1986		2		
1987	2	3		
1988	5	1		
1989	7	2	41	(9)
1990	6	8	14	(1)
Total			82	(19)

Note: Based on the catalog from the Amsterdam exhibition (*Vincent van Gogh on Film and Video. A Review, 1948–1990*, 1990), from which the distribution between documentary and fiction is drawn, with the exception of the four films depicting the concert, ballets, and opera about van Gogh. Kurosawa's *Dreams* (1990), an episode of which is devoted to van Gogh, has been added to the list. The four animated features are included in the documentary category.

his greatness, but he is great for being admired. The period of pilgrimage through which we are living today is characterized by this circular, collective, and many-sided construction of the admired object's greatness by the very marks of admiration.

A Mysterious Phenomenon

There was a kind of psychological earthquake when the Japanese insurance company Yasuda bought the *Sunflowers*, March 30 last at Christie's in London, carrying the masterpiece off for the tidy sum of $36.3 million. . . . As for the *Irises*, they were sold on November 11th at Sotheby's in New York for $53.9 million. [*Libération*, February 4, 1988]

At Christie's of New York, the auctioneer keeps on raising the ante, a million dollars every half-second. . . . On the threshold of the seventy millions, two buyers are striving for a painting that no one is looking at any more. . . . All eyes are on a fortyish Japanese gentleman sitting in the back of the hall. . . . The banging of the gavel is drowned out by applause. Sitting bolt upright in his chair, the Japanese gentleman mechanically bows to acknowledge the ovation. . . . He has bought the painting for a Japanese firm. There was no limit on how much he could bid. [Sale of the *Portrait of Dr. Gachet*, for $82.5 million, *Libération*, May 17, 1990]

A hundred years after van Gogh's death, the media expansively celebrates these historic records, which only confirm the regular increase in his market value that has especially occurred since the 1950s.[7] Even at a time when the market is depressed, such as at Christie's on November 7, 1990, a van Gogh drawing (*Jardin aux fleurs*) broke the record—$8.4 million, "the highest price ever paid for a drawing" (*Libération*, November 17–18, 1990.)

The price of the Greta Garbo collection also went through the roof at that auction. That a drawing signed by a great artist, and the objects having belonged to a great actress, should have shared the same fate on the same date in the same place, suggests that trading in van Goghs on the art market may also be a phenomenon pertaining to the market for relics, in which an object becomes dearer merely by having been touched by a great singular figure. This is also true of the van Gogh relics, which have recently been "proposed to his admirers' love" for sums that are scarcely trifling.

In this year that marks the hundredth anniversary of the great painter's tragic death, the French-Swiss auctioneer has just uncovered two objects that bear witness to van Gogh's life: the chair Vincent sat on when he painted in Nuenen,

its arm still spattered with paint, and the cardboard box in which the artist kept his sketches and drawings. Neither one has ever been exhibited before. The adventure of this relic-chair and of the box began long after van Gogh's death.

Having been kept for over half a century by the Wiegersma family, these two objects, witnesses of the painter's life, are proposed to his admirers' love today, for a price: 50,000 to 80,000 Swiss francs, 38,000 to 62,000 dollars.[8]

Thus, while the market for art is in decline, the market for relics remains buoyant. There, an artist's painting is valued not only for the qualities that demonstrate painterly excellence, but also for the properties that display a person's *presence*. That the person is deceased makes such a display all the more precious. That he or she was great makes the presence all the more desirable. The search for the person invested in the object traditionally targeted saints, although it can extend to all sorts of great people, including great artists. The relics of the saints were one of the few markets to generate price levels as extraordinary as works of art achieve today.[9] There is therefore no need to go far in our culture to find monetary phenomena as surprising as those found in the art market (but the very familiarity of which makes them seem so self-evident as not to be questioned). A shift in time is all that is needed.

Analogous behaviors may also be discovered in other cultures, thanks to a shift in space. The sociology of art borrows the theory of *potlatch* from ethnography in order to interpret auctions. In potlatch, an agonistic system of expenditure observed in certain primitive societies, the exchange of more and more magnificent gifts leads to the ruin of the less powerful donor.[10] An auction combines the same ostentation and publicly organized rivalry in a temporally (bidding is immediate) and spatially (it brings the actors together) concentrated form. To be sure, the bidders do not *give* each other the sums of money they bid, since they exchange them for a work owned by a third party, namely the seller (artist, dealer, collector), represented by the auctioneer.[11] But they are no less involved in a system of agonistic rivalry, in the sense that the rising stakes threaten to bankrupt the potential buyer or, at least, seriously to deplete his resources (see the buyer of the *Irises* who was compelled to sell the painting because he lacked the funds to pay for it, despite exceptional conditions provided by the auction house).

This interpretation holds truer for public auctions than for private sales. As a rule, prices are lower at auctions, although exceptionally "abnormal" price rises may occur there.[12] Despite the possibility of apparently limitless bidding (see the representative of the Japanese firm who had no spending limit), there is a limit to the attempts by a small number of big spenders to outbid each other. However, that ceiling is imposed by the buyer's financial resources, not by the presumed value of the object exchanged. Such

behavior is aberrant, or at least extremely risky, according to the logic of a market economy, since the buyer takes enormous risks (if he acts as a speculator), or loses a great deal of money (if he acts as a collector). But in an economy of "conspicuous consumption" such behavior is perfectly rational,[13] since the buyer acquires not only a work of art, but also an exceptional position, inasmuch as it reveals exceptional assets, within the already highly rarefied circle of those who can presume "to treat themselves to a van Gogh." Buying not only demonstrates a taste for an artist's works. It is also a way of rivaling other potential buyers.[14]

To be sure, such purchases involve only a tiny minority. Yet the huge stakes turn them into public, international, and even virtually universal events. They become topics of ordinary conversation or advertising ploys.

> Van Gogh: 458 million francs—Renoir: 444 million francs—what will the next record be?
>
> Who, for that matter, would have wagered a dime on the future of those painters whose works were shot down in flames by the critics? Those works that are now worth tens of millions of francs. There is a mystery here. [Advertisement for an art book].

The "van Gogh enigma," the sense of being confronted by a "mystery," is made that much stronger by the fact that ordinary people do not have at their disposal the explanatory tools afforded by scholarship, such as the theology of presence applied to relics, or the anthropology of the gift applied to the potlatch. "Why?" people then ask, why such sums of money ("half a million dollars every half-second") spent on "a painting that no one is looking at any more?" Why such inflation, where will it lead, and until when?

The first answer to these questions is to surmise that the huge prices are the fair equivalent of the work's immensity. On this view, the state of the art market faithfully reflects the reality of artistic values, assessed according to various criteria, such as subject, format, color, or author, authenticity, quality, and period, depending on whether one is a layperson or an initiate.[15] This interpretation conforms to an aesthetic disposition that tends to subordinate art history to intrinsic values. However, it immediately runs into a contradiction. If it is true, why do prices increase, if the works by definition always remain identical?

The solution consists in dissociating the value *of* the work from the value *attributed to* the work. This can be done by showing how a painting, and an innovative one at that, can remain temporarily unknown in a specific context, and how there can be delays in the public's perception and evaluation of it. Once again, the motif of incomprehension not only makes it possible to construct the greatness of the artist out of the injustice that he suffered,

but also to explain the mysterious discrepancy between a work's stable artistic value and its unstable monetary value—a discrepancy which then simply means that the painter's contemporaries lagged behind us, as we witness today's skyrocketing prices.

We run into another snag here however, this time in the shape of "till when?" rather than of "why?" How long will prices continue to rise? Whether prices are related to a hypothetical average or to ratings that were previously in effect, incessant inflation erodes any feeling of normality and threatens the belief that prices are indexed to artistic value. It may be reasonable to assume that prices increase on a par with recognition of the artist's oeuvre. Yet what are we to make of the fact that prices continue to go up, although the oeuvre is universally recognized? How can we continue to believe that prices reflect art's authentic value?

Consequently, the mystery persists. But it can be experienced in various ways, with admiration or suspicion. In the first case, an instance of the work's construction as an enigma, the mystery is accepted as proof or evidence of the work's extraordinary character. Emphasis is placed on the supernatural or virtually magical dimension of the work's monetary value, which seems to echo the aspects of the work that are considered miraculous—namely those that exceed ordinary human abilities in this "often superhuman and prodigious undertaking."[16] In the second case, the mystery is rejected. Admiration for the magical or miraculous dimension of the work's monetary value gives way to suspicions of irrationality. Armed with the interpretive resources of the scholarly world, criticism readily ascribes admiration to a naive illusion shared within common sense. The mystery, that "miraculous perversity"—to use Philippe Simonnot's paradoxical expression—must then be elucidated, for fear of arousing dread before the inexplicable, horror before the absurd. "Half a billion francs gleaming before our jaded eyes, what splendor! And yet, how monstrous! Isn't the feeling that grips us one of horror, as when we witness a sacrifice, but to which god? Could it be that market exchange, in rising to such criminal heights, gets transmuted into its opposite, economic rationality into absurd waste, the prosaic into the sublime?"[17]

The greatness of the deceased artist is produced by inflation of the price of his paintings. What is paradoxical is that some of van Gogh's admirers denounce this process, and do so in his name. Loving van Gogh may entail paying huge sums for his work, or delighting that other people do; but it can also mean denigrating those who do, and lamenting that things should be thus. In order to understand admiration for great singular figures in all of its dimensions, we will have to study not only the ways in which van Gogh is celebrated, but also the ways his celebration is criticized—in this case, the commodity form of his celebration, mediated by the monetarized exchanges of his works.

Condemnations of the Market

An initial way of condemning the enormity of the financial tribute to van Gogh, while rationalizing it, is to ascribe it to an erroneous artistic evaluation of an overrated artist. "They aren't worth it!" As an authoritative judge not easily fooled, the skeptic considers that the works are not of sufficient quality to justify the way their prices go through the roof in auction sales. "All that for peanuts!" While dissipating the mystery, such debunking preserves the credibility of market values by sacrificing a discredited artistic value: "As prices catch fire, transmuting the flaming sunflowers into a commodity, reactions often exceed aesthetic serenity. . . . The daily *L'Espresso* does not hesitate to headline Renato Barilli's article: '*Un mito da rivedere*' (a myth to be revised), VAN BLUFF." Are the painter's pictures really worth tens of billions (of lira)? The headline itself provides the answer: "In reality, the Dutch artist is absolutely overrated" (*Libération*, February 4, 1988). The rationality of the market is thus not threatened by the momentary distortion of the link between price and value.

The first principle of condemnation (following Boltanski and Thévenot) invokes market values. The second principle no longer assumes that people are merely mistaken or blind, but that they have been deliberately deceived. Distortions in the market are then ascribed to speculation, which perverts the normal circulation of artistic goods. Evoking the motif of "gangs" (the "law of the underworld"), the mafia, cheating ("dealing in art is like a lottery where you win every time"),[18] the accuser denounces the snobbery of the auction houses and unmasks more or less secret practices: reserve prices—which distort the law of the market and undermine the necessarily public character of auctions—and credits by means of which "it is no longer a question of seducing the seller as in the case of reserve prices and guaranteed prices, but of convincing the buyer by providing him with financial facilities."[19] The sale of the *Irises* thus appears as a "financial imbroglio,"[20] and the bidding on van Goghs as a "set up" organized by the auction houses: "As for van Gogh, apart from the 'phony price' of the *Irises*, one has to go back to March 30, 1987: that is the date that the *Sunflowers* made the headlines by hitting the fantastic price (at the time) of $39.9 million. Christie's pulled that one off."[21]

This critical stance, in which disclosure is the basis for denunciation, makes it possible to retain confidence in the reality of artistic value and in the truth of market values at the same time. It is also particularly "economic," since it preserves monetary rationality, without sacrificing the authenticity of art. The latter is simply no longer measurable on a market temporarily thrown out of kilter by corrupt financial practices. Further-

more this approach receives considerable backing from history, economics, or sociology, which describe the art market as the site of exaggerated financial speculation. Examples of this include the inflation of the 1950s, following World War II, the application to works of art of practices belonging to the stock market, the scarcity of important works due to purchases by galleries, the opening of new markets through the arrival on the scene of Japanese buyers having access to loans on particularly good terms, the intervention of banks in the form of investment funds, the extension to individuals, and not just dealers, of loans granted by auction houses, the illicit bidding wars encouraged by competition between Sotheby's and Christie's, the integration of the art market into the entertainment industry by means of television broadcasts.[22]

Interpretation in terms of speculation builds on a feeling of distortion and produces an attitude of suspicion, as in the case of fake van Goghs, which also herald his paintings' entry into the higher spheres of the market. Some critics attribute the price explosion to a perversion of intrinsic value by absorption into the market, and link it to fraudulent appropriations and secret practices which deprive the public domain of part of the common heritage—from the hidden wheeling and dealing in auction houses to the sequestering of works of art: "But the saddest part of the whole business is the way certain works disappear into the safes of banks or insurance companies" (*Libération*, March 31–April 1, 1990). In this attitude of condemnation, rooted no longer in market but in civic values, every attempt at appropriation appears scandalous, since no one is great enough to give himself the right of reducing to his own private interest an object raised to the level of a public good.[23]

A third way for condemnation to dissipate the mystery of ceaselessly skyrocketing prices is to rescue the belief in *artistic* value by sacrificing belief in *monetary* value. "At that price, money has lost all meaning." Those who are disillusioned deny any claim that money is a good indicator of painterly quality—when they do not simply postulate that price and value, market and art, are in principle incommensurable. "One hundred million or one billion, it's all the same. It is priceless. . . . It is the price of pure myth," one artist claims. Another artist declares: "Van Gogh is worth a lot more than the money that changes hands."[24] Seen from this angle, the immensity of the prices is inverted. Instead of being evidence of van Gogh's greatness, it becomes one more proof of the injustice he suffered, and still suffers today, an injustice that can be discerned in the way his art has been distorted in becoming a commodity. In Abraham Segal's film, a journalist condemns the "nothingness of the astronomical figures reached in the sale of the *Irises*. One is left with the impression that van Gogh's death, too, has been stolen from him."

The point is that every exchange of commodities entails positing an equivalence. This is even truer when the medium of exchange is as vulgar and common a standard as money.[25] Positing an artistic good as equivalent to something else may well be seen as a double attack on its authenticity (which is why the market system is so easily discredited in the art world). On one hand, the work of art is not just a material object, but (should the "fetish of the master's name"[26] apply to it) part of a human being. Consequently, positing its equivalence with something else undermines that within it which is irreducible to any qualification or measure, that which cannot be cashed.[27] On the other hand, when dealing with an artist recognized as great, the positing of equivalence undermines the irreducibility of the singular, an irreducibility that characterizes the genius, as a figure beyond comparison.

The market's mediation is a "lesser evil" when exchanging objects is at stake;[28] but when it applies to "singularities" (the common singularity of the individual person, the uncommon singularity of the saint or genius), it becomes a genuinely "evil" act on the part of those who commit it, and a "curse" for those who are its victims. That is why any monetary evaluation of a work of art is particularly open to being discredited by condemnation based not only on market values or civic values, but on inspired values. Such monetarization of the tribute paid to art borders on sacrilege from the point of view of common celebration, and borders on vulgarity from the point of view of the elite. In any case, it is seen as "misplaced." It can therefore be left to those who demonstrate that they have the (financial) means to indulge in it, only to arouse the suspicion that they may lack the (ethical or aesthetic) means to celebrate the artist in more appropriate fashion. Those who lay claim to the (common) universe of feeling, or the (elite) universe of taste and ideas, show no signs of regret in turning their backs on the universe of the market: "Come on, you Japanese, with your future discount stores of painting, buy up our van Goghs, we'll agree on a price. Hang them in your banks, your insurance companies, over your bathtubs, over your raised johns. . . . We don't give a damn! We have these few pages of Artaud which are not for sale. Poor, ever poorer van Gogh! Great, ever greater Artaud!"[29]

Criticism thus finds various ways of rationalizing an extraordinary economic phenomenon (before predicting the moment when the market will crash). These include the *skeptical* critique of an error that can be attributed to incompetence and that threatens market values; the *accusatory* critique of speculation that can be attributed to self-interested cheating and that violates civic values; the *disillusioned* critique of an inability to comprehend inspired values that leads to their reduction to a monetary equivalent. These interpretations are all linked. Anybody can at times be filled with

astonishment or wonder before the mystery of a value that does not translate into numbers, and anybody can attempt to decipher it by unmasking errors, swindles, or illusions.

The fact remains that prices may well appear to be inadequate indicators of paintings' values, a considerable flaw from the standpoint of the logic of the market, and something which could undermine faith in the rationality of prices or the objectivity of talent. One could reasonably expect that only the few art lovers wealthy enough to take part in the art market would be concerned by this discordance. The fact that it should be criticized and rationalized in so lively a fashion, and so far beyond the bounds of the art market itself, is explained by the fact that it so profoundly violates ordinary values. More fundamentally, it touches upon two orders of value: art (with the necessary determination of artistic values) and money (with the equally necessary determination of monetary values).

The Measure of the Debt

The astronomical prices paid for van Gogh's paintings are a mystery that provokes astonishment, while their apparent falsity arouses indignation. To this we must add a third way in which the enormity of these prices is perceived as scandalous. While some suspect that the prices of van Gogh's pictures do *not* correctly reflect their true value, others feel that the prices are *unfair*, that the artist ought to have had a right to more.[30] The discrepancy between today's prices and those of a century ago generates a sense of injustice. In van Gogh's case, the injustice can be quantified, as well as described, by comparing today's prices to those paid during his lifetime or just after his death, at the time of the "primitive scene of selling at a loss."[31] That was the time when his canvases were dispersed hither and thither, sold for a few cents each, relegated to attics, or used to patch up chicken coops.[32] It was the time when they were demeaned to the status of mere things, denied not only an exchange value, but even their rightful use value as paintings, that is, objects meant to be looked at. It was the time when, even while being treated as genuine works of art, they were ridiculously underpriced: "People sell their 'stock' of paintings: Cézanne for 45 to 370 francs, a half-dozen Gauguins for less than 60 francs a piece, van Gogh for 30 francs, Sisley for 370 francs."[33]

The feeling of an injustice committed against the sacrificial victim (who "never knew anything of this") is embedded in the contrast between today and yesterday: "Van Gogh, whose pictures reach prices so high that I always feel I must be getting them wrong when I write them down, while he never knew anything of this. It makes me shudder."[34] There is more to this injustice than a mere mistake. There is fraud, indignity, shameful behavior,

a real "indecency" which arouses guilt, indignation, rebellion. "That a van Gogh should sell for several million francs, must seem almost indecent to any person with feeling. There is just too glaring a contrast between Vincent's despair at being short of money and seeing that his pictures could not sell, and the fantastic prices that today's collectors are prepared to pay for those same pictures."[35]

The *financial* dimension of the evolution of prices does not in itself explain the effect produced by the monetary phenomenon. The *temporal* dimension too must be taken into account. Its presence in commentaries on van Gogh comes through in the comparisons between past and present: "Could Vincent van Gogh ever have dreamed that his *Portrait of Dr. Gachet* would one day be the world's most expensive painting?"[36] From the perspective thus created, the (monetary) gap between past and present values puts a figure to the (temporal) delay in the recognition granted van Gogh. The numbers are approximately equal to the highest price available today, since (as van Gogh's biographers never tire of repeating) the price of the one painting the artist did sell was virtually nil: "The reader will recall that *Vigne rouge*, the one painting sold during van Gogh's lifetime, went for 400 francs." "He was not understood during his lifetime, and the *Irises* are worth $60 million today."[37] If the legendary $60 million (meanwhile overtaken by the $80 million paid for *Portrait of Dr. Gachet*) put a figure to the value attributed today to a single one of his works, is this not the amount that should have been offered to him when he was alive—is this not the amount of the debt he is owed?

One expert has remarked that van Gogh "entered art history as a symbol of the accursed painter. This martyr's halo is not the least ingredient of his notoriety . . . and indeed it plays a considerable part in the prices of his paintings—prices which, we may recall, are mind-boggling."[38] When the artist's success only comes posthumously, the temporal gap opened up generates a feeling of injustice, and in turn links martyrdom and price inflation. Martyrlike suffering, once transformed into a sacrifice, engenders a feeling of collective guilt with respect to that misunderstood singular figure, the *artiste maudit*.[39] Unlike the saint who is made great by his actions, the artist who is made great by his works is caught up in the circuit of the market. Not only does his fame circulate and extend ever further, but his works appreciate or depreciate—this is especially true of the plastic arts (rather than writing or music) in which materially unique works are produced.[40] The artist must face the test of the market during his own lifetime, whereas trading in saints' relics can only begin, by definition, after their death. But the test of the market can be lasting and, when the artist is successful, can grow to much greater proportions after he has departed. Thus, in putting a figure to the injustice van Gogh suffered during his lifetime, the constant and spectacular increase in the monetary value of his

works only deepens the debt he is owed, since fortunes are spent a century later to buy the least of his paintings, by contrast with the one picture sold (at a derisory price) before his death.

Seen from that angle, the inflationary purchasing of van Gogh's works is the commodity form in which the injustice committed against van Gogh the man can be redeemed. Every price rise puts a figure to the increasing debt, which gets ever higher as the current value of van Gogh's works moves further and further away from their nonvalue a hundred years ago. Hence the need, in order to erase the debt, to redeem the injustice by purchasing van Gogh's works, and at an ever higher price because more must constantly be given in order to wipe out an ever heavier debt. The debt feeds on buying which feeds on the debt, in this equivalent of a modern trade in indulgences toward collective blindness. Once the victim is dead, the injustice cannot be reversed, and the debt becomes inexhaustible. From the moment that what is being negotiated is the price of a human life, there can be no fixed term to the debt either—every life being, as everyone knows, "priceless": just like van Gogh's paintings.

This logic of a debt that deepens in being paid back is in no way incompatible with other forms of indebtedness—such as the specifically financial debt involved in the movement of money. For the scope of moral indebtedness is a function of material investment, which in turn is tributary to the emotional investment connected to the motif of the accursed artist, of the creator who has not been understood. Beginning with van Gogh, this motif has spread to the totality of artistic productions, in particular those of modernity, where the gap between the moment of creation and the moment of recognition predominates. The phenomenon of "redeeming" linked to van Gogh now extends to the whole of the modern-art market, including painters who scarcely suffered from incomprehension, such as Renoir or Picasso. And by contributing to the intensification of emotional and monetary investments, this extension also contributes to pushing prices up, which in turn contributes to deepening the discrepancy, the delay, and the debt.

The Inflation of Notoriety

Purchases [*l'achat*] engender a price discrepancy, which is the manifestation of delayed recognition, which in turn cries out to be redeemed [*le rachat*]. The inflation of the debt by the translation of injustice into figures highlights the circularity of causes and effects. This is more obvious still in the fourth consequence of the monetary phenomenon (after the feelings of mystery, falsification, and injustice), namely the inflation of notoriety by acts of admiration—acts that generate notoriety, which in turn is the basis

for admiration. Van Gogh's fame increases with the publicity given the record prices of his paintings, while the records feed off his fame, which then appears as the cause rather than the effect of monetary inflation. The greater van Gogh's fame, the higher the prices commanded by his pictures. This is an example of the classic phenomenon of a "cumulative dynamic" in an economy of scarcity, where the demand for goods rises and they become more difficult to acquire, the more coveted they are by many potential buyers. However, this works both ways. The more the prices of van Gogh's paintings make headlines, the more famous he becomes.[41]

The mystery of skyrocketing prices leads to condemnation of speculation and to atonement for the injustice committed, while ensuring the artist's notoriety. At the same time, the expression of denunciation, the paying-off of the debt, and the manifestations of notoriety, all contribute to making the works more expensive. But this tautological and inflationary engendering of value does not allow it to be indexed to the intrinsic qualities of the objects exchanged. From the standpoint of ordinary economic logic, this is in principle "scandalous," although it is the rule in the market of rare and unique objects.[42] It remains for us to ask whether the feeling of mystery is not like the hollow space left by the absence of objective values, since there only is a "mystery" if there is belief in an indexing to the "natural" values of art or the market. But if the values upon which prices are constructed are determined by the very mechanisms which set prices and values, then there certainly is the absence of a fixed point to which the valuing of the object could be anchored. Thus, the condemnation of the "lack" of lucidity, honesty, or consideration, like the effort at restitution (in money and words) of what the artist "lacked," can be read as a reaction to the absence of the value that was "lacking," because it was constructed by the very gestures that measure it—as the inflation of prices illustrates.

In order to account for the monetary valorization of van Gogh, it has been necessary to understand the *feeling* of mystery about him, rather than to explain the mystery itself, and to bring to light its effects rather than its causes (or, rather, the fact that they are indissociable). It has become clear that the frequently invoked notion of the irrationality of the art market must be replaced by the highlighting of a multicausal rationality, to which several categories of explanation can do justice—since "the notion of a single, determining cause is prescientific," and "the plurality of truths, shocking as it is from the point of view of logic, is the normal consequence of the plurality of forces."[43] All bidding and purchasing involves some quest: the quest for aesthetic pleasure as much as for financial profit; the quest for the presence of the great departed one in the objects he touched; the quest for prestige through ostentatious spending and the agonistic confrontation of buyers in the public sphere of the auction; or the quest for atonement for the injustice inflicted on the artist by the discrepancy

between what he received in his lifetime and what is granted him today—in money or notoriety. Money seems to be the instrument, rather than the goal, of many of these "reasons," and aesthetic pleasure seems to provide the occasion for them rather than their ultimate purpose. This dooms them to being seen as irrational or unauthentic, both from the standpoint of the logic that spontaneously holds sway over the perception of market phenomena, and from the standpoint of the logic of disinterestedness that holds sway over the perception of matters of taste.

One need only detach oneself from these partial logics to perceive the rationality of forms of behavior that are too regular and too regulated to be dismissed as contingent fluctuations, pure snobbery, or mere aberrations. At the same time, it is equally necessary to grasp the logic of the charges of irrationality levelled against them, in order to pinpoint the absence of which they are a symptom. This absence is constitutive of the exponential logic of the collective construction of greatness by way of celebration, in which admiration feeds off its own impact on the admired object.

However, the circulation of money, and of the words that explain it, is not the only medium of atonement. As we shall see, the body is one as well.

Six

The Gaze As a Medium of Atonement

VISITING VAN GOGH'S WORKS

THE AMSTERDAM and Otterlo exhibition commemorating the centenary of van Gogh's death was a "huge success" according to media reports, drawing 1.3 million visitors (including 130,000 from France), "more visitors in four months than during an entire normal year" (*Le Monde*, July 31, 1990). Our attention now moves from the tiny group of privileged people likely to purchase van Gogh's works to the great crowd of visitors who have traveled to see them. Their tribute to the artist does not involve giving money as much as giving of themselves, by going and seeing (although the trip can be costly enough to remain a privilege).[1] Just as the enormity of the prices paid for his works was a manifestation of their excellence, so the enormity of the crowds mobilized to see them certifies their quality—a quality that in turn justifies seeking them out. Here again we encounter that exponential logic by virtue of which a phenomenon reinforces itself simply by occurring—admiration for greatness elevates its object, which calls for ever greater admiration.

Pilgrimage to the Image

> Our works are relics and small bones. I recently attended a van Gogh exhibition in Arles where people lined up for three hours to get into a dark room which was the place where van Gogh severed his ear; those wanting to see the van Gogh paintings and letters exhibited there, had to put up with similar conditions.[2]

The discussion of auctions in the preceding chapter has already highlighted the analogy between the cultural practices involved in the veneration of relics and the cultic ones involved in the admiration of works of art. This analogy can be pursued here with respect to gazing at the object—the object as souvenir or work of art—during the visit to an exhibition.

Pilgrimage to the image, pilgrimage to the body: the centenary exhibition can be likened to the first of these two traditional forms distinguished by specialists.[3] It includes collective travel to a place dedicated to a great singular figure, public communing with the images, a feeling of emotion

and displays of admiration, recalling the great one's memory and qualities, then the return, enriched by small objects sold to commemorate the moment—postcards and commercialized souvenirs on sale at the exit of the place of devotion. All that is missing to make the analogy perfect is the long lines of people waiting at gallery entrances—a modern form of penance spared the visitors to Amsterdam by a system of purchasing tickets ahead of time. The concern to rationalize queues, typical of the Protestant ethic as described by Max Weber, short-circuited the expiating function of the immobile processions at gallery doors, a foretaste of which had been provided by the spectacular line-ups at the Gauguin exhibition in Paris's Grand Palais in 1989.

If, like the saints' relics, the artist's works are one of the forms of his permanent presence beyond death, there is reason to believe that the emotion expressed in gazing upon them transcends the aesthetic experience associated with the plastic arts, and displays some of the power traditionally ascribed to any object which has been "in an immediate or mediated relation with a saint."[4] The pilgrim expects to partake of the artist's personal qualities through the mediation of the objects that belonged to him.[5] One can imagine what a magnificent relic van Gogh's severed ear would have made, had it been preserved.[6]

Relic-Works

While works of art are subject to a market which nowadays reaches heights comparable to those attained by medieval relics, the same trafficking occurs with regard to both, involving illegal or uncontrolled transactions ranging from forgery to theft. Thus, the "epidemic of thefts" from today's galleries recalls the Middle Ages, while forged paintings, like fake relics, multiply as an artist's reputation grows, as the rapid proliferation of fake van Goghs indicates.[7] Just as with the cult of relics, art forgeries call for the authenticating intervention of specialists and authorities.[8] The scholarly arsenal of catalogs and scientific writings confers a public, official identity on the works (title, author, place and date of creation, measurements, history of movements), thus ensuring against the risk that they might prove unauthentic. The arsenal of security measures at the exhibition site offers protection against the risk of the works disappearing.

The possibility of theft, along with that of forgery, is a necessary consequence of the existence of objects such as saints' relics or artists' works, which are valued for their uniqueness, and are consubstantially linked to an extraordinary person. The question of forgery, more than any other, reveals this quest for a person's presence through the medium of objects,[9]

since forgeries are not discredited because they lack artistic quality, but because they lack authenticity, in other words, because they can be attributed to someone other than had been believed.[10] This is an "almost absolute principle" governing the art market. It sets their prices to a great extent, just as it set those of the market for relics.[11]

There is therefore a homology between works of art and relics. Both involve a personalization of the object, as well as a symmetrical objectification of the artist as a person. The eye directed toward the works can gaze through them at their author—as when people visiting galleries check the name of the artist before the title of the painting. The work then becomes less a product (among others) of a (general) technique, than a (unique) manifestation of a (singular) personality. The visit to van Gogh's works illustrates this well.

Presence and Gaze

The *miracle* will be to see *unveiled* the *living flesh* of paintings about which reproductions always lie. Van Gogh's candor, both the extreme tension of his harmonies and their subtlety, mean that no photographic medium has so far been able to capture the *true* irradiation of his paintings. Their *biological* matter and relief do not come across in reproductions either. We are therefore going to experience a—very brief—moment of intense and overwhelming truth. *Like a man*, a friend, previously encountered only in passport photographs, who is finally seen *for real*. Like a *visit to a person in prison*, for many paintings (those in private collections) are only out on bail (they are usually *sequestered* in vaults!) . . . Look at those duos, trios, quartets—in which he creates a *dialogue* between pictures, which contradict and answer each other—now torn apart and scattered to the four corners of the earth. For a brief moment, they meet again, *living and breathing*, here together as he intended—*Siamese twins physiologically* wed to each other across space. It will take this *family reunion, flesh to flesh*, for me to see *wonderful* truths spring up, which no book of reproductions, no matter how carefully read, ever enabled me to guess. See, *body to body*, how these paintings want to be *lived*. . . . And then there is the *miracle* of Arles, the exploded drawing, luminously reinvented through and through.

This introduction to a trip to Amsterdam, written by an art expert,[12] suggests that for the spectator the visit *must* be (in the putative sense of what is likely to happen) on the order of a "miracle." At the same time, for the works, it must be the opportunity to accede to their full meaning, "as he intended." This presupposes, or calls for, an exchange between what the work offers the visitor and what the visitor offers the work. In the first case,

from the work to the visitor, what is offered is an extraordinary and highly emotionally charged experience. It can take the form of an aesthetic shock at the sight of the painting, or of a feeling of love associated with the absent presence of the painter himself, with whom the admiring gaze enables direct contact. In the second case, from the visitor to the work, what is offered is the gaze, like the reminder of a *regard* due the painter, like a tribute *paid* to him, in the sense of legitimate restitution. This *reparation* is the form of atonement that typifies the pilgrimage to the image evoked by gallery visits.

Correlatively, the text strongly personalizes the work of art (comparing it to "living flesh"), while calling for the visitor's equally strong involvement in contemplating the work (likening it to "visiting a person in prison"). Such involvement suggests that visiting an exhibition not only demands the effort of travelling, which applies to any pilgrimage that brings the visitor face to face with the work. It also requires an effort to invest in the work in its specificity, leading to an active gaze more than a passive presence. This is typical of the aesthete's or scholar's authoritative visit, which is legitimized by the museum institution, as opposed to an economy of presence. The latter places emphasis on the satisfaction experienced at giving one's presence to the celebrated person or object, as well as on the emotion generated by the latter's presence or contact with its traces. Such experience is vulnerable to the scholarly stigmatizing of insufficiently sophisticated cultural behavior which is passively directed toward the painter as a person, instead of being actively invested in the works.

Condemnations of Recognition

This questioning of purely passive visits to galleries leads us back, once again, to the order of criticism. The eye which gazes at paintings cannot avoid being discredited any more than the hand that purchases them. The different kinds of admiration are not equally approved by the different categories of admirers, and the most massive forms are not the least suspect, far from it. Suspicion can bear on three arguments that are distinct, but can he deployed simultaneously: crowd, trade, and institution.

> Inexorably, vangoghmania pours albums and bio-hagiographies into bookshop window displays. They resemble and repeat each other, and can do no other. Lunacy is no doubt very marketable. Van Gogh, society's benign madman? This ultimate, and so vulgar, exploitation of the myth posthumously contradicts Antonin Artaud's fury. . . . Digestion is better than exclusion, tributes kill more surely than exile. One cannot read *Le Suicidé* without regretting that the repressive violence Artaud condemned, not without sometimes lapsing into the my-

thology of the genius struck down, should have been succeeded by the soft and pernicious violence of entertainment. Decidedly, we shall not go to Amsterdam. [*Le Monde*, June 15, 1990.]

This vigorous condemnation brings together the three denunciations of those aspects of celebration which can strike at the "accursed" creator, at the poet Artaud no less than the painter van Gogh. The first of the three is aimed at massive celebrations. They are inappropriate both given the unrecognized creator's initial curse, and with regard to an authentic personal relationship with art, such as advocated for example by the text quoted above. Suspicion may then fall even upon the admired object which, in the face of generalized infatuation, may be considered "overrated."[13]

This is a typically "learned" way of denouncing the vulgarity of forms of admiration germane to the general public. It may be read, to be sure, as an elitist strategy of distinction. But it can also be seen as a requirement of interiority and individuality, which guarantee the authenticity of the relationship between the subject and the object of admiration. Experts and aesthetes tend to dissociate themselves from displays of admiration that are too mass-oriented and too collective (package tours, standardized dates), by steering clear of them ("we shall not go to Amsterdam"), while art critics and journalists will readily denounce such "pilgrimage-bazaars" (*Sept à Paris*, July 1990).

The expression "bazaar" links the motif of vulgarity to that of commerce, the "perverse effects" of "speculation" being the most visible or utterable manifestations of a vulgarity inherent in the way the exhibitions in question target the general public (*Libération*, March 31–April 1, 1990). Commercial exploitation that cashes in on suffering gives rise to a second category of condemnation, aimed not at tourists' gregariousness, but at merchants' greed or, in a more modern vein, at the "tourist industry" (*Le Monde*, July 31, 1990). At the entrance of galleries as in variety stores, the exhibition comes across as a place of simony, and the centenary celebrations as an opportunity to make a killing: "Van Gogh appears on postcards, decked out in sunglasses, toting a Walkman, or dressed up as Mickey Mouse; he shows up on the labels of wine and perfume bottles, and can even be seen with a tie bearing the legendary sunflowers dangling from his neck" (*Libération*, March 31–April 1, 1990).

Besides scholarly abstention from displays of admiration germane to the general public, and besides the stigmatizing of the commercial exploitation of such admiration, there is a third category of condemnation; here again, criticism is deployed in defense of an authenticity threatened by inappropriate expressions of recognition. Recalling the Reformed Christians' struggle against ecclesiastical authorities, these denunciations are aimed

at what the most fervent admirers consider an official "rehabilitation" of authentic love for the *maudit*. Like massification and commercialization, everything that smacks of institutional rehabilitation leads to the paradox of "digestion" of "exclusion," assimilation of marginality.

> A strange anniversary at the Amsterdam gallery, where the van Gogh *family* is celebrating, with much pomp and ceremony, the centenary of a suicide— Vincent's suicide—and is trying to use the occasion *to settle accounts once and for all* with this deplorable relative. A *big production*. A permanent psychodrama which reveals a *latent hostility* toward the painter in the gallery that bears his name, a *contempt* that is so deeply rooted that the people who run the place, unconscious of the paradox, deem this attitude so natural, that they do not even disguise it. . . . This is not a question of a dead man being hounded by those who survived him, but on the contrary, the worst of scandals: life . . . —a *necrophilia* nowadays served by *certain "art historians"* in a hurry to declare that "with van Gogh, it is only ever a question of painting," and *to dissociate the man from the painter*, who is kindly requested to stick to his role as a supplier. . . . One would like not to be conscripted into the horde of butchers, prigs, and speculators. . . . But while it may be too late, not *to save him*, but *to save us* from being deprived of his work and memory, there is still time *to denounce the family powers*, allied with the *lobby-groups*, who, as soon as the centenary is over, will for example relegate most of van Gogh's canvases to *cellars*, for long months. . . . Van Gogh is exhibited, the better *to prevent him from being seen*.[14]

Such ad hominem accusations, dramatically backed up by the unmasking of a plot, belong to the same pamphletary genre that Artaud resorted to after a similar van Gogh exhibition. This is the order of inspired condemnation of scholarly mendacity and official appropriation, by the "predators," of the suffering of a marginal figure who "belongs to no one"—an abusive appropriation that culminates in the centenary celebrations: "Has there ever been a painter held up to ridicule, and negated in the catalog and on the walls of his own exhibition?"[15] Stigmatizing the "officialized, flagrant historical errors," Forrester denounces the "strange turn taken by the commemoration," which is the "celebration of a triumph: that of the hostility which won out, a hundred years ago, over Vincent."

The unauthenticity of the institutional celebration is thus contrasted with the authenticity of the true keepers of van Gogh's memory, who are linked to his sacrifice not by the contingency of family (inheritance) or professional (historians' erudition) ties, but by the true faith of the believer. This defying of all authority, of every authoritative appropriation, can go as far as the refusal of all interpretation as a violation of ineffability: "Self-mutilation? Van Gogh is right to say: 'It is a personal matter.' To seek to interpret a gesture, to discover its possible origins: another sign of our predation."[16] In such extreme cases of anti-institutional protest, the

cult of the artist comes very close to a negative theology: the farther away one gets from words, the closer one comes to the truth.

There is a paradoxical ambivalence to the mediation here. Although it stands between the idolater and his idol, yet it is what enables him to approach it. The mediation of erudition or of an institution may indeed appear as a manifestation of *evil*—a lesser evil inasmuch as it allows the admirer to get closer to the absent object; a curse from the moment that it separates them, forbidding access to the grace of pure presence which is sought in the works of art. "Can there be an immediate relationship to the work?" asks anybody who projects an investment of a religious order on the works—an investment which, in contrast with the readily disdainful abstention of aesthetes or scholars, swings between enthusiastic participation in institutionalized celebration and, by contrast, inspired denunciation of its weight.

From the Desire to the Duty to See

Museum institutions, commodity circulation or massification of the crowd: van Gogh's most fervent admirers respond with condemnation to his official and generalized reception, even though one might have expected them to be satisfied at seeing the painter finally receiving due praise. The point is, however, that admiration is precisely not recognition; it is love added to recognition.

That is why the insufficiency, unauthenticity, or tardiness, of recognition can always be denounced in the name of pure love. Recognition is essentially a gesture, and as such can be suspected of being nothing more, of being a mere act of acceptance and integration, an act of conciliation or, rather, "reconciliation" with the disruptive, alien presence. Unlike recognition, however, admiration is not exhausted by the gesture that demonstrates it. It is also a feeling, which is expressed and experienced. Inasmuch as it is experienced, that feeling necessarily belongs to an interiority, the expressions of admiration for which—words, exclamations, assuming poses, mimicry, actions—are merely exteriorizations, a sign given to oneself as much as to others. Inasmuch as that feeling is one of love, it has something of the gift about it, and excludes envy, jealousy, or resentment; in other words, any form of rivalry over the object. To recognition of the admired one's greatness, which transforms indifference into interest, admiration adds love, which transforms animosity into benevolence, and the wish to take into the wish to give.

With respect to admiration, one could evoke the theologians' *agape*, a love detached from any demand for reciprocity, desiring and expecting no return,[17] were there not, precisely, some measure of desire and expectation

within admiration. Like pure love, admiration entails no desire for another person, yet it does involve desire, namely for the person's presence or what is left of it. And while admiration expects nothing at all of that person, still it does expect something, namely that something should happen *thanks to* that person. This desire is a desire *to see*. It is the (often passionately) expressed wish to go to the exhibition, to be there or to have been there, the object of desire shifting from the admired person to the latter's works. On the one hand, admirers expect the (aesthetic, affective) emotion that arises in the presence of the works. On the other hand, they expect satisfaction at having done their duty. By virtue of this fulfilment, the subject is caught up in the community web of commitments, promises, and exchanges.

What duty *do* admirers expect to fulfil in their desire to visit the exhibition? Like desire, which in the case that concerns us is a desire to see, duty here is a duty *to see*. It is a duty *to look upon* (ad-mire), by going to the place where the works are exhibited. "You've got to," they say, "*you've got to see* that exhibition, *you had to see* it." There is not only an aesthetic (pleasure) or cultural (information) imperative here, but a moral one, because it redeems the indifference suffered by the artist during his lifetime. "You've got to see it" indicates an obligation toward the truth of art. It is no longer a matter of establishing a boundary between oneself and others by conspicuous consumption, but of seeking redemption in a celebration that will strip away the guilt. The "duty to see" should be understood as an oath, as the admirer's promise: "I promised myself I'd go to see that exhibition." From the moment that it is no longer directed toward things (towns, tourist sites), but toward people or their self-expression (works of art), "having to do" takes on a moral dimension. There is an obligation to do justice to the artist who was not understood by posthumously paying tribute to his oeuvre. The gaze directed at his works—a primordial form of regard— becomes atonement.

In the commemorative context of collective recognition, enjoyment gives way more and more to duty, even if the two are not mutually exclusive. "Art exists to give us *pleasure*, and to generate within us a sense of *human greatness*, but also *to give us qualms of conscience*. When it emerges, that guilty conscience is the *ransom* of long-standing *reprobation* and *segregation*, which were too often signs of our fear of the truth."[18] In this logic of transgression and redemption, even the "pleasure" promised by the viewer's good will becomes a source of the "guilty conscience" from which springs the need to atone by going to see. Whatever its nature and intensity, the aesthetic pleasure derived from the contemplation of the pictures is likely to increase the viewer's moral debt, for the painter is also giving the audience the visual enjoyment of his or her work. The guilt is experienced as inextinguishable, because it is tied to the irreversible character of the wrong done the dead artist. Furthermore, the debt is perpetually renewed by contact with the paintings. There is thus an endless pro-

cess here too, an exponential rise of transgression and atonement, in a permanent re-engendering of the creator's gift and of the viewer's debt, produced as much by the ritualized consumption of the pictures as by their purchase.

From Aesthetics to Ethics

The shift from pleasure to duty, from aesthetic delight to ethical obligation, is not made explicit by those concerned. It arises in the interpretation produced by the observer, or from shared experience. Personal experience bears this out. One need only think of the feeling of unease anyone feels in walking from room to room in a very crowded exhibition without slowing down, without stopping, without getting close enough to see any of the paintings. One then feels (as long as one is on one's own) just what an imperative looking is in a public place, just how difficult it is to avoid doing so without being exposed to public amazement and one's own embarrassment. The result is a sense of being marginal, and even a feeling of shame. There is a kind of morality to the act of looking. To abstain publicly from looking at admirable objects may be experienced as just as much of a transgression as looking privately at reprehensible objects. This shows to what extent today's museums have become moral spaces above all else. They are spaces for the public exercise of admiration, where looking is an obligation, where seeing becomes a duty.

The moralization of the gaze also shines forth in the condemnations. If the stakes were merely aesthetic, the critics would respond accordingly. For example, they might express regret, as experts know how, at the poor presentation of the works, at bad lighting, at problems in the way pictures are hung, and so forth. But the condemnations emerge from a much more intense and moralizing indignation, indicating that what is at issue is doing justice to a man's personal qualities, and not just doing things correctly with regard to the qualities of objects.

Admiration is a form of love which makes the act of recognition one of interiority and giving. As such, it gives rise to a certain logic of denunciation. When this love emphasizes interiority, then massification, commercialization, and institutionalization are condemned. When it emphasizes giving, then massification, commercialization, and institutionalization are, on the contrary, deployed as evidence of admiration, as well as of the greatness of the person admired. Gathering together, purchasing, participating in the ritual, all bear witness to the intensity of admiration and show how well founded it is. Abstaining from such demonstrations can implicitly be read as a form of condemnation as well (provided it is the result neither of indifference toward van Gogh, nor of an inability to pay for a trip to Amsterdam). By contrast, approval of the celebrations is demonstrated by

mass gatherings, public purchasing of souvenirs, and obeying the official calendar of commemorations.[19]

Admiration is a form of pacification and love for the admired object. However, the different attitudes toward visiting van Gogh's paintings also teach us that it is nonetheless caught up in violence and rivalry, like purchasing art works, which can be analyzed as a kind of potlatch, as a fight between potential buyers. All admiration is, implicitly, a negative construction, violence, struggle—a struggle of admirers against nonadmirers, a struggle between good and bad admirers, a struggle over what is to be admired and what is the proper way do to so. In that sense, to admire is not just to recognize and love the right object, it is also to denounce and stigmatize bad people. To admire is to classify (what is admirable and what is not), to categorize (the ways in which one should admire), to accuse (those who are indifferent, opponents, pseudo-admirers). Regardless of what is intended, every demonstration of admiration is a form of violence against others, mediated by an object of love.[20]

The fact remains that one is hardly likely to hear some visitor declare that he went to Amsterdam in order to annoy his neighbor, any more than to purge his guilt toward van Gogh. The moral order, whether polemical or redemptive, is not the normal order here. The normal thing to do in artistic matters is to make aesthetic issues of them. There is therefore a discrepancy between two heterogeneous levels, the aesthetic and the ethical registers, or the order of culture and that of religion. Any "moral" interpretation comes across as paradoxical here, as inappropriate to a context which is defined as artistic, and for which excellence is a question of genius, not saintliness. The term "pilgrimage" is not part of the vocabulary of visitors to an exhibition. Its use may surprise, even offend, as an arbitrary juxtaposition of two heterogeneous orders. To deny any artistic specificity to interest in painting would be to do violence to those involved, since painting is most likely to be experienced by them, through an attitude of sheer delight and secularity, as purely aesthetic, as detached from morality and religion. To analyze attendance at exhibitions according to ethical parameters therefore calls for making what is implicit explicit, at the very least.[21]

We have now reached the last stage of our exploration of how van Gogh has been the object of veneration and not merely delight, of how he has been an ethical and not just aesthetic preoccupation. We shall now follow the authentic pilgrims as they leave behind the standard aesthetic event of gazing upon pictures at an exhibition, and join in that standard religious event, the procession that will bring them into the presence of van Gogh's body. One hundred years to the day after the painter's death, as the Amsterdam exhibition comes to a close, we shall end our journey by traveling from a *virtual* pilgrimage to the image, to a *real* pilgrimage to the body.

Seven

Presence As a Medium of Atonement

THE PROCESSION TO VAN GOGH'S BODY

Auvers-sur-Oise, Saturday, July 28, 1990

Signs greet you at the station. Some are permanent, others installed for the occasion. There are not, for that matter, many places to go. There is the park, with Zadkin's statue of the painter, gaunt and bearing an easel on his back like a cross. In the café, behind the bar, there is a fresco with a threefold depiction of Kirk Douglas as van Gogh (with a straw hat, with a child, with crows). Finally, there is the square before the town hall, where a stage, a screen, and rows of chairs have been assembled for an evening event that is soon to begin. It is rather cool for late July. The show will commence around eight P.M., and the film will be shown after nightfall. Every hotel in the area is booked solid. Everybody is praying it will not rain.

In the meantime, you can stroll about and snap a few pictures. In the hardware-store window across from the town hall, color reproductions of van Gogh's most famous paintings have been lined up, like ex-votos on a church wall. There they are again, a few yards away, in the shape of postcards, on the bookshop turnstile. A whole window, decorated with artificial sunflowers, is given over to books recently written about van Gogh. There is the one on the postman whose portrait he painted, and the one on Dr. Gachet's nephew.[1] Both were beneficiaries of the greatness by contamination[2] that people catch when they know, or know someone who knew, a great man.

Between the hardware store and the bookshop, you cannot miss "Van Gogh House" (as the banner proclaims) with its old-fashioned woodwork. It is closed. Posters attached to the uprights relate the history of what was once *l'auberge Ravoux* (the Ravoux Inn) (see "The History of a Place of Worship and Its Elevation Into a Relic"). The last thing to see is the church. You go past the photographer's, where reproductions of van Gogh's works are also being sold. You turn right onto the path that leads to the Daubigny Museum, then you climb the wooden steps heralded by a sign that reproduces a painting of those very stairs. Similar signs are all over the village. The church appears three times from the low-angle perspective from which he painted it: first on the bookshop display shelf, on infinitely reproducible postcards; then at the intersection, on an im-

THE HISTORY OF A PLACE OF WORSHIP AND
ITS TRANSFORMATION INTO A RELIC

From 1891 to 1952, the Ravoux Inn, where van Gogh lived and died, remained the village café, but (as the notice posted on the front of the building indicates) the artist's room was preserved. The sixty years following the artist's death were the first phase in the constitution of a place of worship, and simply involved the preservation of the site in its original state. During the second phase, which lasted some thirty years (1952 to 1985), the inn became an artist's café and "the room was opened to the general public." Two new elements thus appeared, the organization of remembrance (an artist's café) and of the site's visibility (it was open to the public). The third phase came in 1985, when "D. C. Janssens discovered the Ravoux Inn. Struck by the power and authenticity of this place of remembrance, he conceived the project of restoring it and making it into a permanent cultural space." Nearly one hundred years after the martyr's death, the mediator intervenes and, in the face of the authorities' indifference, takes the initiative of organizing the cult of the martyr, and assumes responsibility for it. In 1986, Janssens purchases the site. In 1987, a nonprofit organization, the Van Gogh Institute, is founded, so that "the project acquires an international cultural dimension." The celebration therewith becomes institutionalized (a process that goes hand in hand with a deindividualization of the mediator and a stabilization in time) and acquires greater breadth (a process that goes hand in hand with an extension in space). The sixth moment, as yet uncompleted at the time of the centenary, involves the institution of permanence, with the official opening of the house, restored to its former state and organized as a shrine.

There are several stages to the institution of a cult in a particular place. First, the site must be preserved physically. Second, its visibility must be enhanced on the local scene in order to preserve its memory. Third, a mediator must intervene. Fourth, the place must be transformed into a large-scale institution. Finally, it has to be elevated to an official and permanent status. Although the physical preservation of the place in its original state (as depicted in sepia postcards calling attention to the building's chestnut woodwork) seems a central concern, that is merely an appearance. The conservation drive is merely the *materialization* of the radical change the place is undergoing, a change that alone lends authority to the construction of authenticity and to celebration, and that consists of a broadening out, from private to public, closed to open, temporary to permanent, local to general, personal to institutional, contingent to conventional.

Further on into the village, there is another relic. Only this one is not authentic, or, to be more precise, it has not been authenticated as the Ravoux Inn has. It is a fake relic, an unauthentic relic fabricated by the veneration effect. In 1990, the inhabitants of Auvers-sur-Oise (with help from the municipality, which provided the materials) undertook on a volunteer basis to build an exact replica of a staircase that van Gogh had painted, but which had

later been destroyed. They rebuilt it, complete with its characteristic curve, using the picture as a blueprint. Local admirers have placed a reproduction of the painting close at hand, so that everybody can admire the replica's faithfulness to the original: "The 'Mémoire des lieux' society is dedicated to identifying the motifs in Auvers painted by van Gogh, and to placing reproductions of the paintings at those places. The reproductions are enameled metallic plates executed as faithfully as possible in an unalterable material" (program of the celebration).

Such is the process whereby a place becomes a relic. Not only have the objects van Gogh touched and used been transformed into relics; even the objects he painted have. All around him, the village itself has developed into a relic. In this way, the world is reconstituted as an imitation of the images that have depicted it. A stroll through Auvers, or Arles where the yellow house has been rebuilt, is like walking around inside a painting. This is true of fiction too. In Kurosawa's film *Dreams*, a man walks through an Arles landscape made up of huge blow-ups of van Gogh's paintings. What better expression of a painter's supreme power than the creation of a fictional world which can later serve as a model for reality?

mutable sign; finally in the walker's eye, in the emotion of that special moment of coming into the presence of a unique object designated ahead of time to be admired.

This church is no ordinary shrine; it is a shrine to the power of two, so to speak. It does not hallow the memory of where someone lived, like Van Gogh House. It recalls instead where an artistic oeuvre came into being, and it is to be visited for that very reason. In its openness to van Gogh's Protestant background and lay character, the church readily lends itself to a pilgrimage to his graveside. Thanks to him, the church's fame stretches all the way to Japan. It pays tribute to him right after its patron saint, in a leaflet posted at the entrance. "But it is fair to say that its fame has spread around the world thanks to van Gogh. The artist who painted Notre-Dame-d'Auvers could not have wished for a quieter or simpler resting place. In the lane on the left-hand side of the cemetery, two modest stelas bear a simple legend: HERE RESTS VINCENT VAN GOGH (1853–1890). HERE RESTS THEO VAN GOGH (1857–1891)."

Instituted as a place of remembrance thanks to van Gogh, the village is also a place of miracles, according to the program published by the municipality: "Situated between the new town of Cergy-Pontoise and the industrial zone of Saint-Ouen-l'Aumône, Auvers-sur-Oise has been miraculously preserved in the face of the ravages of urbanization. Why make such ado about this miracle? Because the town is the last refuge of van Gogh, of his final work." The village has thus been elevated to the status of a relic, has been transformed into a place of remembrance, and is regarded as the site of miracles. It can thus become a place of pilgrimage.

The time has come to return to the town hall where the ceremony is to take place, on this eve of the anniversary of Vincent van Gogh's death, one hundred years ago in Auvers-sur-Oise. The commemoration unfolds in two stages: a festive gathering Saturday evening ("a joyous gathering, because we are not going to bury van Gogh, but to celebrate him together"), and silent meditation by his graveside Sunday afternoon, a "pilgrimage from the town hall to the cemetery. . . . This will be a silent pilgrimage that will not be accompanied by any particular festivities."[3] There are two parts to Saturday evening's festivities. The latter part consists of a film on van Gogh's life characterized by the same lyrical tone, the same saccharine images, and the same slight twisting of historical truth (altered texts, disregard for the actual chronology of writings) as evangelical narratives. This is very much in keeping with martyrology where the point is not so much to inform or explain as to commune in the recollection of canonical sufferings and known emotions.[4]

Before the film, the ceremony opens with short speeches by the representative of the municipality, by a citizen of Auvers related to Dr. Gachet, and by a biographer, namely Viviane Forrester. Three actors then read excerpts from letters by Vincent and by Theo and his wife Johanna. "The three main protagonists could only be given back their voices," as the mayor's representative puts it in his speech, by way of a mediator, and a multiple one at that. First there are the mediators attached to van Gogh locally, by domestic ties, or more generally by virtue of their profession. Then there are professional and (in this case) mercenary mediators, namely the narrators. Standing between those who are present and the absent artist, they are, paradoxically, the necessary catalysts of *presence*—the presence of the one who is not there, who was called in the past and is recalled in the present by all of those who, this evening, are offering their own presence in this place. The mediation of the "passers" brings about the passage from the present-day presence of those present to the past presence of the absent one, of one who was once here, on the very spot where the assembled admirers are invoking his presence, by evoking it: "One hundred years ago to the day, to the hour, Vincent was here."

The program makes it very clear that what is being celebrated is the "centenary of Vincent van Gogh's *passing*" through Auvers-sur-Oise: "the *passing* of a meteor, which no one has forgotten, and which no one will forget." This recurring word, evoking both presence and absence, what has been and is no more, suggests that the celebrated artist belongs to another world, the world of transcendence, which has passed beyond the spatial-temporal bounds of earthly existence, and is radically distinct from the commonplace. It is enough for such a separation to occur for an individual to be constitutively absent. From the moment that he is *definitely* no longer present, he is the departed one, who belongs to the past. From the moment

that he is *not yet* present, he is the messiah, who belongs to the future. However, not all of those who have disappeared have the same potential to remain present, the same intensity in *being*. The power of one who is absent is manifested in his potential to transcend the material framework of his own existence, to be so to speak present as a ghost, or an idol, in the very place where he is no more.

The idol is one whose presence (and therewith greatest possible proximity) is collectively sought *in his absence*. The cult of an idol depends upon people and things, such as priests, icons, and mediators, to make it present. Their intercession comes between the idol and its worshippers, the saint and those who adore him, the great man and his admirers, and yet it brings them closer. See Kirk Douglas in the fresco of the Auvers café, not embodying van Gogh himself, but rather an actor depicting him. See Janssens, the Belgian organizer of the shrine. See Viviane Forrester, guardian of the ineffable, inconsolable complainant.[5]

Toward midnight, the ceremony comes to an end.

Sunday, July 29

The next day, the actual pilgrimage takes place, unofficially in the morning, officially in the afternoon. The unofficial part has been organized by the church authorities, according to a photocopied flyer handed out on the street.

> Sunday, July 29—On this anniversary of Vincent van Gogh's death, three events will be held in Auvers: 10.30 A.M., Auvers Church: Lecture by pastor and painter Esposito Fares on "Art and Faith." 11.40 A.M.: Ecumenical prayers conducted by pastor J. M. Droin and L. Zumthor, diocesan ecumenical delegate. 3 P.M.: Pilgrimage from the town hall to the cemetery. The pilgrimage will be held in silence and will not be accompanied by any special festivities.

The official part has been organized by the municipal authorities, according to the glossy color program available at the town hall.

> A Pilgrimage—Sunday, July 29, 3 P.M. Auberge Van Gogh—Town Hall— Cemetery. One hundred years will have gone by on July 29, the day van Gogh died, the day he saw Theo one last time, and spoke to him, and confided in him. A silent walk will bring together those wishing to pay their respects by the brothers' final dwelling-place, that simple bed of stone, near the Church of Auvers.

By way of a curious and noteworthy inversion, a religious expression ("pilgrimage") is used with respect to a secular, official, subsidized demonstration, while the religious demonstration is reduced to the marginal status of activists handing out flyers. The municipal authorities in fact

explicitly rejected any association between their demonstration and the one organized by the Church. They filled the role that ecclesiastical tradition awards to authorities that support popular celebrations, while keeping at a distance from them. In a curious reversal, it is the religious demonstration which takes on the function of popular celebration here.[6] The "official" and "unofficial" character of the ceremonies is thus defined paradoxically by a curious inversion in which a civil authority organizes activities of a religious type, in the nonreligious context of art. A novel and unusual combination comes to the fore, in which the explicitly religious nature of celebration is joined with the indisputably secular nature of the celebrated individual.

But let us stick with the official procession. It begins rather informally in the early afternoon heat, as the delegates of Auvers and of van Gogh's birthplace deposit bunches of flowers at the foot of Zadkin's statue.[7] After a few brief instructions ("We shall follow the same route as van Gogh"), the marchers set out. As the faithful follow the path upon which their idol suffered, they mirror the Catholic practice of appropriating the agony of others (as when the matrons ascend the *Scala Santa* in Rome for all to see).

The procession is headed by the local dignitaries (prefect, mayor, deputy-mayor), who have been joined by a woman of Arles dressed in traditional costume. Draped over her arm, she bears a shawl (another relic) which had belonged to her grandmother, who had worn it when van Gogh painted her portrait. The whole procession is marshalled by the Red Cross. The police bring up the rear. At every point, the march is preceded by the arsenal of publicity, the army of photographers and television crews. In front of the church, where the road begins to rise, a halt is called under the gaze of passers-by and the crackling of camera shutters. The mood is good-natured. There is conversation, even laughter (but not excessively so). However the procession remains serious, if not solemn, even on the path where the ladies twist their ankles a bit. "We have to maintain a certain order," one of the marshals warns, recommending that people slow down at one point in order to preserve the cohesion and dignified aspect of the procession. Accordingly, the march pauses at a bend in a country lane, between a cornfield and a field of sunflowers which almost seem to have been planted there for the occasion. The graveyard is now quite near.

Finally, the procession passes under the arch into the cemetery. The dignitaries walk up the center, between the rows of tombstones, while the rest of the marchers scatter, picking their way around obstacles, till they come to the twin graves, against a wall at the end of the main path. One of the organizers signals a halt, requesting silence and respect for the dead. Once again, many photographs are taken, as if the place and the moment of van Gogh's presence were *here*. Then, a pot of flowers draped with a

blue, white and red ribbon is placed on the grave, and an actor reads out excerpts from Artaud's text—from which the more accusatory passages have been expunged, in particular the ones aimed at Dr. Gachet, a native of Auvers.

The official ceremony has ended. People file past the twin graves in no particular order, trying to decipher the plaque on the wall, which tells the story (in French, English, German, Dutch, Italian, and Spanish) of the ivy planted in 1914 as "a symbol of [the] constant affection." Fathers scold their children, who make way for others. Little by little, the crowd melts away. The woman of Arles approaches and stands before the tomb. In a pure and fragile voice, she sings a strange-sounding song. "It is the Lord's Prayer in Provençal: we owe him at least that," she tells the last bystanders. A woman applauds. Another turns to her husband: "They're sure to show it on T.V. We must be getting back if we're to catch it."

The Denunciation of Participation

Another ceremony had, however, taken place the night before, at the end of commemoration. Around midnight, while the participants were leaving, a band of young people holding candles in their hands, one of them dressed like van Gogh, tried to enlist the few passers-by still in the square. "To the chapel! Come to the chapel!" they shouted—and laughed.

The next afternoon, on the way back from the cemetery, news spread that there would be a concert at five o'clock, "at the chapel." This was the youth chapel, set up in a dilapidated house a little way up from the square, between the museum and the church. Greeting his fellow-citizens on his way to the concert, the mayor made clear that it was a spontaneous initiative, quite independent of the authorities. And there, at the heart of the village, was a grotesque setup, an accumulation of objects smeared with color, glued, hooked, suspended and thrown together, a sun made up of paintbrushes, sunflowers, bottles, old shoes, straw hats, rickety chairs, stalks of wheat, mock crows, potatoes and, on the wall, a fresco depicting three of van Gogh's most famous paintings: *Sorrow*, *Mangeurs de pommes de terre*, a self-portrait. Van Gogh's attributes were thus enhanced with a reminder of his works.

The name "Shapelle 5.20.100" could just be made out, scrawled on the front of the building,[8] confirming that the chapel, the saint, and the torchlight procession the night before, were not genuine, but a joke. The mirth of these fringe celebrations is in marked contrast with the seriousness of the official ceremonies, just as the band of noisy youths is poles apart from the disciplined procession of older people. Echoing the grotesque hero Tartarin de Tarascon,[9] who used to make van Gogh laugh, this parody of

celebration[10] has the carnival-like features that Mikhail Bakhtin[11] ascribes
to popular culture, namely the transformation of seriousness into frivolity,
of attachment into derision.

Derision is no less a form of participation for all that. It is a way of being
there, without really taking part, of celebrating while mocking, or mocking
while celebrating, of miming admiration without slipping into attachment.
It is a way of being present in being distant, while remaining distant in
being present. It is a form of presence, to be sure, but an "upside-down"
one. But it *is* being present nonetheless, and how! One need only consider
the amount of energy that went into organizing a genuine-fake procession,
a genuine-fake chapel.[12] The measure of the energy invested is the true
measure of what is at stake. It shows that those who play this game *must*,
despite everything, be present in the pilgrimage, as much as they *must* not
be there wholly. Derision really is, in Norbert Elias's terms, a play of in-
volvement (inside) and detachment (outside).

By contrast, that other form of detachment, nonparticipation, is that
much more economical and radical, albeit by definition less visible. Those
who are absent from the parade need not be at a great distance, indeed they
may be present—but without participating, like the spectators gathered on
the side of the road or perched high above the marchers. As observers or
critics, *they are there*, watching the event, *without being there*. By their gaze
they reap the advantages of presence and distance, yet without truly experi-
encing them. But nonparticipation may, more radically, involve absence in
the very place of pilgrimage. As a voluntary abstention, and not indiffer-
ence or ignorance, this amounts to passive criticism. Such abstention may
be expressed in various ways, ranging from simple mockery to reactions of
disgust, without necessarily being formulated as actual arguments against
the pilgrimage. The line "I am disgusted by the whole thing" was often
heard with respect to the various commemorative events. A journalist
working on a show to be broadcast on the subject declared: "I find this cult
rather distasteful."

From participation in derision to derision without participation, from
distantiation to abstention, from abstention to denunciation, and from de-
nunciation to repulsion. . . . The least that can be said is that there is noth-
ing self-evident about a pilgrimage to the artist's body. These reactions
betray an emotional intensity which cannot be explained by the arguments
of those surveyed. Mircea Eliade described this phenomenon as "resistance
to what is sacred," which follows from an "ambivalence of what is sacred"
detectable in different religions.[13] The "ambivalence of man's attitude with
regard to the sacred" makes the venerated object both fascinating and re-
pulsive. From this standpoint, the intensity of the reactions to the most
fervent forms of celebration could be seen as an effect of how "historical

man finds it basically repugnant to give himself over completely to sacred experience," as well as how "he is powerless to renounce such experience definitively."

Communities of Pilgrims

The cult of the tomb is rooted in a long tradition. It can be found in the Greek cult of heroes and the Christian cult of martyrs, as well as in the civic cult of great men, which today includes great creators, from Rousseau to Kafka.[14] According to the stricter dictionary definition, pilgrimage means "an individual or collective journey to a holy place for religious purposes and in a spirit of devotion." Albeit subject to denunciation, the pilgrimage to the body of the departed one is laden with tradition, has a coherence, or, to put it differently, has legitimacy, on condition that one enter the universe of values to which it belongs and within which it represents the "highest sacralization."[15] It is not only possible, but necessary here, to rank *sympathy*, sharing misfortune with the idol, higher than understanding his works. The idol's nature is then that of a saint if, as Max Scheler argued, a saint's greatness, unlike a genius's, is not reducible to his work.[16] This is the condition that makes possible the pilgrimage to an artist's graveside. To be sure, such an act is always open to being discredited by those who remain on the outside. But the pilgrims remain indifferent to outsiders' efforts to distance themselves, deeming them the fruit of incomprehension. Those who denounce devotion are miscreants in the eyes of some and rationalists in the eyes of others, but their words and attitudes are met with the unruffled indifference, even commiseration of the celebrants, whom some see as being faithful to the artist's suffering, while others view them as traitors to the truth of art.

Compromises are possible here, however; there are ways to reconcile the pilgrim's involvement and the unbeliever's distance. Guided tours, of the kind available in Arles, Saint-Rémy-de-Provence, or Auvers-sur-Oise,[17] which are modern, subdued, secular forms of pilgrimage, provide typical examples of this. In the broader sense of the word "pilgrimage" ("a journey undertaken with a view to paying tribute to a place, to a great man whom one venerates"), such travel to the places where the departed one lived falls between travel to the place where his works are exhibited (an act belonging to the universe of culture), and travel to the place where he is buried (an act belonging to the universe of cults). But in every one of these cases, a collectivity (groups of visitors, busloads of tourists, processions of celebrants) is formed through a shift in space and a gathering at a specific time for a precise purpose.

In each case, too, the constitution of a collective confers a new dimension on admiration. Recognition extends beyond merely personal demonstrations of admiration, becoming the act of a whole community, without which admiration could not attain the higher, collective, and formalized dimension of celebration, or, in religious terms, of a cult. If it is true that admiration is love added to recognition, to achieve its fullest development it must also be recognition added to love. In bearing witness to the greatness of its admiration for van Gogh, the community of admirers confirms his greatness and admirable character, and thus contributes to the spread of admiration for him. Once again, celebration produces resounding effects, which have an impact on the very properties of what is celebrated, mind-boggling prices in auction houses, record attendance at art galleries, and the creation of collectives that would otherwise not exist.

Every pilgrimage is the constitution, as well as the manifestation, of a *communitas*, a small community. A new, formal, visible, and commensurable dimension emerges as the act of coming together causes communities to materialize out of the informal mass of art lovers and admirers scattered throughout the world, from the Amsterdam exhibition to the Auvers procession.[18] Whether through the gathering of the faithful (pilgrims, visitors, spectators, admirers) or the condemnation of the infidels, miscreants, and slanderers, the moment of pilgrimage generates a bond of community. It is built upon the inclusion of those who enter into the game by wishing to belong, and the exclusion of those who remain outside of the game by dissociating themselves from it by their criticism.

These communities cannot be subsumed under instituted collectives, with their routinized and stabilized (family, professional, geographical) relationships; rather they cut across them. They can be likened to conjunctural gatherings such as shows, ceremonies, and political demonstrations, which provide an opportunity and reason for people who do not know each other to get together for a short time around one or two individuals or a "cause." But what we are dealing with here is a rarer form of gathering, for its focus is a dead person. It is the privilege of great singular figures to generate collectives, public celebrations, and festivities, postmortem. As they form around the sacrificial victim, the processions of pilgrims and crowds of visitors demonstrate and bear witness to that individual's power, a power not given to all, far from it, namely the power to establish a community. The community constituted by the pilgrimage to the idol's body is not merely a community of admiration like those who visit the exhibitions. It is also a community in sorrow, united in potentially shared suffering. The pilgrimage to the dead artist is a new test of the singular one's greatness. It does not offer those who practice it the aesthetic pleasure to be found in the contemplation of images, as a visit to an exhibition can. However, by capturing their attention in the manner of rare objects, the

pilgrimage goes further than the latter in enabling its participants to forget themselves. It also engenders the moral satisfaction of atoning for an injustice by giving one's presence to one who experienced the martyrdom of isolation. Finally, it yields the happiness of being in a group, the relief of not being alone, which is the basis of all social interaction, from ordinary family gatherings to extraordinary, festive events. Ritual appropriation of the great man's relics, and frequent contact with them, provide the opportunity for a possible earthly salvation, for a temporary deliverance from sorrow.

A Saint Unlike Any Other

What is a pilgrimage without any wish or hope for salvation? What is a saint without a miracle? In the absence of requests for healing, and of the expectation of miracles usually associated with pilgrimages, what are those who travel, look, and spend, seeking? In many ways, van Gogh is treated like a saint. But does he, like the canonical saints, wield the soteriological power presupposed by requests for salvation, or the thaumaturgical power presupposed by the expectation of a miracle?

Where salvation is concerned, the pilgrimage to the artist does not offer the *pilgrim* survival in eternal life after death. Its result is rather the *earthly* survival of the *creator* who has become great in posterity. In that sense, pilgrimage does contribute to a form of salvation. It helps the departed one survive in everyone's memory, and assists in the creation of a community of admiration. The soteriological dimension of the expectation of salvation has been toned down and rationalized with respect to its traditionally religious actualization. Salvation appears here as a purely earthly salvation.

The same goes for the van Gogh miracle. We *are* dealing with a miracle here, even if it lacks the supernatural dimension that would make it a miracle in the strict sense of a divine intervention. It is more of a "miraculous event," "which produces incomprehensible and inexplicable effects, wondrous marvels." In the dictionary sense, it is an exceptional, apparently irrational, event that is likely to be repeated inasmuch as it can be imputed to a force residing within an individual, even if that force is not made explicit as the manifestation of a divine power. Although it may be a miracle in the figurative sense, it is in any case *blindingly* obvious. People no longer seem to see it, although they ceaselessly comment on it (a "psychological earthquake"), are amazed by it (something "irrational," "incomprehensible"), and await it ("when will it happen again?"). This miracle imputed to the dead artist is none other than the event which occurs at every public sale, when a canvas "covered with colors thrown together in a certain order" (to quote Maurice Denis's famous definition) is exchanged

for a sum of money that is so enormous, so far outside of the norms, that it exceeds any qualification, any forecast, any understanding. It is the event at which something that was worth next to nothing (the price of the canvas and paint) can suddenly be worth more than anything.

What is also "miraculous" is that a man who lived so isolated, so unrecognized, and so marginal a life should nowadays attract hundreds of thousands of people by virtue of his name alone. To be sure, to speak of a miracle here is to venture far into the realm of metaphor. But what these two extraordinary events (the money spent and the crowds of visitors) have in common, is that those who participate in them impute them to the intrinsic power of a creator, since people buy and look at his pictures, as well as visit his graveside, because of the value of doing so, because van Gogh warrants it. The dizzying prices of the paintings, like the crowds of visitors, are above all (and this, too, is blindingly obvious) the product of admiration carried to the point of celebration or veneration. Without buyers or admirers, nothing would happen, there would only be paintings, colors thrown together in a certain order.

We are dealing here with the circular and exponential logic of celebration which (like a self-fulfilling prophecy)[19] produces the very thing it proclaims, namely the power of the one celebrated. Saint January in Naples may offer the best illustration of this. The crowds that came to witness the miracle of liquefying blood caused a rise in temperature by their presence, which then caused the blood to liquefy. It is by virtue of this very principle that admiration, by the power of its testimony alone, transforms an unknown painter into a universally celebrated hero, and a piece of canvas into a universally coveted treasure. Van Gogh's destiny is "miraculous" indeed.

There are two dimensions here therefore: on a soteriological level there is an expectation that the communion of admirers will bring about salvation; on a thaumaturgical level, there is an expectation that the power of celebration will produce a miracle. The power of celebration takes on a material aspect in the literally extraordinary inflation of the figures measuring the credit of the object of celebration. There is nothing divine or supernatural about this. The only salvation involved is of an earthly nature. Its spatial-temporal coordinates are the community of celebrants and the posterity of the object of celebration. The only power is the recognition of what the artist was able to produce by investing his dispositions. None of which prevents the double expectation of salvation and of a miracle from meshing in the saving and supernatural experience of the grace of the departed one's presence. In the words of a pilgrim present by van Gogh's graveside: "To come here is somewhat to feel his flame burning in me."[20] Van Gogh does not really fit the canonical forms of sainthood, but he is closer to them than appearances would suggest. The positive dimension of his soteriological and thaumaturgical power shows forth in a softened,

euphemistic, and nonexplicit fashion. The cult of van Gogh allows but one wish to be fulfilled, but one miracle to be prayed for: the joint consolidation of a bond of community in the satisfaction of a same demand for justice, and of a bolstered identity in the individual search for an object of love, for someone to whom a person's own requirements for greatness and authenticity can be linked. In the face of confusion born of feelings of injustice and incoherence, such consolidation is not a negligible consolation.

By contrast, van Gogh's hagiographers have elevated him to a sacrificial dimension of existence, and the so-to-speak negative virtues (martyrdom, suffering, incomprehension) of this saint, unlike any other, are quite explicit. He is therefore far more of a sacrificial than a thaumaturgical saint. His sacrifice has been recorded and authenticated. But to be *truly* a saint, he would have to have accomplished real, certified miracles, and to have been recognized as a saint, canonized, beatified, as in the recent case of Fra Angelico, that combination of monk and artist. One could say that van Gogh is not quite a "Catholic" saint yet. On the other hand, he embodies a form of excellence very close to the Protestant ethic as analyzed by Max Weber. It is rational (nothing supernatural about it), ascetic (a great deal of sacrifice is involved), and quite independent of the ecclesiastical authorities. Van Gogh represents what a Protestant saint could be.

From Gift to Debt

On Sunday the village atoned for the indifference it displayed at the time of the painter's funeral on July 29, 1890, by holding a silent march and mass one century later to the day. Five hundred people attended this "funeral." The painter's death scarcely caused any stir at the time. The Auvers parish priest had refused to hold a service because the artist had committed suicide.

On July 30, 1990, an article in *Le Monde*, entitled "Official Funeral," reported on the pilgrimage to Auvers. It was flanked by accounts of the Amsterdam and Otterlo exhibitions, which had just closed. The association of these events is a good expression of how consubstantial the procession to the body and the visit to the work are in the work of celebration. In both cases, groups of people converge on a unique place (where traces of the departed one still remain) at a precise time (the anniversary of his passing). Through the gift of looking and being present, atonement is offered for the injustice committed against the man (denied a religious funeral) and his work (not understood).

The feeling that van Gogh's works have been wrongly evaluated and that he himself has been treated unjustly creates the sense that things must

be set right *materially* (they must be repaired and thus returned to their original state), *legally* (there must be restitution, that which was taken away must be returned), and *religiously* (there must be redemption, that which was abased must be raised up again).[21] But the various condemnations of this poor treatment only strengthen the feeling that what is given is not equal to what is owed. What are market value next to the work's intrinsic value, institutionalized recognition next to the irreversibility of the incomprehension suffered by the artist, religious commemoration next to the artistic nature of his greatness? That is why an implicit rivalry can be observed among van Gogh's admirers. Their criticism of each other's ways of admiring him becomes a part of their admiration, providing additional justification of its necessity. Criticism is just as much a way of loving as love itself. To gather in a special place to recall the unjust and incorrect treatment of van Gogh can only strengthen the feeling of indebtedness and of the need to be more giving of one's money, of one's gaze, of one's presence, or even of one's time and talent, as in the case of the volunteers in Auvers-sur-Oise who sanctified the place of pilgrimage.[22]

There is an exponential spiraling effect that regulates the political economy of the gift, as well as that of notoriety. It is by way of this factor that the tributes to van Gogh contribute to the settling, as well as to the recognition, of a common debt incurred by his sacrifice. These tributes propel the construction of van Gogh's greatness beyond the scholarly world and its learned inscriptions, spreading it to a broader network of "actors" who act by paying tribute by their actions. Three processes are thus conjoined, that is, geographical extension (by way of globalization), numerical enlargement (by way of massification), and diversification of people (by way of popularization) and actions (writing and reading, but also speaking, purchasing, looking, traveling, being present).

In establishing parallels between the various forms of pilgrimage, we must not lose sight of the order that exists among them. There is the temporal order, by virtue of which the pilgrimage to the body occurs after the visit to the works, after the purchases, after the writing of texts. Then, there is the order of resources, by virtue of which only the wealthiest people can buy the paintings, only the most cultivated people can discuss them, and only those most attached to the artist can demonstrate their love by visiting his graveside. Two contradictory political economies clash in the work/man couplet: an exclusionary economics of rarity, which bases excellence on the distance achieved with respect to forms of admiration that are deemed "popular"; and an inclusive economics of community, which bases excellence on being present and on multiplying expressions of attachment.

The ultimate in scholarly admiration thus consists in a small circle of people, or even a single individual, delighting in a work reserved for pri-

vate enjoyment (the case of the collector). The ultimate in common admiration consists in crowd celebrations of someone to whom notoriety has given a public persona (the case of the pilgrim). Midway between these extremes, there is the pilgrimage to the pictures (the case of gallery visitors), which is acceptable to scholars if the exhibition appeals to the elect, but which is to be condemned if it attracts large crowds. On the other hand, a collective celebration of a person (an anniversary), rather than a nonritualized and individualized practice, will be prized that much more by nonscholars. However, these two attitudes are not symmetrical. Unlike the scholar, the simple admirer has no need to denounce the other verbally. His active presence, the gift of his body, suffices to differentiate him from those who are not there. At the other extreme, the economics of rarity require critical speech to compensate for the necessarily negative form of nonpresence by defining it as a choice, as opposed to ignorance or indifference.[23]

Be that as it may, by his sacrifice[24] van Gogh succeeded in joining to himself in posterity all those who partly pay back his gift of himself, by the gift of their presence, of their gaze, of their time or their money, and who thus contribute, whether they intended to or not, to redeeming the offense committed against him by the indifference of his contemporaries, who were unable to recognize that gift. Like any phenomenon of celebration (and whatever the form of collectively admired greatness—heroism, sainthood, genius), the van Gogh effect must be grasped in the light of this cycle of giving and indebtedness.

Entry into the cycle of debt marks a concern with redressing an injustice from the moment that the singular one's pure gift of himself is *grasped*—in the twofold sense of being "accepted" and "understood." The singular one passes therewith from an economy of grace and love into an economy of justice. During their lifetime, the two brothers exchanged gifts within the family circle (paintings were given to Theo, money to Vincent). After the artist's death, that situation was replaced by the infinite debt incurred by the community. François Tricaud has analyzed the analogous shift from an intrafamily system of justice based on giving (the Greeks' *themis*), to an interfamily system of justice based on debt (*dikè*).[25]

Not every gift gets transformed into a debt; not every sacrifice leads to atonement. For that, the debt must be *recognized*. A gift may be declined, or not taken. Van Gogh's gift could quite simply not have been accepted, for example, had posterity persisted in misunderstanding him. Conversely, his gift could have been met with an equivalent offering had he, for instance, been recognized from the start and drawn into the ordinary logic of the market. To accept the gift is to return it, but only after a suitable delay, in order that it be regarded neither as a "countergift," nor as payment of a debt, but clearly as a gift.[26] While a gift establishes a bond by opening an

area of circulation between individuals, payment of a debt dissolves the bond by closing off that area, by halting all circulation, since nothing is then owed any more. In order to maintain the bond created by the offer and acceptance of the gift, it is necessary not only to give something in return, but to give it in the form of a gift, and not in the form of restitution. That alone is in keeping with the economy of a bond which, returning gift for gift, maintains the area of circulation of goods that establishes ties between individuals.

The various ways of atoning can appear here as the payment of a debt, in keeping with the requirement of justice (in which case one is quits with the artist), and also as the offer of a gift, in keeping with the need for a bond (in which case the latter is being reactivated). We are definitely dealing with *dikè* on the one hand, and *themis* on the other. To be sure, these are two distinct orders (like "justice" and "love" in Boltanski's analysis); but they are not opposites, since they are indissociable and follow one upon the other. They are logically incompatible, and simultaneously present in practice. They are incompatible, because no one can claim, without contradiction, to be *restoring* (a just order) and *giving* (a demonstration of love or admiration) by way of one and the same act. Yet they are simultaneously present despite all that, because a gift is being given to van Gogh (out of love or admiration), while indebtedness toward him is being recognized at the same time (out of a concern for justice), by virtue of his own gift that was initially ignored, and then, well after his death, accepted.[27]

But this occurs, precisely, after his death. The bond in question here is therefore necessarily a closed one, since it is impossible for the deceased to return what is proffered—short of imagining him as a "ghost." Paying a debt to the dead person, or expressing love for him, does not suffice to maintain the link with him. The exception is the moment of pilgrimage, when "his presence can be felt." However, payment of the debt does make it possible to maintain a standard of justice that unites the community, because celebration of the deceased preserves the bond of community by satisfying a common demand for justice. From a temporal point of view, however, that justice is not part of present-day existence, but of posterity, an open posterity extending over an indeterminate number of generations. This means that atonement can broaden out to include others. It opens the possibility of a bond, not with the deceased donor, but with his earthly representatives, namely living and future artists. Hence the extension of practices of redemption to all creators, who stand in for the artist who was sacrificed.

The feeling that the evil done is irreversible and that the debt is infinite nevertheless persists in the reactivated memory of the deceased. Anytime the debt owed a dead person is admitted, but not paid back, the debtors are doomed to living with that person's presence, unable to close off the area

of circulation, to dissolve the bond. The deceased is always there, either as a ghost (in the specter of his presence), or as remorse (in the feeling of guilt). Mourning is not truly possible; only commemorations are. In the pooling of common memories, the living are haunted by what is lacking, by that which they cannot mourn, because they have been unable to dissolve the bond by paying off their debt.

What we witnessed in the different moments of the pilgrimage is just such a scenario, the way an open group of individuals united in common admiration *recognize* a debt by *accepting* the sacrificial victim's gift. But to reach this point, we had to retrace the unfolding of a complex process from its origins, that is, from the end of the artist's life. That process of "accepting the gift" (which is the necessary prerequisite of "recognizing the debt") brings about the recognition of the greatness of man and work, in the scholarly and ordinary forms of celebration—on condition that the artist's sacrifice certifies that he belongs to the common humanity, thus escaping accusations of madness. It is within the *play* (in the sense of movement and exchange) of gift and acceptance, sacrifice and recognition, suffering and redemption, offering and debt that the dissymmetry between how little the martyr was recognized during his lifetime and the immensity of what must be paid back after his death is corrected in the form of atonement, while being deepened in the form of delay.

That infinite debt unites the sympathetic community while enslaving it to endless restitution. In the impossibility of altering an irreversible tragedy, what is owed grows heavier with every gift, since the least gift today reinforces the sense of what should have been recognized yesterday, but was not. The recognition of an "infinite unpaid debt" is a very genuine feeling—as this whole story has shown—and a very great burden.[28] Henceforth, van Gogh belongs to a universal heritage. It is a legacy no one can evade, not even by way of critical rejection. Through it a possible community experiences and tests itself by gathering to celebrate the great man, and to share the blame for a fault that calls forever for redemption. Yet narrating his deeds and consuming his works cannot redeem what was done to him. The impossibility of redemption shows forth in the way prices that increase that much more with every sale of his paintings put a figure to the injustice he suffered, while with every gaze, the pleasure of the pictures deepens the collective debt owed a solitary individual who sacrificed himself for posterity.

Conclusion

The van Gogh Effect

How DID van Gogh become a saint? It happened in six stages: his work was made into an enigma, his life into a legend, his fate into a scandal, his paintings were put up for sale and exhibited, and the places he went, as well as the objects he touched, were made into relics. In accounting for all of this, I have drawn on several disciplines and explored a range of theoretical issues. This was necessary, for van Gogh does not belong only to art history and criticism, which are concerned with the construction of artistic greatness. He belongs equally to the history of religion, which is concerned with the sacrificial construction of greatness; to the biographical and hagiographical tradition, which is concerned with systems of admiration and heroization; to psychiatry, psychology, and anthropology, which are concerned with deviance and singularity; to economics, which is concerned with the monetarization of the value attributed to the work; and to the sociology of religion, which is concerned with the status of relics, pilgrimages, and atonement. Although the combination of these many approaches flies in the face of the scientific practice of empirical monographs and theoretical modeling, it nevertheless fits the specific case of van Gogh, whose singularity also consists in connecting heterogeneous (especially artistic and religious) traditions by crystallizing different dimensions of experience.

Van Gogh embodies far more than a new artistic tendency. He embodies a new model of the artist. The ordinary way of seeing artistic creation has not been the same since van Gogh. This singular figure has been raised up in being caught up by, and caught within, the community. But the community has also been transformed thereby. This deviant individual has fundamentally renewed the way not only his own place, but those of his successors and even predecessors, are perceived. He marks a turning point, an aesthetic, historical, and ethical rereading of art. In other words, he is the origin of a new paradigm in the Kuhnian sense. His existence redefines the ordinary meaning of normal, establishing a boundary between a traditional and a modern concept of the artist.

An Artistic Paradigm

The legend of van Gogh has become the founding myth of the accursed artist: his degeneration in the present proves his future greatness, while

bearing witness to the pettiness of the world ("society"), which is guilty of not having recognized him. He has become a model, in the dual sense of an example to be followed, and a pattern determining the configuration of values. Thanks to him, it is possible to exalt the misery of many artists whose lives were wrecked by poverty and alcohol (Utrillo, Modigliani), by sex (Toulouse-Lautrec), by madness (Camille Claudel),[1] and, more generally, by the misguided ways of bohemia, from Montmartre to Montparnasse. To be sure, this "bohemia" antedated van Gogh in the art world; but through him it became an obligatory image, a myth, a stereotype.[2]

By virtue of this "van Gogh effect," the properties attributed to him are transferred onto other artists, and not just those who came after him. The same procedure is applied to the past, which is retrospectively reinterpreted according to the theme of "blindness in the face of painting."[3] The following text illustrates how the van Gogh paradigm makes it possible to reread great sections of art history through the prism of the motif of incomprehension.

> The fatal break which *always* exists between *genius* and *society* takes on its most dramatic form with van Gogh, and also its most impassioned one. People often fail to appreciate the *suffering* involved in the birth of a work of art. In admiring it, in vaunting its qualities, they think they are "*rehabilitating*" their victim, whereas all they are doing is *damning his tormentors even more. We are responsible for van Gogh's "madness,"* just as we are for *the fall of Rembrandt,* who was discredited and abandoned by all, *for the morbid obsessions of Goya,* for *Delacroix's ravings, for Lautrec's degeneration,* for the *curse on Pascin,* for *Utrillo's martyrdom,* for the *"unexplained" death of Nicolas de Staël.* Torrents of remorse cascade from century to century, impelled by Christ's "Why hast thou forsaken me?" They echo most tragically in the night where man, elaborating his own universe, tries to impose it on the society which gave birth to him. Thus, Van Gogh does not represent a pathological problem which will no doubt give rise to endless commentary, but more accurately a sociological problem, as a study of his life and work confirms.[4]

Not only is this rereading of the past an effect of the paradigm shift, but it also contributes to effecting that shift, since the recurrence of the motif of incomprehension bears witness to its permanence, and thus points to its universality. Such naturalization by way of dehistoricization and universalization comes across quite clearly in this other text, which was explicitly meant for a popular audience.

> This is not a *new problem*, as some might think. It must be remembered that it is *eternal*. Many people believe that the divorce between artist and audience is a recent phenomenon. . . . Indeed, the break became apparent in the early days of what has improperly been called "impressionism"; but the phenomenon as such goes back a lot further. If we were to draw up a list of all the great artists

throughout history who died in poverty because of their contemporaries' *complete failure* to understand them, we would be overwhelmed.[5]

Besides its temporal extension in the history of painting, the new "Vangoghian" paradigm has come to be applied retrospectively in other disciplines. This is especially true of the motif of the unfinished work of art. Each field of artistic expression seems to have at least one typical example of this, which is celebrated in the same manner as van Gogh is. In music one thinks of Mozart, who died at the age of 35, in poetry of Rimbaud, dead at 37 (and whose dates of birth and death, 1854–1891, coincide almost exactly with van Gogh's), and in cinema of Vigo, dead at 29. They were all creators prevented from completing their work by a premature death. They were all victims of illness or, directly or indirectly, of their social environment's incomprehension. A shroud of mystery surrounds their birth (van Gogh and his dead brother), the origin of their talent (Mozart the child genius), an episode of their life (Rimbaud in Abyssinia), or the fate of their life's work (the loss of the original version of *L'Atalante*, before it was reconstructed by its admirers). During their lifetime, they had to face adversity (hatred, jealousy, or incomprehension). But someone (father, brother, friend, producer) had confidence in them, and a small circle of the elect recognized them while they were still alive, granting them esoteric success in the absence of any success in the marketplace. At any rate, their work proved strongest, and posterity celebrated its triumph, since they were rehabilitated after their death, precipitating pilgrimages (distribution of their works, biographical inflation, and visits to their gravesides).

In these various incarnations of the prophetic artist, the Christlike image of a persecuted and as yet unrecognized savior does not suggest the poverty of a prophet as much as the dereliction of an ignored and abandoned creator. Van Gogh has not just become the "model" of this image, in Scheler's sense of the term,[6] he is virtually its eponym. As one journalist put it in an interview: "Christ said: in what beggar will you recognize me? Van Gogh said: in what artist will you recognize me?"

> No one has been more completely ignored. . . . He is almost too perfect an embodiment of the artist who garners only contempt during his lifetime, and whose work is universally acclaimed today. . . . Vincent van Gogh was congenitally destined not to be understood. He is a man who spent his life not being understood, and not just with regard to his art.[7]

Far from being the cause or source of these upheavals, which in many respects were already germinating before him, van Gogh was no more than a particularly successful embodiment of them. However, the constitution of his legend, and its propagation to a very broad audience, made him an

exceptional vehicle for the exemplary achievement of transformations that had hitherto remained potential, confidential, or conflictual. Van Gogh really does represent a paradigm therefore. On the one hand, he crystallizes, if not a consensus, at the very least a new norm, a new *doxa* where representations of the artist are concerned. On the other hand, this representation can be generalized, transposed to other artists in the past and the future, as well as other disciplines. Having established this, it is necessary to restate what constitutes the novelty of van Gogh, what makes him a modern figure, how he marks a break with the traditional standards of artistic excellence.

A New Order

A first characteristic of this new order is the personalization of artistic greatness. The importance ascribed to the signature is one of the most visible symptoms of this.[8] Little by little, radical innovations have come to be regarded as normal. For example, artists place their own particular stamp on their works. Similarly, their intimate lives are displayed in the public sphere through the publication of their letters or the proliferation of biographies.[9] Simultaneously, the interiority of the creator becomes the origin and guarantee of creativity in principle and not by accident.

As a corollary of this personalization, abnormality comes to be accepted, even valued. This extends from the mere assertion of originality to the systematic transgression of the norm, of "what is done" according to the codes, conventions, or canons of representation. It is then inevitable that creators cease to conceive their work as a replication or manipulation of canons inherited from established traditions, and instead relate it to the interiority of determinations independent of the common law. To be sure, the exceptional is nothing new in art history, which has seen many extraordinary creative personalities. Michelangelo is one of the earliest and most famous examples of this. What has changed with the Vangoghian paradigm is that abnormality is no longer valued as an exception, but as the rule. The normalization of the abnormal is an a priori principle of excellence that applies to every artist. Henceforth, normality in art consists of being outside of the norms. What is beyond the norm is systematized *as* a norm crystallized around the case of van Gogh, and from now on dictates that what "is not done" is what *is to be done*. The passage from an ethic of conformity to one of rarity thus comes to hold true for common sense, and not just for specialists who have written about van Gogh's work.[10]

One of the many consequences of this paradoxical phenomenon is the extraordinary economic exploitation of everything that remains of the artist, in the shape of works and relics. The price explosion on the art market

does not just affect those who were "sacrificed"—among whom van Gogh ranks first—but also, from Renoir to Picasso, many representatives of the new art world, in which excellence, once recognized, is measured in the absolute terms of singularity rather than in relation to the competition, and in which it is thereby sanctioned in the immensity of a world beyond the norms—the norms of the market.

Another corollary of this "negative normalization" is the way that the notion of beauty is discredited as a standard for evaluating the quality of works of art. On the one hand, beauty can no longer be measured according to a common scale of values. On the other hand, it becomes a secondary end when the expression of an artist's own personality, creative process, or experimentation counts for a lot more than the production of delightful objects for the consumer. This relative dismissal of the criterion of beauty marks a change in the nature of evaluation. The latter now focuses on an earlier phase of the creative process, on the producer instead of the spectator. Henceforth, the work is to be judged less in function of the spectator's feelings, and more in function of what the producer was "trying to say."

This phenomenon is limited, however, to the scholarly sphere of the modernist discourse on art, the only place where specialists jettison the traditional arguments around beauty. The latter remains an essential ingredient of the ordinary process of evaluation. This points to another important consequence of the new application of the ethic of rarity to art, namely the break between specialists and the uninitiated, scholarly discourse and common sense. That break occurred in van Gogh's day and has only become worse, culminating in today's relegation of artistic avantgardes to a ghetto. But in addition to ascribing value to code-breaking and to artistic exploration beyond the norms, scholars seek to dissociate themselves from the emphasis on personalities preferred by humanist psychologists, and instead ascribe primacy to the works themselves, as formalist aesthetes do. The latter tend to be interested exclusively in the intrinsic characteristics of a work. They view it as a vehicle less for experiencing beauty or expressing a personality than for experimenting with a technique specific to the medium in question, or for reflecting on broader phenomena.

Contemporary incomprehension and misappreciation are a necessary effect of breaking away from the canons. As such they have become an almost inevitable image, much used in advertising to get people to buy popularizing books (see "Exploitation of the Motif of Incomprehension in Advertising"). This motif has become so basic that recognition which comes too quickly provokes suspicion, irritation in the face of institutions' zeal in rehabilitating artists and their work,[11] or nostalgia for an era when "sacred fear" still existed.[12] The logical, though seemingly paradoxical, outcome of ascribing value to rarity is that the initiates roundly condemn

EXPLOITATION OF THE MOTIF OF
INCOMPREHENSION IN ADVERTISING

"Until the end of the nineteenth century, the impressionists were all de-
spised. . . . Nowadays, it is understood that they prevented the death of the
art of painting, and ushered the latter into the Twentieth Century" (for a
book on the impressionists).

"You will have recognized those childlike signatures. They belong to the
impressionists, who rank among the very greatest, but who were despised,
even hated during their lifetimes. . . . Although hungering for recognition,
they were not recognized, and remained orphans of their time, few of them
ever knowing fame or fortune. When Monet lived in Vetheuil, he would
sometimes trade a painting for a basket of eggs . . . in order to eat, and to be
able to keep on painting the Seine! Indeed, who would have staked so much
as a penny on the future of such painters, whose works were shot down in
flames by the critics? Today, their works are worth tens of millions of dollars.
There is a mystery. *You will find the key to this mystery in the book, The Impres-
sionists*. Page after page will reveal the gigantic gulf separating those paint-
ers from their predecessors, so different were they. You will discover the rich
creativity through which these artists revolutionized our way of seeing the
world, and you will understand why they were rejected for so long" (for a
publication devoted to art).

"Van Gogh, too, was criticized" (for a line of bras).

popular understanding of van Gogh and infatuation with him. "Reproduc-
tions of van Gogh are in greatest demand. There is hardly a home without
a reproduction of one van Gogh painting or another. You will admit that
such general success, following on such total incomprehension, presents a
real problem. . . . This attitude of smug admiration is relatively recent. . . .
It could create misunderstandings even more tragic than that in which van
Gogh perished."[13]

Finally, the logic of rarity and the necessity of incomprehension entail
that the moment of success or consecration must be displaced onto poster-
ity. All genuinely innovative creators can only clash with the common out-
look, with their contemporaries' *doxa*, because they contravene the ac-
cepted norms. This will continue until such time as the common outlook
has changed (in part because of their efforts) and they can draw recognition
from it. But that often happens too late for them to profit from it during
their lifetime. In today's art world, success becomes ever more undeniable
the longer public demand is deferred. In the world of commerce, by con-
trast, success must be great *and* swift. The value of immediate *notoriety*,
which could always be discredited as an indicator of conformity, gives way
to the value ascribed by posterity, in which the encounter with a mass

audience is deferred till later. Hence, immediate success only has credibility if it involves a small circle of initiates (brief time, restricted space), while large-scale common recognition only has credibility through the mediation of time (long time, extended space).

Such displacement from present to posterity is essential to any kind of avant-garde, because immediate success could only sanction living up to the norms, reproducing accepted traditions, and therefore the inability to transform the latter.[14] Because of its very self-evidence, it may be that insufficient attention is paid today to the importance of this paradoxical inversion which, by extending the temporality of reference, makes it possible to construct excellence by way of ignorance, and to transmute the blackest instances of failure into proof of value or, at least, into favorable arguments. The world of modern art, more than any other, has thus become the place where, in conformity with the Gospels, the last always have good reason to hope that they will one day be first.

The new Vangoghian paradigm quite literally embodies a series of shifts in artistic value, from work to man, from normality to abnormality, from conformity to rarity, from success to incomprehension, and, finally, from (spatialized) present to (temporalized) posterity. These are, in sum, the principal characteristics of the order of singularity in which the art world is henceforth ensconced. That is the essence of the great artistic revolution of modernity, the paradigm shift embodied by van Gogh.

The Test of Posterity

The displacement of the moment of achievement to posterity is a *test*, in every sense of the term. To begin with, it demands the ascetic disposition (the "patience" of martyrs) that makes it possible to bear the pain or vacuousness of the present. Once the test has been accepted, it rules out the innocence that guarantees the authenticity of sacrifice. Van Gogh, after all, lived without knowing what an "accursed artist" was, since he himself so to speak created that role before the play had even been written, before his life had been turned into a legend. But *after* van Gogh, no artist can ignore that suffering and failure could metamorphose into a form of martyrdom, into glorious testimony to his faith in the greatness of his as-yet-unrecognized art. The same difference exists, if the expression is permitted, between heresy before heresy (that of Manet or van Gogh, who worked in a world not yet reconstructed in the "tradition of the new"), and heresy after heresy, represented by a Picasso, a Duchamp, or a Dali, who were able from the start to constitute renewal as a paradigmatic value, and not a merely particular, or even momentary, consequence of a lone individual's work. No artists today could be innovators without seeking to be so, any

more than they could sacrifice themselves innocently, and therefore authentically, to their art, as van Gogh did in an era when (if I may speak thus) "it was not done." That innocence is lost, at any rate, and that loss became irreversible after van Gogh. For that reason, we *cannot* return to van Gogh, to paraphrase Artaud while contradicting him.

Despite these pitfalls, the test of posterity is a key dimension of the new artistic paradigm, for it retrospectively transforms into truth what was only an exploration in the eyes of the artist, and into necessity what was experienced as highly uncertain, what was open to doubt and error. Every judgment after the fact confers the value of necessity on a historical moment, by framing it in an evolutionary process that is seen as what *had to happen*, simply because *it did*, that is, as the truth of history, the truth of art. Hence impressionism and van Gogh had to be stages in the development of painting for it to be what it is in the eyes of posterity. From this ex-post perspective, each painter's endeavors appear as a search for this or that truth, as a movement that could only lead to this or that point. "Art" is thus seen as the very opposite of random; it is regarded instead as the object of an ineluctable and mysterious truth, while artists are construed as its prophets, or at least precursors, both visionary and blind.

Teleological reconstruction in posterity also contributes to the development of collective guilt, which is born of the gap or dissymmetry between the moment when the truth was uttered and the moment when it was heard. As it only occurs after the fact, the revelation of the singular one's greatness grants him the anticipatory role of a prophet or precursor, and turns his curse into a form of prediction. The act of deviation becomes a power of anticipation, and anticipation a power of renewal. Whether he is in the avant-garde without being aware of it, or whether he is consciously or unconsciously working at being part of it, the deviant creator who cuts himself off from tradition takes on the risk of failure, while having a chance of becoming the founder of a new tradition for posterity—as well as the victim of fresh incomprehension. But the test of success is delayed till much later. That is why great creators, in the order of singularity through which modern art is evolving, are great precisely to the extent that they are *ahead*.

A Religion of Art?

Symmetrically, "society" (with its representatives in the specialized world of dealers, historians, critics, curators) is at fault with respect to creators to the extent that it is *late*. Being late is the temporal form of indebtedness, whereas being ahead is the form of the gift, in the dual sense of a "gift" from nature to the talented artist, and a "gift" from the creator to his art in

the form of abnegation and the sacrifice of immediate rewards.[15] The motif of guilt becomes a cliche, and "the culpable indifference of official circles" is repeatedly and regularly stigmatized. The attribution of guilt and the passage to posterity combine to transform the error committed by the artist's contemporaries, and especially art galleries, into a fault perpetrated against the artist, with the concomitant consequences, that is, debt, redemption, atonement. Hence, with the new paradigm, guilt bursts onto the artistic scene for the first time in history.

This innovation provides a good illustration of how sacrifice opens up a gulf between the world of the artists that has potentially been made sacred, and the profane world of their admirers.[16] Van Gogh embodies precisely such a consecration, in both senses of the word (sacralization and apotheosis). It is a consecration of art as a sphere into which expectations traditionally taken up by religion may henceforth be projected. The "tension" between "ethical religiosity" and "aesthetics" analyzed by Max Weber,[17] is replaced by a religious investment in aesthetics. As people desert the churches to fill the galleries, art is no longer an instrument, but instead an object of sacralization.

The religious organization of the artistic world comes in many forms today. Widely circulated reproductions are but substitutes for the pious images sold at the door, in those places where the ordinary person can experience the presence of the originals, preserved as relics. Similarly, immortality has become the concern of galleries and museums, those modern temples that people like best to visit on Sundays, when admission is free for everyone, just like in church.[18] The Van Gogh Hospital, recently inaugurated as a place of culture in Arles, has been described by an official in the very words that would be used to describe a place of worship: "permanent," "dedicated" to contemporary creation, and "open" to the general public.

The curator's profession also takes on the guise of a modern, secular form of the religious bureaucracy described by Max Weber. The poverty traditionally associated with the job may partly be attributed to its feminization and bourgeois origins. But it seems to have as much to do with a spirit of priesthood, by virtue of which the curator is the least self-interested of people, and is wholly devoted to the common good of art. Similarly, the most modern attempts at popularization by opening up galleries to new publics sometimes seem like a kind of proselytizing with religious overtones. Finally, it seems impossible not to regard the current inflation in purchases by state-owned galleries as an echo of the trauma inflicted on the profession by mistakes about paintings, which became offenses against artists committed several generations ago.[19]

Today, as in the Middle Ages, lighting for artworks in Italian churches is still provided by the faithful, who drop a hundred lira into an electrical device to illuminate a work of art for a minute or two.[20] Similarly, the fund

recently set up to enable the state to purchase a painting by Georges de La Tour illustrates how the faithful participate in enriching the treasure of liturgical objects.[21] Art is henceforth the emblem, and even the core, of the nation's heritage. The state can ban exports of works of art, just as much as order the restitution of an artist's remains, as in the recent "affair of state," when Belgium refused to return David's ashes to France.[22] Art is no longer a private affair, but pertains to the general interest; any privatization of great works may thus be condemned. "Art belongs to all, and no one may prevent anyone else from creating," according to a jewelry advertisement warning against forgeries.

"We earlier asked what our expectations of art are today. But the answer is simple: all that we expected of religion in former times. And we expect painters to be saints." In the scholarly world, painting has become the primary site of theological investment.[23] For instance, a recent work explicitly applies the themes of dedication and redemption,[24] atonement,[25] and sacralization[26] to the painter's activity.

While certain religious tendencies are displaced onto a certain art world, "religion" does not for all that subsume "art," any more than there is any identity of the two areas. This is demonstrated by the condemnations leveled at such displacement, which have compelled me to disengage from any critical dimension by treating the common practices and scholarly denunciation of art and religion symmetrically. Indeed, it is not my purpose here to "disclose" that van Gogh, or artists generally, are treated as saints. To a great extent, common sense already guesses it, while the scholarly world has already argued that it is so. But this only describes part of the phenomenon. To be content with tying admiration for the artist to veneration for the saint would be to neglect to ask why the former does not explicitly take on a religious guise, why this saint is not a canonical, but a "lay" saint, made and appropriated by the laity. Why, for example, does no one, to our knowledge, pray to Saint Vincent van Gogh? Neither would we understand the function of applying the most traditionally religious forms of celebration to an object that is not religious. That function is one of distantiation with respect to religion. This is illustrated by the art lover's denunciation of the reductionist violence of sociologists, who deny the specifically secular nature of the aesthetic investment, in order to highlight the religious backdrop of "love of art."[27]

Reactions to sociological analysis (e.g., embarrassment or laughter at the use of the term "pilgrimage" in connection with the centenary exhibitions) must be taken into account if we are to understand that love of art is far from being an illusion about its own (religious) nature; rather, it allows people to be made sacred without being canonized. To put it another way, it makes it possible not to throw away the baby of veneration with the bathwater of religion. It reconciles attachment to objects of admiration

that are initially noncanonical, and then are canonized by the community of art lovers, with detachment from the canonical forms of religion. This rejection of all instituted authority (whether in the form of the artistic tradition or the church) is a way of reconstituting, on a new basis, a community that is "reauthenticated" because it is directed against the recognized forms of acknowledged faith. That is why van Gogh comes across as a Protestant saint.

References to religion here are in no way metaphorical. I have not proceeded "as though" art were "a kind of" religion, fabricating a rhetorical trope, weaving a metaphorical thread, which could not be faulted any more than it could be taken seriously.[28] The religious model is no mystification, no lie or illusion dissimulating the truth about the object. It is a historical fact, as much because, in general, the Christian religion precedes modern painting,[29] as because, in particular, van Gogh the preacher precedes van Gogh the artist. The religious model is not, however, an explanatory matrix or key, any more than it is a metaphor or a mystification. Indeed, before the case of van Gogh could be explained in terms of religious saintliness, the latter would at least have to be defined with some precision, something theologians and anthropologists admit is far from having been done.[30] Any reduction of love of art to religious veneration would lead to burying the question rather than answering it. What should be done instead is to take advantage of the process of displacement or decontextualization of religious behaviors toward the artistic domain, in order to bring out the fundamental components of what is called "saintliness" in a religious context, and "heroism" or "genius" elsewhere. Depending on its extent and context, it is a phenomenon pertaining to love, admiration, celebration, veneration, or idolatry.

To understand the van Gogh effect, we therefore had to extricate ourselves from the a priori categories of "religion" and "art," and to regard them not as given facts, but as mental constructs, which organize the perception of phenomena that, under various forms, are common to different universes. Their shape and definition vary historically, as the case of van Gogh remarkably illustrates. Voragine's model, which has guided this narrative of secular sanctification, is consequently neither a simple metaphor, nor a pure literary artifice. Deviation, renewal, reconciliation, and pilgrimage are the major stages through which a community embraces a singular individual, binds itself to that person by gift and debt, and by that mediation consolidates itself through shared guilt toward a redeemer who is to be redeemed.

APPENDIXES

A

Van Gogh and Art Criticism in France, 1888–1901

Mr. van Gogh vigorously paints broad landscapes, without very great care for the value or exactness of the tones. A multicolored multitude of books evolves toward a tapestry; such a motif, although suitable for a study, cannot afford the pretext for a painting. (Gustave Kahn, "Peinture: Exposition des Indépendants," *La Revue indépendante*, April 1888, VII, p. 163)

These painters alone, who have emerged from optic painting, would suffice to justify the existence of the Association of Independent Artists, if that disparate brotherhood did not number Messrs. Anquetin, Lemmen, de Toulouse-Lautrec, and van Gogh.

The latter's Irises violently tear apart their violet patches against their strip-like leaves. Mr. van Gogh is an entertaining colorist, even in extravagances such as his *Starry Night*: on the sky, squared into a broad weave by the flat brush, the tubes have distinctly placed cones of white, of pink, yellow stars; orangey triangles sink into the river, and, near the moored boats, baroquely sinister figures hurry along. (Félix Fénéon, "50e exposition de la société des artistes indépendants," *La Vogue*, 1889, pp. 260–261)

Here are canvases by Vincent, tremendous in their ardor, intensity and sunshine. (Luc le Flaneur [Aurier's pseudonym], "En quête de choses d'art," *Le Moderniste*, April 13, 1889, p. 14)

And there, suddenly, as I plunged into the ignoble hustle and bustle of the filthy street and the ugliness of the real world, these scattered snatches of verse sang in my memory, quite in spite of myself:

> The intoxicating monotony
> Of metal, marble and water . . .
> And everything, even the color black,
> Seemed refurbished, clear, iridescent;

Note: I reproduce here the complete text or major excerpts of the reviews of van Gogh published up to 1901, with the exception of articles by Georges Lecomte (in *L'Art dans les deux mondes*, March 28, 1891) and Emile Bernard (in *Le Coeur*, 1894), which I was not able to find. The bibliographical documentation is drawn from the work of Brooks and Zemel.

Liquid embedded its glory
In the crystallized ray . . .
And heavy waterfalls
Like crystal curtains
Hung, dazzling,
From metal walls.

Under skies now carved out of the dazzling of sapphires or turquoise, now moulded from who knows what infernal, hot, noxious and blinding sulphurs; under skies like molten metals and fusing crystals, where torrid, irradiated solar orbs sometimes sprawl; under the ceaseless and formidable flowing of all possible lights; in heavy, flaming, scorching atmospheres, which fantastic ovens seem to exhale, ovens in which gold and diamonds and singular gems would vaporize—the disturbing, troubling, display of an alien nature, a nature that is both really real and virtually supernatural, an excessive nature in which everything, beings and things, shadows and lights, forms and colors, rears up, stands up with the raging will to howl out its essential and very own song, in the most intense, the most ferociously excessive high-pitched tone; with their menacing, knotted arms and the tragic flight of their green manes, trees twisted like battle giants proclaim their untameable power, the pride of their musculature, their sap hot as blood, their eternal challenge to the hurricane, lightning, evil nature; cypresses raising their nightmarish silhouettes of flames, which would be black; mountains arching the backs of mammoths or rhinoceroses; white and pink and blond orchards, like ideal dreams of virgins; squatting houses, passionately contorting themselves like beings in the throes of pleasure, suffering, thought; stones, land, brush, lawns, gardens, rivers that seems sculpted out of unknown minerals, polished, shimmering, iridescent, magical; flamboyant landscapes like boiling multicolored enamels in some alchemist's diabolical crucible, foliage that looks like ancient bronze, bright new copper, spun glass; beds of flowers that are less like flowers than the richest of jewels made of rubies, agate, onyx, emeralds, corundum, chrysoberyls, amethysts, and chalcedony; the universal and mad and blinding coruscation of things; matter, nature as a whole frenziedly twisted, paroxyzed, raised to the utmost exacerbation; form becoming a nightmare, color becoming flames, lava and precious stones, light becoming fire, life, hot fever.

Such is, and without exaggeration, although one might think so, the impression left on the retina by the first looking at the strange, intensive and feverish works of Vincent van Gogh, that compatriot and not unworthy descendant of the old Dutch masters.

Oh! how far removed we are, aren't we, from the beautiful, grand old

art, the very healthy and very level-headed art of the Netherlands! How far removed from Gerard Dow, Albert Cuyp, Terburg, Metzu, Peter de Hooghe, Van der Meer, Van der Heyden, and their charming, somewhat bourgeois, so patiently, meticulously, phlegmatically, scrupulously detailed canvases! How far removed from the beautiful landscapes of Van der Heyden, Berghem, Van Ostade, Potter, Van Goyen, Ruysdaël, Hobbema, so sober, so measured, so wrapped in soft, gray, indistinct vapors! How far removed from the slightly cold elegance of a Woutermans, the eternal candle of Schalken, the timid myopia, fine brushes and magnifying glass of the good Pierre Slingelandt! How far removed from the delicate colors of Northern climes that are always a bit cloudy and misty, and from the tireless picking away of those healthy artists from there and then who painted "in their stove," in a calm frame of mind, their feet warm and their bellies full of beer! And how far removed from that very honest, very conscientious, very scrupulous, very Protestant, very republican, very brilliantly banal art of those incomparable old masters who had the one fault—if fault it was in their eyes—of being heads of families and burgomasters! . . .

And yet, let there be no mistake, Vincent van Gogh is not so removed from this breed. He has been subject to the ineluctable atavistic laws. He is well and truly Dutch, of the sublime lineage of Frans Hals.

First of all, like all his illustrious countrymen, he is a realist, a realist in the fullest sense of the word. *Ars est homo, additus naturae* said Chancellor Bacon, and Mr. Emile Zola has defined naturalism as "nature seen through a temperament." This "*homo additus*," this "through a temperament," this molding of the ever-singular objective into ever-diverse subjectives, is what complicates the issue and eliminates the possibility of any unquestionable criterion of an artist's degree of sincerity. In determining the latter, the critic is therefore inevitably reduced to more or less hypothetical, but always debatable, inductions. Nevertheless, in the case of Vincent van Gogh it is my opinion that, despite the sometimes bewildering strangeness of his works, it is difficult, for those who would be impartial and know how to look, to deny or contest the naive truthfulness of his art, the artlessness of his vision. All his canvases exude a sense of good faith, a sense that he had really seen what he was painting. But quite apart from this, the choice of subjects, the constant relationship between the most excessive notes, the conscientious character studies, the continual search for the essential sign of each thing, a thousand significant details indisputably assert his profound and almost childish sincerity, his great love of nature and of what is true—of what is true for him, his own truth.

On this basis, I may legitimately infer Vincent van Gogh's temperament as a man, or rather as an artist, from his very works. If I so wished, I could corroborate this inference with biographical facts. What is peculiar to his entire work is excess, excess of strength, excess of tension, violence of expression. In his categorical affirmation of the character of things, in his

often bold simplification of forms, in the insolence with which he faces the sun head-on, in the vehement ardor of his drawing and color, even in the most minute peculiarities of his technique, a powerful, male, daring, very often brutal and sometimes ingenuously delicate artist is revealed. Furthermore, as one can guess from the almost orgiastic extravagance of everything he painted, he is a fanatic, the enemy of bourgeois sobriety and minutiae, a kind of drunken giant, more able to move mountains than handle delicate trinkets, a mind at boiling point, gushing its lava into every ravine of art, irresistibly, a terrible and panic-stricken genius, often sublime, occasionally grotesque, always a matter for pathology. Finally, and especially, he displays clear symptoms of hyperaesthesia; he perceives with abnormal, perhaps even painful, intensity the imperceptible and secret character of lines and forms, but even more of colors, light, nuances invisible to healthy eyes, the magical iridescence of shadows. And that is why the realism of this neurotic, that is why his sincerity and truth, are so different from the realism, sincerity and truth of those great petits bourgeois from Holland who were his ancestors and masters, they whose bodies and minds were so sound and steady.

Respect and love for the reality of things do not suffice to explain and characterize the profound, complex, very distinct art of Vincent van Gogh. Like all the painters of his ilk, he is no doubt very conscious of matter, of its beauty and importance. But it is also true that more often than not he considers this enchanting matter as no more than a kind of marvelous language designed to render the Idea. He is, almost always, a symbolist. To be sure, he is not a symbolist like the Italian primitives, those mystics who scarcely felt the need to disimmaterialize their dreams. Rather, he is a symbolist who experiences the continual need to clothe his ideas in precise, balanced, tangible forms, in intensely carnal and material envelopes. In almost all his canvases, under that morphic envelope, under the very fleshy flesh, under the very material matter, there lies a thought, an Idea, for minds that can see it; and this Idea, the essential substrate of the work, is both its final and efficient cause. The brilliant and striking symphonies of colors and lines, whatever their importance for the painter, are merely *means* of expression in his work, mere *processes* of symbolization. To refuse to grant the existence of these idealist tendencies within this naturalistic art would be to make a large part of the work in question quite incomprehensible. How else to explain the *Sower*, for example, that noble and disturbing sower, that peasant with his brutally inspired forehead, with his occasional distant resemblance to the artist himself, that sower whose silhouette, gestures and labor have always obsessed Vincent van Gogh, who painted and

repainted him so often, now under reddening twilight heavens, now in the golden dust of blazing middays—how can the sower be explained without reference to the obsession, which haunts van Gogh's brain, of the current necessity of a man, a messiah, a sower of truth, who would regenerate the decrepitude of our art and perhaps of our stupid, industrialist society? And what of his obsessive passion for the solar orb that he loves to make gleam in fiery heavens, and also for that star of the plant world, the sumptuous sunflower, which he tirelessly reproduces, like a monomaniac? How else to explain this without admitting his persistent preoccupation with some vague and glorious heliomythical allegory?

Vincent van Gogh is, indeed, not only a great painter, who is enthusiastic about his art, his palette and nature; he is moreover a dreamer, a rapturous believer, a devourer of beautiful utopias, living by ideas and dreams.

For a long time, he reveled in imagining a renewal of art to be achieved by a shift in civilizations: an art of tropical regions; peoples imperiously demanding works corresponding to newly inhabited environments; painters face to face with a hitherto unknown, tremendously luminous nature, finally admitting the impotence of the old academic gimmicks, and setting out, naively, to find the candid rendition of all these new sensations! . . . Wouldn't he have been the very worthy painter of these lands of radiance, of the dazzling suns and colors that blind, he, the intense and fantastic colorist, grinder of gold and precious stones, rather than Guillaumin, the insipid Fromentin or the muddy Gérôme? . . .

Then, as a consequence of this conviction of the need to begin everything anew in art, he hit upon—and long cherished—the idea of inventing a very simple, popular, almost childish manner of painting, one that could move humble folk who do not refine, and could be understood by the most naive of the poor in spirit. The *Berceuse*, that gigantic and inspired *image d'Epinal*, of which he produced several variations, the portrait of the phlegmatic and indescribably jubilant *Employé des postes*, the *Pont-levis*, so garishly luminescent and exquisitely commonplace, the ingenuous *Fillette à la rose*, *Zouave*, *Provençale*, indicate most clearly this trend toward the simplification of art, which is to be found pretty well throughout his work, and which does not seem to me so absurd or unworthy of respect in this era of excessive complication, myopia, and clumsy analysis.

Are all of Vincent van Gogh's theories and hopes practical? Aren't they vain and beautiful pipe dreams? Who knows? At any rate, I need not go

into that here. To conclude my characterization of this unusual mind, who is so far from the banal paths, a few additional words about his technique will suffice.

The external and material side of his painting is in absolute correlation with his artistic temperament. All his works are vigorously, rapturously, brutally, intensively executed. His raging, powerful, often awkward and somewhat heavy draughtsmanship exaggerates the character, simplifies, passes masterfully, victoriously, over detail, achieves masterful synthesis, sometimes (but not always) great style.

We already know his color. It is incredibly dazzling. To my knowledge, he is the only painter who perceives the chromatism of things with such intensity, with that metallic, gemlike quality. His studies of the coloring of shadows, of tones' effect on tones, of full sunlight, are passing strange. However, he does not always avoid unpleasant crudities, a certain lack of harmony, certain dissonances. . . . Like everything else about him, his actual brushwork and immediate process of illuminating the canvas are spirited, very powerful and very nervous. His brush operates by way of an enormous thickening-out of very pure tones, by way of curved streaks broken by rectilinear strokes, by way of piles of gleaming masonry, and this all gives some of his canvases the solid appearance of dazzling walls made of crystal and sunlight.

This robust and genuine artist, this thoroughbred with the brutal hands of a giant, with the excitability of a hysterical woman, with the soul of a visionary, who is so original and distinct amidst our pathetic art of today, will he ever know—anything is possible—the joy of rehabilitation, the repentant flattery of fashion? Perhaps. But come what may, even if fashion were to rate his pictures at the price of M. Meissonier's little infamies (a very unlikely prospect), I do not believe that such belated admiration by the general public could ever be very sincere. Vincent van Gogh is both too simple and too subtle for the contemporary bourgeois mind. He will only ever be fully understood by his brothers, those artists who are truly artists . . . and by the blessed souls of the common folk, the very humble folk, who will, by chance, have escaped the beneficial teachings of the public school! (Georges-Albert Aurier, "Les isolés—Vincent van Gogh," *Le Mercure de France*, January 10, 1890)

Mr. van Gogh's ferocious thickening-out and exclusive use of easily harmonizing colors lead to powerful effects: the violet background in the *Cypresses* and the symphony of greens in some undergrowth make a strong

impression. (Georges Lecomte, "L'exposition des néo-impressionistes," *Art et critique*, March 29, 1890)

The nature of Vincent van Gogh's talent has been too well defined in the pages of this review by our friend G.-Albert Aurier; there is no need to go into it again. But what a great artist! Instinctive, he is a born painter; in him, there is no hesitation. Like Salvator Rosa, he is a tormented spirit. His power of expression is extraordinary, and everything in his work has a life of its own. Through his rapturous temperament, Nature appears as it does in dreams, or, better still, in nightmares. Level-headed, since line and color unite in a harmonious strangeness. He glimpses objects within nature, but only really sees them in himself. Example: that almost mythological cypress, with its metallic reflections, like a fabled dragon. Some *Sunflowers* in a pot are magnificent. There are ten paintings by van Gogh at the Indépendants that attest a rare genius. (Julien Leclercq, "Beaux-Arts. Aux Indépendants," *Le Mercure de France*, May 1890)

At the Indépendants, amid a few successful efforts and, especially, amid much triteness, shine forth the pictures of the late lamented van Gogh. Standing before them, and before the black mourning crepe that singles them out for the indifferent crowd of passers-by, one feels overwhelming sadness to think that this painter who was so magnificently gifted, this shimmering, instinctive, visionary artist, is no more. It is a cruel loss, and all the more so for art, as irreparable as that of M. Meissonier, even though the masses were not invited to a sumptuous funeral, and even though poor Vincent van Gogh, in whom a bright flame of genius was extinguished, died in the same unjust obscurity and just as unfairly ignored, as he lived.

It would be wrong to judge him by the few paintings currently exhibited at the City of Paris Pavilion, although they seem vastly superior, in intensity of vision, in richness of expression, in stylistic power, to everything that surrounds him. To be sure, I am not indifferent to Mr. Georges Seurat's experiments with light; I very much enjoy the deep and exquisite blondness of his seascapes. I find Mr. van Rysselberghe's stunning moods, feminine grace, and clear elegance, very charming. I am very attracted by Mr. Denis's small compositions, whose tone is so suave, and whose mystical sheath is so tender. I recognize M. Armand Guillaumin's honest and sturdy workmanship, even though his realism is narrow-minded and devoid of ideas. And despite unduly soiling the countenances he paints with black, M. de Toulouse-Lautrec reveals a genuine, spiritual and tragic strength in his studies of faces and characters. M. Lucien Pissarro's engravings display vigor, sobriety and distinction. Even M. Anquetin, amid flagrant reminiscences, academic conventions, botched oddities, grotesque

ugliness, sometimes offers us a pretty vista of light, as in the Parisian hori-
zon entitled *Pont des Saints-Pères*, and some skillful harmonies of grays, as
in several portraits of women. However, none of these unquestionable art-
ists (with whom one should not confuse Mr. Signac, who annoys by his
loud, arid, pretentious insignificance) grips me as much as Vincent van
Gogh. Before him, I feel in the presence of someone higher, more mas-
terly, who disturbs me, moves me, and compels recognition.

It may be too soon to tell Vincent van Gogh's story as it should be told.
His death is too recent and was too tragic. The memories I would evoke
would rekindle grief that still cries out. This study will therefore of neces-
sity be incomplete. What was great and unexpected, and also, sometimes,
too violent, too excessive, in van Gogh's fierce and delicious talent is inti-
mately linked to the cerebral fate that doomed him to die at an early age.

His life was quite disconcerting. He first went into business selling
paintings with his brother, the manager of Goupil's on Montmartre Boule-
vard, and who also died the same death. His was a troubled, tormented
spirit, bursting with vague and ardent inspiration, perpetually drawn to the
heights where human mysteries are elucidated. No one yet had guessed
what was stirring in him, of the apostle or the artist; he did not know it
himself. He soon left the business, in order to study theology. Apparently,
he had received a strong literary education, and had a natural inclination
toward mysticism. For a moment, the new field of study seemed to give his
soul the sense of direction for which it yearned. He took to preaching. His
voice rang out from the pulpit, amid the crowds. But he soon suffered
setbacks. Preaching soon appeared to him as a fruitless enterprise. He did
not feel close enough to the souls he wished to win over; his words burned
with love but bounced off chapel walls and hearts without penetrating
them. He thought teaching might prove more efficient; he gave up preach-
ing and left for London, where he became a school teacher. For several
months, he taught little children about God.

Obviously, all of this seems rather strange and disconnected. Yet it is
easily explained. He was as yet unaware of the artist clamoring within him;
he was drowning in the apostle, losing himself in the evangelist, straying
through forests of dreams that were dark and strange. Yet he felt an invin-
cible force calling him, but where to? He felt that a light would shine forth
somewhere, beyond the shadows, but when? As a result his behavior was
unbalanced, and he acted in ways that were not only disparate, but quite
foreign to him. It was on his return from London that his vocation sud-
denly burst forth. One day, by pure chance, he began to paint. And it just
so happened, on the first try, that this painting was almost a masterpiece.
It revealed an extraordinary painterly instinct, wonderful and powerful
qualities of vision, an acute sensitivity to the living and breathing form
beneath the rigid aspect of things, an eloquence and abundant imagination

that astounded his friends. Then Vincent van Gogh went fiercely to work. Labor took hold of him, unremitting labor, with all of its stubbornness and intoxication. A need to produce, to create, gave him a life without a break, without rest, as though he was trying to make up for lost time. This went on for seven years. And then death came, terrible death, to pluck this human flower. This poor man left behind, wrapped in all of the hopes that such an artist can inspire, a considerable body of work, nearly four hundred canvases, and an enormous number of drawings, some of which are absolute masterpieces.

Van Gogh was Dutch, a countryman of Rembrandt, whom he seems to have loved and admired very much. If one could ascribe an artistic filiation to a temperament of such abundant originality, with such spirit, such hyperaesthetized sensibility, one could perhaps say that Rembrandt was his preferred ancestor, the one in which he could most feel himself coming to life. His many drawings do not so much resemble Rembrandt's, as display a heightened cult of the same forms, a similar wealth of linear invention. Van Gogh does not always have the Dutch master's correctness or sobriety; but he often attains his eloquence and prodigious ability to render life. We possess some very precise and very precious indications of van Gogh's feelings, in the shape of copies he made of various works by Rembrandt, Delacroix, and Millet. They are admirable. But these grandiose and exuberant recreations are not copies, in the proper sense of the word. Rather, they are interpretations, by way of which the painter succeeds in re-creating another's work, of making it his own, while retaining his original spirit and special character. In Millet's *Sower*, rendered superhumanly beautiful by van Gogh, motion is emphasized, vision broadens out, the line is magnified, until it attains the meaning of a symbol. What is Millet's is retained in the copy; but Vincent van Gogh has put something of himself in it, and the painting has taken on a new grandeur. It is clear that nature brought out the same mental habits, the same superior creative gift in him, that artistic masterpieces did. He could neither forget his personality, nor contain it before any spectacle, any external dream. It burst forth from him in ardent illumination of all that he saw, all that he touched, all that he felt. Indeed, he did not absorb himself into nature. He absorbed nature into himself; he forced it to bend, to mould itself to the contours of his thought, to follow him in his flights, even to suffer his characteristic deformations. To a rare degree, van Gogh had that which differentiates one man from another: style. In a host of paintings thrown together pell-mell, the van Goghs can surely be picked out in the blink of an eye, just like the Corots, the Manets, the Degas, the Monets, the Monticellis, because they have a special genius that cannot be otherwise, and that is style, i.e., the affirmation of personality. Under the brush of this strange and powerful creator, all is infused with a strange life, independent of the things that are painted, and that is in him

and that is him. He invests all of himself to the benefit of the trees, the skies, the flowers, the fields, which he swells with the surprising sap of his being. Those forms multiply, become wild and twisted, and van Gogh always retains his admirable painterly qualities, and a moving nobility, and a tragic, terrifying grandeur, even in the admirable madness of skies where drunken stars spin and totter, spreading and stretching into scruffy comets' tails; even in the surging, fantastic flowers that spring upright, waving their crests like crazed birds. And, in the calm moments, what serenity in the great sunlit fields, in the flowering orchards where joy falls from the plum and apple trees like snow, where the happiness of living rises from the earth as a light quivering and spreads into the peaceful, tenderly pale heavens, wafted on refreshing breezes! Oh, how he has understood the exquisite soul of flowers! How his hand, which raises the terrible torches in the black heavens, becomes delicate to gather the perfumed and oh-so-frail shoots! And what caresses he finds to express their unutterable freshness and infinite grace!

And how he has also understood what is sad, unknown and divine in the eyes of poor madmen and fellow sick people! (Octave Mirbeau, *Echo de Paris*, March 31, 1891)

Here I am finally in the fifth room, the one which is first of all devoted to curious and unusual things, where there are bursts of laughter, where young admirations lecture to each other, where discussions and trepidation come easily. Indeed, all those who exhibit here are openly fighting against the academy, against official painting, against what a Prud'homme of the Institute or the quai Malaquais might call the dearest traditions of our masters. . . . Vincent van Gogh, that so curious an artist who sadly died last summer—Vincent van Gogh is a Dutchman, he admired Delacroix, Courbet, Millet, and Rembrandt. His life is one of the oddest psychological novels one could dream of. He was chaste, they say, a relentless worker and a mystic. A powerful imagination, all of the gifts of the painter, and very little of what is frankly known as "common sense," caused him to push the theories he espoused to their utmost limits, to the point of becoming perfectly incomprehensible. Of the ten canvases exhibited at the Indépendants, I must admit that I only understand two or three. . . . Van Gogh's name will no doubt give rise to unusual artistic discussions from which new truths may emerge. This strange painter has passionate admirers, his personality won him strong friendships. (Eugène Tardieu, "Salon des Indépendants," *Le Magazine français illustré*, April 1891)

The Société des Artistes indépendants is mourning three of its members this year: Vincent van Gogh, who was and remains a great painter of this

century. . . . *Resurrection* is the masterpiece of the exhibition of the Indé-pendants, and, moreover, a masterpiece. All has been said about this ad-mirable artist. (Julien Leclercq, "Aux Indépendants," *Le Mercure de France*, May 1891)

Two collections exhibited in this room were already veiled in black mourning crepe, those of Dubois-Pillet, a decent man and sincere artist, and van Gogh, who died tragically at the end of last year. The dozen or so works by van Gogh exhibited here do not suffice to convey the nature of this unbalanced, but original and impulsive painter. However, several of these works are powerful and bizarre, not that they accurately express real effects, such was not the painter's ambition, but because they evoke tragic or gentle sensations with the means of expression of a strong and rare personality.

Seurat and van Gogh were the initiators of the young artists exhibited in this room.

Seurat and his friends, preoccupied with luminosity, have remained re-alists to this day by the spirit of their works, while van Gogh and Paul Gauguin's supporters, more in quest of ideas, sought a return toward the past that one of their followers has defined as *neo-traditionism* in *Art et Critique*.

These are two very dissimilar and most curious trends to consult to learn about the masters of tomorrow. (Jules Antoine, "Critique d'art. Exposition des artistes indépendants," *La Plume*, 1891)

Red-headed (goatee, rough mustache, shaven scalp), with an eagle look and an incisive mouth, so to speak; of average height, stocky but not exces-sively so, with quick gestures and a jerky gait; such was van Gogh, always with his pipe, a canvas or an engraving, or a sketch. Vehement in speech, interminable in explaining and developing ideas, not given to controversy, that was him too; and dreams, oh! dreams! giant exhibitions, artists' philan-thropic phalansteries, founding of colonies in the South, progressive inva-sion of the public for that reeducation of the masses who yet had known art in the Past. . . .

Dutch, Protestant, a pastor's son, van Gogh seemed destined from the start to holy orders; but although he did enter them, he left them for paint-ing. Excessive in everything, he no doubt ruffled the narrow doctrine of his masters! In love with art, he knew Israels and made him his first model, followed by Rembrandt. Then he came to France, to Goupil, where his brother Theodore van Gogh soon replaced him. Thanks to this brother, he was then free to paint. He rushes to Cormon for whom he soon lost his taste, tried out the complementary methods of pointillism which irritated

him, and finally begins to take flight on his own after inspecting Monticelli, Manet, Gauguin, etc. To be sure, he is of a different ilk. Van Gogh is more personal than any. In love with the Japanese, the Indians, the Chinese, of all that sings, laughs, resonates, he found in those born artists the surprising techniques of his harmonies, the extraordinary flights of his drawing, as he found deep within himself the raving nightmares with which he relentlessly oppresses us. (Emile Bernard, "Vincent Van Gogh," *La Plume*, September 1891)

This painter was long considered mad, a fraud, who was taking the general public for a ride.

Van Gogh may indeed have had the good fortune to be a bit mad, but was never fraudulent. It suffices to gaze at the series of paintings exhibited today to realize that he was a fanatic, a true believer. It is sometimes denied that painters are inspired, however van Gogh, who never had a master and never touched a paintbrush before he was twenty, was unquestionably "inspired."

His first paintings are relatively speaking fairly reasonable. One senses him feeling his way, studying; then comes the need to produce freely, no longer respecting anything, and he painted in a feverish state, working, skillfully modeling with the paste itself.

Let no one think that he spread his colors at random: on the contrary, his paintings denote the rare eye of an experienced colorist.

I even have to admit that until now I had seen van Gogh only as a colorist; thus I took a great interest in the drawings which reveal another side of Vincent. Van Gogh, to whom no teacher ever taught the art of drawing, nonetheless produced first-rate drawings. Is that not an undeniable example of what I was saying before about inspiration?

They are landscapes, almost always without characters and their composition is very simple: a vast plain, a few bundles of hay, that is enough in his eyes.

May those who make a joke of him go to Le Barc. They will be forced to admit that many "artists" (the serious ones) would be incapable of drawing with a pen landscapes such as the ones exhibited here. (Francis, "Exposition Van Gogh," *La Vie moderne*, April 1892)

Besides Gauguin, one must immediately mention his friend and, if not his pupil, at least his passionate admirer Vincent van Gogh, that extreme and sublimely unbalanced artist, who died too young, alas, to have left the work promised by his genius, his powerful originality, the wild fury with which he worked, his feverish experiments, his lofty and multiple preoccupations—yet, who lived long enough to bequeath to the museum of our ad-

mirations a thousand canvases of blinding intensity and unforgettable strangeness, blazing symbols of the most tormented soul that ever was. (Georges-Albert Aurier, "Les symbolistes," *Revue encyclopédique*, April 1892)

. . . that these two brothers as it were made up but one idea, that one found sustenance and lived from the thought of the other, and that when the latter, the painter, died, the other followed him into the grave by only a few months, under the impact of a rare and edifying grief. . . . To understand van Gogh, and the path followed by many artists who have not yet been understood, one must have fully absorbed these things:

1. It is not necessary to learn fine arts in a school;
2. The Beautiful is not the imitation of a preestablished type, but the emanation of all the sublime contained in each new truth glimpsed by a temperament. . . .

In real life [the sublime in art] is life's heroism. In art, . . . it is the gift of vision. Vincent van Gogh had that vision. . . .

The most bizarre contradictions could often be encountered in his labored and questing spirit. (Emile Bernard, "Vincent van Gogh," *Le Mercure de France*, April 1893)

To examine . . . whether the alarm of the curious before Vincent van Gogh's pastries and Mme. Jacquemin's stiffs is not, in good faith, a tiny bit legitimate. . . . Let us go into Mr. Le Barc's, into the last room of the Indépendants, so judiciously dubbed the "Chamber of horrors." This is the love of ugliness, of vileness. . . . This is lunacy in its final stage, the work of a brotherhood of madmen, suddenly let loose in a paint merchant's shop. . . . Humorous sketches and workshop jokes are exhibited here. . . . But I am beside myself with happiness in naming Vincent van Gogh. This is a genius, a purebred colorist (you know, today, everybody is recognized as having genius). He has found not only admirers, but imitators. His so abundant color, which in many places is several centimetres high, has aroused infatuations. And yet, how can one not believe it is a fraud?—This man has fought with his canvases. He has hurled clay pellets at them. He has taken mortar from a pot, and flung it before him while tasting the scoundrel's joy in striking blows. Whole trowelfuls of yellow, red, brown, green, orange, and blue have burst into flower like the fireworks of a basket of eggs thrown from the fifth story. He has brought this to the pump and, with his eyes closed, has drawn a few lines on it with a finger soaked in gasoline. Apparently, this represents something, pure chance, no doubt. And, as a wag has it, one cannot quite make out "whether conscientiousness is a pair of shoes, or the shoes conscientious-

ness." (Charles Merki, "Apologie pour la peinture," *Le Mercure de France*, June 1893)

Between the man and the work there was a constant opposition, which the passing years have only strengthened. . . . All is contradiction, mystery, vanity, within us as around us. Our sciences are like pitiful houses of cards, the first breath of air overthrows them. A young Dutch painter, Vincent van Gogh, has left works that are absolutely those of a madman, beyond all reason and all beauty; and at the time he painted them, he judged matters of art with incomparable wisdom, moderation and lucidity. *Le Mercure de France* is publishing a series of his letters to a friend; the conditions and limits of painting have never been spoken of better.

Similarly, Eugène Delacroix left us the work of a sick man; and he was the healthiest of men, I mean in terms of his strength and clarity of mind. (T. de Wyzewa, "Eugène Delacroix," *Le Figaro*, June 1893)

In my yellow room,—sunflowers, with purple eyes, stand out against a yellow backdrop; their feet bathe in a yellow pot, on a yellow table.—In one corner of the painting, the artist's signature: Vincent. And the yellow sun, which passes through the yellow curtains of my room, drenches these blossoms in gold, and in the morning, in bed, when I awake, I imagine how wonderful they smell.

Ah! yes, how he loved yellow, our good Vincent, that painter from Holland; rays of sun that warmed his soul; full of loathing for fog. A need for warmth.

When we were both in Arles, both mad, in continual battle for beautiful colors, I loved red; oh where to find the perfect vermilion?—He, with his yellowest brush traced on the suddenly violet wall:

I am whole of Spirit
I am the Holy Spirit.

In my yellow room, a small still life; this one violet.—Two enormous, worn, deformed shoes. Vincent's shoes. Those he took, one bright, new morning, then, to make his way on foot, from Holland to Belgium. The young priest (he had just finished studying theology to become a pastor, like his father) the young priest was on his way to the mines, to see those he called his brothers. Thus he had seen them in the Bible, oppressed, simple workers, for the luxury of the great.

Contrary to his masters' teaching, wise Dutchmen, Vincent believed in a Jesus who loved the poor, and his soul, suffused with charity, wanted both the consoling word and the sacrifice: for the weak, to fight against the

great. Undoubtedly, undoubtedly, Vincent was already mad. (Paul Gauguin, "Natures mortes," *Essais d'art libre*, IV, January 1894)

As I arrive in Provence, I am haunted by the memory of recent painters who dared to take on that light . . .—only one name could spring to mind, that of van Gogh. Thanks to a colorist's temperament served by a magnificent sincerity, this admirable painter rendered the excess of this nature which allows no more for technique than for style. Once again here, we can salute van Gogh—genius. But how pitiful next to this Mr. Signac's attempts prove to be. (Adolphe Retté, "Notes de voyage," *La Plume*, no. 129, September 1894)

However characteristic, bold, new, ruggedly attractive some of these canvases may appear, however great the pleasure one derives from those rickety green carts with their hard yellow wood wheels, from those famous, colorful and frank sunflowers, from the new forms of that poor and simple furniture, from those nocturnal or fully sunlit landscapes, from the qualities of arrangement and of color of the portraits of the Provençale and that seated woman, from the magisterial portrait of himself that van Gogh created after having torn off his ear and shortly before taking his own life,—the exhibition is too narrow to allow a study of his oeuvre.

Nor do the curiously emotional letters published in *Le Mercure de France* enable us to form a fairly precise idea of his life. We lack the documents.

And yet before the display of his painting, knowing and guessing what we do about his life and martyrdom, we can imagine something no less piteous, to be sure, than what we have learned of Carriès.

They were contemporaries, who died at the same age, both searching, toiling, both artists, and both wretched. But beside the "Calvary" of the one who enjoyed success and triumph, met with such warm devotion, such precious friendships, and left such pretty and seductive work, what more grippingly bitter and original a contrast than the fate of one whose novelty remains untouched and still makes passersby laugh, whose strength draws one in and whose passing was horror incarnate. (Thadée Natanson, "Jean Carriès, Vincent Van Gogh," *La Revue blanche*, 8, 1895)

Van Gogh's works are also only known by a small circle [see Cézanne]. The artist, only a few years ago, died insane in the country to which he had retired. What experiments he engaged in, feeling his way forward, not just from one period to another, but from one canvas to the next. One feels an ardent spirit endeavoring with difficulty to find a way out. Through this chaos, occasional bolts of lightning. An admirer of Delacroix and Monticelli, he found in them personal ways of lifting the colored scale to a high

level of intensity—a broad, unctuous paste, like congealed flows in which tones blossom in sprays of fireworks. Perhaps, as has been noted, this Dutchman suffused with the spirit of the North had the exasperated vision of the dazzling South. . . . In van Gogh we find a drive, a fervent, feverish, almost delirious pursuit of the maximum wealth of colored splendor. There is what, in these two artists, must have attracted and seduced young minds that were enthusiastic about their originality, and that wanted to see them as precursors, despite all their incompleteness. Or perhaps—who knows—because of the mystery of this incompleteness adding to genuine qualities the mystery of the sketch about to blossom into a masterpiece. (André Mellerio, *Le mouvement idéaliste en peinture* [Paris, Floury, 1896])

Van Gogh was one of the first and most resolute of these disinterested and astonished observers. The Vollard Gallery displays several of his paintings which are a triumph of the effervescence of lights, an unbelievable feast for the eyes. They are landscapes . . . , wind . . . , trees . . . , water . . . , a poppy field. . . . The atmosphere works, circulates and struggles; it assails the integrity of once immobile contours, penetrates, corrupts and manipulates them to the point that they sometimes lose their original resemblance and aspect under which people had been accustomed to see them defined. The portraits are faces vanquished by relentlessness. . . . A cubicle . . .

Van Gogh's role, next to Cézanne, so considerable in the most recent movement of French painting . . . , his influence appears as important as that of Gauguin. (André Fontainas, "Art," *Le Mercure de France*, January 1897)

No matter how incomplete a work may seem in isolation, Vincent proves to be very complex in the quantity of his oeuvre; his equal vital turbulence gives him a unity which, in the long run, demonstrates his considerable equilibrium, his logic, his consciousness. Some have seen madness in his last paintings. But what is it when it looks out from the present form, but genius? (Emile Bernard, "Vincent Van Gogh," *Les Hommes d'aujourd'hui*, vol. 8, no. 390, 1898)

B

Chronology

1890	First article devoted to van Gogh.
	First painting sold.
	Vincent's death.
1891	Theo's death.
	Posthumous participation in the Salon des indépendants (France).
1892	First retrospective exhibition in the Netherlands.
1893	First publication of the letters in French (Emile Bernard).
1901	First exhibition devoted exclusively to van Gogh in Paris.
1905	Foundation of the Wereldbibliothek for the publication of the letters.
1906	First appearance of the expression "accursed artist."
1907	First book reproducing van Gogh's works.
1908	First publication of the letters in Russian.
1910	First biography in German (Meier-Graefe).
	First exhibition in London.
1911	Publication of the letters to Emile Bernard.
	First medical study in Dutch.
1913	First novel inspired by his life (M. Irwin).
	First publication of the letters in English.
1914	Publication of the letters in Dutch.
1916	First biography in French (Th. Duret).
	First fictionalized account of his life in German (Sternheim).
	First novel inspired by his life in French (M. Elder).
1920	First psychiatric study (Birnbaum).
1921	First best-selling biography in German (Meier-Graefe).
1923	First exhibition in Great Britain (London).
1924	First psychiatric article in French (Vinchon).
1928	First *catalogue raisonné*.
	First psychiatric monograph in French (Doiteau, Leroy).
	First exhibition in Germany (Berlin).
1930	First publication on the fake van Goghs (La Faille).
1934	First best-seller on his life (Irving Stone).
1935	First exhibition in the United States (New York).
	First mention in philosophy (Heidegger).
1937	First great retrospective (Paris, world fair).

1947 First exhibition in Belgium (Brussels).
 First exhibition in Switzerland (Basel).
 First polemical tract published and broadcast (Antonin Artaud).
 First documentary film (Alain Resnais).
1952 First publication of his complete writings (Netherlands).
1953 First psychoanalytical study (Mauron).
1956 First screen drama (Vincente Minnelli).
1957 Imaginary portrait (Francis Bacon).
1960 First French edition of his complete letters.
1961 Song "L'homme au chapeau de paille" (R. Nyel).
1972 Inauguration of the Vincent van Gogh Museum in Amsterdam.
1987 Theatrical presentation ("Nous, Théo et Vincent van Gogh") at
 the Lucernaire (Paris).
1988 Opening of the Van Gogh Foundation in Arles.
1990 Grand exhibition on the centenary of his death (Netherlands).
 Pilgrimage to his graveside (Auvers-sur-Oise).

Notes

Preface

1. The disqualification of "preconstructed objects" is meant to guarantee sociologists the independence they require from constraints that are foreign to the logic of research. See P. Bourdieu, J.-C. Chamboredon, and J.-C. Passeron, *Le métier de sociologue* (Paris-La Haye, Mouton, 1973).

2. On the "great divide" and the imperative of creating symmetry [*symétrisation*], see Bruno Latour, *Les microbes: guerre et paix, suivi de Irréductions* (Paris, A. M. Métailié, 1984).

3. In the broad sense invoked by Luc Boltanski: "a position of exteriority, from the vantage point of which it is possible to disengage from the world in order to contemplate it as a stranger" (L. Boltanski, *L'amour et la justice comme compétences. Trois essais de sociologie de l'action* [Paris, A. M. Métailié, 1990], p. 49, note 11).

4. See Elisabeth Claverie's remarks on apparitions of the Virgin ("La Vierge, le désordre, la critique. Les apparitions de la Vierge à l'âge de la science," *Terrain*, no. 14, March 1990).

5. See Jeanne Favret, "Etre affecté," *Gradhiva*, no. 8, 1990.

6. See Max Weber, "Science as a Vocation" (1919), in *For Max Weber: Essays in Sociology*, edited with an introduction by H. H. Gerth and C. Wright Mills (London and Boston, Routledge and Kegan Paul, 1948).

Chapter One
From Silence to Hermeneutics

1. Georges-Albert Aurier, "Les isolés: Vincent Van Gogh," *Le Mercure de France*, January 1890.

2. See Carol Zemel, *The Formation of a Legend: Van Gogh Criticism, 1890–1920* (UMI Research Press, 1980), pp. 1, 12, and 43.

3. *La Gazette du Val-d'Oise*, no. 761, May 23, 1990. Emphasis added.

4. The expression is borrowed from historian Alan Bowness, *The Conditions of Success: How the Modern Artist Rises to Fame* (London, Thames and Hudson, 1989), p. 11.

5. Eugène Tardieu, "Salon des indépendants," *Le Magazine français illustré*, April 1891.

6. Ambroise Vollard, *Souvenirs d'un marchand de tableaux* (Paris, Albin Michel, 1984; first published in 1937), p. 78.

7. Ibid., p. 65.

8. Ibid., pp. 138–139. This anecdote, which is unfortunately not dated, illustrates that typical motif in artists' lives: the magical power of the image; see Ernst Kris and Otto Kurz, *Legend, Myth and Magic in the Image of the Artist: A Historical Experiment* (New Haven, Yale University Press, 1979), pp. 71ff and passim.

9. Vollard, *Souvenirs*, p. 35. I might add this equally ambiguous reaction of another painter, Félix Vallotton, in a review of the Salon des indépendants in *La Gazette de Lausanne* (April 11, 1890): "Mr. Van Gogh crowns the edifice with strange brickwork of paint; one has to be quite rich to paint like that. It is once again a matter of distances. Close up, it is multicolored bas reliefs; from far away, it looks like a landscape; from very far away, it is almost good; I have no doubt of its great value when invisible." (Document graciously provided by Carine Huber.)

10. On the field of publications at the time, see Constance Nauber-Riser's article in Jean-Paul Bouillon, ed., *La promenade du critique influent. Anthologie de la critique d'art en France, 1850–1900* (Paris, Hazan, 1990), especially, pp. 317–318 (this book contains biographical information on most of the critics mentioned here). On Aurier, see also James Kearns, "Symbolist Landscapes" (unpublished thesis, 1989), and Patricia Mathews, "Aurier and Van Gogh," *The Art Bulletin*, vol. 68, March 1986.

11. The stands taken by the critics could, for example, be explained in terms of the cultural context of the articles or in terms of characteristics of their authors: social position and origin, political and religious opinions, type of education. Studying the "field" of the criticism of the time according to the method of Pierre Bourdieu would bring to light both the subjectivity of opinions (against discourses' pretense of transparency with regard to their object), and their determination by objective forces beyond individuals' grasp and external to the objects of judgment (against the pretense of an autonomy of taste). This exercise in "reductionist relativism" would, however, not be relevant to the subject at issue here, since the latter does not so much have to do with the principle of distribution of judgments about van Gogh (who said what?) as with the reasons for which there have been so many discourses about him (why has something been said?), which have been so well accepted (in what way can what has been said have been received?).

12. See Paul Veyne, *Comment on écrit l'histoire* (Paris, Points-Seuil, 1978).

13. The first retrospective took place in the Netherlands in 1892, thanks in particular to the efforts of Johanna van Gogh, Theo's widow. The first biographical work was published in Germany in 1910 (see Zemel, *The Formation of a Legend*).

14. Gustave Kahn, "Peinture: Exposition des Indépendants," *La Revue indépendante*, April 1888, VII, p. 163. All the texts quoted here are included in Appendix A.

15. Félix Fénéon, "50e exposition de la société des artistes indépendants," *La Vogue*, 1889, pp. 260–261.

16. See F. Cachin, "Introduction," in Félix Fénéon, *Au-delà de l'impressionisme* (Paris, Hermann, 1966), and Joan U. Halperin, *Félix Fénéon* (New Haven, Yale University Press, 1988).

17. Luc le Flaneur, "En quête de choses d'art," *Le moderniste*, April 13, 1889, p. 14.

18. Aurier, "Les isolés."

19. Georges-Albert Aurier, "Choses d'art," *Le Mercure de France*, February 1892. As his *Oeuvres posthumes* make clear, Aurier had gone through the traditional stages of a literary career (novel, poems, plays, literary and art criticism). What distinguished him was as much the lyricism of his style as his polemical commitment to the cause of the "isolated ones" of painting. He dedicated his first collec-

tion of poems to Caravaggio. He was thereby following the example of Verlaine, who in 1884 devoted his *Poètes maudits* to Corbière, Rimbaud, Mallarmé—among others.

20. Dario Gamboni has rightly noted how criticism, as it was constituted at the time, was fundamentally characterized by this principle of demarcation: "In the spatial configuration of positions defined in terms of mutual opposition that constitutes the cultural field, every critical review necessarily defines the impossible audiences of a work at the same time as its necessary audience" (*La plume et le pinceau. Odilon Redon et la littérature* [Paris, Editions de minuit, 1989], p. 160).

21. *Encyclopédie de l'impressionisme*, edited by Maurice Serullaz (Paris, Somogy, 1974), p. 211.

22. See Maurice Denis, *Du symbolisme au classicisme. Théories* (Paris, Hermann, 1964), p. 57.

23. The latter rejects a henceforth obsolete bipartition, which holds only for the uninitiated: "For the general public . . . we know that there are only two classes of painters: academic painters, i.e., those who, with their proper education, degrees, and official recognition from the Faculty of Arts of the rue Bonaparte, deal second-hand, at Jewish prices, in the officially beautiful, in the antique, modern, or other styles, with government-guaranteed licenses—and, on the other hand, the impressionist painters, i.e., all those who, rebelling against the doltish tastes of boulevard reviewers and against the ignorant formula-concoctors of the academy, allow themselves the impertinent freedom not to copy somebody" (G.-A. Aurier, "Le symbolisme en peinture, Paul Gauguin," [1891] in *Le symbolisme en peinture. Van Gogh, Gauguin et quelques autres* [Paris, L'Echoppe, 1991], p. 18).

24. This is the criterion used by Norbert Elias to distinguish between "detachment" (when one learns principally about the object of the discourse) and "involvement" (when one learns mostly about its subject): a theoretical direction along the lines of which the question of the assumption of opinions should be dealt with here (Norbert Elias, "Problems of Involvement and Detachment," *British Journal of Sociology*, vol. 2, no. 3, September 1956).

25. "Indeed, all those who exhibit here are openly fighting against the academy, against official painting, against what a Prud'homme of the Institute or the quai Malaquais might call the dearest traditions of our masters," wrote Tardieu in 1891, concerning the Salon des indépendants.

26. This is the principle of *primus inter pares*, or "Pip effect," that psycho-sociologists use to designate the "phenomenon of the superior conformity of the self, according to which individuals generally tend, in comparing themselves to others, to present themselves as conforming more than their peers do to the norms of the social situation in which they are engaged" (Jean-Paul Codol, "Effet Pip et conflit de normes," *L'Année psychologique*, no. 75, 1975). Although one cannot subscribe to investigative protocols which, on this theme at least, seem above all, and in an undeterminable proportion, to measure the reaction of subjects to an experimental situation, nonetheless food for further thought may be found in J.-P. Codol, "Différenciation et indifférenciation sociale," *Bulletin de psychologie*, vol. 37, no. 365, 1984, and Gérard Lemaine, "Inégalité, comparaison et incomparabilité: Esquisse d'une théorie de l'originalité sociale," *Bulletin de psychologie*, vol. 20, 1966.

27. For a suggestive application of this opposition, see A. Lessing, "What Is

Wrong with a Forgery?" in Dennis Dutton, ed., *The Forger's Art: Forgery and the Philosophy of Art* (Berkeley, University of California Press, 1983).

28. See Luc Boltanski and Laurent Thévenot, *De la justification. Les économies de la grandeur* (Paris, Gallimard, 1991).

29. See especially Albert Cassagne, *La théorie de l'art pour l'art en France, chez les derniers romantiques et les premiers réalistes* (Geneva, Slatkine Reprint, 1979; first published 1906); Jacques Lethève, *Impressionistes et symbolistes devant la presse* (Paris, Armand Colin, 1959); Lionello Venturi, *Les archives de l'impressionisme* (Paris, New York, Durand-Ruel, 1939).

30. Courbet's Realist pavilion at the World Exhibition of 1855 was followed by the Salon des refusés in 1863, then by the impressionist exhibitions from 1874 onwards, by the Salon de la société des artistes français in 1881, by the Salon des artistes indépendants in 1884, and, in 1890, by the Salon de la société nationale des beaux-arts. On the institutional context of the time, see especially Jean-Paul Bouillon, "Sociétés d'artistes et institutions officielles dans la seconde moitié du XIXe siècle," *Romantisme*, no. 54, 1986, and Marie-Claude Genêt-Delacroix, "Vies d'artistes: Art académique, art officiel et art libre en France à la fin du XIXe siècle," *Revue d'histoire moderne et contemporaine*, vol. 33, January—March 1986.

31. See especially Lethève, *Impressionistes et symbolistes*, as well as the *Bulletin de la Société d'histoire de l'art français*, 1985.

32. Here again, the analysis proposed by Gamboni (*La plume et le pinceau*, p. 72) is illuminating: "The 'discovery' of a new artist is high up on the horizon that guides critics, just as it does media outlets or dealers. Just as with the primacy of artistic innovation to which it is linked, this way of setting one's sights sharpens competition and makes priority an essential criterion."

33. On the establishment, from the first half of the nineteenth century onwards, of the artist/bourgeois opposition, see Cesar Grana, *Bohemian versus Bourgeois: French Society and the French Men of Letters in the Nineteenth Century* (New York, Basic Books, 1964), as well as Malcolm Easton, *Artists and Writers in Paris: The Bohemian Idea, 1903–1867* (London, Arnold, 1964), and Jerrold Seigel, *Bohemian Paris: Culture, Politics and the Boundaries of Bourgeois Life, 1830–1930* (New York, Penguin, 1991).

34. See Donald Drew Egbert, *Social Radicalism in the Arts* (New York, Knopf, 1970); Eugenia W. Herbert, *The Artist and Social Reform* (New Haven, Yale University Press, 1961); Renato Poggioli, *The Theory of the Avant-Garde* (Cambridge, Mass., Harvard University Press, 1968); Madeleine Rébérioux, "Avant-garde esthétique et avant-garde politique," in *Esthétique et marxisme* (Paris, 10/18, 1974).

35. A mystical investment of creation is to be found here, which he was later to express in a long, posthumously published, critical manifesto ("Préface pour un livre de critique d'art," *Le Mercure de France*, December 1892): in it he defends the privileges of "emotion," "sensation," "aesthetics," "exceptional beings," "soul," "love," and "mysticism," against theories promoting "intellect," "environment" (Taine), or even "biography" (Sainte-Beuve).

36. "Please ask Mr. Aurier not to write any more articles on my painting, insist upon this to him, to begin with that he is mistaken about me, then that I am really too overwhelmed by grief to be able to face publicity. Making pictures takes my

mind off it, but if I hear them spoken of, it hurts me more than he can know" (*Letters of Vincent van Gogh to His Brother Theo*, 629, 29 April 1890, III, p. 261 [translation slightly modified]). The letter to Aurier—reproduced in the latter's *Oeuvres posthumes* (a new edition of which was published in 1991)—bears witness by its length to the fact that, despite the unease generated by the article, van Gogh had grasped the opportunity to address an interlocutor about his painting, insisting on his filiation with other painters.

37. See Pierre Bourdieu, "Disposition esthétique et compétence artistique," *Les Temps modernes*, no. 295, 1971.

38. Georges Lecomte, "L'exposition des néo-impressionistes," *Art et critique*, March 29, 1890.

39. Julien Leclerq, "Beaux-Arts. Aux Indépendants," *Le Mercure de France*, May 1890.

40. Julien Leclerq, *Le Mercure de France*, May 1891.

41. Octave Mirbeau, "Vincent Van Gogh," *L'Echo de Paris*, March 31, 1891.

42. Jules Antoine, "Critique d'art. Exposition des peintres indépendants," *La Plume*, 1891.

43. Eugène Tardieu, "Salon des Indépendants," *Le Magazine français illustré*, April 1891.

44. Georges-Albert Aurier, "Les symbolistes," *Revue encyclopédique*, April 1892.

45. Francis, "Exposition Van Gogh," *La Vie moderne*, April 1892.

46. Adolphe Retté, "Notes de voyage," *La Plume*, no. 129, September 1894.

47. Thadée Natanson, "Jean Carriés, Vincent Van Gogh," *La Revue blanche*, no. 8, 1895.

48. André Mellerio, *Le mouvement idéaliste en peinture* (Paris, Floury, 1896).

49. André Fontainas, "Art," *Le Mercure de France*, January 1897.

50. Charles Merki, "Apologie pour la peinture," *Le Mercure de France*, June 1893.

51. Ten years later, his equally sustained praise of van Gogh on the occasion of a retrospective at Bernheim's (*Le Journal*, March 1901) was predicated on a critique, no longer of academicism, but—in a more current, and even more polemical, fashion—of those "poor suckers": "mystics, symbolists" (the very same ones who were valued by the critics that supported van Gogh in the 1890s), "larvists, occultists, neopederasts, painters of the soul."

52. See Kris and Kurz, *Legend, Myth and Magic*, p. 25, passim.

53. Théodore de Wyzewa, "Eugène Delacroix," *Le Figaro*, June 1893.

54. Emile Bernard, "Vincent Van Gogh," *La Plume*, September 1891.

55. Emile Bernard, "Vincent Van Gogh," *Le Mercure de France*, April 1893.

56. Paul Gauguin, "Natures mortes," *Essais d'art libre*, IV, January 1894. He returned to the topic in his autobiography.

57. Emile Bernard, "Vincent Van Gogh," *Les hommes d'aujourd'hui*, vol. 8, no. 390, 1898.

58. "It was artists, not paintings, who were the focus of the dealer-critic institutional system. . . . it dealt with an artist more in terms of his production over a career and thus provided a rational alternative to the chaos of the academic focus on paintings by themselves" (Harrison C. and Cynthia A. White, *Canvases versus*

Careers: Institutional Change in the French Painting World [Chicago, University of Chicago Press, 1991], p. 104).

59. These thoughts on hermeneutics owe a great deal to Francis Chateauraynaud. For an application to literature of the question of "interpretive readings," see Vincent Descombes, *Proust, philosophie du roman* (Paris, Minuit, 1990).

60. See Erwin Panofsky, *Studies in Iconology: Humanistic Themes in the Art of the Renaissance* (New York, Harper and Row, 1967).

61. This is the very foundation of the work of attribution, such as it developed at the end of the last century. See Carlo Ginzburg, "Traces," in *Mythes, emblèmes, traces. Morphologie et histoire* (Paris, Flammarion, 1989).

62. See Settis, *L'invention du tableau*, and Ginzburg, *Piero della Francesca*.

63. *L'Occident*, May 1909 (Maurice Denis, *Du symbolisme au classicisme*, 1964, p. 122).

64. See Paul Ricoeur, *Time and Narrative*, vol. 1, transl. by Kathleen McLaughlin and David Pellauer (Chicago, University of Chicago Press, 1984).

65. On the emergence of the requirement of literary authenticity in the eighteenth century, see Gérard Mortier, *L'originalité. Une nouvelle catégorie esthétique au siècle des Lumières* (Geneva, Droz, 1982), p. 129, passim.

66. For a suggestive analysis of inspiration as the expression of a "voice" that can be referred homologically either to God or the unconscious, see Ernst Kris, *Psychoanalytic Explorations in Art* (New York, International Universities Press, 1952), pp. 292–294.

67. The question of interiority has been evoked in allusive fashion by certain authors (see Otto Rank, *Art and the Artist: Creative Urge and Personality Development* [New York, Agathon Press, 1968], pp. 397–399, or René Girard, *La violence et le sacré* [Paris, Grasset, 1972], p. 229); Norbert Elias has developed it in its historical dimension in *The Society of Individuals* (Cambridge, Mass., Basil Blackwell, 1991).

68. Technical failings were subsequently to be transmuted, under the biographer's pen, into initial handicaps, paradoxically making it possible to highlight the strength of the artist who was able to overcome them: "Often, his drawing lacks firmness, his composition lacks balance; the shaking, swirling, meandering, and dizziness of the forms are no longer stylistic devices, but ways of working or oddities" (Pierre Cabanne, *Van Gogh* [Paris, Aimery Somogy, 1973], p. 258).

69. Van Bever, "Les aînés: Un peintre maudit, Vincent Van Gogh," *La Plume*, 1, 15 June 1905 (see Zemel, *The Formation of a Legend*, p. 91).

70. See Zemel, *The Formation of a Legend*, p. 1.

71. François Duret-Robert, "Le verdict de l'Hôtel des ventes," in Serullaz, *Encyclopédie de l'impressionisme*, p. 251. For comparison's sake, it is worth mentioning that a painting by the academic painter Gérôme sold for 12,200F in 1891, and that a Bouguereau was purchased for over 100,000F in 1885 (see Genêt-Delacroix, "Vies d'artistes").

72. Duret-Robert, "Le verdict," pp. 252–257. I will come back to this phenomenon, which is not subject to economic rationalization, and to the type of "reason" and "economics" that should be invoked to account for it.

73. René Gimpel, *Journal d'un collectionneur marchand de tableaux* (Paris, Calmann-Lévy, 1963), p. 85.

74. Jean-Baptiste de La Faille, *Les faux Van Gogh* (Paris, 1930).

75. See John Rewald, *Post-Impressionism: From van Gogh to Gauguin* (New York, Museum of Modern Art, 1978).

76. The first great public retrospective took place in Paris in 1937 (one year after Cézanne) during the international exhibition. Also worthy of mention are the London exhibition of 1947 and those which occurred in Paris: at the Orangerie in 1954; at the Musée Jacquemart-André in 1960; and at the Orangerie in 1972 (this one was devoted to the collection of the National Vincent Van Gogh Museum of Amsterdam. Works by van Gogh are owned by galleries in the Netherlands, France, the United States, Switzerland, Germany, Great Britain, countries in the former Soviet Union, Brazil, Czechoslovakia, Canada, Denmark, etc. (See Emmanuel Benezit, ed., *Dictionnaire des peintres, sculpteurs, graveurs* [Paris, Gründ, 1976].)

77. Marc-Edo Tralbaut, "Comment identifier van Gogh?" Antwerp, *Bulletin des archives internationales de Van Gogh*, 1967, p. 36.

78. Max Osborn in 1908, quoted in Zemel, *The Formation of a Legend*, p. 117, who also remarks that the Dutch critic Veth had already in the 1890s emphasized the moral, no less than aesthetic, singularity of van Gogh's position. Similarly, a journalist recently discussing the centenary of van Gogh's death stressed that "the work, like the man, is on the margins, cannot be recuperated. The chapter that art histories devote to him does not bear the name of a school. It is simply entitled 'Van Gogh'" (P. Billard, *Le Point*, March 19, 1990).

79. Ernst Kris had already detected this with regard to Michelangelo: "The work of art is—for the first time in European history—considered as a projection of an inner image. It is not its proximity to reality that proves its value but its nearness to the artist's psychic life" (Kris, *Psychoanalytic Explorations in Art*, pp. 198–199). In the conclusion I will come back to the difference between the (exceptional) case of a Michelangelo and the (paradigmatic) case of a van Gogh.

80. This is also Carol Zemel's conclusion. In France and the Netherlands "the profusion of early reviews indicates that despite some disagreement, resistance to Vincent's paintings was minimal" (*The Formation of a Legend*, p. 32).

81. He only began to devote himself genuinely to drawing from 1880 onward. His work was exhibited at the Indépendants in 1888, 1889, 1890 (posthumously), and 1891 (a retrospective).

82. See J.-H. Huizinga, *Rousseau: The Self-Made Saint* (New York, Grossman, 1976).

83. François Duret-Robert, "Destin de ses tableaux," in *Vincent Van Gogh* (Paris, Hachette, 1968), p. 240. This other conjecture invalidates any deduction of professional failure from a premature death: "The artist must live into middle age to enjoy the benefits of this situation. If he dies young, for whatever reason, then the artistic career is likely to appear a failure, and myths about the unsuccessful artist begin to grow. Let me instance the case of van Gogh. He did not begin to paint until he was twenty-six, and his career lasted only eleven years. . . . Thus he simply did not live long enough to see success. . . . Had van Gogh lived to be eighty and died in 1933, he would certainly have been very famous and very rich" (Bowness, *The Conditions of Success*, p. 48).

84. Ernst Kris has correctly stressed the fundamental character of recognition by a small number of initiates, rather than by the "public": "Artists are more likely

than others to renounce public recognition for the sake of their work. Their quest need not be for approval of the many but for response by some" (Kris, *Psychoanalytic Explorations in Art*, p. 60).

85. See *Les Salons caricaturaux*, catalog prepared by Thierry Chabanne (Paris, Musée d'Orsay, Réunion des musées nationaux, 1990). For some thoughts on caricature in art, see the chapter Kris devotes to the topic in *Psychoanalytic Explorations in Art*. Today's equivalent of the common critical space constituted by the Salons and revealed by cartoons in magazines and newspapers can be found in the performances of television personalities. This has become the site par excellence of the caricaturist's activity.

86. For a sociological treatment of this notion, see Luc Boltanski, *L'amour et la justice comme compétence. Trois essais de sociologie de l'action* (Paris, A.-M. Métailié, 1990), as well as Francis Chateauraynaud, *La faute professionnelle. Une sociologie des conflits de responsabilité au travail* (Paris, A.-M. Métailié, 1991).

87. "Who, during his lifetime, except for Theo alone, was touched by van Gogh's painting? Nobody, and Albert Aurier's fine article came too late. The ignoble contempt to which Vincent's painting was doomed transcends the man's solitude, however" (Roger Laporte, "Vincent et Van Gogh," in *Quinze variations sur un thème biographique* [Paris, Flammarion, 1975], p. 121).

88. "The major obstacle to understanding resides in the fact that what is to be understood is a symbolic revolution, on the order of the great religious revolutions, and that this symbolic revolution was successful: our own categories of perception and appreciation emerged from this revolution in our view of the world, and these are the very categories that we ordinarily use in producing and understanding representations. The representation of the world that emerged from this symbolic revolution appears as self-evident to us, so self-evident, in fact, that, in a surprising reversal, it is the scandal generated by Manet's works that surprises, even scandalizes, us. The illusion of self-evidence prevents us from seeing and understanding the labor of *collective conversion* that was necessary to create the new world of which our very *eye* is the product" (Pierre Bourdieu, "L'institutionalisation de l'anomie," *Les cahiers du Musée national d'art moderne*, nos. 19–20, June 1987, p. 6).

Chapter Two
The Golden Legend

1. Up to 1940, there were 135 publications per decade, hence about a dozen per year. In addition, some twenty articles could not be dated. See Charles Mattoon Brooks, *Vincent van Gogh: A Bibliography* (New York, 1942).

2. Table 2 does not record the totality of publications, but a selection of the principal books and articles (283 in all) listed in John Rewald's bibliography (*Post-Impressionism: From van Gogh to Gauguin* [New York, Museum of Modern Art, 1978]). As the author himself concedes, this is not an exhaustive list (it is a "selection of works cited by Brooks, supplemented by a few publications that escaped his vigilance, as well as by those that have been published since 1942"). Nevertheless, it has the double advantage of extending further in time (until 1960) and of being more systematic in its sorting of different types of texts (only the letters have been

listed from Brooks rather than Rewald, which is why no inventory of them is provided for later than 1940). The publications have thus been sorted into four categories, cross-referencing texts on the man and texts on the work with documents (catalogs and reproductions, correspondence) and studies (stylistic analyses, biographies, or novels).

3. The complete edition did not get published in France until 1960, after the Netherlands in 1952.

4. Carol Zemel, *The Formation of a Legend: Van Gogh Criticism, 1890–1920* (UMI Research Press, 1980), pp. 33 and 84.

5. This phenomenon of biographical inflation has also been noted with regard to Rousseau: "The more the great man is made the object of study, the more library shelves are filled with books on his life and works, the greater he seems and the more scholarship he attracts, compelled to mine ever deeper and poorer seams that yield little but trivialities or fanciful interpretations, *ad infinitum risumque*" (J. H. Huizinga, *Rousseau: The Self-Made Saint* [New York, Grossman, 1976], p. 20).

6. Irving Stone, *Lust for Life: The Novel of Vincent van Gogh* (Garden City, N.Y., Doubleday, 1937), p. 345. This first best-seller on the life of van Gogh was immediately translated into Swedish and Danish in 1935, German, Dutch, Norwegian, and Hebrew in 1936, French and Lithuanian in 1938, and Finnish in 1939. The first novel inspired by van Gogh's life had been published in 1913, and the German edition of a 1916 fictionalized account bore the title *Legende. Ein Fragment.*

7. The first book of this type published in France was that of Gustave Coquiot (*Des peintres maudits* [Paris, André Delpeuch, 1924]) on Lautrec, Seurat, van Gogh, Gauguin, Utrillo, Cézanne, Daumier, Modigliani, Sisley (the artists are listed according to the number of pages devoted to each, the ones receiving the most extensive treatment coming first).

8. Irving Stone's novel unfolds, chapter by chapter, the stages in van Gogh's path through life: London, the Borinage, Etten, The Hague, Nuenen, Paris, Arles, Saint-Rémy, Auvers. Similarly, but more recently, the 1990 exhibition at the Salon des indépendants, entitled "The Passion According to Vincent," was divided into five stations: "Van Gogh Prior to Van Gogh," "Van Gogh in Paris," "Van Gogh in Arles," "Van Gogh at Saint-Paul-de-Mausole," "Van Gogh at Auvers-sur-Oise."

9. Théodore Duret, *Van Gogh Vincent* (Paris, Bernheim jeune, 1916). Duret, who was very old at the time, had already written books on Monet, Manet, Whistler, and the impressionists. He was to go on to write about Courbet, Lautrec, and Renoir.

10. With the significant exception of the motif of madness, which is hardly touched upon, save for an allusion to an episode in the Netherlands, a "first crisis of mental breakdown, a crisis of mysticism" that overcame "this visionary," "with his unbridled imagination," who "mixes the fantastic and the real and offers glimpses of madness" (Duret, *Van Gogh Vincent*, p. 174).

11. "In current usage, the word 'legend' and its adjective 'legendary' can easily take on an unfavorable meaning in opposition to 'history' and what is 'historical.' It is necessary not to restrict oneself to this pejorative meaning, and all the more so because the term 'legend' has a rather different, technical meaning in hagiography: . . . legenda, what is to be read. . . . When used in the liturgical sense, which is its proper and technical sense, the word 'legend' implies no value judgement about the

historical or fictional character of the narrative" (René Aigrain, *L'hagiographie. Ses sources, ses méthodes, soon histoire* [Bloud et Gay, 1953], pp. 126–127). See Patrick Geary, "L'humiliation des saints," *Annales E.S.C.*, vol. 34, no. 1, 1979.

12. In their work on the "image of the artist" (the Italian translation of which bears the title *La Leggenda dell'artista*), Ernst Kris and Otto Kurz justify their approach in a similar fashion: "The question whether statements contained in an anecdote in this or that particular case are true then becomes irrelevant. . . . We seek to understand the meaning of fixed biographical themes. In this sense, the anecdote can be viewed as the 'primitive cell' of biography" (Ernst Kris and Otto Kurz, *Legend, Myth and Magic in the Image of the Artist: A Historical Experiment* [New Haven, Yale University Press, 1979], p. 11).

13. Respectively by M. Elder (1917) and M. Jenison (see Rewald, *Post-Impressionism*).

14. A sociological interpretation would emphasize the importance of the notions of exemplariness and particularity in the self-perception of pastors' sons (see Pierre Pénisson, "Fils de pasteur," *Actes de la recherche en sciences sociales*, nos. 62–63, June 1986).

15. Jean Monneret, Introduction to the *petit journal* of the "Vincent van Gogh" exhibition, Salon des indépendants, Paris, May 1990. From now on, I will pay no attention to the chronology of these biographical elements, which I borrow from recent as much as from older texts. Once the main motifs have been deployed with the testimony of the 1890s and Duret's book, genealogy can give way to thematic analysis.

16. "There are lands of eminence in the realm of eternal peace. The Alyscamps of Arles, maybe Rocamadour, are cemeteries of immortality, places that are sacredly and soteriologically elect" (Alphonse Dupront, "Pèlerinage et lieux sacrés," in *Méthodologie de l'histoire et des sciences humaines. Mélanges en l'honneur de Fernand Braudel* [Toulouse, Privat, 1973]).

17. "Correspondence provides documents of outstanding value, and often furnishes irreplaceable data on the inner lives of saints" (René Aigrain, *L'hagiographie*, p. 118). [*Translator's note*: Among other things, the word *sulpicien* refers to religious imagery that is in bad taste by virtue of its gaudy, idealizing character (*Le Petit Robert. Dictionnaire alphabétique et analogique de la langue française*.)]

18. "His native religiosity gave him a kind of human superiority, since religion raises up the individual" (Emile Bernard, preface to Vincent van Gogh, *Lettres à Emile Bernard*, 1911, p. 38).

19. Karl Jaspers, *Strindberg and van Gogh: An Attempt at a Pathographic Analysis with Reference to Parallel Cases of Swedenborg and Hölderlin*, transl. by Oskar Grunow and David Woloshin (Tucson, University of Arizona Press, 1977), p. 175. A sociological analysis would explain this abstention both in terms of the Protestant tradition of refraining from representing religious subjects, and in terms of the situation prevailing in the art world at the time; there was a move away from "historical," and in particular religious, subjects, and a growing predilection for genres considered minor by the academic tradition: portraits, landscapes, still lifes.

20. Pascal Bonafoux, *Van Gogh par Vincent* (Paris, Folio, 1990), p. 14. Or again: "Painting is a gift of oneself like preaching. Vincent never ceases to be a missionary

and a painter, he is an apostle, i.e., a witness. Painting is God's word. And Vincent has in mind a kind of church" (p. 160).

21. Bonafoux, *Van Gogh par Vincent*, p. 28.

22. Rudolf Otto, *Le sacré. L'élément non-rationnel dans l'idée du divin et sa relation avec le rationnel* (Paris, 1949), p. 25.

23. Willem Steenhoff, quoted in Zemel, *The Formation of a Legend*, p. 49.

24. "Patience is especially praised in martyrs, for the patience to suffer is the main act of strength, the secondary act of which is to attack" (*Dictionnaire de théologie catholique*, edited by A. Vacant, E. Mangenot, and E. Amann [Paris, Letouzey et Ané, 1939], p. 221).

25. See Peter Brown, *The Cult of the Saints: Its Rise and Function in Latin Christianity* (Chicago, University of Chicago Press, 1981), pp. 55, 56.

26. Preface to *Lettres de Vincent Van Gogh à Emile Bernard*, 1911, p. 40. Joachim Gasquet can be seen to play the same role with regard to Cézanne: "I have said just about everything I learned either in spending time with him, or from those who approached him, everything I know of Cézanne's life. It is the life of a saint" (Joachim Gasquet, *Cézanne* [Paris, Cyrana, 1988], p. 127). On the role of the witness for the "Romantic" artist, who must have a witness to his life to justify artistic creation, see Otto Rank, *Art and Artist: Creative Urge and Personality Development* (New York, Agathon Press, 1968), pp. 50–51.

27. Duret, *Van Gogh Vincent*, p. 26.

28. Viviane Forrester, *Van Gogh ou l'enterrement dans les blés* (Paris, Points-Seuil, 1984), p. 47.

29. Bonafoux, *Van Gogh par Vincent*, p. 107.

30. The ailments van Gogh complains of are those of the country priest imagined by Bernanos. His stomach has been destroyed by too little poor food and too much bad wine.

31. Pastor de Warquinies, quoted by Louis Piérard in *La vie tragique de Vincent Van Gogh* (Paris, Crés, 1924).

32. Georg Simmel, *Michel-Ange et Rodin* (Marseille, Rivages, 1990), p. 73.

33. See Martin Heidegger, "The Origin of the Work of Art," in *Poetry, Language, Thought* (New York, Harper and Row, 1971); Meyer Schapiro, "The Still Life as a Personal Object," in *The Reach of the Mind: Essays in Memory of Kurt Goldstein* (New York, Springer Publishing Co., 1968); Jacques Derrida, *The Truth in Painting* (Chicago, University of Chicago Press, 1987).

34. Bonafoux, *Van Gogh par Vincent*, p. 17, commenting on a letter in which Vincent writes: "I have the firm intention of not caring a whit for ambition or glory." Similarly, Julius Meier-Graefe, van Gogh's first German biographer, sees in him "a new type in the artistic poverty of our time: the artist who not only does not sell, but convinced of the futility of the effort, gives up any attempt and gains from this insight not bitterness, but on the contrary, pure joy" (quoted in Zemel, *The Formation of a Legend*, p. 116).

35. Forrester, *Van Gogh ou l'enterrement dans les blés*, p. 93.

36. Bonafoux, *Van Gogh par Vincent*, p. 20. [*Translator's note*: The last two lines of this quotation contain untranslatable puns. The French text reads as follows: "Les portraits qu'il peint de lui-même ne regardent que lui seul. La peinture fonde

sa solitude." The first of these two sentences bears the meaning I have provided here; but the French expression used, when rendered word for word, in a literal fashion, reads: "The portraits he paints of himself look only at him." In the second sentence, the term "fonde" refers both to foundation and justification, i.e., both to primordial constitution and post factum rationalization.]

37. See, for example, the letter in which van Gogh, having expressed the hope that he will sell later, denounces the "f— fools" and "lazy little Jesuits" who hold to "the maxim that originality prevents one from making money" (*Letters to van Rappard*, R 43, April 1884, III, p. 398). Consider these passages also: "One reason for working is that canvases are worth money. You will say that in the first place this reason is rather prosaic because you doubt whether it is true. Yet it is true" (*Letters to Emile Bernard*, B 7 [7], June 1888, III, p. 494). "I cannot help it that my pictures do not sell. Nevertheless the time will come when people will see that they are worth more than the price of the paint and my own living, very meager after all, that is put into them" (*Letters of Vincent van Gogh to His Brother Theo*, 557, October 1888, III, p. 92).

38. Pierre Cabanne, *Van Gogh* (Paris, Aimery Somogy, 1973), p. 164.

39. Ibid., pp. 46, 258, 48.

40. Vincente Minnelli (with Hector Arce), *I Remember It Well* (Garden City, N.Y., Doubleday, 1974), p. 291. Elsewhere he notes that the script was particularly easy to put together, given the fact that van Gogh's life already had been very dramatized: "I anticipated the rest of our filming approach would be fairly conventional, for the story was so powerful that we wouldn't need to muck it up with razzle-dazzle" (290).

41. "The introduction of the sacrificial theme tends to foreground violent death, which seems like the 'supreme testimony.' The term 'martyr' begins to take on the technical significance we have given it, of 'having died for the faith'" (Francesco Chiovaro, *Histoire des saints et de la sainteté* [Paris, Hachette, 1986], p. 41). On the connection between martyrdom and giving one's life, see Vacant et al., *Dictionnaire de théologie catholique*, p. 222.

42. This is the "case of martyrs who have taken their own lives. The persecutor is then the occasional, not the efficient, cause" (Vacant et al., *Dictionnaire de théologie catholique*, p. 234).

43. Paul Gauguin, *Avant et après* (Paris, Crés, 1923), p. 24.

44. Duret, *Van Gogh Vincent*, p. 93.

45. In it, he "depicts [him] as brimming with deep mysticism, leading the life of a saint, and tending to identify with Christ, with God. This attitude seems to have left no traces in his painting, with the possible exception of the two versions (1889 and 1890) of the Pietà after Delacroix, in which some have thought they could make out Vincent's own features. Van Gogh's correspondence by contrast provides a key that recalls the ancient dogma of Deus artifex: van Gogh describes Christ as a 'great artist,' an 'incredible artist': 'He lived serenely, as a greater artist than all other artists, despising marble and clay, as well as color, working in living flesh'" (Philippe Junod, "(Auto)portrait de l'artiste en Christ," in the catalog *L'autoportrait à l'âge de la photographie* [Lausanne, 1985], p. 10).

46. *La revanche ambiguë*, a film by Abraham Segal, 1989.

47. Marcel Arland, preface to *Lettres de Van Gogh à son frère Théo* (Paris, 1956).

48. Elias Canetti, *Die Fackel im Ohr. Lebensgeschichte, 1921–1931* (Munich, Carl Hanser Verlag, 1980), pp. 19–20. These events occurred between 1921 and 1924.

49. "By a circular orientation and dynamic strokes in the backgrounds of certain self-portraits . . . , or by a certain play of light . . . , van Gogh did not refrain from applying this discreet hero-making to himself" (Junod, "(Auto)portrait," p. 11).

50. Junod shows how, after Dürer introduced the self-portrait of the artist as Christ, "three centuries had to go by before the explicit figurative identification of the artist with Christ reappears" with Ensor and Munch. On the *imitatio Christi* among the Romantics, see Jean Borreil, "L'enfermé," *Romantisme*, no. 66, 1989, p. 100.

51. On the figures of the prophet, the precursor and Moses in art, see Junod, "(Auto)portrait," p. 12: "In 1841, Millet portrayed himself as a hairy and bearded Moses holding the tables of the law." (Millet was one of the few painters by whom van Gogh claimed to have been influenced.) The other examples of prophetic figures in art cited by Junod either involve caricature (for instance the caricature of Fantin-Latour's *Atelier aux Batignolles* in the *Journal amusant* in 1870, under the title *Jesus Painting among the Disciples, or the Divine School of Manet*), or come later than van Gogh: a Cézanne letter in 1903, a portrait of Rodin by Bourdelle in 1909, a self-portrait by Schiele in 1911.

52. "The Hero as Man of Letters . . . is altogether a product of these new ages . . . one of the main forms of Heroism for all future ages . . . a very singular phenomenon" (Thomas Carlyle, *On Heroes, Hero-Worship and the Heroic in History* [London, Oxford University Press/Humphrey Milford, 1841, 1935], p. 202). In the 1890s a form of sanctification of the poet emerged with respect to Verlaine. There was an article on "Heroic Verlaine" in *La revue blanche* in 1897, and this epistle in *Le Mercure de France* of May 1897: "One day, those who had disowned the poet glimpsed him on the mountain peak; and no one had guessed that he was so great, he who had been so humble. Thus the Poor Man entered the great church and earned a place as one of our venerated Saints" (quoted by Jacques Lethève, *Impressionnistes et symbolistes devant la presse* [Paris, Armand Colin, 1959], p. 272. Chapter 9 of Lethève's book is entitled: "Death and Sanctification of Paul Verlaine. On the Frontiers of Hagiography"). Rimbaud's turn came next. Commentators called him a "seer," "prophet," "precursor," who "never learned his trade" because "he was born to ply it"; he was "brilliantly precocious," had a "Carthusian monk's sense of his calling," and had led a "hermit's life"—like a "Christ," a "Messiah" (see René Etiemble, *Le Mythe de Rimbaud. 1. Genèse du mythe. 2. Structure du mythe* [Paris, Gallimard, 1952], 1954).

53. "Martyrdom is an act of virtue, because it consists in holding steadfastly to truth and justice in the face of persecution. . . . The Holy Innocents would seem an exception to this rule, since the Church honors them as martyrs even though their martyrdom was involuntary" (Vacant et al., *Dictionnaire de théologie catholique*, p. 220).

54. Bob Claessens, *L'incompréhension devant l'art. Un exemple: Vincent Van Gogh* (Brussels, 1973), p. 39.

55. He probably could not even bear not to live communally, and to be doomed to live "in the desert." It was, after all, at the time of his quarrel with Gauguin (when his hope for a community providing external support, someone to share with, had

collapsed) that he first dropped out of the community of normal people by mutilating himself (this remark was suggested to me by Jean Clair).

56. *Letters to Theo*, 524, 1888, III, pp. 16–17, and *Lettres à Emile Bernard*, B14 [9], August 1888, p. 510. Beginning with Max Weber's analysis of the two forms of asceticism, in the world and outside of it (Max Weber, *The Sociology of Religion* [Boston, Beacon Press, 1963]), it would be tempting to elaborate on this comparison between van Gogh and Cézanne as two models of saintliness for the modern artist, Cézanne representing the form of nonheroic sainthood suggested by Ramuz: "His greatness lies in the silence that never ceased to surround him" (Charles-Ferdinand Ramuz, *L'exemple de Cézanne, et autres pages sur Cézanne* [Lausanne, Séquences, 1988]).

57. *Letters to Theo*, 556, 1888, III, p. 90. Significantly, this is the very thing that he felt enabled him to hold madness at bay: "I should have been reduced, and that long ago, completely and utterly, to the aforesaid condition" (i.e., that "of the madness of Hugo van der Goes in Emil Wauters' picture").

58. "The sacralization of the aesthetic sphere became generalized by the dawn of the nineteenth century. The cult of art leads to the cult of the artist, praised as a god on earth, a saint, a hero, or a prophet, through the interplay of a series of typically religious practices, forms and rituals: solemn commemorations, invocations, prayers, pilgrimages, adoration of relics and sanctuaries—[workshops] foster an iconography that revels in scenes of apparitions, ascensions, apotheoses and coronations" (Junod, "(Auto)portrait," pp. 7–8).

59. Erwin Panofsky, *Idea: A Concept in Art History* (Columbia, University of South Carolina Press, 1968); Edgar Zilsel, *Die Entstehung des Geniebegriffs. Ein Betrag zur Ideengeschichte der Antike und des Frühkapitalismus* (Tübingen, Mohr, 1926).

60. These are the properties of the "nature of inspiration" according to Luc Boltanski and Laurent Thévenot, *De la justification. Les économies de la grandeur* (Paris, Gallimard, 1991). On the analogy between the two orders of experience, see William James, *The Varieties of Religious Experience* (New York, Macmillan, 1902), and especially Max Weber, *The Sociology of Religion* (Boston, Beacon Press, 1963). For an application of Weber's analysis of mysticism to modern art, which "appears as the mythical path of a self-individualization in the world," see the last chapter of Vincent Descombes' book (*Proust, philosophie du roman* [Paris, Minuit, 1987]), in particular the pages in which the author recalls Claudel's words about Proust and Joyce: "literary anchorites" (pp. 319–320).

61. The notion of homology has been elaborated with regard to Erwin Panofsky's work (see Pierre Bourdieu, afterword of Erwin Panofsky, *Architecture gothique et pensée scholastique* [Paris, Minuit, 1967], as well as Nathalie Heinich, "Panofsky épistémologue," preface to Erwin Panofsky, *Galilée critique d'art* [Paris, Les Impressions nouvelles, 1993]).

62. See Chiovaro, *Histoire des saints et de la sainteté* (in particular p. 56), as well as Peter Brown, *The Making of Late Antiquity* (Cambridge, Mass., Harvard University Press, 1978); and *Society and the Holy in Late Antiquity* (London, Faber and Faber, 1982).

63. Bonafoux, *Van Gogh par Vincent*, p. 21. For an application of this comparison to the modern artist in general, see Borreil, "L'enfermé," p. 87.

64. See Brown, *Society and the Holy in Late Antiquity*.

65. "These men had wished to distance themselves from the Christian life of urban communities and, on the other hand, had no intention of living a conventional life in which everyone lived together to the tune of the same rule; how could such men learn to 'live according to the Gospel?' Since there were no preestablished norms to which people could be referred, no universally valid models acting as a solid reference point for new arrivals, how were the new recruits who kept flowing in to be trained?" (Jean-Claude Guy, preface to *Paroles des anciens. Apophtegmes des pères du désert* [Paris, Seuil, 1976], p. 6).

66. "To die at this moment is great good fortune for him, it is precisely the end of his suffering, and if he comes back in another life he will bear the fruit of his beautiful behavior in this world (according to Buddha's law). He has borne with him the consolation of having not been abandoned by his brother and of having been understood by a few artists," Gauguin wrote to Emile Bernard in August 1890 (P. Gauguin, *Lettres* [Paris, Grasset, 1946], p. 201).

67. I have developed this point with respect to the literary domain in "Etre écrivain," 1990. On projection into posterity and "magical inversion of hierarchies," see François Héran's reading of Kafka ("Analyse externe et analyse interne en sociologie de la littérature. Le cas de Kafka," in R. Moulin, ed., *Sociologie de l'art* [Paris, Documentation française, 1986]).

68. Camille Mauclair, epigraph to the novel *Le soleil des morts, roman contemporain* (Paris, Ollendorff, 1898).

69. Marc Le Bot has suggested that the term was not used in France before the beginning of the twentieth century: "Artistic polemics do not seem to have taken up this notion before 1910. The term becomes established in France in Guillaume Apollinaire's column on painting from 1902 onward, and especially in his *Aesthetic Meditations* published in 1913" (Marc Le Bot, *Peinture et machinisme* [Paris, Klincksieck, 1973], p. 131).

70. For a fine discussion of this passage, see Borreil, "L'enfermé," p. 103.

71. Jacobus de Voragine, *The Golden Legend of Jacobus de Voragine* (New York, Longmans, Green and Co., 1941), p. 1. Translation slightly modified.

72. According to Pierre Cabanne, "the genius of van Gogh was revealed" to Aurier (*Van Gogh*, p. 224). Of van Gogh's first Dutch critic and defender, Carol Zemel remarks: "As he himself suggested, Veth had experienced a conversion. Van Gogh's greatness came to him as a revelation" (*The Formation of a Legend*, pp. 23–24).

Chapter Three
Van Gogh versus Vincent

1. Pierre Cabanne, *Van Gogh* (Paris, Aimery Somogy, 1973), pp. 236–237. [*Translator's note*: The words "passionate lives" refer to the French title of Vincente Minnelli's film *Lust for Life: La vie passionnée de Vincent Van Gogh*.]

2. As Marc Augé has correctly emphasized, there is currently a well-established, "highly regarded" psychological disposition, which consists of "denouncing the mistaken and mendacious nature of religion, the cynicism and hypocrisy of the princes of the Church, in short the purely ideological character of religion," "to

the point that no difference exists between the religious apparatus and the machinery of power, the true distinction being between those who do not believe but control the apparatus, and the others, the great mass of manipulated and cheated believers" (Marc Augé, *Génie du paganisme* [Paris, Gallimard, 1982], pp. 42–43).

3. These thoughts on critical sociology, and on the need to introduce into the very object of sociology the effects of dealing with that object, owe much to Luc Boltanski.

4. Milan Kundera, "In Saint Garta's Shadow: Rescuing Kafka from the Kafkologists," transl. by Barbara Wright, *Times Literary Supplement*, May 24, 1991.

5. "Following Brod, when Kafkologists write biographies of Kafka, they become hagiographies" (ibid.).

6. "Biography is the most important key to the understanding of the meaning of the work. But there is worse to come: the sole meaning of the work is that it is a key to understanding the biography" (ibid.).

7. "But may a saint visit brothels? Brod expunged from the diary not only its references to prostitutes but also everything to do with sexuality. Kafkology has always cast doubt on its author's virility, and likes to expatiate on the martyrdom of his impotence" (ibid.).

8. "Following Brod, Kafkology ignores the existence of modern art" (ibid.).

9. "Following Brod's example, Kafkology systematically removes Kafka from the domain of aesthetics" (ibid.).

10. "[A]t the top, Kafka's life as an example to be followed; in the middle, the aphorisms, namely all the sententious 'philosophical' passages in his diary; at the bottom, the narrative works" (ibid.).

11. "Kafkology is not literary criticism . . . ; Kafkology is an *exegesis*. And as such, it can see nothing in Kafka's novels but allegories" (ibid.).

12. "Despite the astronomical quantity of its texts, Kafkology always develops, in infinite variants, the same theme, the same speculation, which, while becoming more and more independent of Kafka's work, feeds only on itself. In innumerable prefaces, afterwords, notes, biographies, monographs and university lectures, it produces and fosters Kafka's image, with the result that the author known to the public by the name of Kafka is no longer Kafka, but Kafka mythologized" (ibid.).

13. Maurice Serullaz, *Peintres maudits* (Paris, Hachette, 1968; from the chapter entitled: "From Bohemia to Suicide: Toulouse-Lautrec, van Gogh").

14. Martyrs "are not extraordinary beings, but ordinary people who have accomplished extraordinary feats. In that sense, they represent more the type of the classic anti-hero" (Francesco Chiovaro, *Histoire des saints et de la sainteté* [Paris, Hachette, 1986], p. 28).

15. See Jean-Pierre Vernant's analysis of Greek heroes and heroic legends: "The feats [that legends] celebrate are valid in and for themselves, independently of those who accomplish them. . . . How could a hero be responsible for success he did not have to conquer, he never had to earn? The hero is neither the source and origin of his act, nor the cause of his triumph; they are to be found outside of him. He does not achieve the impossible because he is a hero; he is a hero because he has achieved the impossible. His feats are not the realization of personal virtue, but signs of divine grace, manifestations of supernatural assistance" (Jean-Pierre Ver-

nant, "Aspects de la personne dans la religion grecque," in Ignace Meyerson, *Problèmes de la personne* [Paris, Mouton, 1978], p. 34).

16. According to Max Scheler, the genius is he who "is to the world what the saint is to God, and the hero to his community: he enters into this world and makes us see new horizons" (M. Scheler, *Le saint, le génie, le héros* [Fribourg, Egloff, 1944], p. 151). His "active influence ... is passed on through his *Oeuvre*, in which the individuality of the spiritual person is made present and visible" (ibid., p. 109).

17. A myth that had begun being celebrated later in England than in other European countries (see Carol Zemel, *The Formation of a Legend: Van Gogh Criticism, 1890–1920* [UMI Research Press, 1980], pp. 146, 148).

18. Pascal Bonafoux, *Van Gogh par Vincent* (Paris, Folio, 1990), pp. 11–12.

19. Ibid., p. 18.

20. The question of the mediation's value could be related to the Catholic tradition, in which the image is venerated (to the point of idolatry) as a good conductor, as a revealing mediation. It could also be linked to the Protestant tradition, in which the image is denounced (to the point of iconoclasm) as an obstacle, an occluding mediation.

21. For a critique of the idolatry of genius in the name of irreducible human values, see Hannah Arendt, *The Human Condition* (Chicago, University of Chicago Press, 1958). An intermediate position consists in refusing any hero-making, whether in the name of the great man or the great oeuvre. Maurice Pialat takes this stand in a discussion of his film on van Gogh, when he distances himself equally from popular legend and scholarly celebration: "Above all, I wanted to go against the legend of the mad painter, the accursed painter, the down-and-out painter, which is a complete fabrication. ... Vincent van Gogh was a man like any other. ... [One must] resist the common belief according to which artists are by nature abnormal people ... show a normal man. ... I believe that I am closer to the truth, to what is authentic, than all of the "authorized" biographies" (interview in *Le Monde*, May 9, 1991).

22. "'Popular' belief was treated as the belief of populations at a lower stage of moral and intellectual evolution. This approach produced an exceptionally static and elitist view of ancient belief." (Peter Brown, "The Rise and Function of the Holy Man in Late Antiquity," in *Society and the Holy in Late Antiquity* [Berkeley, University of California Press, 1982], p. 107). Those familiar with Peter Brown's work may feel surprise at seeing his conclusions used to back up the "two-tiered model," the "monotonous outlook" which he precisely sets out to deconstruct. Brown criticizes the learned and denunciatory *post factum* interpretations of this model. However, I feel that there are grounds for having some reservations about this criticism, for it verges on denial of the model's actual reality. Such denial is less than convincing and prevents any inquiry into the reasons for which the dichotomy between "learned" and "popular" celebration (whether it is real, exaggerated, or a complete fantasy) is such a constant.

23. Here are, higglety-pigglety, a few of the terms Etiemble uses with respect to the "Rimbaud myth" and the authors who "expatiate upon Rimbaud in a religious mode, and respond to him as though he were a sacred icon": "myth, gospel, miracle, prophet, new avatar of god, hagiography, heretic, legend, rites, illusions,

collective mistakes, frightful ravages, dangerous myth, fashionable, lies, misinterpretation, mythical, fable, holding reason up to ridicule, promoting irrationality, hoaxes, insanity, cabal, initiate, magician, fantastic anecdotes, saint Rimbaud, mystical, angel, apotheosis, metaphor of God, incarnation, annunciation, resurrection, modern crucifixion, transfiguration, cult of Rimbaud, pilgrims, ex voto, litanies, suicide ritual, cult of relics, cult of icons, Bible of modern times, great holy writings, great family of believers, to give the biographers less, biography is hagiography, to get back to the texts" (René Etiemble, *Le mythe de Rimbaud. 1. Genèse du mythe. 2. Structure du mythe* [Paris, Gallimard, 1952, 1954]).

24. With respect to the cult of saints, the practices stigmatized as "popular" may emerge in the oral vs. the written word, the local vs. the central, or the private vs. the public (see Aline Rousselle, *Croire et guérir. La foi en Gaule dans l'Antiquité tardive* [Paris, Fayard, 1990]). The case of van Gogh has also been interpreted as opposing "private" and "public" meanings (see Mark Roskill, " 'Public' and 'Private' Meanings: The Paintings of van Gogh," *Journal of Communication*, vol. 29, no. 4, Fall 1979). But this confuses "private" with "selective," and "public" with "open." The author does not see that the scholarly universe can be just as "public" as the common universe (if not more so, thanks to access to the media and publishing), and that the opposition constructed by the scholar is far from timeless. On the contrary, it surfaces in certain periods in particular, especially at the end of the last century.

25. Pierre Bourdieu, *La distinction. Critique sociale du jugement* [Paris, Minuit, 1979].

26. Individuals call upon different "natures" in order to constitute judgments and argue the case for them. Luc Boltanski and Laurent Thévenot have opened up new avenues of research by their analysis of the plurality of these "natures" (*De la Justification. Les économies de la grandeur* [Paris, A.-M. Métailié, 1991]). In the light of this, the relationship to celebration highlights the tension between domestic and inspired natures that characterizes sainthood. Celebration marked by the valuing of closeness (in the search for *presence*—being present, in the presence of the saint) and precedence (in the cult of elders and tradition) pertains to a domestic nature characteristic of "popular" hagiography. By contrast, an inspired nature characteristic of scholarly hermeneutics prizes the distance from the object that works afford (their mediation erects a protective screen against closeness to the other); it also stresses projection into the *future* (which tends to be an investment in posterity). The scholarly critique of devotion to the deceased is thus to be understood by grasping such devotion as a form of *domestication* of the object of admiration.

27. "In order for the hagiographer to be dealing with his own special subject, this state of saintliness, with all of the heroic virtues it comprises, must have been recognized by the authority of the Church, the consequence of such recognition being the manifestations of a liturgical and public cult, . . . a cult without which the heroism of his life, the splendor of his service, or the renown of his virtues, could not suffice to justify his inclusion in the list of saints" (René Aigrain, *L'hagiographie. Ses source, ses méthodes, son histoire* [Bloud et Gay, 1953, p. 8]). On the constitution of an authorized biography in the history of painting, see Nathalie Heinich, *Du peintre à l'artiste. Artisans et académiciens à l'âge classique* (Paris, Editions de minuit, 1993).

28. Jean Gimpel's *Contre l'art et les artistes* (Paris, Seuil, 1968) is a good example of the scholarly condemnation of the reduction of art to a form of religious cult. Gimpel shows the historical relativity of the artist's status in order to denounce the blindness of those who "have allowed themselves to be converted gradually to the religion of Art by the active proselytizing of that sect's followers; this contact sparked the revelation that paintings were not just objects of profit, but objects of a cult. Touched by grace, they learned to commune in a same aesthetic faith with the keepers of that faith" (p. 170). Similarly, Jean Dubuffet (*Asphyxiante culture* [Paris, Minuit, 1986]) constantly laments the fact that "culture tends to occupy the space previously taken up by religion. Like the latter, it has retained priests, prophets, saints, and colleges of dignitaries. . . . Prevaricating lords seeking absolution no longer build abbeys, but art galleries. Today, people are mobilized, crusades are preached, in the name of culture. It has now taken on the role of 'opium of the people'" (p. 10).

29. This level of critique orchestrated by sociology can also be taken over by the supporters of "dominated art" against "dominant art": see the example of "raw art," over which historians get stigmatized for "[converting] themselves into hagiographers to construct the highly profitable myth of the inspired genius" (Michel Thévoz, *L'art brut* [Geneva, Skira, 1980], p. 146, as well as pp. 5, 18, 198).

30. Here we encounter the sociological debates about "popular culture" that have absorbed the energy of many people over a generation. (See in particular Charles Grignon, Jean-Claude Passeron, *Le savant et le populaire* [Paris, Gallimard-Seuil, 1989]).

31. Karl Jaspers, *Strindberg and Van Gogh: An Attempt at a Pathographic Analysis with Reference to Parallel Cases of Swedenborg and Hölderlin*, transl. by Oskar Grunow and David Woloshin (Tucson, University of Arizona Press, 1977), p. 174.

32. "Vincent van Gogh au Salon des indépendants," *Le Journal des indépendants*, Grand Palais, May 1990.

33. "An immediate and obvious identification of a work of art is always possible per se, given that such and such a work is by such and such a genius, without there being any need to resort to other sources of information or other external confirmations. After all, in ordinary speech one just says 'a Rembrandt', period. . . . The work of a genius, besides being a work in the proper sense of the term, is the only work that is a source bearing witness to its own origin" (Scheler, *Le saint, le génie, le héros*, p. 115).

34. There have been attempts to justify and denounce a popular infatuation with van Gogh's work that is quite detached from any admiration for the man himself, by appealing to the work's characteristics. In the first case, a Viennese critic, who has sought within van Gogh's painting for a link between the aesthetic interest *of* the works and the popular interest *in* them, concludes that van Gogh was able "to achieve some of his utopia of an art for the people" (Fritz Novotny, "Die Popularität van Goghs," *Alte und neue Kunst*, vol. 2, no. 2, 1953). In the second case, a French critic denounces the misreading, the misunderstanding of van Gogh's work: "Finally, once the suppression of relief, half-tones and chiaroscuro—the great refuge for the mediocrity of chromo-makers—has been accepted, the technique is reassuring. Vaccinated against van Gogh's stylistic freedom and the intensity of his colors, the general public loves his canvases for being so alive, for the

energy of his full tones" (Frantz-André Burguet, "La popularité de Van Gogh," *L'Arc*, special issue on van Gogh, n.d., p. 23). The condemnation of the misunderstanding inherent in popularity is a recurring motif in the biographies of accursed artists. Since an artist who is both accursed and popular is a contradiction in terms, it is necessary to minimize his popularity if one wishes to foster compassion.

35. Bonafoux, *Van Gogh par Vincent*, p. 15 (concerning the self-portraits).

36. Jean-Michel Alberola, *Astronomie populaire* (Nîmes, Maeght, 1990). (It should be mentioned that Alberola is an artist one of whose traits consists of not signing his work, whether with his own name or with a pseudonym).

37. "But though it doesn't matter in the least this time, in the future my name ought to be put in the catalog as I sign it on the canvas, namely Vincent and not van Gogh, for the simple reason that they do not know how to pronounce the latter name here" (*Letters to Theo*, 471, March 1888, II, p. 537).

38. Of 135 paintings examined by de La Faille in his catalog of fake van Goghs (1930), 40 were signed "Vincent." "The fundamental importance people attach to a signature is quite unbelievable; they do not realize that in most cases it plays no role whatsoever, or only a very minor one, in an expert appraisal" (Marc-Edo Tralbaut, "Comment identifier van Gogh?" *Bulletin des archives internationales de Van Gogh* [Antwerp, 1967], p. 13).

39. Viviane Forrester, *Van Gogh ou l'enterrement dans les blés* (Paris, Points-Seuil, 1984), p. 47.

40. Bob Claessens, *L'incompréhension devant l'art. Un exemple: Van Gogh* (Brussels, 1973), p. 33. On the question of the given name as it pertains to Rembrandt and the great artists of the Renaissance, see Bonafoux, *Van Gogh par Vincent*, p. 129.

41. See Peter Strawson, *Individuals: An Essay in Descriptive Metaphysics* (London, Methuen, 1959). For an application of this approach to writers, see Nathalie Heinich, "Etre écrivain" (Paris, Centre national des lettres, 1990).

42. On this point, see Norbert Elias, *The Society of Individuals* (Cambridge, Mass., Basil Blackwell, 1987).

43. "The later spread of Christian names reflects the need to link the identity of the individual to a saint" (Brown, *The Cult of the Saints*, p. 58).

44. "The epic hero's dimensions emerge in several ways. To begin with, while like all heroes he is alone, raised up or doomed to solitude, his adventure is not a solitary one; he affirms his heroism under the gaze of others, and supported by the gaze of others; he requires at least one confidant or friend: he always needs a witness" (Augé, *Génie du paganisme*, p. 158).

45. "The saintly type can therefore only exist as a real person. The saint, as a positive historical figure, must also be real historically" (Scheler, *Le saint, le génie, le héros*, p. 105).

46. Forrester, *Van Gogh ou l'enterrement dans les blés*, p. 8. The author turns this coincidence into a fundamental cipher of van Gogh's fate—a hypothesis taken up by others: "Living in another's stead (i.e., his stillborn brother Vincent), his birth sounded like a death knell" (Jean Monneret, Introduction to the *petit journal* of the Vincent van Gogh exhibition, Salon des indépendants, Grand Palais (Paris, 1990).

47. Otto Rank, *The Myth of the Birth of the Hero* (New York, Random House, 1964).

48. Gustave Coquiot, *Des peintres maudits* (Paris, André Delpeuch, 1924), p. 191.

49. "At a social level, the hero is destroyed continuously in real life in order that he or she may be venerated in myth" (Bernard Smith, *The Death of the Artist as Hero: Essays in History and Culture* [Melbourne, Oxford University Press, 1988], p. 9).

50. See Emile Durkheim, *Les Formes élémentaires de la vie religieuse* (Paris, Presses universitaires de France, 1985); Mircea Eliade, *Traité d'histoire des religions* (Paris, Payot, 1949); R. Caillois, *L'homme et le sacré* (Paris, Gallimard-Folio, 1950).

51. Cabanne, *Van Gogh*, p. 7 (emphasis added).

52. "The nucleus of their agreement evidently lies in the predestination of the child artist to achieve future greatness. All the chance events that lead to his discovery, and thus to his brilliant ascension, appear in the biographical presentations as inevitable consequences of his genius. The miracle of being a child prodigy is itself merely an expression of the special favors bestowed upon him" (Ernst Kris and Otto Kurz, *Legend, Myth and Magic in the Image of the Artist: A Historical Experiment* [New Haven, Yale University Press, 1979], p. 38).

53. Victor Doiteau and Edgard Leroy, *La folie de Van Gogh* (Paris, Esculape, 1928), p. 17.

54. On autodidacticism, see Kris and Kurz, *Legend, Myth and Magic*, pp. 13ff: "The autodidact represents . . . the elevation of the creative individual to the status of a culture hero" (ibid., p. 20).

55. "For the artist too is a totalist type that, unlike the average, cannot live in perpetual 'partialization,' but is forced to totalize every act of his life" (Otto Rank, *Art and Artist. Creative Urge and Personality Development* [New York, Agathon Press, 1968], p. 109).

56. "Throughout his life, he remained the product of his violent and secret childhood; the seed of his work resides there, in the seething mind as in the dread, the convulsions, the dejection, the solitude, the quivering passion, the repressed tenderness and the vague guilt of a soul lost in a world in which poets, heroes and saints frighten other men" (Cabanne, *Van Gogh*, p. 9).

57. "The '*hero*' is the ideal type of the human, semi-divine (Greek heroes), or divine figure . . . , who, at the core of his being, dedicates himself to what is noble, and to the *achievement of what is noble*. . . . Like the genius, the hero must act with an exuberance that overflows the common measure in some specifically spiritual function. But this exuberance is not the power of the soul's effusions (as in the case of the religious man), nor is it an overabundance of thought and of spiritual contemplation, contrasted with a simple practical utilization catering to the needs of life (as in the case of the genius): it is an overabundance of '*spiritual will*'" (Scheler, *Le saint, le génie, le héros*, p. 169).

58. Louis Piérard, *La vie tragique de Vincent Van Gogh* [Paris, Crés, 1924], p. III.

59. See Roland Barthes, "L'acteur d'Harcourt," in *Mythologies* (Paris, Seuil, 1957).

60. For example: "I shall have to make a lot of noise, as I aspire to share the glory of the immortal Tartarin de Tarascon" (*Letters to Emile Bernard*, B4 [4], April 1888, III, p. 482).

61. Alphonse Daudet, *Tartarin de Tarascon* (Paris, Gallimard, Garnier-Flammarion, 1968), p. 55.

62. "The original saint is not, for those who follow in his footsteps, one man among several, as even the greatest geniuses and heroes are: he is always 'the one and only'. . . . The original saint, within a given group, can only supplant another saint: he cannot be ranked as his equal" (Scheler, *Le saint, le génie, le héros*, p. 84). "An immediately perceivable presence is part of the essence of being a saint. The saint does not act upon posterity by his actions, as the hero does . . . ; nor does he do so as the genius does, whose spiritual individuality is immediately present in his works; the saint himself is present for posterity" (ibid., p. 89).

63. To use the expression coined by Thomas Kuhn in his discussion of science (T. Kuhn, *The Structure of Scientific Revolutions* [Chicago, University of Chicago Press, 1962]).

64. See Nathalie Heinich, "Le chef-d'oeuvre inconnu, ou l'artiste investi," in *Autour du chef-d'oeuvre inconnu de Balzac*, ed. by Thierry Chabanne (Paris, ENSAD, 1986).

65. See T. R. Bowie, *The Painter in French Fiction: A Critical Essay* (Chapel Hill, University of North Carolina Press, 1950).

66. According to Max Scheler, this model is "the value embodied in a person, a figure who constantly floats before the soul of the individual or the group. . . . The choice of models is not determined by 'leaders'; on the contrary, it is the actually existing models that (along with other factors) determine the decision as to who will be chosen as leader, and which leader will be chosen" (Scheler, *Le saint, le génie, le héros*, pp. 53–54).

67. And for a history of sainthood such as Peter Brown proposes: "In studying both the most admired and the most detested figures in any society, we can see, as seldom through the evidence, the nature of the average man's expectations and hopes for himself. It is for the historian, therefore, to analyse the image as a product of the society around the holy man. Instead of retailing the image of the holy man as sufficient in itself to explain his appeal to the average late Roman, we should use the image like a mirror, to catch, from a surprising angle, another glimpse of the average late Roman" (*Society and the Holy in Late Antiquity* [London, Faber and Faber, 1982] p. 107).

Chapter Four
Madness and Sacrifice

1. "Je suis sain d'Esprit/Je suis Saint-Esprit" [*translator's note*].

2. According to Gauguin's 1894 account.

3. Théodore de Wyzewa, "Eugène Delacroix," *Le Figaro*, June 1893.

4. Marthe Robert, "Le génie et son double," in *Vincent Van Gogh* (Paris, Hachette, 1968), p. 172.

5. Théodore Duret, *Van Gogh Vincent* (Paris, Bernheim jeune, 1916), p. 75.

6. J. Audry, "La folie dans l'art," *Lyon médical*, no. 134, 1924; J. Vinchon, *L'art de la folie* (Paris, Stock, 1926); Victor Doiteau and Edgard Leroy, *La folie de Van Gogh* (Paris, Esculape, 1928). The first medical study was published in Dutch in 1911, and the first truly psychiatric study was published in German in 1920.

7. "The various authors' assessments are contradictory and quite inconclusive" (Georges Bataille, "La mutilation sacrificielle et l'oreille coupée de Vincent Van

Gogh," *Documents*, no. 8, 2d year, 1930) (*Oeuvres complètes* [Paris, Gallimard, 1970], vol. 1, p. 259).

8. "1920 and 1922, Birnbaum, epilepsy; 1922 and 1926, Jaspers, schizophrenia; 1924, Westerman Holstijn, schizophrenia; 1925, Riese, schizophrenia; 1926, Evensen, epilepsy; 1926, Leroy, epilepsy; 1926, Thurler, crude form of epilepsy; 1928, Doiteau and Leroy, epileptoid psychosis; 1930, Koopman, epilepsy; 1930, Bolten, psychopathy; 1932, Minkowska, epilepsy; 1932, Bader, *tumor cerebri?*; 1935, Lange-Eichbaum, uncertain diagnosis; 1938, Rose and Mannheim, periodic schizophrenia. . . . 1940, Kerschbaumer, schizophrenia, probably of the paranoid type" (G. Kraus, 1941, quoted in Charles Mauron, "Notes sur la structure de l'inconscient chez Van Gogh," *Psyché*, vol. 8, nos. 75, 76, 77–78, 1953).

9. Audry, "La folie dans l'art," p. 632.

10. L. Roetlandt, preface to *Lettres à Van Rappard*, 1950.

11. Paul Gauguin, October 1890, *Lettres* (Paris, Grasset, 1946), p. 204.

12. Quoted in Carol Zemel, *The Formation of a Legend: Van Gogh Criticism, 1890–1920* (UMI Research Press, 1980), p. 21.

13. "Vincent van Gogh was a failed saint. . . . His mental illness drove him to a martyrdom without meaning," claim D. Jablow Herschmann and Julian Lieb in *The Key to Genius* (New York, Prometheus Press, 1988), p. 142—a book focusing on "manic-depression" on the basis of monographs on Newton, Beethoven, Dickens, and van Gogh.

14. Karl Jaspers, *Strindberg and Van Gogh: An Attempt at a Pathographic Analysis with Reference to Parallel Cases of Swedenborg and Hölderlin*, transl. by Oskar Grunow and David Woloshin (Tucson, University of Arizona Press, 1977), pp. 204, 181, 170–171.

15. "Certain 'connoisseurs' do not hesitate to attribute such extraordinary achievements to the effects of madness," wrote Gustave Coquiot (*Des peintres maudits*, 1924, p. 197), who, for his part, imputed van Gogh's derangement to the *mistral*. "Van Gogh was a genius, there is no question of that. Was he mad? It is most unlikely. . . . Chronically malnourished, he preferred to purchase paint rather than bread, and had aggravated his latent alcoholism." (E. Zarifian, *Le Point*, no. 913, March 19, 1990).

16. Dr. Joachim Beer, *Essai sur les rapports de l'art et de la maladie de Vincent Van Gogh* (Strasbourg, Editions du médecin d'Alsace et de Lorraine, 1935), pp. 17, 20, 21.

17. A. van Bever, "Les aînés: Un peintre maudit, Vincent Van Gogh," *La Plume*, 1, June 15, 1905, pp. 90–91.

18. Françoise Will-Levaillant (in "L'analyse des dessins d'aliénés et de médiums en France avant le Surréalisme," *Revue de l'art*, no. 50, 1980, p. 34) has stressed "the ambivalence of all observers before 'creative madness.' Medical literature in the early twentieth century therefore oscillates between recognition of the *same* and rejection of the *other*."

19. "By his practice if not by his words, Freud smashes the idol embodied by the artist, and he cannot fully suppress a feeling of guilt. Indeed, 'applying' psychoanalysis to art is to a certain extent tantamount to murdering the artist *qua* genius, *qua* 'great man'" (Sarah Kofman, *L'enfance de l'art. Une interprétation de l'esthétique freudienne* [Paris, Payot, 1970] p. 26). The medical profession's interest in artists

is not unconnected with its involvement in society life: "At the height of his career, every famous physician boasts some noted artist as a client, with whom he keeps up a dialogue concerning the genesis of the creative faculty: Dr. Blanche is consulted by van Gogh and de Maupassant, Edouard Toulouse by Zola and Artaud, etc." (Elisabeth Roudinesco, *La bataille de cent ans. Histoire de la psychanalyse en France—1. 1885–1939* [Paris, Seuil, 1986], I, p. 41).

20. This notion is borrowed from Luc Boltanski and Laurent Thévenot's work (*De la justification. Les économies de la grandeur* [Paris, A.-M. Métailié, 1991]) to establish the rules enabling agreement on issues of justice. For some thoughts on the variability of the limits of "the common humanity," see Francis Chateauraynaud, *La faute professionnelle. Une sociologie des conflits de responsabilité au travail* (Paris, A.-M. Métailié, 1991).

21. Henri Perruchot, *La vie de Van Gogh* (Paris, Hachette, 1955), p. 284.

22. On the "pathological characterization of genius," see Philippe Junod, "Voir et savoir," *Etudes de lettres*, 4th series, vol. 3, April–June 1980, and Guillerm, "Psychopathologie du peintre," *Romantisme*, no. 66, 1989 (especially with regard to El Greco, pp. 76–78, and to the relation between the imputation of madness, the rejection of the Academy, and investment in color, which foreshadow the characteristics later emphasized in van Gogh: "The emergence of madness in pictorial discourse thus unfolded on two levels which were to become the fundamental stakes of nineteenth-century critical discourse: color to begin with, then the relationship with the Academy. . . . To distinguish oneself by way of color meant to take on the Academy" (p. 77).

23. Between Rogues de Fursal's 1905 *Ecrits et dessins dans les maladies nerveuses* and Marcel Réja's 1907 *L'art chez les fous*, Dr. Paul Courbon published his *Etude psychiatrique de Benvenuto Cellini* in 1906, following on his studies of William Blake (1888, 1892). In 1907 and 1908, studies of Raimondi, Ensor, and Fra Angelico were published. In 1909, Pailhas d'Albi published *Iconographie de la Salpêtrière* and Keraval wrote in *L'information des aliénistes*. Subsequently there were studies on Tolstoy and Strindberg (1911), Ensor, van Gogh, van Dongen, Redon, and Rousseau (1912), etc. (See F. Will-Levaillant, 1980, and N. Heinich, "Le muséum des muses," unpublished manuscript).

24. See Daniel Sangsue, "Vous avez dit excentrique?" *Romantisme*, no. 59, 1988. A *Physiologie des écrivains et des artistes* had been published in 1864 by Emile Deschanel.

25. Georges Hirth, *Physiologie de l'art* (Paris, Alcan, 1892); Max Nordau, *Psychophysiologie du génie et du talent* (Paris, Alcan, 1897; he also published *Vom Kunst und Künstler* in 1906); Lucien Arréat, *Psychologie du peintre* (Paris, Alcan, 1892; as Hirth's translator, he describes the artist as an "exceptional character who arouses envy or pity according to whether he appears as the divine workman or as a wretched creature who hungers and thirsts for bread, pleasure and praise: one who is noble through the deprivation he suffers in order to be his own man, who is ill-suited to the chores that others live on, who is indulgent toward ragged people, who rails against the servile and ready human herd, who is a semi-stranger amongst his own kind, who basically quite despises the crowd, which remains defiant and cannot be his friend").

26. Francis Galton, *Hereditary Genius: An Enquiry into Its Laws and Consequences*

(London, Macmillan, 1869); Cesare Lombroso, *L'homme de génie* (Paris, Alcan, 1889).

27. In 1922 already, Jaspers had noted (*Strindberg and van Gogh*, p. 200) that "one is now about to recognize the art of insane persons as art and not merely as the psychological material for psychiatric research." Dubuffet's first explorations in "raw art" began towards the end of World War II.

28. "Hölderlin's late poems, van Gogh's paintings, Kierkegaard's philosophy remain foreign to a Goethe who seems able to do everything. [In contrast with him, the] creative person will perish" (K. Jaspers, *Strindberg and van Gogh*, pp. 177–178).

29. On madness as the artist's self-inspiration, in a modern version of creation as a theology without God, see Karl Popper: "In other words the modern theory is a kind of theology without God—with the hidden nature or essence of the artist taking the place of the gods: the artist inspires himself" (Karl Popper, *Unended Quest: An Intellectual Autobiography* [London, Routledge, 1992].) On the question of the "divine artist" in the history of art, see especially Erwin Panofsky, *Idea: A Concept in Art History* (Columbia, University of South Carolina Press, 1968), as well as Ernst Kris and Otto Kurz, *Legend, Myth, and Magic in the Image of the Artist: A Historical Experiment* (New Haven, Yale University Press, 1979), pp. 38–61, passim.

30. "The 'encultured' person whom one makes aware of a *raw art* outside of the cultural domain, invariably thinks one is speaking of productions belonging to the cultural register, like those of van Gogh, Henri Rousseau, or the surrealists—but they bear the same relationship to raw art as tourist agency tinsel does to a desert island" (Jean Dubuffet, *Asphyxiante culture* [Paris, Minuit, 1986], p. 44).

31. "Madness is one of the various notions that raw art induces people to question. . . . It is a fallacy to suppose that the works presented in this book were made blindly by their authors. . . . They produced those works with all of their wits about them, fully conscious of their special innovative character" (Jean Dubuffet, preface to Michel Thévoz, *L'art brut* [Geneva, Skira], 1980, p. 6). See p. 42 also.

32. "From the point of view of raw art, the concept of mental illness is irrelevant and impertinent" (ibid., p. 150).

33. Robert, "Le génie et son double," p. 172 (an article comprising a bibliography of the psychoanalytical literature on van Gogh). Another way of constructing intermittence consists of dissociating the genius (Vincent) from the madman (van Gogh): "Vincent, the artistic genius, was forever chained to van Gogh, the madman, right up to the moment that an end was put to that unbearable double life" (Roger Laporte, "Vincent et Van Gogh," in *Quinze variations sur un thème biographique* [Paris, Flammarion, 1975], p. 121).

34. *Translator's note*: In French, insanity is "aliénation mentale"—literally mental estrangement or otherness.

35. Louis Piérard, *La vie tragique de Vincent Van Gogh* (Paris, Crés, 1924), p. vi.

36. Pierre Cabanne, *Van Gogh* (Paris, Aimery Somogy), 1973, p. 80.

37. Pascal Bonafoux, *Van Gogh par Vincent* (Paris, Folio, 1990), pp. 100, 111, 117.

38. Akira Kurosawa, "The Crows," in the film, *Dreams* (1990). It is worth recalling Caillois's interpretation of the martyr's sacrificial gesture: "Often they redeem themselves from death by mutilating their bodies, generally by cutting off

a finger: in this way they offer a part in order to retain the whole" (Roger Caillois, *L'homme et le sacré* [Paris, Gallimard-Folio, 1950, 1988], p. 36).

39. Cabanne, *Van Gogh*, p. 183.

40. "Whether one circumvents sacrifice from above by consuming absolutely pure foods like the gods or, in the most extreme case, odors, or whether one subverts it from below by knocking down all the distinctions sacrifice establishes, by collapsing the barriers between men and beasts . . . in both cases the point is to establish, by individual asceticism or collective frenzy, a type of relation to the divine that official religion rules out and forbids by means of the procedures of sacrifice. In both cases too, but by opposite means and with contrary implications, the normal distance between the sacrificer, the victim and the god gets blurred, and disappears" (Jean-Pierre Vernant, *Mythe et religion en Grèce ancienne* [Paris, Seuil, 1990], p. 87).

41. Cabanne, *Van Gogh*, p. 132 (referring to spring in Arles).

42. The duplication of madness and sacrifice replays the opposition between scholarly discourse and common sense that structures the modalities of admiration. One need only distinguish two aspects of madness, along the lines suggested by Michel Foucault: on the one hand the scientific construction of the notion of mental illness in the modern era; on the other hand, the common "imagined dimension" [*imaginaire*] of extravagance and unreason. This differentiation reveals that "sacrifice" may be subsumed under the second of these two aspects, "madness" being a name given "sacrifice." If such is the case, we are faced with an opposition, not so much between two hypotheses of a similar order, but more fundamentally between two ways—scholarly and common—of dealing with singularity: on the one hand by way of scientific reduction, on the other hand by way of sacrificial heroization.

43. Georges Bataille, "La folie de Nietzsche" (1939), in *Oeuvres complètes* (Paris, Gallimard, 1979), p. 548.

44. Antonin Artaud, "Van Gogh, le suicidé de la société" (1947), *Oeuvres complètes*, vol. 13 (Paris, Gallimard, 1974), p. 168.

45. See Marc Angenot, *La parole pamphlétaire* (Paris, Payot, 1982).

46. "It is not because of himself, because of the throes of his madness, that van Gogh parted from this world. It is from being pressured by that evil spirit who, two days before his death, was called Dr. Gachet, that improvised psychiatrist who was the first, efficient, and sufficient cause of his death."

47. "The cooked hand" alludes to an episode in which van Gogh burned his hand with a candle out of lovesickness.

48. Viviane Forrester, interviewed in Abraham Segal's film, as well as Viviane Forrester, *Van Gogh ou l'enterrement dans les blés* (Paris, Points-Seuil, 1984), pp. 16, 283, 65, 14–15.

49. "The *Persecutor* and the martyr must be two distinct persons; the former must intervene directly in the latter's death" (A. Vacant et al., *Dictionnaire de théologie catholique* [Paris, Letouzey et Ané, 1939], p. 223).

50. Ascribing responsibility can be done by way of a simple voice inflection. During the evening commemorating van Gogh's death in Auvers-sur-Oise (see chapter 7), the actor in charge of reading Vincent's letters declaimed the end of the last letter to Theo in a very vindictive tone, uttering the final "mais que veux-

tu?" in an admonishing, rather than resigned manner, like a polemical challenge, strongly implying the guilt of the letter's addressee for its writer's helplessness.

51. Forrester, *Van Gogh ou l'enterrement dans les blés*, pp. 273, 283, 336, 286, 316.

52. Cabanne, *Van Gogh*, p. 339.

53. "What now is to be made of the situation in which the wound . . . which is not fatal in itself, nonetheless brings on death because care is not forthcoming? That would be martyrdom" (Vacant et al., *Dictionnaire de théologie catholique*, p. 225).

54. "Van Gogh à Auvers: 70 jours, 70 toiles," *La Gazette du Val d'Oise*, no. 761, May 23, 1990.

55. Forrester, *Van Gogh ou l'enterrement dans les blés*, p. 18.

56. The theme of a blame shouldered by the community ("we") appeared very early on in studies devoted to van Gogh. In 1893, a Dutch critic who had recently been "converted" to van Gogh, linked "our shame" with the "genius cast out like a leper" (Veth, quoted in Zemel, *The Formation of a Legend*, p. 24). Three years later, one of his colleagues, in an even more explicit process of ascribing collective guilt, was to make the whole of "society" responsible for the artist's suffering (Vermeylen, in ibid., p. 30).

57. Jean Monneret, Introduction to the *petit journal* of the Vincent van Gogh exhibition, Salon des indépendants, Grand Palais (Paris, 1990.

58. Fauconnet described those "new forms, in our contemporary societies, of collective and communicable responsibility: the responsibility of moral persons, of the criminal crowd; the joint responsibility of society as a whole," i.e., *culpa or an offence due to negligence*: "The action is neither fortuitous, nor intentional: I did not do it 'on purpose,' and yet it is my 'fault'" (Paul Fauconnet, *La responsabilité. Etude de sociologie* [Paris, Alcan, 1928], p. 369).

59. Karl Jaspers, *The Question of German Guilt*, trans. by E. B. Ashton (New York, Capricorn Books, 1947), p. 71.

60. "To pronounce a group criminally, morally or metaphysically guilty is an error akin to the laziness and arrogance of average, uncritical thinking" (ibid., p. 42).

61. "But moral and metaphysical guilt . . . are by their very nature not atoned for. They do not cease. Whoever bears them enters upon a process lasting all his life. . . . Purification in action means, first of all, making amends" (ibid., pp. 120–121).

62. "The victim's heirs proclaim his innocence and weakness; the consequence of this is maximum guilt. The latter can be ascribed either to the agents of the sacrifice, or, as in Christianity, each believer can be held responsible, because of his sins, for Christ's death. A great sensitivity can develop with respect to the faculty of considering oneself guilty. . . . A subtle casuistry even links guilt to *omission*: not accomplishing a work of charity, not helping another out in his moment of destitution, not granting him one's *initial confidence* are lapses that morality condemns, and that are often to be found at the root of the social malaise in its unconscious guilt" (Guy Rosolato, *Le sacrifice. Repères psychanalytiques* [Paris, Presses universitaires de France, 1987], p. 65).

63. Viviane Forrester, commemorative celebration at Auvers-sur-Oise, July 28, 1990.

64. "In responding to each other, the respective complaints tighten the community of situation in the world and perhaps give rise to the pleasure of feeling united in the face of the world's woes" (Patrick Pharo, "Agir et pâtir au travail. Souffrance morale et injustice," *Revue de médecine psychosomatique*, no. 20, 1989). Pharo's analysis of the search for injustice applies very closely to the case that concerns us here: "But there are many cases of horrendous misfortune in which one cannot find anything or anyone, not even oneself, to incriminate. Can one still speak of injustice? It seems to me that one cannot. One thing is for sure, the clear absence of injustice does not prevent suffering. Perhaps injustice is the name suffering takes on in the language of men, that is to say in their intercomprehension. One could perhaps say then that it is a consolation more than a cause."

65. "The man who is said to be 'normal' symmetrically satisfies the demands of reality and of his own instincts. On the one hand, he exchanges goods and services for money; on the other hand, with this money he secures warmth, food, love, and survival for himself. But in certain other, no less valid, cases, such as those mentioned above, the mother, the saint, or the artist, there is a dissymmetry—a fortunate one if it receives compensation. That is what Theo did for Vincent" (Charles Mauron, "Vincent et Théo," *L'Arc*, special issue on van Gogh, n.d.).

66. Forrester, *Van Gogh ou l'enterrement dans les blés*, p. 114.

67. Michel Foucault, *Histoire de la folie* (Paris, 10/18, 1971), p. 304.

68. "The necessarily profaning aspects of the work turn around, and the world experiences its guilt in the space of a work that has collapsed into lunacy. Henceforth, through the mediation of madness, the world itself becomes guilty (for the first time in the Western world) with regard to the work; the latter summons the world, subjects it to its linguistic order, compels it to recognize and atone, to give an explanation *of* and *to* this insanity" (ibid., p. 303).

69. Georges Bataille, "Van Gogh Prométhée," *Verve*, no. 1, December 1937 (*Oeuvres complètes* [Paris, Gallimard, 1970], vol. 1, p. 500).

70. In the sense in which Norbert Elias uses the term (Norbert Elias, *The Civilizing Process* [New York, Urizen Books, 1978]).

71. "A standard by which persons measure themselves, the hero is a means by which an aggregation of persons becomes a community, members one of another. . . . Though singular in the sense of being one and not common, a hero is the reverse of independent" (Kenelm Burridge, *Someone, No One: An Essay on Individuality* [Princeton, Princeton University Press, 1979], p. 44.) For some thoughts on incommensurability in a state of singularity, see Eric de Dampierre, *Penser au singulier* (Paris, Société d'ethnographie, 1984).

72. See René Girard, *La violence et le sacré* (Paris, Grasset, 1972), especially his analysis of the role of Oedipus, p. 119, passim; Peter Brown, *Society and the Holy in Late Antiquity* (London, Faber and Faber, 1982).

73. On the view of the singular as a "danger" to "purity," see Mary Douglas, *Purity and Danger: An Analysis of Concepts of Pollution and Taboo* (New York, Praeger, 1970), especially on the mechanisms used to manage anomalous phenomena, and on the avoidance of the bizarre. On the unusual as taboo, see Mircea Eliade, *Traité d'histoire des religions* (Paris, Payot, 1949), or Jean Cazeneuve, *Sociologie du rite* (Paris, Presses universitaires de France, 1971), pp. 63–64 ("What is not subject to

this rule, what is abnormal, appears straightaway as impure. . . . And that which is a revelation of impurity is taboo in itself").

74. The stigmatization of witches on trial is the symmetrical and inverted form of the heroization of saints: the judge takes the place of the hagiographer, the monster inhabited by the devil takes the place of the saint inhabited by Grace, inhumanity replaces the sublime, horror replaces admiration. See Nicole Jacques-Chaquin, "Vies de sorcières," *Cahiers de sémiotique textuelle*, vol. 4 (Paris-X, 1985), pp. 72–73.

75. See Pharo, "Agir et pâtir au travail," p. 41.

76. "Sacrifice is an effective antidote to the problem, since it provides some purchase on guilt, *for it can arouse and temper it, fix and move it, transform it from something imaginary into something real* by way of *irreversible* acts, violence being furthermore . . . diverted and channelled toward the outside. Moreover, this guilt is directed from each onto the other (the victim, the leader, or the outside enemy) in the collective movement of alliance" (Rosolato, *Le sacrifice*, p. 64).

77. For some thoughts on envy, see George M. Foster, "The Anatomy of Envy: A Study in Symbolic Behavior," *Current Anthropology*, February 1972.

78. The conjunction of singular and community in prophecy comes to the fore in Paul Ricoeur's remark that "no matter how singular a call may be, it only begins inasmuch as it follows and connects. The conjunction in suffering of an *exceptional selfness* and a *traditional community* is thus an essential aspect of the prophetic utterance. In this conjunction, the prophetic ego gets 'established' and 'ordered'" (Paul Ricoeur, "Le sujet convoqué. A l'école des récits de vocation prophétique," *Revue de l'Institut catholique de Paris*, October–December 1988).

79. Freud suggests this line of thinking when he refuses to define the substantial properties of "great men," and instead seeks to define them functionally, in terms of the influence they had. This does not stop him from attempting, immediately afterwards, to define that influence in substantial terms. See Sigmund Freud, *Moses and Monotheism*, translated from the German by Katherine Jones (New York, Vintage Books, 1939), pp. 136 ff.

Chapter Five
Money As a Medium of Atonement

1. On the components of so-called "popular" culture, see Richard Hoggart, *The Uses of Literacy: Aspects of Working-Class Life* (Harmondsworth, Penguin, 1958).

2. For example, there were several hundred showings of *Van Gogh* staged at the Lucernaire in Paris in 1987.

3. "L'homme au chapeau de pailles" (1961), "Vincent, mon frère" (1970), "Vincent" (1972), "Van Gogh" (1988), "Théo je t'écris" (1989) (respectively sung by Robert Niel, Lenny Escudero, Don McLean, Vittorio Pugnetti, and Pierre Bachelet (this information was kindly provided by SACEM).

4. The "Van Gogh" exhibition at the Orangerie in Paris drew 495,000 people in 1972. 1.3 million people attended similar events in Amsterdam and Otterlo in 1990. For comparison's sake, and looking only at attendance records in Paris, 1.2 million people passed through the turnstiles at the Tutankhamen exhibition in

1967, 347,000 visited Matisse in 1970, and 506,000 saw the Impressionism exhibition in 1974 (see *Des chiffres pour la culture* [Paris, La Documentation française, 1980]).

5. This is shown to be true when a van Gogh painting is prohibited from leaving France, on the basis of the law of June 23, 1941, which declares that the state may prevent a work of art from being taken out of the country, if it is "of artistic or historical national interest."

6. L. Roelandt, preface to *Lettres à Van Rappard*, p. 19.

7. Not taking into account the general decline registered in the 1930s (see Raymonde Moulin, *Le marché de la peinture en France* [Paris, Minuit, 1967]). Between 1900 and 1906, *Roses trémières* increased in market value by 135%; a still life by van Gogh had gone up by 450% by 1919; *Usines à Clichy* had increased by 28,900% by 1928, and by 158,000% in 1957, in relation to 1884 (see François Duret-Robert, in *Vincent Van Gogh* [Paris, Hachette, 1968], pp. 234–235). "It is generally considered that Mrs. Walter triggered the race toward ever higher prices for modern paintings (a race in which van Goghs were to score brilliant results), when she offered thirty-three million for a still life by Cézanne at the Cognacq auction in May 1952. . . . It must be admitted that van Goghs have enjoyed spectacular increases since 1950" (ibid., p. 236).

8. *La Tribune de Genève*, October 3, 1990, and the auction catalog, Geneva, December 6, 1990 (note that the chair had been purchased in 1927).

9. "The trade was so deeply rooted in custom that relics tended to be seen as just another valuable object" (Nicole Hermann-Mascard, *Les reliques des saints. Formation coutumière d'un droit* [Paris, Klincksieck, 1975], p. 353).

10. See Marcel Mauss, "Essai sur le don," in *Sociologie et anthropologie* (Paris, Presses universitaires de France, 1950). "Tense competition directed not just toward the stake (in this case the coveted painting), but toward victory over the opponent, is a ludic element. The agonistic tendency is present not only among the bidders, but also among the auctioneers, who compete internationally to set the world record for the highest bid" (Moulin, *Le marché de la peinture en France*, p. 390, as well as p. 204 passim). See Jean Baudrillard also, "L'enchère de l'oeuvre d'art," in *Pour une critique de l'économie politique du signe* (Paris, Gallimard, 1972).

11. The gift's lack of reciprocity here allows the temporal concentration of an exchange which, in its canonical form, requires some waiting period so as not to appear as an obligation (see Pierre Bourdieu, *Esquisse d'une théorie de la pratique* [Geneva, Droz, 1972]—the expenditure, much more than the gift, appearing here as the fundamental element in the transaction.

12. "At public auctions, prices are usually noticeably lower than in art galleries. Of course, from time to time there are big show auctions, at which prestigious collections get sold off. . . . During these shows, prices can sometimes exceed what the paintings would have fetched in a gallery. But it goes without saying that those are exceptional cases" (Duret-Robert, *Vincent Van Gogh*, p. 10).

13. Thorstein Veblen, *The Theory of the Leisure Class* (New York, Modern Library, 1934).

14. See the analysis upon which Michel Aglietta and André Orléan (*La violence de la monnaie* [Paris, Presses universitaires de France, 1982], p. 17) base their analy-

sis of monetary phenomena: "Market relations are defined by acquisitive violence, i.e., a violence (that we call all-consuming) which is diverted onto objects."

15. "In van Gogh's case, the hierarchy is as follows, always in decreasing order of significance: the period of Arles, that of Saint-Rémy, that of Auvers, that of Paris, and finally the Dutch period" (François Duret-Robert, *Marchands d'art et faiseurs d'or. A quoi tient le prix d'un tableau* [Paris, Belfond, 1991], p. 126).

16. Maurice Rheims, quoted in an advertisement for a book on van Gogh. The work's very novelty can also appear as a manifestation of the power to work miracles of a creator who is able to rise above the rules. The same holds true for the extraordinary and unforeseeable monetary fluctuations of his works, their constantly increasing prices: "The new always happens against the overwhelming odds of statistical laws and their probability, which for all practical, everyday purposes amounts to a certainty; the new therefore always appears in the guise of a miracle" (Hannah Arendt, *The Human Condition* [Chicago, University of Chicago Press, 1958], p. 178).

17. Philippe Simonnot, *Doll'art* [Paris, Gallimard, 1990], pp. 89, 45. It is not irrelevant, in this critical context halfway between the ordinary and scholarly worlds, that Simonnot is a journalist committed to exposing scandals and swindles.

18. Simonnot, *Doll'art*, p. 34.

19. Duret-Robert, *Vincent van Gogh*, pp. 285 and 111.

20. Georges Bernier, *L'art et l'argent* [Paris, Ramsay, 1990], p. 277.

21. Simonnot, *Doll'art*, p. 44.

22. These various interpretations are borrowed from the previously cited works of Bernier, Duret-Robert, Moulin, and Simonnot, as well as from the contributors to X. Dupuis and F. Rouet, eds., *Economie et culture. Les outils de l'économiste à l'épreuve* [Paris, La Documentation française, 1987]. On how speculation has permeated the art market, see Raymonde Moulin, "Le marché et le musée. La constitution des valeurs artistiques contemporaines," *Revue française de sociologie*, vol. 27, no. 3, July–September 1986.

23. On this topic, see Luc Boltanski, *L'amour et la justice comme compétences. Trois essais de sociologie de l'action* [Paris, A.-M. Métailié, 1990, p. 30]. The reader may recall the story of the Japanese billionaire who had to give up his idea of being cremated along with a Renoir and a van Gogh ("two of the most expensive paintings in the world," *Le Figaro*, May 14, 1991), in the face of international protests—especially those of the French authorities, who were thus compelled to face a legal vacuum with respect to the protection of works of art as a part of the heritage of mankind, the only legislation currently available regarding the moral rights of living artists.

24. Gérard Garouste (quoted in Simonnot, *Doll'art*, p. 45) and Edouard Pignon (interviewed in Abraham Segal's film).

25. "At first money appears as the principle of homogenization that makes various commodities commensurable. . . . But a logic of equivalence is by definition a violent logic, for it designates a process which negates all differences; heterogeneity becomes insignificant" (Aglietta and Orléan, *La violence de la monnaie*, pp. 56–57). Similar thoughts are also to be found in Georg Simmel, *The Philosophy of Money* (London, RKP, 1978), and Arendt, *The Human Condition*, p. 167: "Among the

things that give human artifice the stability without which it could never be a reliable home for men are a number of objects which are strictly without any utility whatsoever and which, moreover, because they are unique, are not exchangeable and therefore defy equalization through a common denominator such as money; if they enter the exchange market, they can only be arbitrarily priced."

26. To use Walter Benjamin's expression ("Eduard Fuchs, collectionneur et historien," *Macula*, nos. 3–4, 1978).

27. On the notion of irreducibility applied to persons, see Paul Ricoeur, *Soi-même comme un autre* (Paris, Seuil, 1990).

28. The value of "works of genius" is not indexed to the "cost of living," or to any calculable indicators such as time or the cost of the materials used. One specialist has pointed out that such works regularly fetch higher prices than *objets d'art*, to the extent that the popular press dubs them "priceless," even though they bear an all-too-obvious price tag (Gerald Reitlinger, *The Economics of Taste* [London, Barrie and Rockliff, 1963], II, p. 2).

29. *Art Press*, July–August 1990 (review of a re-issue of Artaud's text).

30. On the correctness/fairness (*justesse/justice*) binomial, see Boltanski, *L'amour et la justice comme compétences*.

31. "It is the immense, dizzying, radical, primitive under-rating which keeps up the fantasy of speculation, and therefore the *reality* of speculation, since this fantasy suffices to make speculation real. What makes the price of a van Gogh today is the fact that its market value in 1890 was equal to zero; one month after the spectacular stock-market crash on Wall Street (October 19, 1987), the *Irises* were auctioned off in New York for $54 million. The initial complete absence of market value makes a van Gogh an ideal object in the speculative circuit" (Jean-Joseph Goux, "Les monnayeurs de la peinture," *Cahiers du Musée national d'art moderne*, special issue on "L'art contemporain et le musée," 1989, p. 32).

32. Duret-Robert, *Vincent Van Gogh*, p. 232.

33. Viviane Forrester, *Van Gogh ou l'enterrement dans les blés* (Paris, Points-Seuil, 1984), p. 216 (referring to père Tanguy).

34. J. Coignard, *Elle*, June 11, 1990.

35. Duret-Robert, *Vincent Van Gogh*, p. 240.

36. Advertisement for an art magazine. There is a scene in Michael Rubbo's 1990 film, *Vincent and I*, which also plays on that discrepancy: a young woman of today visits van Gogh in Arles a century ago, and tells him about the prices paid for his work one hundred years later—to the painter's incredulous amusement. Robert Altman draws particularly well on this feeling in his 1989 film, *Vincent and Theo*, which opens in a documentary broadcast of the *Sunflowers* auction, the soundtrack of which is then juxtaposed with fictional footage of a scene of poverty in the Borinage region.

37. Henri Perruchot, *La vie de Van Gogh* (Paris, Hachette, 1955), p. 372; Jean Monneret, Introduction to the *petit journal* of the Vincent van Gogh exhibition at the Salon des indépendants, Grand Palais (Paris, 1990).

38. Duret-Robert, *Vincent van Gogh*, p. 68.

39. Besides specifically financial motifs, which naturally play their part, the familiarity of the theme of self-sacrifice in the Japanese tradition suggests an additional explanation of the strong Japanese presence in the bidding for van Gogh. In

that tradition, suicide (perceived as an "expiation of failure") is considered a form of self-sacrifice which arouses "admiration and gratitude." "Companionship suicide" is also practiced; and this could furnish a model for reading Theo's premature death shortly after Vincent's voluntary demise (cf. Maurice Pinguet, *La mort volontaire au Japon* [Paris, Gallimard, 1984], pp. 49 passim, 66, 75 passim).

40. This difference has been theorized in terms of an opposition between "autographic" and "allographic" arts (Nelson Goodman, *Languages of Art: An Approach to a Theory of Symbols* [Indianapolis, Bobbs-Merrill, 1968]).

41. "This is a cumulative dynamic. . . . The more an object is coveted, the more desirable it becomes" (Aglietta and Orléan, *La violence de la monnaie*, p. 59). "It is a fact: usually paintings change value when they change authors. When their new author is better known than the previous one, their prices rise" (Duret-Robert, *Vincent Van Gogh*, p. 62).

42. This point of view owes much to Michel Henochsberg's suggestions. See Raymonde Moulin, too ("La genèse de la rareté artistique," *Ethnologie française*, vol. 8, nos. 2–3, 1978, p. 242): "The work of art is unique, irreplaceable, and nevertheless inalienable, a virtually indestructible object of enjoyment because the gaze that contemplates it does not alter it; it is a sterile product like gold, which like gold falls into the category of sheltering or speculative investments. The work of art is the ideal-type of a rare commodity of which the supply is rigid, and the value is determined by demand."

43. Paul Veyne, *Comment on écrit l'histoire* (Paris, Points-Seuil, 1978), p. 229, and P. Veyne, *Les Grecs ont-ils cru à leurs mythes?* (Paris, Seuil, 1983), p. 100.

Chapter Six
The Gaze As a Medium of Atonement

1. To give an indication of this: one of the associations organizing trips to Amsterdam charged 2200 francs for two days, and 2975 francs for three days, departing from Paris; 3750 francs for five days departing from Lyon and 3925 francs from Marseille; 4970 francs for six days departing from Lyon and 5250 from Marseille.

2. Christian Boltanski, interviewed in the *Journal of Contemporary Art*, vol. 2, no. 2, 1989, pp. 22–23.

3. "The first is the acquisition or veneration of relics; the second draws on the cult of the holy body" (Alphonse Dupront, *Du sacré. Croisades et pèlerinages, images et langages* [Paris, Gallimard, 1973], p. 193). "Pilgrimage to the image, the medium of the miracle's power, is presently by far the most important [form of pilgrimage], at least from a statistical point of view" (ibid., p. 196).

4. Since relics are "all that is left on earth of a saint or a beatified person after his or her death, . . . material objects which have been in an immediate or mediated relation with the saint or beatified person, . . . everything that recalls the saint and conjures up his or her presence, in our minds as before our eyes, can be considered a venerable relic" (A. Vacant et al., *Dictionnaire de théologie catholique* [Paris, Letouzey et Ané, 1939], pp. 2312–2314).

5. "The cult of relics is based upon the principle that contact with, as well as ingestion, use or veneration of, something which was part of a person rich in virtue (or belonged, or was close to that person, makes it possible to partake of that

person's qualities" (Nicole Herrmann-Mascard, *Les reliques des saints. Formation coutumière d'un droit* [Paris, Klincksieck, 1975], p. 12).

6. Unfortunately, "the mutilated lobe suffered a curious fate. Madame Virginie, who ran the brothel, gave the ear to Officer Robert; twenty-four hours later, the police chief had it transferred to Rey. It was by then too late to sew it back on, so they put it in a jar, which was destroyed several months later, during the intern's stay in Paris" (Pierre Cabanne, *Van Gogh* [Paris, Aimery Somogy, 1973], p. 275, note 159).

7. On the "epidemic of thefts of relics," "the only sure means of obtaining authentic relics," and on fake relics, see Hermann-Mascard, *Les reliques des saints*, chapter 5.

8. "The faithful can only be asked to revere relics, if the authentic attribution of those relics has been recognized in a written, official document. . . . This stern measure has been applied to prevent dubious or superstitious relics from being honored. The piety of the faithful has nothing to lose from the love of truth or the progress of historical science. The Ordinaries must therefore cautiously remove relics when they are certain of their unauthenticity. . . . The public exhibition of a false relic, known to be fake, *scienter*, would open the way *ipso facto*, to the excommunication reserved for the local Ordinary" (Vacant et al., *Dictionnaire de théologie catholique*, p. 2374).

9. "To attribute this painting to van Gogh is to insult the master," de La Faille wrote in the first book on fake van Goghs (Jean-Baptiste de La Faille, *Les faux Van Gogh* [Paris, 1930], p. 26), significantly interweaving an error with respect to the object and a fault committed against the man. We encounter the same overlap in a newspaper account of a spring 1990 theft from a Dutch gallery: the victim is personalized ("Van Gogh victime de l'insecurité," *Le Monde*, June 30, 1990), as are the works, which are held to be "unsaleable," and therefore likely to be "held for ransom," just as in a kidnapping case (*Libération*, June 29, 1990).

10. See Alfred Lessing, "What Is Wrong with a Forgery?" in Dennis Dutton, ed., *The Forger's Art: Forgery and the Philosophy of Art* (Berkeley, University of California Press, 1983), in particular.

11. "Art lovers, . . . who are prepared to spend a fortune on a painting as long as they think it is by a master, refuse to spend a nickel on it if they see it is by someone unknown. This is an almost absolute principle, and its impact on the art market is constantly felt" (François Duret-Robert, *Marchands d'art et faiseurs d'or. A quoi tient le prix d'un tableau* [Paris, Belfond, 1991], p. 32).

12. Unpublished, dated May 30, 1990. Emphasis added.

13. Thus, an English television program entitled "J'accuse" devoted an episode to van Gogh, among the most overrated personalities: Virginia Woolf, the Rolling Stones, Mozart, Dior, Britten . . . (*The Times Literary Supplement*, February 1991).

14. Viviane Forrester, "Van Gogh ou comment s'en débarasser," *Art Press*, July–August 1990. Emphasis added.

15. Viviane Forrester, in an interview with Abraham Segal, and in "Opération van Gogh," *Libération*, June 2–3, 1990. In particular, Forrester reproaches the catalog for presenting van Gogh as a "clever go-getter," for speaking of an "unfinished oeuvre," as well as of "personal and commercial success," of a "career," of "commercial opportunities," and for saying that in Auvers "his zeal and ardor were extin-

guished"—whereas, on the contrary, "of the petition of the citizens of Arles, 'those virtuous cannibals' as Vincent put it, who obtained his incarceration in the Arles asylum, not a trace. Never." Forrester also attacks the "descendants," the "family," the "official documents, in which the painter's point of view is sagaciously ignored, and only contemporary reproof is taken into account."

16. Viviane Forrester, *Van Gogh ou l'enterrement dans les blés* (Paris, Points-Seuil, 1984), p. 275.

17. See Luc Boltanski, *L'amour et la justice comme compétences. Trois essais de sociologie de l'action* (Paris, A.-M. Métailié, 1990), p. 137 passim.

18. Maurice Serullaz, *Peintres maudits* (Paris, Hachette, 1968), p. 12. Emphasis added.

19. This discussion of interiority and giving owes much to the work of Charles Fredrikson (see especially his forthcoming "Les intermittences du don").

20. This shows up the limitations of any "pure" aesthetics that would claim to account for artistic experience by relating it to a metaphysics of works, independently of a sociology, psychology, or anthropology of viewing subjects. Analogous limitations apply in the cases of a "pure" economics founded on a metaphysics of values, and of a "pure" theory of love (a love that is itself "pure," free of all ambivalence and rivalry) founded on a metaphysics of beings.

21. However, what is implicit is not necessarily hidden or unknown, for the moral character of behavior which is not explicitly moral can be known and experienced by the subjects even if it remains unspoken. To make it explicit, as I am doing here, is not tantamount to saying the obvious or disclosing "hidden things." If the latter really were obvious, they would or could be uttered by the people involved without any sense of provocation, violence or revelation. Were they really hidden, nobody would be able to recognize them, no feeling of truth would be felt in hearing them. Making explicit what is implicit is rather a question of rendering visible what normally remains unseen by the members of a common culture, what is both present and unnoticed, invisible yet familiar. The analyst's role is to transform this unspoken familiarity into something strange and foreign. (These thoughts owe much to the work of Francis Chateauraynaud).

Chapter Seven
Presence As a Medium of Atonement

1. Pierre Michon, *Vie de Joseph Roulin* (Verdier, 1988); Roger Golbery, *Mon oncle Paul Gachet* (Paris, Editions du Valhermeil, 1990).

2. See the notion of the "contagiousness of the sacred" proposed by Durkheim (*Les formes élémentaires de la vie religieuse* [Paris, Presses universitaires de France, 1985], p. 455).

3. It was the same with martyrs: "The anniversary of their death, once commemorated quite timidly, almost intimately and not without recurrent anguish, is transformed into a day of joy and elation. The faithful in the area get together, their neighbors join in, the local bishops hasten to make the proceedings more solemn by their presence" (H. Delehaye, *Les passions des martyrs et les genres littéraires* [Brussels, 1921], p. 183). "The careful noting of the anniversaries of the deaths of martyrs and bishops gave the Christian community a perpetual responsibility for

maintaining the memory of its heroes and leaders" (Peter Brown, *The Cult of the Saints: Its Rise and Function in Latin Christianity* [Chicago, University of Chicago Press, 1981], p. 31).

4. The same characteristics are to be found in the canonization of martyrs: ". . . building houses of worship near or over the martyr's tomb, gathering the community to celebrate the anniversary of his death, entering his name into the Church calendar. In addition, the martyr's tomb becomes a center for pilgrims. . . . The *Passion* is the epic of the hero, the tale of his feats which focuses community attention upon him. Reading his *Passion* during the celebration of his anniversary contributes to maintaining a memory that is essential to the cult's continuation" (Francesco Chiovaro, *Histoire des saints et de la sainteté* [Paris, Hachette, 1986], p. 75).

5. Mediation is full of ambiguities. The president of the van Gogh foundation in Arles "asks artists to create some work and offer it to van Gogh." "But, Abraham Segal points out in his film, it is *you* they are offering it to, isn't it?" Embarrassed, she replies, "Yes, but I am only a mediator." The point is that the quality of the mediator who brings the admirer closer to the idol is commensurate with his or her ability to identify with the object of worship, and in particular to take up the latter's burden of suffering. A photograph of the filming of Maurice Pialat's *Van Gogh* bears the *legend* (the word's polysemy is not gratuitous in this case): "This has been the hardest shoot of his acting career. . . . For four months, Jacques Dutronc has had to endure virtual torture at the hands of his director. Marie-Laure de Decker's photograph records the hell he has been through. The distress that can be read in his features is so profound, it is hard to say whether the pain is his own or van Gogh's. Will the actor-painter be rewarded with some acting prize at the end of this martyrdom?"

6. "The cult of martyrs thus appears as a spontaneous movement in the community. The hierarchy's role is limited to repressing abuses and purging exaggerated behavior. The bishop's panegyrics to the martyrs do not appear as official approval of the cult, but as the hierarchy's participation in the expression of the common feeling of the faithful" (Chiovaro, *Histoire des saints et de la sainteté*, p. 75).

7. The pattern observed here corresponds to Charles Fredrikson's unpublished analysis of traditional religious demonstrations, which also begin with a pre-procession (at the center), followed by a procession to the idol (at the periphery).

8. *Translator's note*: "Shapelle 5.20.100" is an untranslatable pun on the name *Chapelle Saint-Vincent* (Saint Vincent's Chapel).

9. Or, to be more precise, borrowing Goffman's "frame analysis," the setting is transformed by means of a parodic "keying" of the ceremonial framework, which has for its part already been "keyed" with respect to the primary setting of ordinary experience (see Erving Goffman, *Frame Analysis: An Essay on the Organization of Experience* [New York, Harper and Row, 1974]).

10. The ambivalence of tragedy and comedy (highlighted in the subtitle of the English edition of J. H. Huizinga's book on Rousseau: *The Making of a Saint: The Tragi-Comedy of Jean-Jacques Rousseau*) has been noted by one of van Gogh's biographers: "as tragic as the loss of life, as comical as Tartarin" (Yvon Taillandier, "Voyage à travers une oeuvre," in *Vincent Van Gogh* [Paris, Hachette, 1968], p. 64).

11. See Mikhail Bakhtin, *Rabelais and His World*, trans. by Hélène Iswolsky (Bloomington, University of Indiana Press, 1984). In the same spirit, a flyer posted by other young people in the streets of Arles read: "3615 Vincent—*l'oreille qui vous écoute* (lending an ear to your problems)" (cited in Abraham Segal's film).

12. In his short story, "The Birthplace," Henry James offers a good description of the denunciation of celebration by way of parody and excess. The story portrays the different ways in which the cult of authenticity and the legend of the great man are deployed, from the popular devotion of "simple people" enthusiastically embracing their hero, comforted by "authorities," to the skepticism of the expert or the critical outlook of the scholar: "There would be more than one fashion of giving away the show, and wasn't *this* perhaps a question of giving it away by excess? He could dish them by too much romance as well as by too little. . . . It was a way like another, at any rate, of reducing the place to the absurd" (Henry James, "The Birthplace," in Leon Edel, ed., *The Complete Tales of Henry James* [Philadelphia and New York, J. B. Lippincott, 1964], vol. 11 (1900–1903), p. 453).

13. "On the other hand, an opposite tendency [to sacralization] has been observed, that of resistance to the sacred, a resistance that emerges in the very core of the religious experience. Man's ambivalent attitude toward the sacred, which is simultaneously attractive and repulsive, beneficial and dangerous, can be explained not only with respect to the ambivalent structure of the sacred in itself, but also with respect to man's natural reactions to a transcendent reality that attracts and terrifies him with equal force" (Mircea Eliade, *Traité d'histoire des religions* [Paris, Payot, 1949], pp. 386–387). "All that is unusual, singular, new, perfect, or monstrous becomes the recipient of magical-religious forces and, according to circumstances, an object of veneration or fear, by virtue of the ambivalent feelings to which the sacred constantly gives rise" (ibid., p. 25). Durkheim used the term "ambiguity" in this context (Durkheim, *Les formes élémentaires de la vie religieuse*, p. 584 passim). The ambivalence of the sacred also appears in René Etiemble's *Mythe de Rimbaud. 2. Structure du mythe* (Paris, Gallimard, 1954), p. 435 passim.

14. "The cult of heroes is associated with a precise location, a tomb, marking the subterranean presence of the deceased, whose remains have sometimes been sought in distant lands in order to return them to their proper place" (Jean-Pierre Vernant, *Mythe et religion en Grèce ancienne* [Paris, Seuil, 1990], p. 59). "For the cult of saints . . . designated dead human beings as the recipients of unalloyed reverence, and it linked these dead and invisible figures in no uncertain manner to precise living representatives" (Brown, *The Cult of the Saints*, p. 21; on pilgrimages to Rousseau's tomb, see Huizinga, *The Making of a Saint*, p. 13). As for Kafka, his grave in Prague "is covered with hundreds of slips of paper, derisory messages left by visitors" ("Franz Kafka's Last Address," *Libération*, September 21, 1990).

15. "To rediscover the life of the founder, the man who is God, to imbue oneself with his entire story, to bring back stones, earth, or debris of any sort, that is the highest sacralization in the act of the pilgrim" (Alphonse Dupront, "Pèlerinage et lieux sacrés," in *Méthodologie de l'histoire et des sciences humaines. Mélanges en l'honneur de Fernand Braudel* [Toulouse, Privat, 1973], pp. 192–193).

16. "To seek to make understanding of his works the condition of the reality of the presence and spiritual existence of a saint would be to demean him and to

reduce his greatness to that of a genius" (Max Scheler, *Le saint, le génie, le héros* [Fribourg, Egloff, 1944], p. 89).

17. "In the footsteps of van Gogh"; "Van Gogh in Provence"; "A Weekend in Provence"; "Walking Tour"; "A Summer in Auvers-sur-Oise"; "Cruises on the Oise" with a visit to the village, graveyard, and Daubigny workshop; "Day Tour" of Giverny, Auvers, and the Prieuré museum in Saint-Germain-en-Laye (tourist information brochure).

18. On the notion of *communitas* in pilgrimages, see Victor and Edith Turner, *Image and Pilgrimage in Christian Culture: Anthropological Perspectives* (Oxford, Basil Blackwell, 1978).

19. See Robert K. Merton, "The Unanticipated Consequences of Purposive Social Action," *American Sociological Review*, no. 65, March 1936.

20. Those words were spoken to Abraham Segal by a German woman who had come on her own (and not in the context of any collective celebration) to meditate in the Auvers graveyard.

21. *Translator's note*: The author uses the word *réparations* here to bring out all of these dimensions. Its various meanings include repairs, atonement, redemption, reparations, restitution.

22. As in the case also of artists like Edouard Pignon. In 1988, the Van Gogh Foundation in Arles approached him to produce a painting. "I hadn't in the least made up my mind to paint the picture," he said. "I suddenly decided to do it, and with a sudden surge of enthusiasm, after the strange shock of the sale of the *Irises*."

23. This problem typically arises in the case of people called upon to sign petitions, as Bourdieu has pointed out. Those who refuse to sign must explain why publicly, if they wish it to be known that their silence is voluntary, and not due to being excluded from the circle of petitioners.

24. Or, to be more precise, his self-sacrifice, which joins giving and interiority. The sacrificial gift acquires the additional interiorized dimension of a self-sacrifice. The author of the sacrifice separates himself from the commonplace by *parting*, not with some external thing, but with a part of himself—part of his hope for happiness, part of his mind, even part of his body. "Such is the principle both of asceticism and the offering, indeed of every act whereby one spontaneously deprives oneself of pleasure or goods. It is a well-known fact that asceticism is the way of power. Individuals voluntarily do not go to the limits of their legal or material possibilities, avoiding actions that would be legal or within their power, thus maintaining an ever-widening margin between what they could do, *de jure* as much as *de facto*, and what they are content with: and lo and behold, every renunciation is credited to them in the mythical world, assuring them an equal margin of supernatural possibilities. . . . Ascetics who increase their powers inasmuch as they reduce their pleasures distance themselves from men, grow closer to the gods, and soon become their rivals. The equilibrium is now broken in their favor" (Roger Caillois, *L'homme et le sacré* [Paris, Gallimard-Folio, 1988], pp. 34–35).

25. "*Themis* is separated from *dikè* by the fact that the former, unlike the latter, is utterly removed from the world of calculating and accounting; while revenge, which is the violent face of *dikè*, points toward the recovery of a debt" (François Tricaud, *L'accusation. Recherche sur les figures de l'agression éthique* [Paris, Dalloz, 1977], p. 77).

26. See Pierre Bourdieu, *Esquisse d'une théorie de la pratique* (Geneva, Droz, 1972).

27. On the question of giving and indebtedness, see the work of Charles Fredrikson ("Don et dette. La fabrication du social," unpublished, 1990).

28. Even if the "demand that an infinite unpaid debt be settled" is impossible and insane, as Boltanski notes, borrowing an expression from Ricoeur (Luc Boltanski, *L'amour et la justice comme compétences. Trois essais de sociologie* [Paris, A.-M. Métailié, 1990], pp. 121–122). See Tricaud, *L'accusation*, p. 8.

Conclusion

1. Van Gogh has come to symbolize the madness of unjustly neglected artists. In Bruno Nuytten's 1989 film, *Camille Claudel*, a copy of the *Crows* can be seen hanging in the critic's office where Camille Claudel is supposed to have suffered her first attack of paranoia around 1900. The film also features the motif of collective guilt (of the family, society) toward the misunderstood creator, as well as the ambivalence of the brother, who is both an ally and suspected of treason (Paul Claudel and Theo).

2. See Jerrold Seigel, *Bohemian Paris: Culture, Politics and the Boundaries of Bourgeois Life, 1830–1930* (New York, Penguin, 1987). On the emergence of the notion of the "accursed artist," see Philippe Junod, "Voir et savoir," *Etudes de lettres*, 4th series, vol. 3, April–June 1980. "Gauguin's failure to adapt to society, van Gogh's illness and suicide, the deviant behavior of the Montparnos, all contributed to forging the stereotype of the accursed artist at least as much as the financial difficulties associated with the great masters' early days" (Raymonde Moulin, *Le marché de la peinture en France* [Paris, Minuit, 1967], p. 33).

3. To use the title of Pierre Daix's book, *L'aveuglement devant la peinture* (Paris, Gallimard, 1971).

4. Pierre Cabanne, *Van Gogh* (Paris, Aimery Somogy, 1973), pp. 237–238. Emphasis added.

5. Bob Claessens, *L'incompréhension devant l'art. Un exemple: Vincent Van Gogh* (Brussels, 1973), p. 5; emphasis added. The author wrote these lines as a member of the Popular Education Circle, and stressed that his book was not to be read as a scholarly work. He also discusses the cases of Rembrandt, Seghers (forced to paint on bed sheets), and Hobbema, who ended up washing dishes in a sleazy bar.

6. "The primary starting point of value systems . . . is always the models that exist at a given time, the people who are the living embodiment of those values" (Max Scheler, *Le saint, le génie, le héros* [Fribourg, Egloff, 1944], p. 56).

7. Claessens, *L'incompréhension devant l'art*, pp. 5, 9, 10.

8. From "canvases" to "careers," this phenomenon only systematizes the process highlighted by Harrison and Cynthia White (*Canvases versus Careers: Institutional Change in the French Painting World* [Chicago, University of Chicago Press, 1993]). For a discussion of this question in connection with the "careers" of van Gogh, Duchamp, Dali, and Picasso, see Nathalie Heinich, "Peut-on parler de carrière d'artiste? Un bref historique des formes de la réussite artistique," *Cahiers de recherche sociologique*, no. 16, Spring 1991.

9. The publishing of biographies, and then of artists' biographies (by 1906 and

1918, in the case of Gauguin), became generalized, respectively, from the twenties and forties onwards. (See John Rewald, *Post-Impressionism: From van Gogh to Gauguin* [New York, Museum of Modern Art, 1978]).

10. The connection between personalization and rarity in the modern view of artistic value has been drawn well by Raymonde Moulin: "Rarity is transferred from the work to the artist. . . . The emphasis has shifted from the unique character of the work to the unique character of artist, artists have been forced to differentiate themselves from each other at any cost" ("La genèse de la rareté artistique," *Ethnologie française*, vol. 8, nos. 2–3, 1978, p. 249).

11. "In order to provoke a strong attachment, a work of art must take on an exceptional aspect. Its great value derives from its exceptional character. Those who are attached to it see themselves as exceptional too; it is the exceptional character of their attachment to that work that fuels that attachment. But should they, in their zeal, invite the general public to share their feeling, and should they succeed, what would then happen to the exceptional nature of their attachment? Things have value because they are rare; the more people they reach, the more they depreciate" (Jean Dubuffet, *Asphyxiante culture* [Paris, Minuit, 1986], p. 19).

12. "The instances are now extremely rare in which a person faced with an unfamiliar idiom of painting will dismiss it as the trick of a buffoon who cannot draw. These tantrums we are now happily spared; but the surrender to art on almost any terms seems equally alarming. It is as if the flood-gates of the imagination had been opened and the waters were streaming in without meeting resistance. The sacred fear is no longer with us" (Edgar Wind, *Art and Anarchy*, 3d ed. [London, Duckworth, 1985], p. 35).

13. Claessens, *L'incompréhension devant l'art*, pp. 7–8. In the same spirit, Claessens denounces the "misunderstanding" underlying the popularity of the great artists Giorgione, Titian, and Rubens: "Their case was perhaps more tragic still. . . . Their success was above all based on a misunderstanding; they were admired for what was least great about them. People were attached to the minor aspects of their works; their true contribution was not understood. Cocteau, in a lesson of heroism to artists, was so right to say: 'If the public criticizes something in you, cultivate it; it is you.'"

14. The reference to posterity did not emerge in painting until the second half of the nineteenth century, according to the Whites (whose examples include Zola, Duret, and Houssaye in 1870, and Mallarmé in 1874): "Exclusion from the Salon not only made a painter a figure of interest to readers; it became, in articles by favorable critics, a positive reason for the artist's greatness. It was said, in effect, that public rejection and disapproval of an artist were sure predictors of his essential acceptance as a master. This is an all-too-familiar idea to us now; it has become part of twentieth-century culture. But looking back at the first half of the nineteenth century and earlier one does not find it" (Harrison and Cynthia White, *Canvases versus Careers*, p. 123).

15. Less than a generation after van Gogh's death, Duchamp dubbed the paintings "belated"—perhaps less arbitrarily than he himself had suggested. In this connection, one could quote Robert Klein: "Purely historical considerations of dates and priority by that token become artistically relevant (. . .). This plunge of ex-absolute artistic value into historical 'value of position' also comes across in the

anxiousness to be timely that is as frequent among today's artists as the concern for anatomical correctness or the fear of anachronism in historical compositions were in the past." (Robert Klein,"L'éclipse de l'oevre d'art," in *La forme et l'intelligible* [Paris, Gallimard, 1970], p. 409.)

16. "Sacrifice always entails a consecration: in every sacrifice, an object passes from the common domain into the religious one; it gets consecrated" (H. Hubert and Marcel Mauss, "Essai sur la nature et la fonction du sacrifice," 1899, in Marcel Mauss, *Oeuvres*, I [Paris, Minuit, 1968], p. 203).

17. See Max Weber, *Economy and Society: An Outline of Interpretive Sociology*, ed. by Guenther Roth and Claus Wittich (New York, Bedminster Press, 1968).

18. "It was necessary, too, that going to the gallery be that secular communion of a Sunday afternoon, when devotion to the *corpus* of precious objects, some confiscated from fallen royalty, others looted in wartime, is marked by the silent, patient procession in slow motion from painting to painting, under the dead gaze of guards dressed in black and gold" (Jean Clair, "Du musée comme élevage de poussière," *L'Arc*, "Beaubourg et le musée de demain," n.d., p. 47).

19. See Nathalie Heinich, "La muséologie face aux transformations du statut de l'artiste," in *Cahiers du Musée national d'art moderne*, "L'art contemporain et le musée," 1989. When the theme of the accursed artist became a commonplace, one consequence was the creation, from the 1930s onward, of a series of modern-art museums, aimed at protecting living artists from the ill fate of their predecessors (see Krzystof Pomian, "Le musée face à l'art contemporain," in *Cahiers du Musée national d'art moderne*, "L'art contemporain et le musée," 1989).

20. Wealthy patrons who subsidize exhibitions just raise such offerings to a much higher level: "Quite often, wax, oil, and candles are brought by the faithful. This oblation can be very small. However, such offerings are sometimes so considerable that they provide genuine reserves for ecclesiastical institutions" (Nicole Hermann-Mascard, *Les reliques des saints. Formation coutumière d'un droit* [Paris, Klincksieck, 1975], p. 277).

21. "Virtually all of the faithful are prepared to make genuine sacrifices in order to participate, according to their means, in the ornamentation of the saints' sepulchers and reliquaries" (ibid., p. 279).

22. "The return of the body of the painter of the Revolution and Napoleon, buried in Brussels in 1825, generated considerable controversy in Belgium. The ceremony, which several ministers were to have attended, had already been postponed" (*Libération*, February 13, 1990).

23. Jean Paulhan, "L'artiste moderne et son public" (1954), in Robert Motherwell, *Peintre et public* (Caen, L'Echoppe, 1989).

24. "The painter must first face perdition in order to save others (and save himself). Like Christ, he only receives and saves others because he first gives himself over, without any ever knowing beforehand whether he is headed for perdition or salvation. The painter is not always accursed, but is always consecrated" (Jean-Luc Marion, *La croisée du visible* [Paris, La Différence, 1991], p. 54).

25. "As we file past the paintings, we do not so much consume them like a feast for the eyes, as, willingly or unwillingly, knowingly or unknowingly, pay them the royal tribute that is rightfully theirs" (ibid., p. 58).

26. "Before the least of paintings, we must therefore lower our eyes, to revere its

gift of itself. Only then may we raise them up, in slow respect, to what this gift provides. And finally, we can then attempt to see the outcome of this" (ibid., p. 81).

27. See Pierre Bourdieu and Alain Darbel, *L'amour de l'art* (Paris, Minuit, 1966). The latter is of fundamental importance for its disclosure of the priestly dimension of attendance at galleries and museums. However, it has given rise to interpretations that erroneously identify religious practices as "dominant." In fact, the most immediately devout forms of love of art are the most ordinary ones, by contrast with the more learned practices.

28. Here, for example, is one of those comparisons, in which the assertion of "affinities" between art and religion, simultaneously rules out their analysis: "These affinities work both ways: there is an aesthetic dimension in religion, and a religious dimension in the aesthetic. . . . The religiosity of art—or, if you like, the sacredness of the beautiful—has often been invoked, in very diverse languages and with various intentions. But it is more readily asserted than analyzed" (Marcelle Brisson, *Expérience religieuse et expérience esthétique* [Montreal, Presses de l'Université de Montréal, 1974], p. 231).

29. That is why, as Scheler has noted, "all other types of models, from the genius or hero to leaders in the economy, are, directly or indirectly, dependent on the religious models of their time" (*Le saint, le génie, le héros*, p. 80). On the application of the religious model to the "religion of writing," see Vincent Descombes, in particular, *Proust, philosophie du roman* (Paris, Minuit, 1987), p. 322.

30. "Saintliness is one of the most frequently used words in the Old Testament. But its primitive meaning is unknown and its precise significance is rather difficult to determine" (Vacant et al., *Dictionnaire de théologie catholique* [Paris, Letouzey et Ané, 1939], p. 841). For a critique of the naive or uncontrolled use of the category of "religion" or "the religious" by anthropologists, see Carmen Bernand and Serge Gruzinski, *De l'idôlatrie. Une archéologie des sciences religieuses* (Paris, Seuil, 1988).

Index